The
SWORD
and the
PEN

The
SWORD
and the
PEN

Women, Politics, and Poetry
in Sixteenth-Century Siena

KONRAD EISENBICHLER

University of Notre Dame Press
Notre Dame, Indiana

Copyright © 2012 by University of Notre Dame
Notre Dame, Indiana 46556
www.undpress.nd.edu
All Rights Reserved

Manufactured in the United States of America

Library of Congress Cataloging-in-Publication Data

Eisenbichler, Konrad.
The sword and the pen : women, politics, and poetry
in sixteenth-century Siena / by Konrad Eisenbichler.
p. cm.
Includes analysis and reproduction of many poems
in Italian and modern English translation.
English and Italian.
ISBN 978-0-268-02776-6 (pbk.) — ISBN 978-0-268-07865-2 (e-book)
1. Italian poetry—16th century—History and criticism. 2. Italian poetry—
Women authors—History and criticism. 3. Women and literature—
Italy—History—16th century. 4. Italian poetry—Italy—Siena—History
and criticism. 5. Italy—Politics and government—16th century.
6. Italian poetry—16th century. 7. Italian poetry—Italy—Siena.
8. Italian poetry—Translations into English. I. Title.
II. Title: Women, politics, and poetry in sixteenth-century Siena.
PQ4103.E47 2012
851'.4099287094558—dc23

2012024896

In memory of

Anna "Nelly" Martinolich
(1928–1986)

CONTENTS

APPENDIX
Selected Poetry by Sienese Women

ACKNOWLEDGMENTS

While conducting research for this book over the span of fifteen or more years, I have contracted innumerable debts of gratitude with many generous archivists, librarians, and scholars.

My expressions of thanks must start in Siena. First and foremost, I wish to thank the staff at the Archivio di Stato di Siena and at the Biblioteca degli Intronati di Siena. Everyone at these two wonderful institutions, from their respective directors, Carla Zarrilli and Daniele Danesi, to the reading room personnel, was not only patient with my innumerable requests but also generous with advice. At the State Archive of Siena I am deeply grateful to Patrizia Turrini, Maria Assunta Ceppari, Maria Ilari, and Fulvia Sussi, while at the Municipal Library little could have been done without Mario De Gregorio, Marco Muzzi, Renzo Pepi, Rosanna De Benedictis, and Rosa de Pierro; they are but a few of the many individuals who helped me gather such an abundant harvest from the rich holdings at their institutions. In Siena I am also indebted to Luca Lenzini and his staff at the Biblioteca della Facoltà di Lettere e Filosofia, where I spent many a summer hour browsing the shelves and taking notes. And then there are the local scholars who, at all three institutions, at a café in the Campo, or in the various *contrade,* provided me with sound advice and friendly collegiality. Among them I wish to thank in particular Mario Ascheri, Duccio Balestracci, Elena Brizio, Giulia Maria Calvi, and Giuliano Catoni, as well as the Marquis Tommaso Bichi Ruspoli Forteguerra.

In Florence, I have a debt of gratitude with the staff at the Biblioteca Nazionale Centrale di Firenze and at the Archivio di Stato di Firenze

for their patience and assistance over the many years in which I have carried out this and other projects. I also benefited from the Medici Archive Project, whose database and expert staff helped me on more than one occasion. I am particularly grateful to Joseph Connors, for many years director of the Villa I Tatti, the Harvard University Center for Italian Renaissance Studies, and his wife Françoise, for welcoming me at the Villa on many occasions and sharing not only their knowledge but their friendship with me.

While I never had the opportunity to work at the Biblioteca Nazionale Centrale di Roma, I did benefit greatly from the long-distance help I received from dott.ssa Livia Martinoli, whose kindness and generosity seemed to know no bounds.

Research overseas obliges one to leave home and transplant oneself for long periods of time into a foreign (but often welcoming) new environment. When one can count on local colleagues who become personal friends, the research trip becomes that much more wonderful and rewarding. My travels to Tuscany were, in fact, generously blessed by two wonderful families who welcomed me into their houses and made me feel at home. I am thus particularly grateful and indebted to Ludovica Sebregondi, a colleague and friend of many years, her husband Mario Ruffini, and her sons Federico and Clemente, all of whom became and still are my Florentine family. In Siena I was made to feel part of the family by Elena Brizio, her husband Simone Bartoli, and their wonderful daughters Giovanna and Margherita, all of whom welcomed me not only into their home but into their *contrada*. While Ludovica Sebregondi helped me navigate the labyrinths of the archive in Florence, Elena Brizio did the same for me in Siena. Their learning, scholarship, and generosity seem to have no bounds, and I thank them *dal profondo del cuore*.

In the wider circles of fellow *appassionati* of Italian literature, art, and history, I benefited tremendously from conversations or correspondence with so many that I simply cannot list them all, but I do want to express my thanks at least to the following: Giovanna Benadusi, Pamela Benson, Manuela Berardini, Marlen Biwell-Steiner, Judith Brown, Giovanna Casagrande, Hélène Cazes, M. Luisa Cerrón Puga, Stanley Chojnacki, Gianni Cicali, William J. Connell, Jane Couchman, Virginia Cox, Natalie

Zemon Davis, Bruce Edelstein, John Edwards, Edward English, Meg Gallucci, Margery A. Ganz, Philip Gavitt, Laura Giannetti, Paul Grendler, Mary Hewlett, Brenda Hosington, Philippa Jackson, Margaret King, Vicky Kirkham, Christiane Klapisch-Zuber, Christopher Kleinhenz, Sergius Kodera, Milton Kooistra, Carol Lansing, Alison Williams Lewin, Anne Lind, Giuseppe Mazzotta, Ed Muir, Jacqueline Murray, John Najemy, Elisabetta Nardinocchi, Jonathan Nelson, Nerida Newbigin, James Nelson Novoa, Pina Palma, Sandra Parmegiani, Marie-Françoise Piéjus, Michel Plaisance, Lorenzo Polizzotto, Olga Zorzi Pugliese, Lidia Radi, Sheryl Reiss, Matteo Residori, Diana Robin, Michael Rocke, Giancarlo Rostirolla, Guido Ruggiero, Pasquale Sabbatino, Manuela Scarci, Deanna Shemek, Nicholas Terpstra, Sandrine Thieffry, Stephanie Treloar, Jane Tylus, Anne Urbancic, Paolo Viti, Mary Watt, Elissa Weaver, Raffaella Zaccaria, and Domenico Zanrè, not to mention the colleagues and students who attended the many talks on Sienese women poets I delivered at universities and congresses in Canada, the USA, Italy, Austria, Australia, and South Africa.

Closer to home, I wish to acknowledge the support I have received from the Centre for Reformation and Renaissance Studies (Toronto) and from Victoria University in the University of Toronto, both of whom have been not only my intellectual and professional home but also a source of unfailing support.

This book is dedicated to my aunt and godmother, Anna "Nelly" Martinolich, an indomitable woman who, like the poet Virginia Salvi, suffered exile but never gave up thinking of her homeland, Lussinpiccolo.

All poems in the chapters and the Appendix have been edited on the basis of their earliest printed edition and the extant manuscript sources. To standardize the orthography and facilitate reading for a public not accustomed to the heterogeneity of sixteenth-century printed Italian, I have

- —expanded abbreviations such as the ampersand, macron, and slash (&, ‾, /)
- —rectified u/v and i/j variance to modern usage
- —removed the pleonastic "h" in words such as *anchora, chori, habbi, Helicona, herede, Hiacinto, Himeneo, hoggi, honesta, honorata, hora, horrenda, hostello, talhor, trahe*
- —transcribed the Latinizing "ph" and "th" as "f" and "t" respectively in words such as *ninphe, Thebro*
- —rectified the conjunction *et* as *e,* unless followed by a vowel
- —added accents and apostrophes in words such as *che* → *ché, cosi* → *così, gia* → *già, ne* → *né, piu* → *più, poiche* → *poiché, u* → *u', virtu* → *virtù, vo* → *vo'*
- —rectified capitalization to modern usage: *Io* → *io, Me* → *me* (but retained it in forms of direct address, *Voi,* or in references to the divinity, *Egli*)
- —introduced word division to reflect modern usage: *cha* → *ch'ha, c'hor* → *ch'or, lalata* → *l'alata, lalma* → *l'alma, lhonore* → *l'onore, talche* → *tal che*
- —revised punctuation to modern usage

All translations are mine.

Introduction

In the mid–sixteenth century, as the ancient republic of Siena was coming to an end, torn apart by insoluble internal divisions and by overwhelming external forces, a group of women suddenly appeared on the city's cultural landscape and began to compose poetry that attracted the attention not only of the local literati but also of prominent writers elsewhere in Italy. While today the names of these women sound completely unfamiliar to most scholars of Italian literature, in the sixteenth and seventeenth centuries they rang out loudly to the honor not only of the women who bore them but of their families, their city, and their sex. The poems they composed—sonnets, madrigals, and canzoni—appeared in many of the collections of poetry published in those centuries. They also formed an integral part of the three major collections of women's poetry assembled over the course of three different centuries by Ludovico Domenichi (1559), Antonio Bulifon (1695), and Luisa Bergalli (1726), thus attesting to their enduring popularity.

What is fascinating about these Sienese women poets is not so much that they composed poetry in the Petrarchan style that was current at

1

the time but that some of them engaged with Petrarch's poetic legacy in ways that were significantly different from those of more traditional and better-known Italian women poets of the time, writers such as Veronica Gambara (1486–1550), Vittoria Colonna (1490–1547), Tullia d'Aragona (ca. 1510–56), Gaspara Stampa (1523–54), and Veronica Franco (1546–91), to mention just a few. This volume will thus look at these Sienese women poets as persons who, though part of and fully engaged with a much larger literary, intellectual, social, and political dynamic, were nonetheless individuals in their own right, contributing in an original manner to the world around them. Firmly grounded in the realities of their time, these Sienese women used the Petrarchan idiom to correspond, to plead, to congratulate, and to lament. In so doing, they called upon a network of contacts, both private and public, both literary and political, both lay and religious, that extended well beyond the medieval walls of Siena to reach across the Italian peninsula and as far as the royal house of France and the Imperial family of Spain. And, in one case at least, they crossed the boundaries of normative sexuality to express a profound same-sex affection between two women that was seen as "lesbian" (to use a modern word) even by their own contemporaries.

While it might be tempting to align the current study with Carlo Dionisotti's periodization of women's writing in Italy, this should not be done. In his highly influential "La letteratura italiana nell'età del Concilio di Trento," the Italian scholar acknowledged the presence of women writers throughout medieval and Renaissance Italy but also claimed that such a presence had been limited to a few exceptional individuals. He then suggested that, as a group, women did not appear on the Italian literary stage until the mid–sixteenth century and then only for a very brief time, that is, from about 1538 to 1560.[1] Although Dionisotti's periodization fits very closely with the flowering of women poets in Siena discussed in this volume, I would like to distance my study from it on the grounds that the Sienese case should not be seen as representative of all of Italy. A much more accurate picture of women's writing in Renaissance Italy is presented, instead, by Virginia Cox when she points out that women's presence in Italian letters was "much more durable" than Dionisotti suggested. As Cox convincingly points out, "By at least the last decade of the fifteenth century, women had attained a fairly high-

profile place within Italian literature, a place they held, with fluctuations, for over a century, until the early decades of the seventeenth."[2] My study is thus better seen as yet another *tessera* in the greater mosaic that is women's participation in Italian letters. As a *tessera,* it is small but not insignificant, for it bears some similarities with but also some marked differences from the other *tesserae* in the picture. My study should also be seen in line with Diana Robin's *Publishing Women* (2007) for the contribution it makes to mapping out the networks that encouraged, supported, and disseminated women's writings in Italy. As in the case of the Gonzaga-d'Avalos women studied by Robin, a number of the Sienese women were related to each other by blood or by marriage. Similarly, they were part of a "virtual salon" (to use Robin's fortunate phrase) that, in this case, comprised not only women but also men, not only educated laypersons but also academicians. My first chapter on the *tenzone* between Alessandro Piccolomini and five Sienese women highlights this poetic dialogue across genders, space, and opinions and underlines the active involvement of contemporary women writers in (traditionally) male discourse on the question of fame.

The most important difference between the Sienese women and most other Italian women writers is to be found, however, in their active involvement in the political, religious, and social questions of the time. From the internecine struggles tearing Siena apart to the reform movement spreading silently across the peninsula, from the social constraints faced by many of the women in the group to the same-sex affections motivating at least one of them, the poems composed by these women blurred the line between literature and reality, between fictional and actual. Because of this, my study echoes Deanna Shemek's "understanding of literature as embedded in multiple contexts and in many other discourses."[3] It also follows closely Guido Ruggiero's advice to engage in "a cooperative effort between those who study the texts of literature and those who read the texts of history, especially in the archives," so as to carry out a "close analysis of texts in their historical perspective common to much of the new social history and the new cultural poetics of criticism."[4] As a result, my analysis of the poetry composed by these Sienese women is firmly grounded in archival research and in a sensitive awareness of the contemporary historical context, be it political or

religious, social or sexual. In the words of Sarah Gwyneth Ross, I have sought "to merge rhetoric with lived experience."[5] Such an approach has allowed for a variety of voices, interests, and lives to come to the fore and thus to illustrate the richness of women's presence on the Sienese cultural landscape.

As diverse and perhaps unprecedented as the Sienese case was, it has passed generally unnoticed in the study of Italian history and letters. Apart from some brief and fairly generic references to these women in literary histories and biographical dictionaries (which, for the most part, originated from a local Sienese context), Italian scholars on the whole have remained strangely silent about this exceptional moment of female participation in and engagement with the Italian literary canon from Dante to Bembo, or with the sociopolitical crises of the final years of the Republic of Siena, or with the reform movement in Italy.

The major reason for this silence is, without a doubt, the serious lack of reliable biographical information on these women. Sienese archives provide, at best, only birth and marriage records for them, while manuscript collections in Italian libraries offer even less. The few printed books that mention them merely repeat the same generic platitudes and, worse still, advance unsubstantiated information that, over the course of time, has misled more than one reader. As a result, scholars have tended to ignore these women poets as persons and to dismiss them as writers. The first eminent historian of Italian literature, Girolamo Tiraboschi (1731–94), librarian to Duke Francesco III d'Este, complained that lack of information on Virginia Salvi and other women poets of her time had forced him to remain silent about them in his multivolume history of Italian letters. Clearly exasperated and mindful of the amount of time and energy he would have had to expend in order to remedy this situation, Tiraboschi exclaimed: "But I cannot go searching minutely through everything, and so I must pass over in silence many more women who, as practitioners of vernacular poetry, are praised by the writers of those times, even though none or very few of their poems survive."[6]

Tiraboschi was not alone in ignoring these women writers—nearly all scholars of Italian literature who followed him have done the same. To defend themselves, some have suggested that these women's work

was mediocre and uninteresting and therefore should be ignored—an attitude that has not only excused but even sanctioned a scholarly lack of interest in doing archival research on these women, producing reliable critical editions of their works, or advancing scholarship on them. One example of these naysayers is the late nineteenth-century scholar Eduardo Magliani, who exclaimed, in an obvious fit of irritation:

> What is all this chatter about love and this monotonous and cold procession of verses that sound like so many ideas strung together one after the other without any feeling? Emptiness: the emptiness that was in their souls. Naturally, the poetry of [Isotta] Brambatti Grumelli, so full of subtleties and strange, obscure images, yet another labyrinth, displays the same characteristics; and so does the poetry of Lucrezia Marcelli, who engages in insipid and ineffectual descriptions, and that of Virginia Salvi, who even seems to imitate the aforementioned [Isabella] Andreini:
>
> > Sweet disdains and sweet wraths
> > Soft truces and peace
> > That make sweet every bitter, wicked suffering,
> > Oh, happy flames of love,
> > That burn your breast and mine
> > With such a welcomed fire
> > That suffering is sweet to me, death is a game . . .
>
> You can hear in these verses a laxity and a monotony that, in the end, must have bored them, too.[7]

Magliani was clearly not interested in lifting his critical gaze beyond the standard Petrarchism of these women writers in order to put his scholarly skills to use in a more comprehensive examination of their lives and works. Indeed, he was also so unconcerned with historical precision that he nonchalantly claimed that Salvi "imitated" Andreini, even though Salvi (b. ca. 1510) lived two generations *before* Andreini (b. 1562). Setting aside Magliani's intemperate judgment and his cavalier approach to historical fact, it is very much worth our while to consider these women and their poetry more patiently and attentively so as to gain a more

nuanced insight into the literary, intellectual, political, and social culture of the sixteenth century, especially as it affected literate women.

To start the process of filling the enormous void with knowledge similar to what we have for the canonical writers of their times, this volume will focus on the women themselves, their works, their place in contemporary culture, and their contribution to it. It will present what little biographical information is available for them in archival and manuscript sources, dispelling, when necessary, incorrect information or fabricated and unsubstantiated stories that have infiltrated the literature over the centuries. Because the vast majority of these women's works survive only in manuscript or in sixteenth-century editions, when poems are discussed this study will provide the complete text of these works either in the chapters or in the Appendix. They will be given in modern spelling and will be followed by an English translation so as to make them readily accessible to both Italian and non-Italian readers. The English translation will also offer, when necessary, a plausible rendering and interpretation of difficult passages. The women and their works will be contextualized in the political and social context of their time so as to provide a historical and cultural frame for their poetry and its message. Finally, the poems themselves will be expounded in an attempt to begin an interpretative process that, we hope, will be continued by subsequent scholars. Because many of these women were not only producers but also recipients of literary creativity and cultural products, this study will survey the works other writers composed for or dedicated to them. This will help us contextualize more fully these women's participation, both active and passive, in the culture of sixteenth-century Italy and will grant us an insight into the gendered dialogue between the majority male writers and their minority female counterparts.

The first chapter will begin the process by examining one very special poetic event—the sonnet exchange, or *tenzone,* between the young Sienese scholar Alessandro Piccolomini and five of his Sienese women friends. The occasion for the exchange was offered by the pilgrimage Piccolomini made in August 1540 to Petrarch's tomb in the sleepy Venetian town of Arquà and the sonnet he composed to mark the event. Five Sienese women responded "rhyme for rhyme" to Piccolomini's sonnet, and he, not to be outdone, responded "rhyme for rhyme" to

each of theirs. The exchange is clearly a gendered dialogue colored by reciprocal respect and personal affection, by charming gallantry and subtle reprimands, by wishes and restrictions. It provides us with an insight into the social realities that conditioned the daily life of a noble Sienese woman and the level of literary knowledge such a woman might enjoy. The exchange also marks a debut, of sorts, for Sienese women writers who, starting in these years, suddenly begin to engage, firsthand, in poetic composition in the Italian vernacular in a manner and to an extent previously unseen either in Siena or elsewhere in Italy.

Admittedly, Vittoria Colonna, Marquise of Pescara, had by this time composed a significant number of poems and had recently seen them published as a collection (1538),[8] but as a woman poet she operated primarily on her own, not within a group of literate women from a well-defined civic or cultural circle, as did the Sienese women who engaged with Alessandro Piccolomini in the *tenzone* of 1540.[9] And in spite of her sex Colonna was also very much a part of a male, not a female, circle of intellects, very much the gendered anomaly in a group that included the likes of cardinals Reginald Pole and Gasparo Contarini; reformers such as Juan de Valdés, Pietro Carnesecchi, and Bernardino Ochino; literati such as Pietro Bembo and Baldassare Castiglione; and artists such as Michelangelo Buonarroti (who, in a sonnet, famously described her as "a man inside a woman, in truth, a god").[10]

The Sienese women poets, on the other hand, formed part of a loosely knit familial and social ensemble of literate noblewomen, several of whom were related by blood or by marriage to each other, and many of whom were, in fact, rather young—in their twenties and thirties. Although only five women participated in the *tenzone* with Alessandro Piccolomini, in those decades in Siena at least a dozen or more women were composing poetry, and they included Ermellina Arringhieri de' Cerretani (b. ca. 1520–25), Pia Bichi (pre-1559), Laura Civoli (doc. 1553–54), Atalanta Donati (1530–88), Lucrezia Figliucci (pre-1559), Laudomia Forteguerri (1515–55?), Virginia Luti Salvi (b. 1513), Eufrasia Marzi Borghese (b. 1512), Onorata Tancredi Pecci (1503–post-1563), Camilla Piccolomini de' Petroni (b. 1506), Aurelia Petrucci (1511–42), Cassandra Petrucci (doc. 1530s-40s), Girolama Biringucci de' Piccolomini (b. ca. 1500), Silvia Piccolomini (b. 1526?), Virginia Martini Casolani Salvi (doc. 1530s-70s), and Ortensia Scarpi (pre-1559). The 1540 *tenzone*

thus points to the presence in Siena of literate women who dabbled in poetry and willingly engaged in poetic dialogue with their male counterparts. The sonnet exchange allows us to contextualize this world of local letters and then move forward with a more detailed examination of three women in particular who, each in her own way, could be seen as emblematic of literate women in the final years of the Sienese Republic. These three women will form the basis of our three subsequent chapters.

Aurelia Petrucci, who left us only two sonnets of her own, is the focus of the second chapter. Petrucci was not only an exceptional beauty but also a keen observer of contemporary politics and an extremely well-connected person. With a sequence of lords of Siena on her paternal side and two popes and several high prelates on her mother's side, she seemed to have been blessed by fortune. Yet fortune was unkind to her, first by dispossessing her birth family of political power in Siena and then by allowing her to die young at only thirty-one years of age (1542). In her brief life, however, Petrucci managed to attract significant interest from Sienese literati, who dedicated several of their works to her and, at her death, composed a number of poems and an eulogy in her memory. Possibly part of a frivolous brigade of noblewomen who enjoyed dressing with great elegance, Aurelia was also a politically savvy person who realized that internecine fighting between the various Sienese factions was opening the way to a foreign invasion that would bring about the end of the centuries-old republic. Her sonnet on the political strife that was tearing Siena apart is not only a moving patriotic composition but also a poignant analysis of the current political situation. Within a few years her analysis proved to be correct not only for Siena but for all of Italy. At this point her sonnet became a lament for all of Italy, divided within itself and dominated by a foreign power. In 1559 the polymath Ludovico Domenichi used it as the opening poem for his groundbreaking variorum collection of women's poetry (the first ever published in any European language), thus bringing Petrucci's sonnet to the attention of readers across the peninsula and beyond. The French expatriate Antonio Bulifon, working as a printer/publisher in Naples, used it in the same way for his 1695 edition of women's poetry, thus attesting to the longevity of Petrucci's sentiments and the continuing Spanish political influence in Italy. Although it is

tempting to see Petrucci as a maverick, her personal life reveals that she was not, by any means, a rebel. Admittedly a complex individual, in her personal life she clearly accepted current social conventions and obediently carried out her familial obligations as daughter, wife, and mother. She inspired a number of male writers and received several dedications in books, but she did not step outside the limits imposed upon her by her society and her times. This would be done, instead, by her distant cousin on her mother's side—Laudomia Forteguerri.

Laudomia Forteguerri broke all sorts of conventions—from social to sexual, from literary to religious, from intellectual to practical. Forteguerri was, in fact, a maverick. In her first appearance in literature, as an interlocutor in Marc'Antonio Piccolomini's dialogue on whether Nature creates perfect beauty by chance or by design (1538), Laudomia was cast as a heterodox thinker who claimed that Nature did not have a plan but worked by chance—an assertion that was tantamount to denying the existence of a providential design. In a city still rife with heterodox religious ideas advanced by the likes of the reformers Bernardino Ochino, Aonio Paleario, and various men from the Sozzini family, Forteguerri's stand on the question of a providential design, fictive though such a stand might have been, could certainly have been problematic for the young woman and her family. Two years later, Marc'Antonio's cousin Alessandro Piccolomini redressed in part his cousin's wrong to Laudomia's image when he dedicated to her a compendium of astronomical information that he had composed in Italian so that she might use it to advance her own studies. While in this case the gesture of dedicating a scientific compendium to a woman would not damage her reputation, what Alessandro said of Laudomia in his dedicatory letter to that compendium did continue to paint a somewhat unusual picture of her, depicting her as a woman who expounded Dante's *Paradiso* to other women and as someone who was keenly interested in astronomy. This is not the usual picture of a literate woman reading Petrarchan poetry or spiritual works of a pietistic nature. It is, instead, the image of a woman eager to advance her knowledge of matters normally reserved for male scientific inquiry and ready to share her critical understanding of Dante's most complex and abstract canticle with her women friends. Clearly, this Laudomia was a woman who read, not

octavo-sized books such as Alessandro Velutello's *Il Petrarcha,* but quarto-sized works such as Piccolomini's compendium or Cristoforo Landino's commentary on the *Divine Comedy.* So while at first glance Piccolomini's dedication of his astronomy compendium to Laudomia appears to offer a favorable, positive image of her, in the final analysis it is, in fact, a somewhat dubious image that reveals a young woman who did not really conform to the norms of feminine behavior and interests for her times.

Forteguerri's reputation was put on the line once again the following year (1541), when an unauthorized edition of Alessandro Piccolomini's exposition of one of her own sonnets was published in Bologna. In this *Lettura,* Piccolomini revealed publicly that Forteguerri was in love with another woman, Margaret of Austria, and that this love was reciprocated. Piccolomini described the two women's first meeting, how they fell immediately in love with each other, how they continually sought each other out, and how they maintained their love in spite of the physical distance that separated them (Laudomia had remained in Siena while Margaret had been obliged by family politics to move to Rome). Admittedly, Piccolomini did contextualize Laudomia's affection for Margaret within the parameters of contemporary Neoplatonic love theories, but his choice of words alluded to a more physical and less platonic relationship between the two women. Piccolomini's "outing" of Laudomia and Margaret caught the imagination of his contemporaries both in Italy and abroad, who repeated, reused, and embellished the narrative until, in the hands of the French scandal-monger Pierre de Bourdeille, Seigneur de Brantôme, it became a story of illicit "lesbian" sexuality founded on an abuse of power.

In the end, however, whatever Forteguerri's sexuality might have been, her maverick character is best exemplified, not by what literati said about her or by the love sonnets she composed for Margaret of Austria, but by her alleged involvement in the defense of Siena just before the fateful siege of 1554–55. In this narrative, Forteguerri becomes a quasi-military leader who organizes the women of Siena into veritable troops of workers to help shore up the city's defenses in anticipation of the forthcoming siege. This episode of "the women of Siena" has become emblematic of Sienese valor at the end of the republic. Constantly

elaborated over the centuries by writers with ever-increasing imaginations, this episode eventually created an image of Laudomia Forteguerri as a strongly patriotic woman with exceptional leadership skills, dauntless courage, great determination, and a ready willingness to sacrifice her life for her city's freedom. Such an image may well be far from the truth, but it does point to the existence of an intriguing maverick among the women poets of Siena.

With the fall of Siena in 1555 we lose track of Laudomia Forteguerri, who may well have died in the siege, but another courageous woman poet takes her place and carries the flag for the fallen republic— Virginia Martini Casolani Salvi. Chapter 4 looks at this controversial figure, who, probably alone of all our poets, died in exile from her beloved homeland. Married into one of the most turbulent and bellicose families in Siena, Virginia followed the Salvi brothers in their firmly pro-French politics and in their uncanny penchant for getting into trouble. Arrested in 1546 on charges of sedition against the state because of some sonnets she had composed that were critical of the current government, Salvi's life was spared only thanks to Imperial intervention. In spite of such grace, Virginia remained firmly anti-Spanish in her politics and wrote many a poem to the French royal house begging them to remove the hated Spaniards from her city. She even tried to convince Catherine de' Medici, queen of France, to evict Cosimo I de' Medici from Florence and seize the city for herself. Virginia addressed her sonnets not only to Henri II of France, his sister Margaret of France, and his wife, Catherine de' Medici, but also to a number of cardinals with declared and undeclared pro-French leanings, all in an effort to garner support for a war of liberation by the French in favor of Siena. But that was not to be. With the final settlement of the Italian question brought about by the Treaty of Cateau-Cambrésis (1559), the political situation in Italy stabilized in favor of Spain. Virginia quickly realized that Spanish hegemony over the peninsula and Medicean control of Tuscany were now unalterable facts of life. At this point she tried to mend her ways and declared her loyalty to the new ruler of Siena, Cosimo I de' Medici, asking him to allow her to return and serve him as a loyal subject; but Cosimo denied her petition and Virginia remained in exile in Rome until the early 1570s, when we finally lose track of her.

Though a highly political poet, Virginia was also a gifted Petrarch-ist. Many of her more than sixty extant poems speak in Petrarchan terms of love, loss, absence, and suffering. The beloved (male, in her case) is never identified, so we are unable to determine the exact nature of this affection. Unlike Vittoria Colonna, who mourned the death of a beloved husband, or Gaspara Stampa, who lamented the inconstancy of a previous lover, Virginia Martini Salvi seems to have had no one in particular in mind. Pending the discovery of biographical information to the contrary, her love poetry seems to be addressed to a fairly generic lover who may or may not have existed. So in composing love poetry Virginia may have merely been exercising her poetic skills rather than expressing her heartfelt personal feelings. Though lacking a personal emotional inspiration, her love poetry did not, however, lack technical ability. Her command of the Petrarchan idiom and of the necessary linguistic skills is clearly evident in a number of compositions, one of which even elicited a response from the great arbiter of literary taste Pietro Bembo. In another poem, Salvi glossed Petrarch's poem 134, "Pace non trovo e non ho da far guerra," as a fourteen-stanza octave sequence. Her gloss met with such success among her contemporaries that it was set to music, first in the 1550s in Rome by Giovanni di Pierluigi da Palestrina, the chapel master of the Cappella Giulia at the Vatican, and then in the 1580s in the Netherlands by Jean de Turnhout, *maître de chant* at the royal chapel in Bruxelles. In his *Dialogo della musica,* the Florentine *literato* Anton Francesco Doni reveals that as early as 1543, at a meeting of the Academy of the Ortolani in Piacenza, one of Salvi's poems was extemporaneously set to music by Count Ottavio Landi, a proficient amateur musician who sang and accompanied himself on a *viuola.* In short, Salvi's exercises in Petrarchan poetry were circulating throughout Italy and even beyond the Alps and were attracting the interest of contemporary musicians who set some of them to music. Not surprisingly, the members of the Florentine Academy praised Virginia Salvi as a poet, calling her an "immortal woman" who had gained eternal fame from her "worthy and discerning rhymes."

Alessandro Piccolomini's *tenzone* with his five Sienese women friends and the very individual poetry of Aurelia Petrucci, Laudomia Forte-guerri, and Virginia Martini Casolani Salvi point to a closely knit world

of literate women who, in the brief span of about two decades, made a significant mark on their city's literary culture and establishment. Although, for the most part, these Sienese women poets composed verses fully in line with the dominant Petrarchism of the times, it is clear that Petrarch and Petrarchism could, and did, offer them the opportunity to engage with the Italian lyric tradition in a novel and distinctive manner. While the *tenzone* may well be nothing more than a gracious exchange of lavish compliments, it points to a poetic dialogue between men and women that is not, at least this time, about pining away for unrequited love or lamenting for deceased beloveds. Instead, it grants the women poets of Siena the chance to discuss the topic of poetic fame and, within their own limits, to participate in it. Aurelia Petrucci's participation in the literary culture of Siena points to the respect and admiration a talented woman could garner among her fellow citizens, both male and female, and to the political perspicacity that even a young woman could have at that time in Siena. Laudomia Forteguerri's ambivalent position as poetic muse for Alessandro Piccolomini and as poetic lover of Margaret of Austria provides us with an unparalleled insight into the ambiguous world of sixteenth-century women, constantly objectified by the men around them but, at the same time, sentient subjects of their own emotional life. Although Forteguerri framed her feelings for Margaret firmly within the Petrarchist dialectic that governed such poetic expressions at the time, the fact that she voiced those feelings poetically and that contemporary literati acknowledged and even praised them opens a fascinating window into premodern same-sex female affection. The poetry of Virginia Martini Salvi, the most prolific and eventually the most famous of these Sienese women, is both versatile and intricate. From her home in Siena or from her exile in Rome, Salvi corresponded incessantly with poets, prelates, and rulers in verses that reveal a thorough command of the poetic idiom and an extensive network of political, ecclesiastical, and cultural contacts available to a woman of her rank and class. With Salvi we draw closer to the contemporary male Petrarchists who seemed naturally predisposed to jot down a sonnet at the drop of a hat.

Whatever the inspiration and whatever the result, the poetry of these and other women of mid-sixteenth-century Siena opens a fascinating

new window into the cultural, literary, social, and political world around them. At the same time, their poetry provides us with invaluable insights into their own network of contacts and into their own interior world. Their works may not have entered the (overwhelmingly male) canon of Italian literature, but in this postfeminist era they may well help modern scholars gain a more nuanced insight into the lives of educated and talented women who clearly enjoyed writing poetry, conversing with intellectuals, and participating in the world around them.

At Petrarch's Tomb

The First Bloom of a Short Springtime

There is a tomb in Arqua;—reared in air,
Pillared in their sarcophagus, repose
The bones of Laura's lover: here repair
Many familiar with his well-sung woes,
The pilgrims of his genius.
—Lord Byron, *Childe Harold's Pilgrimage,* 4.31

The story of women's poetry in Renaissance Siena begins with a man and a pilgrimage. When Alessandro Piccolomini visited Petrarch's tomb in August 1540, his journey inspired a number of women to unite virtually with him and enter into a poetic dialogue that stretched across time, space, and the sexes. The sonnet exchange that ensued was the first bloom, tentative but respectable, in what would become a sudden, unprecedented, and regrettably short springtime of women poets in Siena. This book opens with that first bloom. In doing so, it must by force start with a man, but it soon turns to the women who engaged him in poetic dialogue as his interlocutors and expressed their views to him on such diverse matters as women's freedom to travel, the need for personal religious reform, and female sociability. An examination of

who these women were and what they had to say will open a window
not only on the poetic conversations across space, time, and sex that
Piccolomini's journey to Arquà inspired but also on the networks and
dynamics at play among literate women and learned men in Renais-
sance Italy.

A Pilgrimage to Arquà

As a budding poet, an aspiring intellectual, and a university student, the
Sienese Alessandro Piccolomini was very much in line with sixteenth-
century fashion when, in August 1540, he made his pilgrimage to Arquà
to pay his respects at Petrarch's tomb.[1] Unlike other visitors, however,
he did not have far to go—that summer he was whiling away his time
at a villa in Valsanzibio, less than ten kilometers away from Arquà, that
was owned by the Contarini family of Venice. While the distance was
minimal, the results of this outing had some fairly extended echoes
because the journey inspired Piccolomini to compose a sonnet and
then to send it to a number of friends in Padua, Florence, and Siena.[2]
This act of obvious self-promotion led to a sonnet exchange that quickly
turned into a *tenzone,* that is, into a dialogue between friends by way of
poetry.

Alessandro's original sonnet was devised as a conversation with
the deceased Petrarch. In it, the Sienese student congratulated the dead
poet by pointing out that the excellence of his verses assured him of
everlasting fame. Piccolomini then invited the local nymphs to always
honor the poet's tomb.

> Giunto Alessandro a la famosa Tomba
> Del gran Toscan, che 'l bello amato alloro
> Cultivar seppe sì, che i rami foro
> U' forza unqua non giunse o d'arco o fromba,
> "Felice," o disse, "a cui già d'altra tromba
> Non fa mestier, che il proprio alto lavoro.
> Con vivi accenti e suon chiaro e sonoro
> Sempre più verso il Ciel s'alza e rimbomba.

Deh, pioggia o vento rio non faccia scorno
A l'ossa pie; sol porti grati odori
L'aura, c'ha pien d'amor le penne e 'l seno.
 Lascin le ninfe ogni lor antro ameno
E raccolte in corona al sasso intorno
Liete li cantin lodi e sparghin fiori."[3]

When Alessandro reached the famous tomb / Of that great
Tuscan who so well did tend / The fair beloved laurel till its
limbs / Reached higher still than bow or sling e'er did; //
"Happy are you," he said, "for you require / No other trumpet,
but your own fine work / That with strong voice and clear and
vibrant sound / Still rises up to heaven and resounds. // Let not
the rain or wicked wind offend / These pious bones; but let the
air, with wings / And breast replete with love, bring fragrance
sweet: // Let all the nymphs depart their pleasant glens / And
gather as a crown around this stone / And let them sing glad
songs and scatter flowers."

The dialogue was twofold. Alessandro's composition was not only a
conversation with the deceased poet but also a response, across the cen-
turies, to Petrarch's sonnet "Giunto Alessandro a la famosa tomba."[4]
Petrarch's own sonnet had been a response too, across the centuries, in
his case to a very ancient story about Alexander the Great that told
how, on reaching the site of ancient Troy, the young Macedonian con-
queror visited the tomb of the ancient Greek hero, Achilles. Standing
in front of it, Alexander the Great allegedly burst into tears at the reali-
zation that, while Achilles had been fortunate enough to have a poet of
the caliber of Homer to sing and immortalize his deeds, he, Alexander,
had no such poet and so his own great deeds were destined to disap-
pear in the mists of history. The story met with great success in antiquity
and throughout the Middle Ages because it nicely embodied the never-
ending discussion on the power of literature to immortalize great deeds,
a discussion that would eventually lead to the debate on which is might-
ier, the pen or the sword. Petrarch used the story, as he did everything
else, to promote himself and his work. In his sonnet, he points out that

his beloved, Laura, also has no great poet to sing and immortalize her glory, that is, her beauty.

> Giunto Alessandro a la famosa tomba
> del fero Achille, sospirando disse:
> "O fortunato che sì chiara tromba
> trovasti et chi di te sì alto scrisse!"
> Ma questa pura et candida colomba
> a cui non so s'al mondo mai par visse
> nel mio stil frale assai poco rimbomba.
> Così son le sue sorti a ciascun fisse;
> Ché d'Omero dignissima e d'Orfeo
> o del pastor ch'ancor Mantova onora,
> ch'andassen sempre lei sola cantando,
> stella difforme et fato sol qui reo
> commise a tal che 'l suo bel nome adora
> ma forse scema sue lode parlando.[5]

———

When Alexander reached the famous tomb / Of fierce Achilles, with a sigh he said: / "O lucky you, to find a trumpet clear / And someone who might write so well of you!" // But this white dove so pure, whose equal never, / I think, did dwell upon this earth, will find / That my weak style does not prolong her fame: / And thus each person's fate is fixed forever. // She's worthy of Homer, or of Orpheus, / Or of the shepherd Mantua reveres, / That they might always sing of her alone, // But some distorted star or wicked fate / Bestowed her to someone who loves her name / But mars her praises when he speaks in words.

As Petrarch explains, Laura's beauty is such that it should be sung by poets of the caliber of Homer, Orpheus, or Virgil, but unfortunately it has only Petrarch to immortalize it, and his poetic skill, or style, is "perhaps" not up to the task. Petrarch's concerns are, however, just a smokescreen. As in most of his other poems, Petrarch is much more interested in speaking of himself than of Laura, so his poem on Alex-

ander's visit to Achilles' tomb becomes not so much a paean to Laura's beauty as a self-centered compliment to his own poetic skills. In the sonnet, Petrarch uses reverse logic to suggest that Laura does not need to fear the passage of time because she does have a poet comparable to Homer, Orpheus, and Virgil to sing her praises and immortalize her beauty. Much as Dante did when he described himself as meeting five great poets from ancient Greece and Rome during his travels through Limbo and joining them so as to become the sixth among them ("io fui sesto tra cotanto senno"; *Inf.* 4.102), Petrarch imagines himself to be part of, and on a par with, a group of eminent ancient Greek and Roman poets. Clearly alluding to Dante's comment about being sixth in a group of ancient poets, Petrarch suggests that he himself is fourth in a group of ancient poets, thereby suggesting, as Dante did, that he is an excellent poet and that modern Italians in general can stand on a par with ancient Greek and Latin poets.

Petrarch's belief in the power of poetry to immortalize great men (or women) was very much shared by the poets and humanists who followed him, including Alessandro Piccolomini. Like many intellectuals of his generation, Piccolomini knew his classics, both ancient and modern, so it was completely natural for him, as for others, to use Petrarch's verses as a starting point for his own comments on the question of fame. Baldassare Castiglione, for one, had already done so in his *Book of the Courtier* (Venice, 1528) when, in a discussion on the *vexata quaestio* of the greater power of the pen or the sword, he had the character of Pietro Bembo cite the opening four verses of Petrarch's sonnet 187 to point out that Alexander the Great was jealous not of Achilles' deeds (*fatti*) but of his luck (*fortuna*) in having a poet like Homer to immortalize him; this, in Bembo's opinion, proved that Alexander valued Homer's pen more than Achilles' sword.[6] Just a decade or so before Piccolomini, the Ferrarese courtier and writer Ludovico Ariosto had used the Achilles story in his epic poem *Orlando furioso* (1516–32) to say that Vittoria Colonna's poetry would immortalize the military fame of her deceased husband, Ferrante d'Avalos, Marquis of Pescara (*O. f.* 37.19–20). Although Ariosto does not refer directly to Petrarch, his verses and rhymes certainly allude to sonnet 187, picking up on words and phrases such as "fero Achille," "chiara tromba," and "rimbomba." It is not surprising,

therefore, to see Alessandro Piccolomini drawing on both the story and Petrarch's elaboration of it to advance his own views and agenda.

In what is, in fact, a multilayered compliment to Petrarch, Piccolomini responds to Petrarch's concerns about his poetic skills and the continuing fame of Laura's beauty by echoing sonnet 187 both structurally and thematically, and then by complimenting the long-dead poet on the longevity and high quality of his verses. Piccolomini's sonnet does not, however, stop there—it goes further and emulates Petrarch's sonnet even in the not-so-subtle attempt to sing one's own praises: as Petrarch compared himself favorably with Homer, Orpheus, and Virgil, Piccolomini now does the same with Alexander the Great by playing on his name and the ambiguity present in the poem's opening line, "Giunto Alessandro a la famosa tomba." Piccolomini's implied amalgamation of himself and Alexander the Great was clearly inappropriate: Alexander the Great had been a mighty warrior and conqueror, while Alessandro Piccolomini was merely a university student whose future career, though still undetermined, was clearly not going to be in the military—at least, not with a degree in the humanities from the University of Padua. In spite of its inherent presumption, Piccolomini's sonnet met with success and, instead of raising eyebrows, raised people's awareness of him as a poet.

Piccolomini's sonnet also inspired a number of his contemporaries to respond with verses of their own. In a letter of 31 May 1541 to the author and poet Pietro Aretino, Piccolomini proudly informed his friend that he had received quite a number of response sonnets from his colleagues in the Academy of the Infiammati of Padua as well as from many Sienese young men and women.[7] Piccolomini explains that when the Sienese heard that the Infiammati had composed about twenty-five or thirty responses, they decided to do the same and to match, if not outdo, their Paduan counterparts. In a way, such competition seems to suggest the presence of "patriotic issues" setting Sienese against Paduan academicians, Intronati against Infiammati.[8] The ensuing sonnet exchange attracted so much interest that three decades later, in his eulogy for the recently deceased Piccolomini, the Sienese scholar Scipione Bargagli (1540–1612) recalled that every member of the Academy of the Infiammati of Padua and many other poets had responded in rhyme to

Alessandro's original poem and that the various responses had been gathered into a volume entitled *La Tombaide*. This volume, however, seems not to have come down to us, either in printed or in manuscript form. Bargagli's information may, in fact, be an exaggeration.[9] What has come down to us instead is a much more restricted sonnet exchange that involved, not members of the Infiammati or the young Sienese gentlemen Piccolomini mentions, but five contemporary Sienese women plus three men, one a Roman (Leone Orsini), another a Florentine (Benedetto Varchi), and the third a Genoese (Emanuele Grimaldi). Extant in only four manuscripts, and incomplete in each of them, this small collection is indicative not so much of wide peninsular fame as of a fairly limited dialogue among friends, both male and female.[10] It is also evidence that, as Virginia Cox points out, much of women's writing before the 1540s circulated in manuscript, not in printed form.[11]

While the sonnet exchange with the three men, who were all connected with the Infiammati, is neither surprising nor exceptional, Piccolomini's poetic exchange with the five Sienese women is another story altogether. The women's responses are of great interest to us because they bring to light a fascinating world of personal connections between an aspiring male *literato* in mid-sixteenth-century Italy and a group of literate noblewomen in his hometown of Siena. The *tenzone* thus provides a privileged entry point into the dialogue that existed between learned men and literate women while, at the same time, bringing to light a much wider network of female-male literary relationships that forms the background to, and eventually the framework for, this poetic dialogue. One of the women who formed part of Piccolomini's literary world was the beautiful Eufrasia Placidi de' Venturi, the first to receive his literary endeavors.

Eufrasia Placidi de' Venturi (b. 1507)

When he sent off his sonnet and thereby started what would become a *tenzone,* Alessandro Piccolomini was still far from reaching the middling fame he would eventually acquire as a man of letters, a philosopher, and, eventually, a prelate. In 1540 he was still attending university

and frequenting literary academies. Though still uncertain of his future career, Piccolomini was already certain of his interest in the demi-monde of Sienese noblewomen that was to form an essential part of his scholarly and intellectual endeavors for many years to come.

Already a few years earlier, in the mid- to late 1530s, Piccolomini had shown an interest in catering to a female reading public. He had participated, for example, in a group project to translate Virgil's *Aeneid* into Italian for the reading pleasure of a group of literate (but not Latinate) women, all but one of them Sienese. Piccolomini contributed a translation of book 6 and dedicated it to the noblewoman Eufrasia Placidi de' Venturi,[12] whom the seventeenth-century Sienese *erudito* Isidoro Ugurgieri Azzolini described as a woman with a "very refined intellect in the lively gatherings of witty ladies and wise gentlemen that used to be held in Siena at that time, a woman who on many occasions triumphed in gaiety, sensibility, wit, and modesty"[13]—though not always. The late sixteenth-century erudite Girolamo Bargagli recalls that one evening Eufrasia was careless enough to publicly ask a well-known joker, Conte del Rondina, known among the Intronati as "il Fastidioso" (the Annoying One), to explain the meaning of the Terentian phrase *Nostri fundi calamitas*. Del Rondina obliged by saying that it meant that Eufrasia's bottom was a calamity, a response that "was received with no less embarrassment by Madonna Eufrasia than laughter by everyone else."[14] Aside from this unfortunate occasion, however, Eufrasia was generally in good company, as she was in this collection of translations from Virgil. The five previous books of the *Aeneid* were translated by the Sienese *literati* Alessandro Sansedoni, Bernardino Borghesi, Bartolomeo Carli Piccolomini, Aldobrando Cerretani, and the Florentine cardinal Ippolito de' Medici. Their group effort was published in 1540 in Venice and then again in 1544. The dedicatees or recipients of these translations were the Sienese noblewomen Aurelia Tolomei, Giulia Petrucci, Aurelia Petrucci, Girolama Carli Piccolomini, and the Venetian noblewoman Giulia Gonzaga. Unfortunately, we do not have any surviving documentation on how any of these women responded to such gallant attention and flattery, but we can safely assume that they were not displeased. All of these men were, after all, scions of eminent families, each with high personal aspirations and a solid promise of success. And the work itself, Virgil's *Aeneid,* was one of the masterpieces

of classical Latin culture that had yet to enjoy a suitable translation into Italian.

In his dedicatory letter, Alessandro informs Eufrasia that he completed the translation of *Aeneid* 6 the previous summer but has not yet sent it to her because he wants to send it together with his translation of Xenophon's *Oeconomicon,* on which he is currently working. This letter is not dated, but the dedicatory letter in the *Oeconomicon* is dated "From Lucignano di Valdasso, 8 January 1538" (that is, 1539 in modern style).[15] So we can safely assume that the translation of *Aeneid* 6 was completed in the summer of 1538 and that of the *Oeconomicon* in the fall/winter of 1538–39. Piccolomini did not wait for 1539 to send his translation to Venturi; in the undated dedicatory letter he admits that he changed his mind because, hearing that she was spending some time at her villa, he thought she might enjoy reading his effort. For this reason he is now (we assume in the fall of 1538) sending her the *Aeneid* 6 so that she may not only pass her time but also come to know "many things about Aeneas's lofty spirit, such as his marvelous compassion and love for his father . . . [and] his infinite goodness and profound religious beliefs and reverence." Piccolomini then points out that in *Aeneid* 6 Virgil spares no effort in including "all profound doctrine and hidden sciences, all drawn from the fountainhead of antique theology."[16] At this point Alessandro asks Eufrasia to read the work so that she may understand just how much he is moved and inspired by the "image" of her he carries in his mind, very much as Aeneas was moved and inspired by the golden bough that helped him overcome all dangers in his voyage into the Underworld. With her image impressed firmly in his mind, Piccolomini concludes, he not only has already sustained great intellectual travail but is prepared to continue his labors.

While this letter is charming in its audacious comparison of Piccolomini's mental image of Eufrasia Placidi de' Venturi with Aeneas's golden bough, it does not really tell us much about Eufrasia. The 1539 dedication of the *Oeconomicon,* on the other hand, is much more informative and interesting. Xenophon's *Oeconomicon* is a work on agriculture, household management, and the daily activities of a wealthy Athenian gentleman, complete with a discussion of how such a gentleman farmer teaches his wife the proper management of their house, household, and lands. Appropriately enough, Piccolomini's letter was composed not in

an urban setting but at his family's country estate in Lucignano Val d'Asso, a small hamlet in the Tuscan countryside near Pienza that was completely owned by the Piccolomini.[17]

In this dedicatory letter, Alessandro points out that he translated Xenophon's work from Greek into Italian to hone his translating skills, but then he adds that, having heard of Eufrasia's interest in the topic, he decided to send it to her—not that she needs it (for she is, after all, most learned, *dottissima,* in the science of household management), but simply to show her just how highly esteemed economic science was among the ancient Greeks—as it is not in contemporary Italy, he adds. In his later work, *De la institutione di tutta la vita . . .* (composed in the winter of 1539–40), Piccolomini repeats his praises of Eufrasia de' Venturi as an exceptional woman *(singularissima)* who is "most beautiful, most prudent, and most honest" and whose best virtue is that she knows how to manage her house well.[18]

In a way, the exchange is fraught with gendered assumptions. First of all, Xenophon's *Oeconomicon* is a text on how to educate (read: train) one's wife; furthermore, although Alessandro grants that Eufrasia may be interested in household management, he also does not fail to praise and prioritize her physical beauty, her charm, and her gentility—which, he adds, are clear indications of her great abilities in household management and economics. On the other hand, however, the dedication of a book on household management and economics to a literate noblewoman reflects a significant gendered switch from the original—we must remember that Xenophon wrote the book to instruct men on how to educate their wives and manage their household. Piccolomini's dedication of the book to a woman and thus his suggestion that there is a viable female reading public for such works are indicative of the fact that in Italy noblewomen did manage large households and estates: an excellent and well-known contemporary example is Eleonora di Toledo (1522–62), Duchess of Florence, who not only personally owned extensive tracts of land in Tuscany but managed them herself with fine business sense, so much so that she derived great financial profit from them.[19] Another such enterprising woman was Alessandra Macinghi Strozzi (1406–71), who, a century earlier, had not only managed her marital family's estates in the wake of her husband's exile and subsequent death but also succeeded in marrying her children, male and fe-

male, honorably, so much so that the family was eventually allowed to return to Florence.[20]

The picture this dedicatory letter draws of Eufrasia de' Venturi is thus quite different from the one in the dedicatory letter to *Aeneid* 6. Here we do not have a woman idling away time at her villa by reading from Virgil's epic poem, replete as it may be with occult science and antique theology, but rather an active manager of a large household and an extensive estate who is very much interested in, and conversant with, economic matters. Since we know nothing about the historical Eufrasia de' Venturi, this image remains an idealized portrait in want of support, but it is nonetheless of interest to us because it gives us a completely different perspective on upper-class women in sixteenth-century Italy. As with Eleonora di Toledo and Alessandra Macinghi Strozzi, what we glimpse here is a formidable woman very much in charge of her wealth and resources.

Laudomia Forteguerri (1515–55?)

Alessandro Piccolomini's interest in the charming, talented, and business-minded Eufrasia de' Venturi was, however, short-lived. By the time his translations of *Aeneid* 6 and of the *Oeconomicon* were published in Venice in 1540, his roving gallantry had already turned to another young woman, twenty-five-year-old Laudomia Forteguerri, whom we will discuss at greater length in chapter 3. Undeterred by the fact that Laudomia was a married woman, mother to three children, and clearly not interested in him, over the course of five or six years (1539–44) Alessandro dedicated a variety of works to her and praised her highly to his friends and correspondents, so much so that knowledge of his affection for her spread throughout Tuscany and beyond and continued to thrive even after his interest in her had long since waned.

When, in 1539, Laudomia gave birth to her first son, Piccolomini addressed to her a volume on the education and upbringing of noble children, the *De la institutione di tutta la vita de l'homo nato nobile e in citta libera, libri X (On the Organization of the Entire Life of a Man Born Noble and in a Free City)*. The work was published in Venice three years later (1542) and then, in the wake of great editorial success, was republished several

times during the century.[21] One year after the *Institutione di tutta la vita*, in August 1540, Piccolomini dedicated two very different books to her, the astronomical digests *De le stelle fisse (On the Fixed Stars)* and *De la sfera del mondo (On the Sphere of the World)*, both compilations of scientific information on the heavens drawn from classical sources. In his dedicatory letter to the digests, Alessandro explains that he undertook this project to provide Laudomia with astronomical information that might help her when she explains Dante's *Paradiso* to her female friends, as he has had occasion to see her do. A few months later, in December 1540, Piccolomini delivered a public lecture at the newly founded Accademia degli Infiammati in Padua; its subject was Forteguerri's own sonnet "Ora ten vai superbo, or corri altiero," a work in which the poet (Laudomia) laments the absence of her beloved (Duchess Margaret of Austria). As we can see, Laudomia Forteguerri's gendered dialogue is same-sex— but that seems not to have bothered or deterred Alessandro Piccolomini, who continued to express his affection and respect for Laudomia, while she, on the other hand, continued to ignore him completely.

A reflection of Laudomia's disregard for Alessandro may well be her obvious lack of interest in participating in the *tenzone* on Petrarch's tomb. Although at the time Forteguerri was already writing sonnets and circulating them among friends and fellow poets, she did not join with the other five Sienese women in praising Alessandro for his verses, even though she probably knew and spent time with several, if not all, of these women and therefore would have been aware of Alessandro's visit and the *tenzone*.[22] In short, Laudomia never acknowledged Alessandro's interest in her or even his existence. In a way, she played the part of Beatrice or Laura to perfection. Ironically, then, in this case the dialogue (or lack thereof) between lover (Alessandro) and beloved (Laudomia), or between the writer and his muse, fits perfectly with what was expected of the female beloved in the tradition of Petrarchan lyric poetry.[23]

Virginia Martini Casolani Salvi (1510/13 to post-1571)

One of the women who did respond to Piccolomini's sonnet was the talented, prolific, and politically engaged Virginia Martini Casolani

(b. ca. 1510–13), wife of the Sienese Matteo Salvi (b. 1503), whom we will discuss at greater length in chapter 4.[24] Her response sonnet to Alessandro Piccolomini's is of interest to us because, alone in the entire *tenzone,* it laments what we might call one of the plights of "proper" Renaissance women—their inability to travel freely, a difficulty that is often exploited on the Italian Renaissance stage to cross-dress young heroines as men and then use the ensuing gender confusion for comic effect.[25] As Ricciarda Ricorda points out, "Italy did not boast a great tradition of women travellers" because, even as late as the nineteenth century, Italian women of rank and intellect were strongly discouraged both by men and by their women peers from traveling to expand their minds or to educate themselves.[26] Ricorda points out that "as late as 1840 Paolina Leopardi spoke with regret of her family's total opposition to her desire to travel" (p. 107). Virginia Martini Salvi seems to fall into the same category of willing but unable travelers. Responding to Alessandro's initial sonnet, she writes:

> Perché veder on poss'io la gran tomba
> Di quel che celebrò l'amato alloro,
> Di cui le verdi cime alzate foro
> Ove mai non aggiunse arco né fromba?
> Felice voi, poiché la chiara tromba
> Vostra alza al Ciel così ricco lavoro
> E in dotti versi e in stil raro e sonoro
> Cantate, e 'l vostro nome alto rimbomba.
> Deh, se vi sia lontano oltraggio e scorno
> Di morte, non vi spiaccia arabi odori
> Per me offerir a l'almo e sacro seno.
> Et ai vostri desir si mostri ameno
> Il Ciel, e liete Ninfe sempre intorno
> Vi stiano, ornando il crin di vaghi fiori.[27]

———

Why can I not see the noble tomb / of the man who sang of the beloved laurel / whose verdant tops were raised to heights so great / that ne'er before were reached by bow or sling? // Happy are you, because your trumpet clear / to heaven lifts

such splendid work and you / in learned verses sing, your voice both rare / and vibrant, and your name on high resounds. // Oh, if the harm and scorn of Death be far / from you, be not displeased to bring for me / Arabian scents to that pure and sacred breast. // And to your wishes may the Heavens consent / and happy nymphs be always at your side, / as they adorn your brow with lovely flowers.

As we can see, Virginia Martini Salvi responds *per le rime* to Piccolomini's sonnet, picking up not only his rhymes but also his rhyme words. She does not, however, follow his example either in the structure of her initial verse or in the manner of addressing her reader. Her opening verse breaks from Piccolomini's calm narrative mode, slow rhythmic cadence, and extended vowel sounds in order to shock the reader with a sudden, direct, and challenging question: "Why can I not . . . ?" Virginia crashes on the scene with an air of rebellion that disturbs the status quo. Her abrupt question underlines the geographical but above all the cultural distance that exists between her (unable to travel to Arquà) and Piccolomini (free to travel at will). Virginia emphasizes the difference poetically by associating herself with short, piercing vowel sounds ("Perché veder non poss'io") that contrast sharply with the longer, calmer vowel and nasal sounds in Alessandro's own self-referencing phrase ("Giunto Alessandro a la famosa tomba"). The potential for confrontation is present but soon disappears; as quickly as it started, Virginia's challenge, both poetical and cultural, dissipates, and her sonnet falls in line with a verse-by-verse emulation of Alessandro's original. Not only the rhymes but the images and at times even the phrasing now follow Piccolomini's lead. With her outburst over, Salvi turns to paying her respects to her fellow poet and friend by complimenting him for his poetic skills. Such acquiescence is, however, deceptive: as Salvi echoes Piccolomini's words and praises his poetry she shifts the focus of the conversation first from Petrarch to Piccolomini, and then, in the sextet, from Piccolomini to herself and her situation—she asks Piccolomini to do her a favor, which is to scatter on her behalf Arabian perfumes *(arabi odori)* on Petrarch's tomb. As Salvi's sonnet comes to a close, she manages, in a way, to achieve by proxy what her "fate" was preventing her from doing in person—to be present at Petrarch's tomb.

Piccolomini's response sonnet picks up on Salvi's comments and develops them, praising her poetic skills, promising to bring her works to Petrarch's tomb, and introducing two Sienese "nymphs," Placida and Flori, into the discussion.

> Benché il venir voi stessa a la gran tomba
> Del gran cultor di quel ben nato alloro
> Che s'erse u' non mai pini ascesi foro,
> Le vieti del suo fato invida fromba,
>
> Felice è pur, poiché sì chiara tromba,
> Verginia, in onor suo l'alto lavoro
> Dei vostri versi, in suon dolce e sonoro,
> Qua d'ogn' intorno al Ciel alto rimbomba.
>
> Porgerollo io per voi, con onta e scorno
> Di queste Ninfe, i propri stessi odori
> Ch'arrivan qua dal vostro saggio seno.
>
> Voi, in guiderdon, con lieto ciglio ameno
> Coronate dei fior ch'aprite intorno
> Sopra l'Arbia e l'Ombrion, Placida e Flori.[28]

———

Although the dreadful sling of Fate forbids / your coming to the tomb of the great lover / of the well-born laurel that rose to heights / that never pines or firs were able to match, // Still, he's glad, for the clear trumpet, / Virginia, of your lofty verses honors him / from everywhere here below up to the highest heaven / with sound both sweet and full. // On your behalf, and to the shame and dread / of nearby nymphs, I'll pass the very scents / that hither come to me from your wise breast. // And you, instead, with glad and pleasant brow / do crown with those same flowers you cause to bloom / by the Arbia and the Ombrione, Placida and Flori.

Piccolomini recognizes the harsh reality of Virginia's inability to travel, calling it "the dreadful sling" of her fate. The "fate" to which he refers may well be the fact that Salvi is a noblewoman and thus unable to travel alone, but it could just as well refer to a more specific situation, possibly familial or even political. Perhaps Virginia was restricted

in her travels because of the political involvements of her marital family, one of the most rambunctious group of siblings in Sienese history—Roberto Cantagalli describes them as "seven ambitious brothers, all more or less turbulent and hotspurs."[29] Virginia herself may well have been an active contributor to Salvi political meddling—in 1546, for example, she composed several letters and sonnets highly critical of the current Sienese government that led to her being arrested on charges of political sedition, "jailed" briefly in a convent, and then confined for a year to house arrest at her paternal house in Càsole, a town halfway between Florence and Siena (see below, chapter 4). Clearly, Virginia was more than a mere observer of contemporary politics, and this, in turn, may have severely reduced her ability to travel.

To Salvi's request that Piccolomini bring "Arabian perfumes" *(arabi odori)* to Petrarch's tomb on her behalf (an image with strong Christological echoes), Alessandro responds that he will bring those "scents" that come from her "wise breast" *(saggio seno),* that is, her inspired poetry (and here there is a clear echo of the poetic theories of the Sweet New Style and of Dante's famous comment from *Purg.* 24.49–57). The statement may be just a poetic metaphor, but it does refer to the vogue, among certain sixteenth-century literati, to visit the places associated with Petrarch and, in the case of Arquà, to leave a composition or a letter of their own on the tomb. The practice did not fail to arouse some humorous comments, such as in the following verses:

> Ho inteso che in Arquato è una bell'arca
> lontan da Padoa circa a dieci miglia,
> dove son l'ossa del divin Petrarca;
> che 'l loco a un Paradiso s'assomiglia,
> e d'Italia non pur gente vi corre,
> ma di Francia, Lamagna e di Castiglia;
> e ognun, ch'o bene o male sa comporre,
> la vuol vedere: e non verrìa contento
> senza in quel loco un breve o scritto porre.
> Io di lodar quest'uom tal ardor sento,
> che adesso voglio far venti terzetti,
> et attaccargli un dì sul monumento.[30]

I heard there is a beautiful tomb in Arquà, / About ten miles
outside of Padua, / Where the bones of the divine Petrarch
lie; // That the place looks like a heaven, / And people flock
to it not only from Italy, / But from France, Germany, and
Castile; // And everyone who writes poetry, good or bad, /
Wants to see it: and will not depart happy / Without first
placing a letter or a poem upon it. // I feel such a yearning to
praise this man, / That I want to compose twenty tercets, right
now, / and attach them someday to that monument.

The author of these humorous verses indicates that the fashion was
international, drawing poets not only from Italy but also from France,
Germany, and Spain—strangely enough, England is spared the jab,
though one would imagine that the many English students at the Uni-
versity of Padua must also have taken part in the craze. The poet ends
on a sarcastic note, expressing his urge to compose a large number of
terzine to have handy for his own eventual pilgrimage to the tomb.

While the author of these satiric tercets saw the entire practice as
silly, Piccolomini and Salvi clearly did not. Nor did they consider them-
selves aspiring poets of inferior abilities. Piccolomini was dead serious
in his initial sonnet and also in treasuring the responses he received
from Sienese women and fellow members of the academy. In a letter
of 31 May 1541 to Pietro Aretino, whom Piccolomini himself spon-
sored into the Infiammati, the self-promoting Sienese student proudly
tells the Scourge of Princes about the proliferation of responses his
original sonnet has elicited both in Padua and in Siena and sends him
copies of those he received from a number of Sienese women and of his
own responses to them. Piccolomini says he is certain that Aretino will
pass a pleasant half hour reading these poems and adds that he looks
forward to hearing his friend's opinion of them next time they meet:

Molto onoratissimo Signor Mio, perché voi vedessi il saggio de
l'ingegno de le nostre Donne Senesi, avevo pensato di portarvi io
stesso in questa Ascension alcuni Sonetti, che mi sono stati man-
dati di Siena, fatti da alcune nostre Gentildonne sopra le Rime di

quello istesso Sonetto [p. 131] ch'io feci questo Agosto passato in
Arquà al Sepulcro del Petrarca, co i quali ne sono ancora molti altri
di piú gioveni Gentilomini Senesi; però che avendo loro avuto a le
mani non so venticinque o trenta Sonetti fatti in Padova da diversi
Signori Infiammati, sopra le medesime Rime, volsero essi ancora
far prova di aggiongervene a gara. Volevo dunque portarveli, e l'arei
fatto, se alcuni non mi avessi impedito il venire a Venezia. Onde mi
son risoluto a mandarvegli, e con essi insieme alcuni altri Sonetti
miei, che sopra le stesse Rime ho fatto in risposta a quei de le Gen-
tildonne. Vi piacerà per amor mio d'intertenervi una meza ora con
essi, e a bocca me ne direte poi il parer vostro; perché tosto sarò
da voi.[31]

My most honored Lord, so that you may see a sample of the wit
of our Sienese women, I meant to bring you personally this com-
ing Ascension Day some sonnets that were sent to me from Siena
composed by some of our gentlewomen on the rhymes of that son-
net of mine I composed this past August [1540] at Petrarch's tomb in
Arquà, together with many others by several young Sienese gentle-
men: because, when twenty-five or thirty sonnets composed by
the Infiammati in Padua upon those same rhymes came into their
hands, they decided to enter the fray and add some more to the
competition. So I wanted to bring them to you, and I would have
done so, had someone not prevented me from coming to Venice.
For this reason I have decided to send them to you along with some
sonnets of my own that I composed in response to those gentle-
women. You might enjoy spending a half hour with them out of
love of me, and [then] you can tell me what you thought of them
when next we meet; for soon I will be by you.

A month earlier, in a letter to Benedetto Varchi dated 27 April 1541,
Piccolomini explained that he was not including copies of the sonnets he
had received from a number of Sienese women because "Hemmanuel"
(presumably Emanuele Grimaldi), who had received them from Count
Troilo, would bring them personally to Varchi.[32] Clearly, the sonnets
were circulating in manuscript form among the literati connected with

the Academy of the Infiammati and were attracting some attention. Piccolomini, for one, seems to have had a good opinion of Virginia Martini Salvi's poetry, so much so that he says that her poems put the local nymphs to shame. This suggests that, in Piccolomini's view, Virginia's poetry surpassed the poetry of women Petrarchists in the area of Padua and, by extension, of women poets in all of Italy. Such an opinion may well be an exaggeration, but it does suggest that Salvi's poetry was well received. As we will have occasion to point out later on, Piccolomini may not have been the only one to hold such a view (see below, chapter 4).

Piccolomini's response to Virginia Martini Salvi is noteworthy also because it refers to two other women in Siena by traditional pastoral names: Placida and Flori. It is not easy to identify the women behind these names. Placida might be Eufrasia Placidi de' Venturi, whom we have already met, but we have no better proof for this than the mere coincidence in names. From within the "Tombaide" it is impossible to determine who Flori might be, but from the sonnet "La Vergin, cui servì la prima gente," first published in Domenichi's *Rime* of 1546, it appears that this is the pastoral name of his "beloved," and this would suggest that it refers to Laudomia Forteguerri (see below, chapter 3). Tilli, another nymph whom we will meet in a later sonnet from the "Tombaide," remains unidentified. We do know, however, that Clori (Chlorys) is a pastoral name for Camilla Piccolomini de' Petroni and that Fillide or Filli (Phyllis) is a pastoral name for Girolama Biringucci de' Piccolomini (see below). While it may be futile to identify the real persons hidden by these fictitious names, one may perhaps be satisfied with the observation that in mid-sixteenth-century Siena the presence and participation of women in the literary culture of the time were constructed, at least poetically, within a pastoral frame that harkened back to a mythological world.

Virginia Luti Salvi (b. 1513)

The other women who engaged in the *tenzone* with Piccolomini are not as famous or as productive as Virginia Martini Casolani Salvi. Virginia's namesake and sister-in-law, Virginia Luti, wife of Matteo's brother,

Achille Salvi (b. 1504), does not appear in any other contemporary anthology of poetry, and her extant production is limited to the one sonnet she composed for the *tenzone*.

There is little biographical information available on Virginia Luti. She was born in 1513, the daughter of the jurist Cristofano Luti, a member of the Monte dei Riformatori.[33] We have no record of her marriage to Achille Salvi, but it probably took place around 1530–31, if the sudden flurry of children sired by Achille in the early 1530s can be taken as evidence.[34] The seventeenth-century Sienese erudite Isidoro Ugurgieri Azzolini describes her as a prolific poet who inspired many members of the Sienese Academy of the Intronati to engage in discussion with her and to write poetry in praise of her: "Virginia Luti, a Sienese noblewoman, was the wife of Achille Salvi, and at the Sienese soirées she showed such a sublime spirit that on many occasions she persuaded the loftiest wits among the Sienese academicians to loosen their tongues and move their pens in order to consecrate her rare abilities with voice and with ink. We have seen many of the octaves and sonnets she composed, very beautiful and numerous."[35] Unfortunately, however, neither her many octaves and sonnets nor the poems in praise of her have come down to us. All we have of hers is the one poem she composed for the *tenzone* with Alessandro Piccolomini, and it seems to reveal, not the brilliant conversationalist who sparks men's intellect and poetic skills but rather a somewhat self-effacing woman. In the sonnet Virginia Luti Salvi draws back from any attempt to "honor" Petrarch's tomb with a poem of her own because she fears that any effort on her part would be completely overshadowed and surpassed by Piccolomini's own work. She thus limits herself to praising Piccolomini and wishing that his head might always be crowned with the scents of laurel, myrtle, and flowers.

> Come poss'io onorar la sacra tomba
> Di chi tanto lodò 'l suo amato alloro
> Che le gradite frondi alzate foro
> Assai più su ch'arco no' spinge o fromba
> Poiché non s'udì mai più chiara tromba
> Della tua, che canti oggi il bel lavoro,
> Alessandro, con suon' tanto sonoro
> Che sol' d'ogn'altro più chiaro rimbomba.

Io non vorria col mio dir' noia e scorno
Recarti, ma di nuovi grati odori
Empirte s'io potesse il dotto seno.
　　Quel' ch'io posso prego or, che sempre ameno
L'aer si aggiri a la tua testa intorno
E porti odor di lauri, mirti, e fiori.[36]

———

How can I honor the sacred tomb / of he who praised his
beloved laurel so much / and raised the cherished branches
higher / than ever a sling or a bow could cast, // for never was
a clearer trumpet heard / than yours, who praise the graceful
work today, / Alessandro, with such a resonant sound / that
it alone, among the rest, resounds. // I would not want my
words to trouble you / or to offend, but to imbue with new /
and welcome scents your learned breast. // With all my
strength today I pray the air / to always gently waft your brow
and bring / to you the scents of laurel, myrtle, and flowers.

On first reading, Virginia Luti Salvi's sonnet seems to be nothing
more than a polite compliment addressed to a person she knows and
admires. It does not contain any of her sister-in-law's anguish and con-
cerns, nor does it suggest that the author might wish, even remotely, to
visit Petrarch's tomb. If anything, Virginia Luti Salvi seems to be quite
happy to remain in Siena and . . . pray!

The strongest sentiment she expresses is, in fact, her desire to pray
(prego). If there is a hidden agenda or a subtle suggestion in the poem,
it might well be that Piccolomini is in dire need of prayer and should
worry about his eternal soul. This suggestion comes to light in the last
tercet, when, in the rhetorically important final verse, Virginia Luti Salvi
offers Piccolomini (and not Petrarch) a combination of laurel, myrtle,
and flowers. When taken separately, the laurel is symbolic of immor-
tality acquired either in battle or in poetry, while the myrtle is symbolic
of love and remembrance; together, the two plants symbolize eternal
life. Is Virginia Luti Salvi suggesting that Piccolomini ought to worry
more about eternal life, that is, about the salvation of his soul, and less
about visiting Petrarch's tomb? When one rereads the sonnet with this
thought in mind, a number of details suddenly seem to support such

an interpretation. We note, for example, that from the very first verse Virginia Luti Salvi firmly refuses to pay homage to Petrarch's memory or to his tomb. Unlike her sister-in-law, she is not interested in leaving laudatory sonnets at the grave site. Is Virginia doing this because Petrarch's love for Laura and the poetry he wrote in praise of her, both of which Piccolomini is praising, were expressions of a profane, illicit, and earthly affection that was inimical to the Christian goals of spiritual salvation?

In the sextet, which traditionally responds to the preceding octave, Virginia Luti Salvi clearly says that she hopes her previous comments have not troubled or upset Piccolomini ("non vorria . . . noia e scorno recarti"). She then quickly adds that her intention was simply to fill Piccolomini's "learned breast" *(dotto seno)* with "new and welcome scents." It is inconceivable that Virginia might be referring to her own poetry or her own ideas as "new and welcomed scents," so what could she be referring to? Taken together with her suggestion that Piccolomini should be paying more attention to his eternal life, the new and welcomed scents may well refer to a new and desired form of religion—perhaps the renewed faith and reformed Catholicism of the Spirituali, the religious movement that in the 1530s and 1540s found quite a number of adherents in Siena at all levels of society.

It is tempting to think that Virginia Luti Salvi might have heard, or even been a follower of, the Capuchin friar Bernardino Ochino (1487–1564), general of his order, who was preaching his reformist ideas in Siena at exactly that time (1539–40) and was "raising enthusiasm, discussions, but also the first hostilities" against him.[37] Ochino would eventually be faced with accusations of holding and preaching heretical views and with an inevitable summons to Rome, which he would answer by fleeing across the Alps and adhering to the Protestant cause. In those years in Siena laymen such as the humanist and teacher Aonio Paleario (1500–1570) and Bartolomeo Carli Piccolomini, and several members of the Sozzini (or Socini) family, were also all actively engaged in reformist thinking and discussions.[38]

Aonio Paleario was a newcomer to Siena, having settled there in 1536. He married a local woman, set up house, and raised a family in Colle Valdelsa, all the while supporting himself by teaching Greek and

Latin privately and by publishing original works touching on theology and religion. In 1540, the year of the "Tombaide," he became embroiled in a controversy with the Dominican preacher Vittorio da Firenze, who, on a preaching assignment in Colle Valdelsa, publicly accused Paleario and his group of Sienese and Florentine friends of harboring heretical ideas. The controversy was soon cut short by ducal intervention against the Dominican friar, but it did stoke the fires and eventually led to a formal charge of heresy (1542), from which Paleario defended himself successfully. A suspicion, however, remained, so much so that in 1546 Paleario was obliged to flee to Lucca, leaving his family behind in Colle Valdelsa, where they remained safe and sound even after his arrest (1568) and eventual execution as a heretic (3 July 1570).[39]

Siena also had its own local "heretics." Several member of the Sozzini family, which had a long tradition of being "freethinkers," were suspected or tried for heresy. Some of the Sozzini men were forced to flee Siena and Italy before the Inquisition could arrest them—Lelio Sozzini (1525–62) and his nephew Fausto Sozzini (1539–1604), for example. Others were not as lucky: Lelio's brothers, Cornelio and Celso, were arrested and tried in Bologna (1558); Cornelio was re-arrested and tried once more, this time with his brother Dario, in Siena (1560); a fourth brother, Camillo, narrowly escaped arrest and fled to Geneva (1560). The religious climate in Siena was such that, in 1568, under the pontificate of Pius V Ghislieri (who had previously been Grand Inquisitor), the Holy Office began to examine systematically Siena's religious past with a view to cleansing the city even of its past errors.[40]

With this in mind, the opening verse of the final tercet of Virginia Luti Salvi's sonnet becomes highly significant. In it, Virginia says that she will pray as much as she can ("Quel ch'io posso prego or") that Alessandro may understand what eternal life really is. Her wish that his head be circled with, or wafted by, the *scent* of laurel, myrtle, and flowers (not the leaves and blooms themselves) may indicate that she cannot give him the actual thing (only God can grant that) but that she can give him an idea or a hint of what eternal life is. To use a more modern image, she may be thinking that if he smells the coffee, he just may wake up! Was Virginia Luti Salvi preaching reform to Piccolomini? And what kind of reform was it? Her suggestion that Piccolomini's learning

(dotto seno) needs to be filled with new and welcomed scents—that is, with reformed religion—may well point to a crypto-Lutheran belief in salvation by faith alone *(sola fide)*.

Piccolomini, however, was not ready to abandon his secular studies, nor was he ripe for conversion. The future bishop of Patras and eventual coadjutor of the archbishop of Siena (1574) appears to have understood Salvi's intentions, but he was clearly not ready to join the choir. At this point in his life Piccolomini was still a very secular student at the University of Padua, much more interested in literary academies and the worldly life of a student than in a career in the Church or in reformist religious ideas. Not surprisingly, then, his response to Virginia Luti Salvi is polite but firm. He achieves the first by setting up a linguistic distance between them—while she used the familiar *tu* form to address him (vv. 6, 10, 11, 13, 14), he instead uses the polite *voi* form (vv. 5, 7, 9, 10, 11, 14). Then he rebuts her views, saying:

> Chi potrà più onorar la sacra tomba
> Di chi del bel Toscan' secondo alloro
> S'ornò, i cui rami mai scosti non foro
> Dall'ardente di Giove orrida fromba.
>
> Di voi, che con dorata inclita tromba,
> Saggia Virginia, ogni mortal lavoro
> Far potete immortal, suon' sì sonoro
> Dal pol' nostro all'altrui dolce rimbomba.
>
> Grazie ben vi debb'io, ch'oltraggio e scorno
> Fate in parte al mio duol, mentre di odori
> Mi empite ad ambe man' dal proprio seno
>
> Ma, lasso, allor fia sol', ch'aere ameno
> Possa inspirar, ch'io veggia all'Arbia intorno
> Flori, Placida, e voi tra l'erbe e i fiori.[41]

Who now the sacred tomb might better praise / than one who, second, is bedecked with that fair Tuscan's / laurel tree, whose limbs were never torn / by Jupiter's dreadful burning bolt? // With its sweet sound your pure and golden voice, / wise Virginia, can raise all human works / to immortality and ring out sweetly / with vibrant sounds from our pole to the other. // I thank you,

surely, even though you mock / and scorn my pain while with both hands / you fill me with sweet scents from your own breast. // Alas, let me but hope to breathe the air / so fine and by the Arbia see you with / Flori and Placida among the grass and flowers.

Reaffirming the validity of Petrarch's love for Laura, Piccolomini points out that the laurel tree was never struck by Jupiter's dreadful lightning bolt. In other words, God was never displeased by the love Petrarch bore for Laura. Having set Virginia straight, as it were, about the legitimacy of this supposedly earthly and profane love, Alessandro is quick to set Virginia's mind at peace and to avoid offending her, so in the second quatrain he compliments her for her "pure and golden voice" that can grant immortality and fame to any human endeavor. In the first tercet he thanks Virginia for her interest in him but subtly suggests that, in his eyes, such interest really amounts to scorn and disdain for what he feels, that is, for his profound love pains. In the last tercet, as he brings his sonnet to a close, Alessandro expresses his hope he may soon return to Siena (where the air is much more pleasant than in Padua) and his desire to see once again Virginia and her two friends, the "nymphs" Flori and Placida (whom we have already tentatively identified as Laudomia Forteguerri and Eufrasia Placidi de' Venturi).

The exchange between Piccolomini and Luti Salvi reveals that some women of the Sienese upper class were interested not only in letters but also in religion and possibly even in religious reform. Virginia Luti Salvi seems to have been not only concerned about the dangers of profane earthly love but also ready to warn her friend against them. Unfortunately, we do not have sufficient biographical information on her to pursue this suggestion further, but we might take her sonnet and Alessandro's response as a signpost for future research to gain a fuller understanding of the place and role of women in Sienese society at the time of Siena's involvement with the Italian reform movement.

Eufrasia Marzi Borghesi (b. 1512)

Virginia Luti Salvi was not the only Sienese woman poet interested in religious questions. Eufrasia Marzi, about whom we know a little more,

also appears to have been part of women's conversations on questions philosophical and religious. Eufrasia was born in 1512 to Messer Giovanni di Petrone Marzi (or Martij) and his wife Andrea di Bartolomeo Bellanti. She had at least two brothers, Giulio (b. 1521) and Annibale (b. 1523), neither of whom seems to have sired children, and perhaps also a sister, Maria (b. 1524).[42] Because their mother died when Eufrasia was still a young girl, her father placed her with the nuns at the monastery of Santa Petronella, where she had an aunt. There Eufrasia was educated as befitted a girl of her rank—in the words of her contemporary biographer, Marc'Antonio Piccolomini, in the convent she learned "all those things that noble girls and all women ought to know . . . how to live in a saintly manner, and the ornaments of the soul, such as how to play a musical instrument, how to sing, how to embroider, and the other skills suitable for young women."[43] Although brought up separately from her brothers, Eufrasia seems to have been close to them; when Annibale died, she composed a tender sonnet for him, "Tu spargi dolce lode, io duro pianto" (You scatter sweet praises, I bitter tears).[44] Eufrasia was also close to Girolama Carli Piccolomini, not only visiting her (as we will see below) but also composing a number of poems (*stanze*) to comfort her on the death of her husband (1538).[45] In 1537 Eufrasia married Lodovico di Simone Borghesi (b. 1494), bringing with her a dowry of 2,000 florins. The couple had at least one daughter, Cornelia Maria (b. 1545).[46]

The seventeenth-century erudite Isidoro Ugurgieri Azzolini remembered Eufrasia Marzi as a fine poet and added that he could vouch for this because he had been fortunate enough to read many manuscripts of her works.[47] More recently, Ubaldo Cagliaritano remembered her as a "poet, writer, and exceptional interpreter of orations, poems, and madrigals."[48] These are neither profound nor informative records, but the little contemporary documentation on Eufrasia Marzi that survives does allow us to catch a glimpse of the woman and to formulate, at least in part, an impression of her.

The first time Eufrasia appears in literature, as it were, is in 1538, when Marc'Antonio Piccolomini used her as one of the three interlocutors (with Laudomia Forteguerri and Girolama Carli Piccolomini) for a dialogue on "whether Nature creates a beautiful woman by chance

or by design."[49] Marc'Antonio's dialogue is imbued with profound and dangerous religious implications that touch on matters of fate, free will, and the existence of purgatory. Possibly because of the heterodox views it advanced and debated, the dialogue remained untitled and unpublished until 1992.[50]

The dialogue is set in contemporary Siena at the palazzo of Girolama Carli Piccolomini. Its premise is that Girolama has met Laudomia Forteguerri in the street, dissuaded her from going to church, and invited her to come home with her for a chat, an offer the young Laudomia (twenty-three years old at that time) is quick to accept. As they settle in, their conversation turns into a discussion on the beauty of some of the women they know. Laudomia advances the view that these women's beauty is accidental because Nature created it by chance, not by design. Such a view implies that there is no master plan in the world, which is tantamount to denying a divine plan. Girolama argues against this view, proposing instead that Nature does have a plan (to attain perfection) and that a beautiful woman is proof of that plan. To support her point, Girolama alludes to their mutual friend, the beautiful Eufrasia Marzi, who is not yet present (she will arrive shortly). The discussion continues until Laudomia concedes the point and they agree that Nature (that is, God) does have a plan and that it is, in very Aristotelian terms, to move toward and eventually attain perfection. The belief in a master plan, however, undermines the belief in personal free will, and this, in turn, brings into question the idea that one is responsible for one's actions and therefore punishable for one's deeds. At this point the two women engage in a discussion on the existence of purgatory and on whether a soul needs to undergo purgation before entering heaven—a dangerous topic in Siena in the 1530s, when crypto-Protestants such as Bernardino Ochino, Aonio Paleario, and various Sozzini were in town promoting reformist ideas. While Laudomia advances the heterodox hypothesis that souls do not need purgation (and therefore denies the existence of purgatory), Girolama strongly defends the need for and existence of purgatory. As they debate, Eufrasia Marzi arrives and begins to interject occasional comments into the discussion but does not take sides in the debate until the end, when they all agree that souls do need to be purged and therefore that purgatory does exist. Eufrasia's role in the dialogue is to serve

as an inspiration and as a model—her beauty sparks the dialogue, and she herself serves as a mirror for the discussion. While she does not personally engage in questions of philosophical or religious truths, her very existence, that is, her beauty, is sufficient to raise such questions and to ignite discussions. She is, in short, the catalyst.

While the topic of this dialogue may be interesting, especially in the context of contemporary theological debates, what is perhaps more fascinating for our purposes is that Marc'Antonio Piccolomini, a male author very much involved in political and religious debate at the time, is using three eminent noblewomen of his time and town to advance diverse views on sensitive questions and then to resolve these views with an orthodox conclusion that reflects the peace and tranquillity of the state. The gendered dialogue in this long-unpublished work is not among the interlocutors, who are all women, but between the author and his characters, all well-known local figures whose reputation is placed on the line by Marc'Antonio's risky maneuver. Although Rita Belladonna, the dialogue's modern editor, has provided an excellent introduction to the work, a thorough analysis of the social and political implications this work may have had for the three women who supposedly spoke these words still remains to be carried out.

The beautiful Eufrasia Marzi reappears a second time in Marc'Antonio Piccolomini's oration "La vita de la Nob.ma M.a Arithea de Marzi."[51] Here, too, Eufrasia is reduced to a mere figure of beauty that inspires the author to compose not only the oration but also the three sonnets in praise of her that he then incorporates into the oration. The work is addressed directly to Eufrasia, whom the author calls Arithea because, as he puts it, "in Greek Aris means Mars, and Thea sounds like the Italian word 'Dea' [Goddess], so I put them together and then to obtain a sweet sound I removed the s, and this produced Arithea, as if to say Marzia Goddess" (fol. 15v). The logic is somewhat convoluted and the philology not very sound, and the same could be said for the oration itself as it lauds the still-living Eufrasia by presenting her with a rather over-the-top biography of herself—a sort of "This is your life, Eufrasia Marzi!"

Marc'Antonio begins with an apology and an explanation for his desire to compose an oration in praise of Eufrasia, citing antique sources and suggesting a need to counteract *invidia,* envy (fols. 1r–5r). He then

follows with a biographical sketch of Eufrasia that begins with an imaginative history of her family's divine ancestry, complete with descent from the god Mars and a Roman virgin named Tilesia (fols. 5v–8r). He describes her auspicious birth in the springtime and mentions her convent education, her obedience to her father, her husband's devotion to her, and the respect her peers have for her (fols. 8v–11v). Pointing out that her body is bigger than that of most women, he adds that it is nonetheless perfectly proportioned, so much so that it recalls the harmony of the celestial spheres. At this point Marc'Antonio transcribes a sonnet on the subject, "Fra sì alte bellezze, alto il pensiero" (Amid such lofty beauty, the lofty thought), which he then uses as the cue for a discussion of death, pointing out that there are four types of death—two of the soul and two of the body (fols. 12r–15r). Remarking that Eufrasia cares little for the two deaths of the body but keeps her eyes firmly fixed on heaven, Marc'Antonio transcribes a second sonnet, "Io viddi 'l ciel di lucide faville" (I saw the sky with shining stars), and moves on to a discussion of her physical beauty (fol. 15r–17r), which, as he says, "is so excellent that it has led someone to wonder whether it was created by chance"—a clear reference to his previous dialogue. And so he begins to describe her ebony hair and eyebrows, her white complexion, her spacious forehead, and her lively and beautiful dark eyes that lead the viewer to contemplate the "first beauty" *(primo bello)*. At this point Marc'Antonio inserts a sonnet on the beauty of her gaze, "Quando madonna suavemente gira" (When my lady softy turns; fol. 17r–v), that is firmly in line with Sweet New Style and Petrarchist sentiments. Such is the grace and beauty of Eufrasia's eyes, he continues, that none of the many local artists and not even the foreign ones who have come to Siena on commission to paint her portrait have succeeded in reproducing their spark, nor could ancient masters such as Apelles, Phidias, Zeuxis, or Parrasius.[52] After mentioning once again Eufrasia's size, Marc'Antonio praises her agility *(destreza),* her lightness *(leggiadria),* and her hands (fols. 18v–19r) before moving on to her mature speech, judicious counsel, pleasant conversation, wise words, and courtly manners. He compares her with famous queens from antiquity such as Semiramis, queen of the Assyrians, and Tomyris, queen of the Massagetae (whom Piccolomini calls the Scythians), pointing out that she would be an excellent queen and captain, but then, clearly worried about gender confusion, he quickly moves

on to praise her modesty in dress, her grace when wearing beautiful clothes and jewels, her courtesy, her morality *(honestà),* and her good manners (fols. 19r–21r). Having praised Eufrasia to the skies, Marc'Antonio now turns, for the sake of truth and "history," to point out what bothers him about her—the fact that too many unworthy men enjoy the sweetness of her words, that she embellishes her discourse with too many lively phrases *(leggiadri motti),* that she is quick to rebut and that she is quick-witted (fols. 21r–23r). At this point Marc'Antonio complains that too many people love Eufrasia and says this is not good because nowadays people love "for reasons [he] won't mention" (fol. 24r); fortunately, however, Eufrasia is able to discern true love from false love, so she is safe from public scrutiny. With this implied criticism, Marc'Antonio explains that if Eufrasia has not understood that his love for her is true, it's not because of any failure on her part; the failure is his. And this brings Marc'Antonio to his conclusion, where, referring back to Phaeton's fatal hubris in trying to steer his father's chariot, he expresses the hope not to have made a fool of himself by attempting a task that is too difficult for him, that is, to sing Eufrasia's praises (fols. 24v–25v). Marc'Antonio's last comment points to Eufrasia's "learned verses" that contain her "lofty ideas" and will defend her "from the dark night," but he declines to discuss them until he has collected enough of them, supposedly to form a more well-rounded opinion of them.

Modern scholars are also faced with Marc'Antonio's problem. Eufrasia Marzi's work does not appear in any published or manuscript collection and is difficult to locate. The sonnet on her brother's death and the stanzas to console Girolama Carli Piccolomini, mentioned by Marc'Antonio in his oration, have yet to be discovered. Only her poem from the *tenzone* with Marc'Antonio's cousin, Alessandro Piccolomini, has managed to come down to us. In it we find Eufrasia addressing Petrarch's tomb and complimenting both the tomb and Alessandro, the first for its contents, the second for his poetic voice:

> Tu pur, superba e avventurosa tomba
> Cuopri il cultor del glorioso alloro
> Per cui i bei rami al ciel alzati foro
> Che non tanto mai salse arco nè fromba.

D'Alessandro una assai più chiara tromba
Ti canta con ricchissimo lavoro,
Tal che di te e di lui chiaro e sonoro
Splendida fama il Ciel rompe e rimbomba.
 Chi dunque fia, che ad ambi faccia scorno
E non vi esalti con sublimi odori
Di quei che ad Alessandro ornaro il seno?
 Fa' festa all'ombra e al cener' grato ameno
Per cui sei celebrata intorno intorno
Da teste cinte d'edra, allori e fiori.[53]

And you, exalted and most blessed tomb, / enclose the lover of the glorious laurel / that raised its branches up to heaven / to heights that never bow or sling did reach. // Alessandro's trumpet, clearer [than mine], / sings out your praises with the richest skill / so that your fame, and his, resplendent rise / to open heaven's gate and sound within. // Who then will dare to scorn either of them / and not exalt you both with scents sublime / like those that once adorned Alexander's breast? // Extol that shade and his most sacred ashes / that are the reason why you are revered / by heads bedecked with ivy, laurel, and flowers.

Eufrasia Marzi's sonnet is not indicative of great poetic skill. For example, it contains some awkward linguistic moments best epitomized by the strangely ambivalent fifth verse, which, in a reading that respects the grammar of the sentence, says that there *is* a much clearer trumpet than Alessandro's ("una tromba assai più chiara d'Alessandro ti canta"); such an idea is clearly not what the poet wished to express, so the reader must overlook the bad grammar and supply the intended correct meaning.

Marzi's concluding image of people with heads bedecked with ivy, laurel, and flowers celebrating Petrarch's tomb and Alessandro's poetry suggests that these people may, in fact, be women poets—the ivy, a symbol of conjugal love, coupled with the laurel and with flowers may well refer to the group of Sienese women who responded to Piccolomini's original sonnet. This would suggest that the women were aware

of each other's participation in the *tenzone*. Marzi's poem is thus impor-
tant because it suggests that these women were writing, not in solitude
or in dialogue with a man but as part of a group activity that engaged
them both singly and collectively. Such an idea is fully in line with the
lively and well-established tradition in Siena of women's participation
in literary and cultural activities, best exemplified by their contribution
to the literary soirées described by Girolamo Bargagli in his *Dialogo de'*
giuochi. So, while Marzi's poetry may not be of the highest quality, it is of
interest to us for what it suggests about Sienese women's self-awareness
as poets and their participation in the local literary culture.

Overlooking the sonnet's weaknesses, Alessandro Piccolomini po-
litely praises Marzi's poetic effort and shamelessly suggests that her
work surpasses Petrarch's.

> Martia gentil, ch'ogni più oscura tomba
> Giardin' vago rendete, il Tosco alloro
> Non alzossi, se ben suoi rami foro
> U' non temon del tempo invida fromba,
>
> Quant' i vostri (se 'l ver con chiara tromba
> Fama ne apporta). Il proprio alto lavoro
> Già n'erge, e un' mormorio dolce e sonoro
> Tra le frondi gentili alto rimbomba.
>
> Deh, perché tanta terra oltraggio e scorno
> Mi fa, che men' lontano i grati odori
> Non senta uscir dal culto vostro seno?
>
> Pur potrei respirar l'aer, ch'ameno
> Rende l'odor de' vostri frutti intorno
> Mentre ch'a l'ombra vostra apronsi i fiori.[54]

Gentle Marzia, who turns the darkest tomb / into a lovely
garden, the Tuscan laurel / did not rise as high, although its
limbs / reached heights where they feared not Time's envious
sling, // as do your own (if Fame reports the truth / with
trumpet clear). Your own fine work already / soars beyond, and
vibrant sweet, a murmur / among the gentle branches echoes
high. // Oh, why does so much land insult and scorn me, /

why not reduce the distance from those scents / that come so
welcomed from your learned breast? // Then I could breathe
the air that renders sweet / the fragrance that exudes from
'round your fruits / while in your shadow flowers blossom forth.

Piccolomini's compliment is clearly pro forma and should not be taken
seriously. His aim is to be gallant and to encourage Marzi in her poetic
efforts. What might be more sincere is Piccolomini's wish to be back
in Siena where he could engage more personally and more directly
in literary and poetic conversations with Marzi and his other women
friends—among them, two fellow members of the Piccolomini clan,
one by birth, the other by marriage: Camilla Piccolomini de' Petroni
and Girolama Biringucci de' Piccolomini. We know very little about
them. Neither woman appears in Ludovico Domenichi's collection of
poetry by women or in any other published source, then or now, and
all that we have by them is their single sonnet contribution to the *ten-
zone*. In their anonymity they are excellent examples of the average lit-
erate woman in Siena.

Camilla Piccolomini de' Petroni (b. 1506)

Camilla Piccolomini de' Petroni was born in 1506 to Guid'Antonio
di Buonsignore Piccolomini (b. 1483). In 1535 she married Valerio di
Pietro Petroni (b. 1508), bringing with her a dowry of 1,800 florins.
They had four children together: Petro Maria Romulo (1536), Ippolita
Maria (1537), Propitia Maria (1539), and Fabio Romulo (1545).[55] In her
response sonnet to Alessandro Piccolomini, Camilla returns to the pas-
toral setting we have already encountered in some of the other poems
in the "Tombaide" and imagines the nymph Chlorys gathering flowers
and thinking what she will do with them.

> "Parte ne spargerò sopra la tomba
> Di quel saggio pastor, di cui d'alloro
> I sacri rami tanto alzati foro
> Che di gagliarda man' non temon fromba.

Degl'altri per ornar poi ogni tromba
Farò ghirlande con gentil lavoro.
La più vaga abbi quella 'l cui sonoro
Suon' più chiar' eco e più volte rimbomba.
 Poscia pregarò il Ciel' no' faccia scorno
Con venti ingrati al luoco, e solo odori
L'aura gl'apporti con l'aurato seno."
 Così diceva Clori; e al canto ameno
D'adunati pastor ch'udiva intorno
Desiosa sen' gia carca di fiori.[56]

———

"Some I will scatter upon the tomb / Of that wise shepherd, who raised the laurel's / Sacred branches to such heights that they / Fear not the slings of a daring hand. // The rest I'll weave in wreaths with graceful skill / To decorate the trumpets, one and all. / The fairest wreath is for the one whose sound / So vibrant echoes and resounds the most. // Then I'll pray Heaven not to scorn this place / With thankless winds, and may the breeze bring him / Only perfumes from its laurel breast." // This is what Chlorys said as pleasant songs / Were heard from nearby shepherds and she walked / Along full glad, her arms replete with flowers.

Camilla's sonnet exudes the tranquillity normally associated with the pastoral, but, like all pastorals, it also hints at an underlying potential for turmoil and disaster. The implied threat from an audacious sling, the possibility of thankless winds, not to mention Chlorys's own name and legend (Chlorys was a nymph raped by Zephyrus, god of the west wind, who then changed her name to Floris and made her the nymph protector of springtime flowers),[57] all suggest that peace and tranquillity are tenuous at best—a suggestion that certainly fits with Sienese politics at that time, especially from the perspective of the Piccolomini clan to which Camilla belonged. Camilla's own way of dealing with the tense sociopolitical situation of the time may well be reflected in Chlorys, who spends her time weaving garlands and listening to the song of shepherds, two images that suggest that Camilla preferred to spend her time

in the company of poets and literati, whom she gladly rewarded with gifts and with her appreciation. The pastoral world and, by extension, the world of letters are thus ways for Camilla to escape from the harsh realities of the times.

Piccolomini's response picks up on the tranquillity of Camilla's pastoral setting but also on the potential for turmoil lying just below the surface.

> "Dunque la bella Clori alla gran' tomba
> Del Tosco ch'onorò l'amato alloro
> Spargendo fior, che sì ben nati foro
> Che non temon del verno ispida fromba
> Parte, Damon, su la tua stessa tromba
> Ne sparge ancor' co' bel vago lavoro,"
> Dicean Toschi pastori, almo e sonoro
> Mandando il suon ch'al Ciel' alto rimbomba,
> "Felice te, che con oltraggio e scorno
> Della Brenta ti versa grati odori
> ninfa così gentil dal suo bel seno."
> Ed egli allora: "O benigno, alto, ameno
> Aer fatto seren da Clori intorno,
> O discesa dal Ciel pioggia di fiori."[58]

———

"And so, fair Chlorys, at the splendid tomb / That holds the Tuscan who revered the laurel / He loved, is scattering flowers, born so blest / They do not fear the winter's bristly sling. // Some she scatters, Damon, on your own / Trumpet, too, in her delightful work." / Thus spoke the Tuscan shepherds, sending out / A noble, vibrant voice as far as Heaven. // "Happy are you, for, much to Brenta's scorn, / So elegant a nymph pours out to you / Such pleasant fragrances from her fair breast." // And then he said: "Fine air, so sweet and kind, / That's made serene by Chlorys's presence here, / Oh rain of flowers falling down from heaven."

The initial "And so" *(Dunque)* and the tone of the comments made to Damon (that is, Alessandro) by the Tuscan shepherds suggest an

atmosphere of gossip and teasing among the Italian literati. The implied jealousy present in their words is heightened, in a way, by Damon/Alessandro's own response to the shepherds/literati: two expressions of pleasure both introduced by the exclamation "Oh," one for the wafting breeze that caresses him and one for the shower of flowers that descends upon him. With these two last images Piccolomini is clearly alluding to Petrarch's famous canzone "Chiare, fresche, e dolci acque," in which the poet recalls how he once spied upon Laura bathing in a river pool and then lying out on the grass to dry herself while a shower of petals fell upon her:

> Da' be' rami scendea
> (dolce ne la memoria)
> una pioggia di fior' sovra 'l suo grembo,
> et ella si sedea
> humile in tanta gloria,
> coverta già de l'amoroso nembo;
> Qual fior cadea sul lembo,
> qual su le treccie bionde
> ch'oro forbito et perle
> eran quel dì a vederle,
> qual si posava in terra et qual su l'onde,
> qual con un vago errore
> girando parea dir: "Qui regna Amore."
> (*RVF,* 126, vv. 40–52)

———

From the beautiful branches descended / (sweet in my memory) / a rain of flowers upon her lap / and she sat there / humbly in so much glory, / already covered by the lovely cloud; / some fell on her skirt, / some on her blond braids / that burnished gold and pearl / seemed to be that day, / some came to rest on the ground, some on the waters, / some wandering about / in lovely confusion seemed to say, "Love reigns here."[59]

Petrarch's description of this episode is highly erotic (for that time and genre), with its detailed description of the poet's voyeurism and

the beloved's exhibitionism (Laura sees Petrarch hiding in the bushes looking at her but still continues with her bathing and sunning). This underlying sexual motif is heightened by the poet's compulsive return to a place associated with the beloved. Piccolomini takes advantage of this eroticism to endow his own sonnet with a sexual frisson that was not been present in Camilla's sonnet or indeed in any of the other women's responses—though it is often present in the pastoral genre, as exemplified by Poliziano's *Favola d'Orfeo* (1480?) and Torquato Tasso's *L'Aminta* (1573). Piccolomini subtly eroticizes the shepherd's comments to Damon by having them start with a *Dunque* that could easily be interpreted as a prelude to a jocular comment; he follows them up fast with a *bella Clori,* continues with a reference to Damon's *tromba,* and finishes with a reference to Chlorys's *bel vago lavoro.* When uttered by fellow males "complimenting" another male for the attention a pretty woman is showering upon him, the exchange suddenly becomes very ambivalent. After a short pause, the playful shepherds continue their teasing of Damon by complimenting him on the welcomed fragrances that this *gentil* (read, accommodating) nymph is bestowing on him directly from her beautiful bosom. Damon clearly picks up on this ambivalence, for his response whimsically mocks the entire situation by having recourse to a well-known, and well-worn, image from Petrarch describing how Laura herself at one time gratified Petrarch's erotic voyeurism.

If this interpretation is even slightly correct, Alessandro's response sonnet to Camilla Piccolomini de' Petroni is somewhat unexpected. Admittedly, Alessandro was no stranger to ambivalent and even blatant sexual mischief, as his racy dialogue *La Raffaella* can easily attest, but one would really not expect him to respond in a playful sexual manner to a noble kinswoman. Perhaps the answer can be found in the practice of playing word games that was so popular at social soirées in Siena at that time (see below, chapter 2), or in the pastoral genre itself, which allowed for such sexual banter to take place as long as it was politely couched in refined language and set in an idealized golden age. This pastoral world reappears, in fact, in the next exchange, this time with an in-law, Girolama Biringucci de' Piccolomini.

Girolama Biringucci de' Piccolomini (b. ca. 1500)

Girolama di Giovanni Biringucci was born sometime around 1500. In 1526 she married the forty-three-year-old widower Guid'Antonio di Buonsignore Piccolomini (b. 1483), bringing with her a dowry of 1,500 florins.[60] They had several children together, among them Buonsignore Niccolò Maurizio (b. 1527), Lattantio Maria (b. 1528), Fabio (b. 1531), Verginia Maria (b. 1533), Mutio Maria Torquato (b. 1534), and Girolamo Agnolo (b. 1538).[61]

In her sonnet, Girolama Biringucci picks up on the use of classical pastoral names that we have already encountered and creates a bucolic moment of some melancholic charm.

> Fillide giunta alla famosa tomba
> Di chi le dotte tempie dell'alloro
> Ornate dalle tosche muse foro
> E alzate in parte u' non giuns' arco, o fromba,
> "Felice, o" disse "poi che sì gran' tromba
> Per fare eterno il sacro tuo lavoro
> Manda fuor suon' sì dolce e sì sonoro
> Ch'all'orecchie divine omai rimbomba.
> Facciti pur scarpel del tempo scorno,
> Ché scemar non potrà quei grati odori
> De' quai si trova il mondo pieno il seno.
> Io sempre ch'andrò fuor dell'antro ameno
> A le ninfe e ai pastor che son' qui intorno
> Dirò che spargan meco e latte e fiori."[62]

———

When Phyllis reached the famous tomb / of him whose learned brow the Tuscan muses / had once adorned with the laurel's leaves / and raised to heights not reached by bow or sling, // "Happy are you," she said, "that such a trumpet / eternalizes your most sacred work / by sending forth such sweet and vibrant sounds / that even now resound in ears divine. // Well may you scorn the scythe of time, / for it will not diminish these sweet scents / that fill the breast of the entire world. // Whenever

from this pleasant cave I go / to see the nymphs and shepherds that dwell here / I'll ask them to strew milk and flowers with me."

Biringucci imagines that when the nymph Fillide (Phyllis) leaves her cave and joins her friends around Petrarch's tomb, she praises the dead poet, saying that time will not be able to chisel away his fame because he has a poet as excellent as Alessandro to sing his praises. She then invites the local nymphs and shepherds to perpetually offer sacrifices upon the tomb by pouring milk and scattering flowers on it.

With the suggestion that Fillide dwells in a cave, Biringucci creates a melancholy moment by gently reminding the reader of the ancient myth of Phyllis, daughter of the king of Thrace. When, after the end of the Trojan War, the handsome hero Demophon, son of Theseus, king of Crete, stopped in Sidon on his way home, the two young people fell deeply in love. As he departed to go home, Demophon promised Phyllis he would marry her at his return to Sidon; but when he failed to appear on the day set for the wedding, Phyllis assumed she had been abandoned at the altar and so, distraught, committed suicide by hanging herself from a tree. Taking pity on the unfortunate girl, the goddess Athena changed her into an almond tree. When Demophon, who had been delayed in Crete for reasons beyond his control, finally returned to Sidon, he hugged the barren almond tree and wept bitterly for his lost love, at which point the tree burst into bloom. The myth is thus an emblem of love that surpasses death. By recalling it and speaking in the first person under the assumed name of Fillide, Girolama Biringucci presents herself as a woman (or wife) whose love for her beloved lasts beyond the grave—an appropriate image in a poem that pays homage to Petrarch's enduring love for Laura.

The allusion to the myth of Phyllis is reinforced by Biringucci's suggestion that she will pour libations of milk and scatter flowers on Petrarch's tomb. Since classical antiquity libations of milk have been a part of religious rituals, especially those associated with the cults of Demeter, the Greek goddess of agriculture; her Roman counterpart, Ceres; and Osiris, the Egyptian god of the underworld. All three divinities governed the cycle of birth, death, and renewal that allowed for regeneration and continued prosperity. By offering libations of milk,

the devotees were alluding to the life-giving powers and vigor inherent in the offering and in the divinity. With her exhortation to her fellow nymphs and shepherds to join her in pouring milk on Petrarch's tomb, Biringucci is thus alluding to the life-giving power of poetry that renews and invigorates the memory of both Petrarch and his beloved Laura. Alone of all the respondents, Biringucci thus weaves a subtle web of allusions that combines references to the power of poetry to grant immortality with the regenerative mythologies of pagan antiquity, and despair at the loss of one's beloved with the strength of love to reach beyond the grave.

Alessandro Piccolomini responds by complimenting Girolama (under the pastoral name of Filli, a familiar variant of Fillide) for the high quality of her poetry and concludes by wondering when he may return to Siena and raise an altar to her and Flori so as to honor them by sacrificing milk and flowers on it.

> Filli, dal cui bel sguardo oscura tomba
> Par poi ciò che si vede, il tosco alloro,
> Le cui cime sì in alto alzate foro
> Che riman' dietro ogni buon arco o fromba,
> Le vostre tempie e la vostra alma tromba
> Ben cinger' dee, poi ch' in sì bel lavoro
> Rime intessendo un suon dolce e sonoro
> Mandate sì, che 'l sen' d'Adria rimbomba.
> Ecco, ninfa gentil, ch'ad onta e scorno
> Del camin' lungo, i vostri stessi odori
> Dolce ne fan' questo Antenorto seno.
> O quando fia, ch' al bel paese ameno
> A Filli e Flori un altar' erga e intorno
> Gli versi latte e sparga rose e fiori?[63]

―――――

Phyllis, when one has gazed into your eyes / all else on earth seems but a somber tomb. / The Tuscan laurel, whose tops were raised so high / that every bow or sling was left behind, // your brow and your unblemished trumpet must / now gird, for you do weave your rhymes so well / that they send forth a sweet and vibrant sound / that echoes and resounds in Adria's breast. // Look, gentle nymph,

how to the shame and scorn / of this great distance your own scents do make / Antenor's bosom seem so sweet to us. // Oh, when will I, in my fine, pleasant land / an altar raise to Phyllis and to Floris / And scatter flowers, milk, and roses 'round it?

From this exchange it is clear that Fillide or Filli (Phyllis) is the poetic name for Girolama Biringucci herself. Drawing on external sources, we will propose in chapter 3 that Flori is the poetic name for Laudomia Forteguerri. Even after the women concealed under the two pastoral names are identified, it remains unclear why Piccolomini would want to raise altars and make sacrificial offerings to them while they are still alive. One possibility is that he wished in this manner to praise their beauty (by strewing flowers), their maternal femininity (by pouring milk), and his love for them (by offering roses). Such an interpretation, however, is admittedly tentative.

Alessandro's response opens with a charming but gratuitous compliment to Girolama's eyes and then continues with a standard compliment to her poetic abilities. Neither compliment seems to have anything to do with either his or her sonnet, but both do reflect the polite reciprocal admiration that we have already encountered in the other contributions to the "Tombaide." What is perhaps new and more interesting is that, unlike Virginia Martini Salvi, Girolama does visualize her own visit to Petrarch's tomb. Her opening words, "Fillide, giunta," recall Piccolomini's "Giunto Alessandro" not only in their structure (though admittedly in a chiasmic reversal) but also in their tone and their affirmative certainty, which creates a sense of reality missing from the other women's sonnets (except, perhaps, that of Camilla Piccolomini de' Petroni). Girolama Biringucci seems not to feel restricted in her movements and has no difficulties imagining a voyage to Arquà. Perhaps for this reason in his response sonnet Alessandro makes two very specific geographical references, one to the River Adria, which runs by Padua, the other to the city of Padua itself (Antenor's bosom).

———

Alessandro Piccolomini's *tenzone* with five talented Sienese women reveals that in sixteenth-century Siena there existed a lively network of

men and women who were connected not only by familial and personal bonds but also by common literary interests and poetic imagination. The quality of their poetry is not stellar by any means, but the contents and the context of these poems are of great interest to us. They speak of aspirations and good wishes, of limitations and dreams. They introduce us to women who were friends or relatives but who were not necessarily all the same. All were well read and charming, but some were also firmly opinionated and gently made their points.

The women were clearly literate. One is naturally tempted to ask: What were they reading? Clearly Petrarch's *Canzoniere* was a fundamental text for them. They knew their Italian classics and now, through the good auspices of their admirers, at least the first six books of Virgil's *Aeneid* were available to them in an Italian translation. But what should we make of Xenophon's *Oeconomicon* or of Piccolomini's two compilations of astronomical information for Laudomia Forteguerri, complete with charts and diagrams of the heavens and of the heavenly bodies?

Several of the women shared a poetic imagination that transported them and their friends into a pastoral world of loving shepherds and nymphs, a world connected with and nourished by the literary academies that flourished in Siena at the time. This world was, perhaps, also an intellectual escape mechanism that allowed them to find at least temporary relief from the sociopolitical tensions that plagued the city at midcentury, as we will see in the chapters that follow.[64]

More than intellectual escape, however, women's participation in literature and culture in midcentury Siena could indicate their personal involvement in the discussions touching the severe crises that Siena was facing at that time. To use a phrase from Virginia Cox, "These [women] were not necessarily 'silent' in the manner of [Petrarch's] Laura" but were "more substantial feminine presences . . . constructed as paragons of beauty, grace, nobility, and wit."[65] As we will see in the following chapters, they were also actively engaged in some of the major questions affecting their lives. In the case of Sienese women poets of the Cinquecento, there is plenty of evidence pointing to their active participation in some of the fundamental political, religious, and intellectual debates (and actions) that defined Sienese and Italian life at midcentury.

The *tenzone* of 1540 is just the start of their involvement. It marks a debut for a female writing experience in Siena that will flourish for a

couple of decades and then disappear. Over the course of these years, Sienese women will write, will be written about, will act, will be eulogized, will be remembered as never before. In a way, their participation in the cultural and literary debates of the time is part of a bourgeoning interest in women evident in the various "defenses of women" composed in the vernacular in exactly those years and in the so-called *querelle des femmes* that was so amply debated in the sixteenth century. In another way, it is also part of their *prise de position,* both cultural and political, in the debates and conflicts that marked their times. As I will propose in the Epilogue (echoing Pamela Benson's own observation), in times of crisis women step forth and rise to the challenge.[66] In the case of Siena, they did so not only through their poetry but also by their actions.

The following chapters will examine at greater length three of these Sienese women: Aurelia Petrucci, Laudomia Forteguerri, and Virginia Martini Casolani Salvi. They were clearly exceptional women—all very different and very differently engaged. In their diversity they reflect the heterogeneity of literate women in Siena during the final years of the republic. In their drive to make their voices heard and to act for the ideals they held dear, they give us a privileged insight into the determination, talent, and energy to be found among sixteenth-century women.

Aurelia Petrucci

Admired and Mourned

"They love blonde women in Siena," says Mr Syson. "They were famous for
their beautiful women. They would send them out to meet visiting dignitaries."
— Cyar Byrne, *The Independent,* 24 October 2007

Aurelia Petrucci was born in Siena in 1511 and died there in 1542 at just thirty-one years of age.[1] Although her life was brief, her renown was not so, at least not among Tuscan writers who praised and remembered her beauty, her charm, and her poetic talent. In her short life, Aurelia enjoyed a number of distinct advantages, not the least of which was to have been born into a wealthy, privileged family that had been, for some time, at the very center of Siena's political life.

Aurelia was, in fact, a woman born to privilege. She was the daughter, granddaughter, niece, or cousin of five consecutive lords of Siena. Her grandfather, the Magnifico Pandolfo Petrucci (1452–1512), had ruled the city from 1497 to 1512, much beloved by the general population.[2] In February 1511, just months before his death, the aging Pandolfo was able to marry his young son and heir, Borghese (1490–1526), to Vittoria Todeschini Piccolomini (1494–1570), the youngest daughter of one of the most powerful families in Siena. Vittoria's father was Andrea Todeschini Piccolomini (1445–1505), *signore* of Castiglione della

Pescaia and the Isola del Giglio, *consignore* of Camposervoli, a knight of the Order of Santiago, and a past *capitano del popolo* in Siena. Her mother was Agnese Farnese (ca. 1460–1509), daughter of Gabriele Francesco Farnese, *signore* of Ischia and Canino, and of Isabella Orsini of the counts of Nola and Pitigliano.[3] The match was clearly a political maneuver meant to tie the Petrucci family both to the powerful Piccolomini clan of Siena and to the rising star of the Farnese family of the Kingdom of Naples.

Although the match offered great political opportunities, these were soon lost by a drastic reversal of political fortunes. The following May Pandolfo died and the mantle of power in Siena passed to his twenty-two-year-old son, Borghese, who, according to general historical consensus, was neither as savvy nor as astute as his father. One modern historian describes him as "inept" and soon "discredited."[4] But not everyone agrees with this assessment—another modern scholar points out that Borghese was a steady and faithful follower of his father's politics and that, rightfully concerned with the presence of a Medici regime in Florence and another in Rome, he tried desperately to keep Siena independent by drawing closer to Spain and the empire, a strategy that, unfortunately, backfired.[5] On 16 March 1516, after only four years in power, Borghese was suddenly and unexpectedly overthrown in a coup organized by Pope Leo X and was immediately forced into exile along with his younger brother Fabio. Borghese was replaced at the head of the Sienese government by his cousin, Raffaele di Jacomo Petrucci (1472–1522), bishop of Grosseto, a longtime Medici supporter who would eventually be rewarded by Leo X with the cardinalate (1517). Although a cousin to Borghese, Bishop Raffaele was viscerally opposed to him and to the other heirs of Pandolfo Petrucci.[6] At Raffaele's death in 1522, power passed to his cousin Francesco di Camillo Petrucci, who had been the cardinal bishop's right-hand man for the previous two years. Francesco, however, held it for just over one year before being forcibly removed in yet another coup d'état. At this point Borghese's brother, the eighteen-year-old Fabio Petrucci, the youngest of Pandolfo's brood of sons, seized power in Siena but managed to hold on to it for just one year (December 1523–December 1524) before republican elements ousted him and seized control of the government, re-

turning the city to the so-called government of the Ten Priors that had been in place before the Petrucci dynasty wrestled power away from them. So Aurelia could claim an illustrious political pedigree, though not without its ups and downs—one with great men, their not-so-great sons, and their rival cousins.

Aurelia could also claim an illustrious pedigree in ecclesiastical government. On her mother's side she was a great-grand-niece of the humanist Pope Pius II (Enea Silvio Piccolomini, 1405–64), a great-niece of Pope Pius III (Francesco Todeschini Piccolomini, 1439–1503), and a niece to three different cardinals. Her mother's brother was Cardinal Giovanni Todeschini-Piccolomini (1475–1537), who had been elected bishop of Siena in 1503 and, among his many positions, had served as legate *a latere* for the Republic of Siena (1516–22). Her father's brother was Cardinal Alfonso Petrucci (1492–1517), bishop of Sovanna (1510), famous for having conspired to assassinate Pope Leo X. When his letter outlining the plot to poison the pontiff was intercepted, Alfonso was captured, obliged to confess publicly in front of the entire consistory, demoted, and then secretly strangled in his cell in Castel Sant'Angelo. Aurelia's second cousin on her father's side was the much more astute and politically savvy Cardinal Raffaele Petrucci, whom we have already met.

With two popes, three cardinals, and five rulers of Siena in the immediate branches of her family tree, Aurelia certainly grew up as one of the privileged young women of Italy. In spite of her pedigree, however, very little biographical information on Aurelia has survived. From archival sources we know her birth and death dates, the years of her two marriages, the names of her husbands, the name of one of her four children, and very little else.

Aurelia was a mere child of four when her father was removed from power and forced into exile. When Borghese literally fled overnight from Siena, he took only his young brother Fabio and a few trusted men with him as he headed straight to Naples, leaving behind his wife and their four daughters.[7] With her marital clan out of power and out of the picture, Vittoria Todeschini Piccolomini turned for protection to her paternal clan. She also left Siena but moved with her daughters only as far as the nearby town of Sarteano, sixty kilometers (forty miles) southeast

of Siena, where she went to live in the Palazzo Piccolomini, previously owned and extensively renovated in Renaissance style by her uncle, Pope Pius III Piccolomini.[8] Once separated by their different exile locations, Vittoria and Borghese did not have any further children together, an indication perhaps that, at the personal level the marriage had not been a successful union and there was no further interest in staying together, let alone in maintaining conjugal relations. While exile may have been disastrous for Borghese, who seems not to have amounted to much or done anything noteworthy, it apparently did not have terribly adverse effects on Vittoria, who seems to have regained her personal independence and retained both her lands and her wealth. Nor did it have adverse effects on their four daughters, who were all able to marry honorably into some of the most eminent families in Siena.

Aurelia, the couple's oldest daughter, was married twice. In 1524, at the age of thirteen, Aurelia was wed to Iacobo di Giovanfrancesco di Iacopo Petrucci, also known as Giacoppino, the grandson of Pandolfo Petrucci's brother (and therefore her second cousin). This was clearly a political marriage arranged by her uncle, Fabio Petrucci, in an effort to bring peace between the two warring sides of the Petrucci clan.[9] The timing of the marriage coincides perfectly with Fabio's short-lived *tirannia* in Siena from December 1523 to December 1524. Aurelia's father seems not to have been involved in the process or even present at the event.[10] When the Petrucci were again ousted from Siena, Aurelia's new husband of a few months followed his in-laws into exile—we find him in Bologna in the fall of 1529 with "all the major *fuorusciti*" who had flocked there in the vain hope that Pope Clement VII, in Bologna to crown Emperor Charles V, might advance their cause with the emperor.[11] Less than two years later Iacobo was dead and Aurelia a teen-aged widow and mother to two orphaned daughters. She remarried in 1531 at the age of twenty, this time to Camillo di Girolamo Venturi, with whom she had two more children—a son and a daughter. That same year, 1531, all three of her sisters also married: the second-born, Giulia, who would have been about eighteen or nineteen years old at that time, became the wife of Enea Borghesi; sixteen-year-old Agnese married Giovanni di Alessandro di Pietro Sozzini;[12] and fifteen-year-old Pandolfina married Anton Maria Petrucci, who, just a few years later, would

on more than one occasion host in his house Emperor Charles V as well as the emperor's daughter, Margaret of Austria, Duchess of Florence.

In 1531, when the four girls married, their father and all their paternal uncles had already died, either in exile or in prison; so the question arises as to who arranged their marriages. With no paternal males in the picture, it is most likely that it was the girls' mother and her kin who did this. In 1531 Vittoria Todeschini Piccolomini was still alive. She would live long into old age, dying in her palazzo in Sarteano circa 1570 at the age of about seventy-six. The fact that she was able to marry her four daughters well in spite of their father's and their paternal uncles' checkered political careers suggests that she enjoyed social prestige and political connections that were sufficiently elevated and independent of her husband and his clan to not affect the marital possibilities of her four daughters.

Dedicatee of the First Edition of Leone Ebreo's *Dialoghi d'amore*

Given her pedigree and her two patrician marriages, Aurelia would have lived her life quietly and unnoticed as a noble Sienese matron had she not been involved with men in literary and erudite circles. She first enters into the history of humane letters in 1535, when she appears as the dedicatee of the first edition of Leone Ebreo's *Dialoghi d'amore,* a work that had enormous success and influence in the sixteenth century and became one of the fundamental texts of Renaissance Neoplatonism.

The first edition, published in Rome by the printer Antonio Blado and dedicated to Aurelia Petrucci, is important because it forms the basis for all subsequent re-editions and translations. William Melczer points out that in the seventy years following the *editio princeps* the *Dialoghi d'amore* was reprinted eleven times with few changes just in Venice alone and underwent many translations into other European languages, including two in Latin, four in French, and five in Spanish. Melczer concludes that in the sixteenth century the *Dialogues* became a philosophical text read not only by specialists but by the cultured general public across wide sections of the European population.[13] Marc D. Angel goes even further and says that "in terms of the number of

editions printed, the *Dialoghi* rivaled Ficino's commentary on the *Symposium* and Pico's commentary on some sonnets by Beniviente [*sic* for Benivieni] as a main source of sixteenth century neo-Platonism."[14] Discussions on the *Dialoghi d'amore* are still quite lively, focusing not only on its contents but also on the circumstances of its publication. The jury is still out on whether this is an original work in Italian or a translation from Spanish or Hebrew. The context for this work is also a topic of great interest. In his 1983 edition of the work, Giacinto Manuppella pointed out that the earliest editions and three of the early manuscripts of the third dialogue contain so many obvious Tuscan elements that they point to an archetype "manipulated" by Tuscan humanists probably belonging to a Sienese context and most likely ("quasi sicuramente") connected with various branches of the Piccolomini family.[15] Similarly, until recently there was much debate on the identity of Mariano Lenzi, who prepared the manuscript for publication and for whom we lacked even the most basic biographical information until James Nelson Novoa identified him convincingly as a Sienese noble, nephew to Claudio Tolomei.[16]

The dedicatory letter signed by Mariano Lenzi is quite standard for the genre and would normally be overlooked by scholars except for that fact that it gives us the first written indication that Leone Ebreo, who was born in about 1460 and is documented until the mid-1520s, is now dead. Unfortunately for us, it does not, however, say very much about Lenzi, the circumstances of how he came upon Leone's text, and what led him to edit and publish it. The letter is a little more generous in what it reveals about Aurelia Petrucci, the dedicatee of this publication (whose mother, we should remember, was a Piccolomini). Lenzi praises the twenty-four-year-old Sienese woman for her intelligence and virtue, declaring her to be a model to which all others aspire—and by "others" Lenzi is clearly thinking of men rather than women. As he explains it, those who have refined intellects ("ingegni purgati") can see how Aurelia's life is nothing but a reflection and an ideal of how others ought to live ("uno specchio e una idea del modo come si convenga vivere agli altri"). Lenzi's language is clearly gendered masculine, not feminine, so Aurelia is presented as a mirror of life for refined male intellects, and not for women aspiring to be, according to Renaissance expectations for them, chaste and faithful wives.

Female chastity is not, however, very far from Lenzi's sociocultural radar. In his presentation of the text he is quick to point out that Leone Ebreo's dialogue on love contains "chaste matters of love for a chaste woman who inspires love; celestial thoughts for a woman adorned with celestial virtues; most lofty ideas for a woman full of very lofty thoughts."[17] The repetition and parallel structure certainly do underline the fact that Aurelia is a woman, but they also elevate the discussion of love to a higher sphere, something reminiscent of the medieval Italian tradition of the *donna angelicata* who inspires men to overcome their earthly limitations and thus rise to a higher level where love becomes a heavenly or spiritual experience free from the restriction of the physical realm—a concept best illustrated by Dante in his *Divine Comedy*. Finally, Mariano Lenzi says that by offering this work to Aurelia he is satisfying a debt he owes her—he does not, however, explain the nature of this debt.

Further research on the elusive Mariano Lenzi would certainly help us understand better the circumstances that led to the publication of this important work and the role played by Aurelia Petrucci in the project. Some scholars have even suggested that she (or her immediate family) were the owners of the manuscript and that she herself asked Lenzi to see the manuscript to press, but the evidence is not clear about this. What is clear, instead, is that one of the most important philosophical works of the century aimed at a general but also at a specialized readership was closely connected with a young twice-married Sienese woman, mother of four children and scion of a deposed ruler.

By 1535, when the book was published, Siena was no longer in Petrucci hands and had returned, instead, to a more oligarchic form of republican government, the so-called government of the Nine Priors (1525–45). This was a government that was closely tied to Spanish Imperial interests. The publication of an important philosophical work composed by an expatriate Iberian Jew and edited by a minor Sienese intellectual may well have had more than just a cultural or intellectual impulse behind it: by publishing the work of a Spanish philosopher, Mariano Lenzi may have been advancing the political interests of Aurelia Petrucci's natal or marital clans. We should remember, for example, that in October 1511 Aurelia's grandfather, Pandolfo Petrucci, had signed an important treaty with Ferdinand of Aragon that established

strong ties between Siena and Spain and set the course for a political understanding that was then continued by Aurelia's father, Borghese Petrucci, who was keen to maintain Siena's autonomy and independence in the face of encroaching Medici power in Florence (1512) and Rome (1513).[18] We must also remember that when the Petrucci were forced into exile (1515), Borghese fled to the Kingdom of Naples, at that time part of the Spanish crown, where he was elevated to the rank of baron. A pro-Spanish stance continued to characterize Sienese politics, even after the Medici were obliged to switch their allegiance from the French to the Spanish in the wake of the sack of Rome (1527), the reconquest of Florence (1530), the appointment of Alessandro de' Medici as Duke of Florence (1532), and his marriage to Charles V's daughter (1536). The publication of the *Dialogues* could also have been a way to mark a distancing from the current pope, Paul III Farnese, who was unquestionably more favorable to the French and bent on diminishing Spanish influence on the peninsula—even though his grandson Ottavio Farnese had married the emperor's daughter, Margaret of Austria. So there certainly are grounds for further considering a possible political undercurrent in the publication of the *Dialoghi* by an expatriate Sienese intellectual working under the aegis of an expatriate, pro-Spanish political family from Siena.

Dedicatee of Antonio Vignali's *Dulpisto*

Aurelia reappears in the cultural world of Sienese letters five years later, in 1540, as the dedicatee this time of Antonio Vignali's *Dulpisto,* a dialogue in which two young men, Filetimo and Dulpisto, talk about the latter's love for a local Sienese noblewoman.[19] This dialogue is not what people familiar with Antonio Vignali would have expected from him. Vignali (ca. 1500–1559) was the founder of the Sienese Accademia degli Intronati. About fifteen years earlier, in 1525–27, he had composed and published, under his academic name of "Arsiccio Intronato," the absolutely scurrilous dialogue *La Cazzaria,* a vulgar but riotously funny conversation between Arsiccio (Vignali himself) and his friend Sodo Intronato (Marc'Antonio Piccolomini). In the dialogue Arsiccio chastises Sodo for his ignorance of sexual matters and takes it upon him-

self to educate the young man in matters ranging from sex to language and then even to politics. For this last topic Arsiccio uses a sustained bawdy allegory based on the most obscene parts of the human body, an allegory that describes and analyzes the reasons behind the troubled political situation in Siena in the 1520s in terms of a raging battle between human sexual organs and other parts of the lower anatomy. As Judith Thurman, the literary critic of *The New Yorker,* summarizes it in simple terms for her readers:

> Arsiccio describes to Sodo how the Big Cocks and their prideful consorts, the Beautiful Cunts, once formed a dominant party that tyrannized a coalition of the lesser-endowed: the Little Cocks and their allies, the Ugly Cunts and Assholes, whose plot for a democratic revolution was betrayed by the cowardly and opportunistic Balls. In the course of the fable, the victors reassert their mastery and wreak their revenge with the kind of atrocious violations that recent history has reclaimed from the realm of Sadean fantasy. But then, Arsiccio continues, at the urging of a wise if bloodthirsty seeress known as the Great Cunt of Modena, the vanquished negotiate their differences in a fraternal fashion, and strike back at their oppressors, who are, in turn, slaughtered or dispersed. "I will say this about the Big Cocks," Modena concludes. "It is very possible they have taken refuge with some foreign power, from where, in a short time, seeing our discord, they may return to ruin and destroy each of us." Her moral is a little vague, though it seems sound: the phallus represents power without a conscience; it cannot, therefore, be trusted; while it sometimes lies low, you can't keep it down.[20]

Needless to say, in the wake of this exceedingly vulgar dialogue Vignali had acquired a tainted reputation. Not surprisingly, when he sent his dialogue *Dulpisto* to press in 1540 Vignali found it advisable to publish it anonymously, though he felt no need to safeguard the identity of the dedicatee of the work. In the brief, one-page dedicatory letter addressed to Aurelia Petrucci and dated 20 May 1540, Vignali indicates that his dialogue is part of a series of works currently being composed by various members of the Sienese Academy of the Intronati in honor of Aurelia Petrucci. He tells her that "while in the Academy of our

Intronati people are busy writing in praise and honor of your grace and *onestà,* most beautiful lady, I, too, though a most weak member of this academy, thought I could do something in your service, for I do not consider myself any less desirous or any less obliged to do so than anyone else."[21] Unfortunately neither I nor the modern editor of the dialogue, James Nelson Novoa, have been able to determine what these other works or their authors might have been.

The *Dulpisto* is very much in line with the standard discussions of love penned in the sixteenth century and presents the usual Renaissance ideas about love in a socially much more acceptable and literarily much more elegant manner than the earlier *Cazzaria.* Aurelia does not appear in the actual dialogue, but in the dedicatory letter she is described in terms of her *bellezza, grazia,* and *onestà,* all fairly standard attributes for a sixteenth-century noblewoman in Italy. What is more interesting for us is a throwaway comment in which Vignali suggests that Aurelia might enjoy reading this dialogue when "she will be free from her more demanding studies,"[22] a comment that reveals that Aurelia is currently engaged, in some way, in more serious readings that constitute "study"—a rather amazing activity for a mature noblewoman, twenty-nine years old, twice married and mother of four. One wonders what these "more demanding studies" might be. Vignali's comment brings to mind a comment made by another Sienese intellectual in dedicating one of his works to another local woman. In a dedicatory letter penned just about a year earlier, on 10 August 1539, by Alessandro Piccolomini for his book *De le stelle fisse* (published in 1540), the author tells us that the Sienese noblewoman Laudomia Forteguerri, for whom he has assembled this compendium of astronomical information and to whom he is now dedicating it, is accustomed to sitting in her garden and engaging with other women in "very learned and philosophical discussions" on the heavens and on the movements of the stars and that she in fact has said that she regrets not having been born a man because this has prevented her from studying some learned science, and especially astronomy.[23] Laudomia Forteguerri's interest in astronomy and Aurelia Petrucci's "more demanding studies" seem to suggest that in mid-sixteenth-century Siena some noblewomen did engage in some sort of more advanced reading and learning. We know that they did attend the meetings of the Academy of the Intronati, and this would suggest

that they were fairly up-to-date with current discussions in literature, language, and philosophy. As Marie-Françoise Piéjus points out, Sienese women participated in more than just a formal way at the meetings of the Intronati.[24]

We also know from Girolamo Bargagli's *Dialogo de' giuochi che nelle vegghie sanesi si usano di fare,* a dialogue on the parlor games popular in Siena in the mid–sixteenth century, that women took an active part in these events, challenging the men and at times even outshining them in linguistic, cultural, and intellectual games. But Vignali's and Piccolomini's comments go even further and suggest that literate Sienese women may well have pursued more demanding interests than just literature or language.

Dedicatee of Bartolomeo Carli Piccolomini's Translation of *Aeneid* 4

Petrucci's "more demanding studies" were not, however, in Latin because apparently her Latin was not up to the task. We know this because sometime in the 1530s Aurelia was the dedicatee of yet another literary work, this time a translation of book 4 of Virgil's *Aeneid* carried out by the Sienese nobleman, *literato,* and past chancellor of the Sienese Republic, Bartolomeo Carli Piccolomini (1503–37/38). This translation was part of a group effort by six contemporary men at rendering into Italian the first six books of Virgil's *Aeneid.* Each man translated one book and dedicated it to a woman; then, in 1540, their efforts were published as a single volume in Venice.[25] Aurelia not only was in very good company in this group but also could count on the company of at least two of her relatives: the Sienese nobleman Bernardino Borghesi, who had dedicated his translation of book 3 of the *Aeneid* to her sister Giulia Petrucci; and Alessandro Piccolomini, who had dedicated book 6 to her sister-in-law Eufrasia Venturi.

In his dedication of book 4 to Aurelia, Bartolomeo Carli Piccolomini mentioned that he had wanted to follow in the footsteps of Cardinal Ippolito de' Medici, who had translated book 2 in honor of Giulia Gonzaga. He then added that he wished to make Virgil's wonderful work available to Aurelia, who, unfortunately, had been obliged to interrupt her studies of Latin far too soon to allow her, now, to appreciate the work in its original language.[26] This may well be a reference to

Aurelia's forced departure from Siena at the age of four in the wake of her father's exile, but I, for one, wonder why her education and her study of Latin could not have taken place just as well at her mother's palazzo in Sarteano as at her father's palazzo in Siena. What is perhaps more interesting for our purpose is that in this dedicatory letter we encounter, once again, the rationale for offering a text translated into the vernacular to a Sienese noblewoman whose Latinity was not sufficient for reading the text in the original. It is evident, then, that even talented noblewomen with strong literary abilities and scientific or scholarly interests of their own were not able, in mid-sixteenth-century Siena, to read Latin well enough to gain knowledge from scientific works written in that language or simply to enjoy the classics in the original.

With the dedications she received and the reputation she enjoyed, Aurelia's fame was now spreading both inside and outside Siena's medieval walls. The long-absent Sienese intellectual and diplomat Claudio Tolomei (1492–1556), who for many years represented the Sienese Republic at the French court, apparently never met Aurelia but was inspired by her reputation for beauty and intellect to write to her and send her a complimentary copy of one of his works on the Tuscan language.

To Madonna Aurelia Petrucci,

I do not care if others will think it presumptuous of me to write to you, whom I have never met nor seen, but the fame of your virtue and your courtesy is so great that it protects me from all those who might consider me presumptuous, and even more so since it seems to me that I have admired you with a much nobler part than with my physical eyes. For after I had been made fully aware of the high nobility of your spirit, I have always had in front of my eyes the living image of your virtues, and it now obliges me (whether this be out of respect for you or because of my presumption) to send you a portrait of this new Tuscan poetry that, just one year ago, I presented to many of my friends in Rome. Out of courtesy you will deign to glance at it, and I will consider it not a small reward for my labors that it might have pleased you in some small part.

Be well.
From Rome.[27]

Tolomei's description of the gift as a "portrait" of the new Tuscan poetry identifies the book as his *Versi e regole della nuova poesia toscana,* first published in Rome by Antonio Blado d'Asola in October 1539—an apt gift for a woman who by now was starting to be known as a poet in her own right. This identification confirms that Tolomei's undated letter was written in October, or at least in the fall of 1540—more or less contemporaneously with Antonio Vignali's dedication of his *Dulpisto* to Aurelia and the publication of *I sei primi libri dell'Eneide di Virgilio* containing Bartolomeo Carli Piccolomini's dedication to Aurelia of his translation of book 4—a bumper crop year for Aurelia, indeed. By 1540, her fame as a woman with literary interests and inclinations had clearly begun to spread.

Aurelia Petrucci's Poetry

Claudio Tolomei's complimentary letter and his gift to Aurelia strongly suggest that she was developing a reputation as a poet. She may not have participated in the "Tombaide" that was being composed in those very same months (fall 1540), but she was apparently writing poetry. Although scholars in later centuries claimed that she had been a prolific poet, her contemporaries did not engage in such hyperbole[28]—they praised her beauty and charm but did not elaborate on her poetry, probably because she had not written very much. In fact, only two of her poems have actually come down to us, and this suggests that the corpus of her works may not have been much to start with. One poem is a response sonnet to Mariano Lenzi's dedication of Leone Ebreo's *Dialoghi d'amore* to her and so is datable to 1535.

> Di quel ch'il buon Filon disse a Sofia
> Mal posso giudicar, ch'io ben conosco
> Esser l'ingegno mio torbido e fosco,
> Né tanto in sè capir la mente mia.
> Però l'error' in vostro biasmo sia,
> Ché mal prato esser può d'orrido bosco
> E Amor spesso veder fa torto e losco
> Ancor che buon giudicio in altri stia.

Più ricche donne il bel paese nostro
Di me ritien, ricche, dic'io, del bello
Ch'attribuite a me co 'l chiaro inchiostro.
 Io provo il Ciel troppo contrario e fello,
E de' suoi doni in me sì pochi ha mostro
Ch'io son d'ogni dolor continuo ostello.[29]

———

All those things that good Philo did say to Sophia / I am not fit
to judge, for I know very well / that my intellect is cloudy and
foggy, / nor can my mind comprehend so much. // So, let this
error be upon your head, / for a dreadful woods makes a bad
meadow / and Love often slants and obscures someone's vision /
even though one may otherwise exhibit sound judgment. // Our
beautiful land holds women far richer / than I, richer, I say, in
the beauty / you attribute to me with your clear writing. // I find
that Heaven is too cruel and contrary toward me, / and it has
bestowed few of its gifts on me, / for I am a constant home for
all sorts of pain.

The sonnet begins with a direct reference to the two interlocutors
in Leone's dialogue—Philo and Sophia. Chiding Lenzi for the mistake
of having dedicated his work to her, rather than to one of the many
women in Italy more worthy of such an honor, Aurelia engages in an
extended *topos humilitatis* that is slightly flirtatious when she accuses Lenzi
of having fallen into error because he has been blinded by love (suppos-
edly for her). The sonnet ends in what might well be a lament—not
for herself, as a first reading might suggest, but for Italy, or perhaps for
her homeland, Siena. In the final tercet, in fact, Aurelia laments that the
heavens have bestowed so few gifts upon her that she is "a constant
home for all sorts of pain" (io son d'ogni dolor continuo ostello). The
phrase is a clear echo of Dante's "Ahi, serva Italia, di dolore ostello,"
the pilgrim poet's heartfelt cry in *Purgatorio* 6 for the condition of Italy at his
time, a land reduced to being, as he says, a house of woe, a ship without
a pilot, not a palace lady but a brothel woman (vv. 76–78). Aurelia Pe-
trucci may well have thought that her homeland, Siena, and by extension
Italy, had fallen into similar dire circumstances. In fact, by 1535, when

Aurelia was composing these lines, Siena was in a state of internal chaos, with pro-Spanish and pro-French factions in the city openly battling it out in the council chambers, in the streets, and even in literary writings. The relative calm and peaceful prosperity of her grandfather's reign were a distant memory as the political factions of contemporary Siena struggled to undermine one another and wrest power from whoever held it at that moment.

Aurelia's lament for her city is expressed even more clearly in her other published poem, "Dove sta il tuo valor, Patria mia cara?"

> Dove sta il tuo valor, Patria mia cara,
> Poichè il giogo servil misera scordi
> E solo nutri in sen pensier discordi
> Prodiga del tuo mal, del ben avara?
> All'altrui spese, poco accorta, impara
> Che fa la civil gara e in te rimordi
> Gl'animi falsi e rei, fatti concordi
> A tuo sol danno e a servitute amara.
> Fa delle membra sparse un corpo solo
> Ed un giusto voler sia legge a tutti,
> Ché allora io ti dirò di valor degna.
> Così tem'io, anzi vegg'io, che in duolo
> Vivrai, misera, ognor piena di lutti,
> Ché così avvien dove discordia regna.[30]

Where is your valor, beloved Homeland, / That, wretched, you forget the servile yoke, / And in your breast you nourish only discordant thoughts, / Prodigal with what's bad, stingy with what's good for you? // Learn, careless, from the mistakes of others / Where civil discord leads, and punish in yourself / Those false and evil spirits now united / Only to bring you harm and bitter servitude. // Draw your scattered limbs into a single body, / And let one just will be everyone's law, / For only then Will I call you worthy of valor. // As it is, I fear—or rather, I see—that you will live / In grief, wretched, always full of woe, / For this is what happens where discord reigns.

The sonnet not only cries out the pain of a city in turmoil but also correctly identifies the problem and its consequences—the inability of the Sienese to get along with each other, a problem that would soon lead to foreign intervention and eventual subjugation. As I have had occasion to point out elsewhere, Aurelia was not a starry-eyed young poet expressing patriotic sentiments and idealistic hopes but an intelligent young person from an important political family.[31] She had benefited from immediate personal connections with powerful men in the political and ecclesiastical government of her city and of Italy. Her opinions were based on her privileged access to these powerful men and on her direct experience of the current political situation.

Aurelia opens her sonnet by reprimanding the Sienese for their lack of valor and patriotism. This, in her view, has led them to accept the yoke of foreign domination. In the late 1530s and early 1540s, when this sonnet was conceivably written, Siena was officially ruled by the government of the Nine Priors (1531–45), who had sought to return the city to the republican systems in place before the various Petrucci signories had seized power (1497–1524). By the 1530s, however, power was really in the hands of Emperor Charles V, who had taken advantage of the chaotic political situation in Siena to set up a permanent Spanish garrison in the city (1530). The emperor had also placed his own representative in the city to "advise" the government. The strong Spanish presence was meant to calm the volatile political situation and prevent any attempt by the French to gain a foothold in the city and consequently in central Italy. The emperor's plans did not succeed, for the Spanish garrison and the Imperial representative did not manage to defuse the situation. The city continued to be torn asunder by factionalism and power struggles between the various sociopolitical groups. In the late 1530s, for example, the Salvi family was openly flirting with the pro-French Florentine *fuorusciti* and was especially close to Piero Strozzi, the dashing young scion of a strongly anti-Medicean and therefore anti-Spanish family.

Aurelia clearly saw the dangers inherent in the presence of foreign forces and agents in the city, as well as in the inability of the Sienese to act in unison for the well-being and survival of the state. In her second quatrain, she urges her fellow citizens to look at history and to learn from others, rather than at their own personal expense, how civil strife

leads to disaster and how the only way to safeguard the state is to re-move the false and evil citizens that work against it. Machiavelli would have been proud of Aurelia's grasp of history and political science, not to mention of her ruthless approach to problem solving. He would also have agreed with what she says in her next stanza when she urges the Sienese to form a united front and follow a single leader—after all, that was very much what he had urged Italians to do in chapter 25 of *The Prince* (manuscript 1513, print 1532). Aurelia's recommendation to draw the "scattered limbs" back together into a "single body" is a clear plea to bring back the *fuorusciti* and to reintegrate them into the body politic. By this time her father, uncles, and even her first husband, all of whom had become exiles in the wake of the overthrow of the Petrucci, were long dead, so her appeal to welcome back the exiles should not be inter-preted as a piece of self-serving advice. As I indicated earlier, although she was a Petrucci and had been married *in prime nozze* to a Petrucci, from the age of four and a half she had actually been raised by her Pic-colomini mother in the Piccolomini estates, so we can safely assume that she was probably not advancing a Petrucci agenda. Her words to the Sienese are not, therefore, colored by partisan intentions; hers is a patriotic vision that rises above factional interests.

In the end, however, Aurelia fails to convince even herself, and she remains pessimistic about the future of Siena. She ends her sonnet with a tercet that reveals fear for her city and a conviction that her fellow citi-zens will never be able to unite and find a solution to their plight. The final note is one of resignation. Aurelia's knowledge of history leads her to conclude with a verse that could just as easily have been written by Machiavelli: this is what happens where discord reigns.

The poem was so well received by Aurelia's contemporaries and subsequent generations of Italians that it appeared in the standard col-lections of poetry by women published in the sixteenth, seventeenth, and eighteenth centuries. In Ludovico Domenichi's groundbreaking col-lection of poems by Italian women, *Rime diverse di alcune gentilissime e vir-tuosissime donne* (Lucca, 1559), Aurelia's sonnet held pride of place, serv-ing as the opening poem for the entire collection—as if to set the tone, subtly, for a lament for the state of Italy in the throes of the Habsburg-Valois Wars on the Italian peninsula and in the wake of final Spanish hegemony over the peninsula with the Treaty of Cateau-Cambrésis

(signed, incidentally, the very year Domenichi's collection was published). The second variorum collection of Italian women's poetry, Antonio Bulifon's *Rime di cinquanta illustri poetesse* (Naples, 1695), also used Aurelia's sonnet as the opening lines for the entire volume. Thus both in the mid–sixteenth century and at the end of the seventeenth century these anthologies gave Petrucci's sonnet and its author not only pride of place but also a much more important meaning in a larger Italian, not just a local Sienese, context. Aurelia's lament for Siena seems to have served as a lament for all of Italy.

Aurelia and the Frivolous World of Siena

To characterize Aurelia as a disheartened observer of the current political situation would, however, do a disservice to someone who was, by all accounts, a lively and delightful person. Her response sonnet to Mariano Lenzi shows that she knew how to be charming and amusing, and even how to poke some light fun at others. An unpublished anonymous sonnet addressed to Aurelia by a female relative hints at the playful, witty tone that must have characterized Aurelia's friendship with other women and possibly refers to her involvement in the Sienese parlor games so well described by Girolamo Bargagli in his *Dialogo de' giuochi*:

Aurelia cognata amata

> Generosa e magnanima cognata,
> Fonte di gentilezza e vero amore
> Per sfogare in parte il mio dolore
> Messo ho la man non per dir cosa grata.
> Più non daremo che dire a la brigata
> Del nostro suntuoso portar fuore;
> A me certo non scoppia e criepa il core
> Che questi cittadini ce l'han calata.[32]
> Colpa del suntuoso e gran vestito
> Che 'l Doccio fe' portar alla sua figlia
> Ha mosso ognuno a pigiarci partito.

El partito del oro, quel che si piglia,
E delle perle han fermo e stabilito
Che non le portiam più per porci briglia
O che cativa . . .[33]

Aurelia, My Beloved Kinswoman

My dear and most generous kinswoman, / fount of gentility and
true love, / I've written this to vent, in part, my pain / and not to
speak of things that are most welcomed. // No longer shall we
give the group a reason / to talk about the sumptuous way we
dress; / it surely does not break my heart to see / these city folk
now mocking us this way. // The fault lies with that great and
sumptuous gown / that Doccio had his daughter wear [in public], /
and this induced all people to take sides. // The party of the gold
(the gold one takes) / and of the pearls, so as to rein us in, / has
firmly ruled we must no longer wear them, // or else a bad . . .

The poem is undated and alludes to a particular incident that we
cannot pinpoint but that appears to revolve around the imposition of
sumptuary restrictions in the wake of one particular woman's appear-
ance in what was probably too expensive a gown. As it voices the (fe-
male) poet's reaction to these constraints, we can detect her disdain for
those who mock women for the clothes they wear and her disdain for
"city folk" *(cittadini)* who disapprove of such finery. While there may be
some seriousness in the poem, the general tone is rather jovial, with
well-aimed barbs directed at the city folk and the "party of the gold and
pearls." This last phrase is admittedly obscure, but it may be a sarcastic
allusion by antonymy to those who would do away with gold and pearls
on women's attire and jewelry. In this reading, the phrase "the gold one
takes" inserted at line 12 suggests that those who seek to do away with
gold ornaments on women are those who would much rather pocket
than display wealth; this may be a criticism of the mentality of mer-
chants who, in cities such as Florence or Venice (and in this case Siena),
were always haranguing and legislating against the perceived squan-
dering of wealth in nonessential display. The poet, and by extension the

recipient of the poem, Aurelia Petrucci, would then be in the opposite camp, that is, among those "noncity" and "nonmercantile" people who have no qualms about engaging in conspicuous consumption. As the scion of two major ruling families such as the Petrucci and the Piccolomini, and as someone who was raised away from the city in the family palazzo in Sarteano, Aurelia easily fits the profile of the "landed aristocrat" implied by the anonymous author.

Another cue for a correct interpretation of this anonymous sonnet comes from its structure. Although the only extant copy lacks its concluding verses, it is clear that the author has composed a *sonetto caudato,* that is, a sonnet "with a tail"—a genre that was always used for humorous, and often obscene, effects. The addition of an extra tercet or two after the obligatory fourteen verses constituted the "tail" (*cauda,* in Latin) and inspired Italian Renaissance poets to engage in all sorts of double entendres. What is surprising about this *sonetto caudato* is that it is composed by a woman. Italian women poets did not, normally, use this verse form. In fact, in Domenichi's groundbreaking collection of women poets published in 1559 there is not a single *sonetto caudato* in the entire book. Clearly, it was not an appropriate verse form for the gentler sex—though in Siena the situation was perhaps different, especially in the context of the *veglie,* the evening social visits and parlor games that, according to some observers, could become quite risqué. In a *capitolo* (another verse form often used for comic purposes), the Friulian poet Giovanni Mauro (ca. 1490–1536) describes a *veglia* he attended in Siena in December 1532 while traveling from Rome, where he was residing, to Bologna, where he was going to rejoin his friends in the entourage of Pope Clement VII:

> Poi vidi certi giuochi alla Senese:
> Huomini, e donne insieme mescolate.
> Eran domestichezze a la franzese,
> O per non gir più oltra alla lombarda,
> Non usitate nel Roman paese.
> Non era già ballare alla gagliarda
> A suon di trombe, ma una certa festa
> Che si facea quasi alla muta, e tarda;

Da seder si levava or quella, or questa,
E le davate certa cosa in mano,
Che lungo il corpo avea, larga la testa.
La cosa intorno gìa di mano in mano,
L'un si levava in piè, l'altro sedea,
Chi s'accostava a ragionar pian piano.
Da' circustanti il tutto si vedea,
Ma quel ch'altri dicesse non s'udia,
Ma pensar facilmente si potea.
Egli era un giuoco di malinconia
In apparenza, ma egli era in fatti
Un giuoco da rizzar la fantasia.
Dicon poi, che quegli huomini son matti,
Iddio volesse, che per ogni loco
Del mondo si trovasser de' sì fatti.
Tutto quel tempo, che mi parve poco,
E durò dalla sera alla mattina,
Io stetti dritto in un canton al foco.
E vidi la Spannocchia, e Saracina,
La Silvia, e la Ventura, e Forteguerra,
Quali a veder parea cosa divina.[34]

I saw some games, then, played the Sienese way, / with men
and women all together mixed. // There were familiarities, the
French way, / Or, not to travel far, the Lombard way, / Things
that are just not done in Roman lands. // There was no dancing
of the galliard there / With trumpet sounds, but some strange
game / Played nearly without words and rather slowly; // A
woman sitting here or there would stand / And in her hand you
placed a certain thing / That had a longish body and large
head. // The thing went all around, from hand to hand, / One
man would stand, another would sit down, / Then one drew near
and softly whispered words. // The whole thing could be seen
by those around, / But what was said no one could hear at all, /
Though one could guess, I'm sure, what it might be. // This
seemed to be a melancholic game / But only in appearance, for

in fact / The game did prick your fantasy right up. // They say the men in Siena are all mad, / But, God be pleased, if only one could find / This sort of men in every corner of this world. // Throughout the game, which seemed to me quite short / And yet it went from sunset to sunrise, / I stood up straight next to the fireplace. // And there I saw Spannocchia, and Saracina, / Silvia, and Ventura, and Forteguerra, / And they did seem a thing divine to see.

Giovanni Mauro is obviously no prude, having composed a number of salacious Bernesque poems himself, but in this *capitolo* he plays the part with gusto to describe an evening game that, played in mixed company, was rich in sexual overtones and phallic references. Half a century later Girolamo Bargagli describes this same game in his nostalgic *Dialogo de' giuochi* (1572) but does not find anything salacious in it (though he does quote Mauro's *capitolo*). Bargagli calls it the "Giuoco dell'Invidia" (the Game of Envy) and says quite briefly that it consists in touching someone with a wooden spoon (of the kitchen variety) and taking his or her place, thus obliging the other person to take the spoon and do the same to someone else.[35]

Mauro's list of local female beauties present that evening adds an element of male gazing to the entire soirée. Nearly all the same names reappear in Bargagli's *Dialogo de' giuochi* when the character of "il Sodo Intronato" (Marc'Antonio Piccolomini) recalls the participation of Aurelia Petrucci and other women in these games as they were played in the 1530s. He points out that at first the women had been coached so as to ensure that the games played out well, especially when there was a foreign visitor, but that as time went on they became quite skilled and at times even led the way in these amusements. In Bargagli's dialogue, Sodo Intronato turns to the other discussants and explains:

And in my time it was much appreciated when a game succeeded with elegance. When the Marquis of Vasto and the Prince of Salerno passed through town and were both enrolled into the Intronati, we were not ashamed to organize among us, the day before, those games we thought of playing in front of them. Not that we de-

vised together in every detail what we were going to say, but we did propose and choose two or three games so that everyone could think up some clever fancy; and, what is more, we went to visit some of those women who were going to participate in the soirée, and we chatted with them about some nice things they could say. As a result, that evening we heard some fine ideas and clever witticisms, and the women, with just that little help, said marvelous things. After this first assistance, the women became so accustomed [to the games] that suddenly and on any occasion one could hear from them conversations, witticisms, and miraculous discussions that brought eternal fame to Lady Aurelia and Lady Giulia Petrucci, Lady Frasia Venturi, Saracina, Forteguerra, Toscana, and some other women.[36]

Given this atmosphere of lively conversations and clever witticisms in mixed company that included a number of fairly young persons, it may not come as too much of a surprise to find a Sienese woman poet writing a *sonetto caudato* against merchant-class moralists who wished to impose their parsimonious austerity on others.

Who could the author of this *sonetto caudato* be? Since she refers to Aurelia as a *cognata,* she must have been a relative. In modern usage, the term *cognata* is used to refer to a sibling's wife. Because Aurelia did not have a brother, it would have been impossible for her to be a *cognata,* in the modern sense of the word, to another woman. So we must assume that in this poem the term is used in its older meaning of "kinswoman" and that it is being used by a female cousin, aunt, or niece. Although Aurelia had a large number of female relatives who could fit the bill, one is tempted to focus on Cassandra Petrucci, who, as a published poet in her own right, could well have written this *sonetto caudato.* But who was Cassandra Petrucci, or, more correctly, which Cassandra Petrucci are we talking about?

There were five different women with the name Cassandra Petrucci living in Siena at that time. In order of birth year, they were:

1. Cassandra di Jacopo (or Giacoppo) di Bartolommeo Petrucci, born sometime in the late 1480s or early 1490s. She married Francesco

d'Alessandro Arringhieri, with whom she had at least two children, Gismondo (b. 1509) and Portia (b. 1522). She died on 17 April 1551 and was buried in the Church of San Domenico, where her husband had already been interred.[37] She would have been a niece of the Magnifico Pandolfo (through his eldest half brother, Jacopo) and thus a first cousin to Aurelia's father, Borghese, and a second cousin to Aurelia.

2. Cassandra di Camillo di Bartolomeo Petrucci, of the Petrucci di Piana branch of the family. Born sometime in the 1490s, in March 1512 she married Francesco di Scipione di Messer Bartolomeo Sozzini, bringing with her a dowry of 2,800 florins. Together they had a large brood of children: Fabio, Ottavio, Tiberio, Camillo, Scipio, Faustina, Filomena, Proserpina, Flavia, Isabella, and Lavinia.[38] She also was a niece of the Magnifico Pandolfo through his brother Camillo and thus was a first cousin to Aurelia's father, Borghese, and a second cousin to Aurelia.

3. Cassandra, the illegitimate daughter of the Magnifico Pandolfo Petrucci. She was baptized on 30 July 1506, and her godfather was Bartolomeo Piccolomini. After having been educated by the nuns in the Augustinian convent of Santa Maria Maddalena, on 9 February 1531 she married Conte (also known as Cristoforo) di Ludovico Petrucci, with whom she had no children. This may well have been a marriage of convenience contracted to resolve some inheritance difficulties in Pandolfo's will. It may also have served to solve other family difficulties of a rather different nature—it seems, in fact, that Conte had no sexual interest in women and was instead drawn to a certain young man, Giovanbattista di Alessandro Petrucci, whom he kept as his lover and eventually adopted as his son.[39] This Cassandra was a half sister with Aurelia's father Borghese, so she would have been Aurelia's aunt.

4. Cassandra di Niccolò di Benedetto Petrucci, of the "San Martino" branch of the family. She was born in 1510, a twin with Verginio, who died in infancy, and was an older sister to Captain Petruccio Petrucci (b. 1513), the second husband of the poet Laudomia Forteguerri, whom we will discuss in the next chapter. In 1532 this Cassandra married Lattanzio d'Alessandro Ciglioni, bringing with her a

dowry of 1,320 florins.[40] She would have been a rather distant relative of Aurelia Petrucci.

5. Cassandra di Lorenzo di Girolamo Petrucci. She was baptized on New Year's Day, 25 March 1524. Her mother was Jacoma Francesconi, and her siblings were Laura, Ottavia, Anton Maria, Giulio, Girolamo, Camillo, and Alessandro. On 4 November 1541 she married Lorenzo d'Antonio Marescotti. This Cassandra was a great-niece of Pandolfo and thus a fourth cousin to Aurelia.[41]

No information has been found that might give us a clear indication of which one(s) of these five women might have authored the many poems attributed to that name. For the present discussion, we will assume only that Cassandra was a relative of Aurelia and will not venture a guess as to which one of the five relatives might have been the poet who composed this anonymous *sonetto caudato* or the other poems attributed to "Cassandra Petrucci."

Poetry on Aurelia's Death

Cassandra Petrucci was, in fact, a prolific poet. In 1559 Ludovico Domenichi published fourteen of her poems.[42] One of them is a sonnet on Aurelia Petrucci's death. Addressing the deceased as an "immortal woman," she declares Aurelia to be a "new sun" that draws to herself the souls of the blessed to burn with pure and holy zeal around her.

> Immortal Donna, anzi or lassuso in cielo
> Un nuovo Sole a cui l'alme beate
> Stan liete intorno e tra fiammelle grate
> Ardon piene d'un puro, divin zelo,
> Che qui scendesti in bel corporeo velo
> Per far palese a questa nostra etate
> Quanta gratia è nel ciel, senno, e beltate,
> Senza temer tra mortai caldo o gelo,
> Iddio, per ristorare opre sì belle
> Ch'or splender fan quel bel ch'egli ascondea
> Nel puro ciel dintorno al tuo bel viso,

Non sol t'ha posta sopra a l'altre stelle,
Ma come degna e onorata Dea
Nel più bel seggio in mezzo al paradiso.[43]

Immortal woman, or better yet, new Sun / Up there in heaven
now, the blessed souls / Around you gladly draw and in these
flames, / So welcomed, burn with pure and holy zeal. // You
came to earth in such a splendid veil / To manifest to our entire
age / The wisdom, grace, and beauty that's in heaven, / Without
concern for earthly cold or heat. // Now to restore those
wondrous works of his, / That shed bright light on beauty once
concealed / By that clear heaven of your lovely face, // God set
you not just high above the stars / But, as a goddess worthy and
most honored, / In heaven's center on the finest throne.

Picking up on the usual themes of thirteenth-century Sweet New
Style poetry, Cassandra presents Aurelia as a heavenly being who has
descended to earth and assumed a physical body only to reveal to us
mortals just how much grace, wisdom, and beauty there is in heaven.
God, however, has now called her back to heaven in order to revitalize
his own beautiful creatures, that is, the souls of the blessed mentioned
in the second verse of the poem. In the final tercet the poet explains
that God has placed Aurelia, the "new Sun," above all the other stars
and has given her the most beautiful seat in heaven, which is, not sur-
prisingly, right in the middle of paradise. To a reader of Italian me-
dieval and Renaissance poetry, the echoes of the Sweet New Style,
Dante's lyrics from his *Vita nuova,* and Petrarch's *Canzoniere* are un-
mistakable. Cassandra is positioning the image and memory of her
deceased kinswoman firmly within the tradition of the *donna angelicata,*
the angelic woman who is more of a heavenly than an earthly being
and whose presence on earth is, therefore, very brief. Like other an-
gelic women such as Dante's Beatrice or Petrarch's Laura, Aurelia
makes only a fleeting appearance and then quickly returns to her ex-
alted place in paradise.

Aurelia's death inspired other poetic works, in particular an elegy
and an ode, both anonymous and both unpublished till now. The elegy

sings the grief of the poet at the death of Aurelia Petrucci and describes how various classical figures and gods mourn the loss of the young woman to the point that even their activities come to a standstill.

Elegia in morte di Madonna Aurelia Petrucci

> Poi ch'al gran pianto mio manca l'umore,
> Poi ch'a' sospir vien men lo spirto lasso
> Onde il duol più s'interna ogni or nel core,
> Cerco sfogarlo con stil rozo e basso
> Qual ben conviensi a' miei sì gravi mali 5
> Che di pietà potrian rompere un sasso
> E se fosser a quei le voci eguali,
> Ch'Amor sovente par ch'a l'Alma spiri,
> Foran queste mie lagrime immortali
> Ché ovunque il sol l'aurato carro giri 10
> Sempre sarian da chiari spirti accolte
> Col mormor di pietosi sospiri
> Ma s'esser non può, questo almeno ascolti
> Chi n'è cagion (se pietà vive in Cielo)
> Le muse che son meco a pianger volte. 15
> Ahi belle Ninfe, ahi docte suore, ov'è lo
> Abito vago? U' le ghirlande sono
> Di quai v'ornate al gran signor di Delo?
> Che mesto è questo e lamentevol suono?
> Che voci afflitte? Che dogliosi accenti 20
> Gir sento al cuor mentre con voi ragiono?
> Perché d'Amor son tutti i lumi spenti
> E rotti i dardi? E la faretra giace
> Negletta in terra et ei non par che senti?
> Ove Imeno lasciata ha la sua face? 25
> Ove ha gittati l'odorati fiori?
> Perché è sì in vista attonito e sì tace?
> Veggio le gratie ben, ma non già i cori,
> Né i lieti eterni balli veggio che esse
> Soglian menar coi pargoletti amori. 30

Oimè, perché le care chiome svelle?
Perché Venere il suo gradito cinto
Lacera e il petto insieme e le mamelle?
 Ahi, biondo Apollo, qual Dafne, o qual Iacinto
A noi, al mondo, a te stesso ti toglie? 35
Chi sì per tempo ha il tuo bel lume estinto?
 Ditel voi, Muse. Omai la lingua scioglie
Tu, saggia Clio, cui son le glorie conte
Di quella che è cagion di sì rie voglie.
 Odi la Dea, odi le voci pronte, 40
Chiare voci divine e pur intanto
Da se stesse pel duol paian disgionte.[44] 42

———

Elegy on the Death of Lady Aurelia Petrucci

Since my great weeping does not have the strength, / Since my
exhausted spirit fails my sighs, / So that the pain stays deep
within my heart, // I'll try to vent it with my lowly style / That
fits so well these grievous pains I feel / That could, with pity,
break apart a stone, // And if they could but equal those fine
words / That Love so often seems to teach the soul / My tears
would live immortal on this earth, // For everywhere the sun
would wend its way, / They would be ever welcomed by fine
souls / With sounds of sighs so piteous and so kind, // But if
this cannot be, let he who is / The cause (if pity lives in heaven)
hear how / The Muses are crying here with me. // Alas, fair
nymphs, alas, learned sisters, / Where are your graceful gowns,
where are the wreaths / That graced your brows to honor Delos'
lord? // What is this sad and grievous sound I hear? / These
voices so distressed ? These mournful words? / They touch
my heart as I converse with you. // Why are the lights of Love
extinguished now / And broken all his darts? Why lies the
quiver / Forgotten on the ground and he hears not? // And
where has Hymenaios left his torch? / Where has he scattered
all his fragrant flowers? / Why does he seem astonished and
so hushed? // I see the Graces well, but not their choirs, /
Nor do I see the timeless joyful dances / That with the Amorini

they would weave. // Alas, why does she tear her wondrous hair, /
And why does Venus rip apart her girdle / fair and strike her
bosom and her breasts? // Ah, blond Apollo, what Daphne or
Hyacinth / Takes you from us, from earth, from your own self? /
Who has extinguished your fair light so soon? // Speak out, oh
Muses; loosen now your tongue, / Wise Clio, you to whom the
deeds were told / Of she who is the reason for this grief. //
Hear now the goddess, hear the ready voices, / Clear voices
so divine, and yet they seem / To have been ripped asunder by
the pain.

The work displays the author's classical erudition and contains
many clear echoes to earlier poets and their well-worn images, some-
thing that was standard in serious sixteenth-century poetry. At times
the verses and some sentences could have benefited from more refine-
ment, but on the whole the poem is not without some merit or, for our
intentions, some interest. Aurelia is remembered first and foremost as
a poet, with nymphs and Amorini lamenting her death. She is so closely
associated with poetry that at one point she is apostrophized as "Apollo"
(v. 34) and is asked what lover might have taken her away. There is, in
this, a fascinating transgendering of Aurelia into a male god, Apollo,
and an equally teasing suggestion that the "lover" who takes her away
even from herself could be either male ("what Hyacinth") or female
("what Daphne"). One should not, however, look too deeply into this
sexual ambivalence, for the anonymous poet points out that the god
of marital ceremonies, Hymenaios, also mourns Aurelia's passing, and
with this she is celebrated as a spouse and wife. The elegy ends with a
call to Clio, the muse of history, to keep Aurelia's name alive—a rather
strange request, seeing that normally one would have expected poetry,
not history, to immortalize the name of a beautiful, graceful, and tal-
ented woman. Was the poet thinking of actual deeds that Aurelia had
undertaken and had brought her various *glorie* (v. 38) or simply pulling
words and images out of a hat and thus carelessly mixing poetry and
history? In spite of Aurelia's stunning political pedigree, the answer
probably lies more with the latter than the former.

Aurelia's death inspired a third poem, an anonymous ode, also pre-
viously unpublished.

In morte di Mad. Aurelia Petrucci: Oda

 Tessi negra corona,
Musa, a' tuoi crini intorno e la tua lira
di ciprisso incorona,
vesti or di bruno, e meco alto or sospira,
sospira e mesto suona. 5
 Non sempre a noi mortali
dura il gioire, anzi che il mondan riso
a fuggir tosto ha l'ali
e 'l più del tempo hanno bagnato il viso
gli uomini infermi e frali. 10
 Quella di cui pur ieri
con meraviglia non egual cantasti
morte ha rapita, e i neri
suoi lumi ha spento sì leggiadri e casti,
di santo amor guerrieri. 15
 O che sì raro esempio
di beltà, di pensier, di bel costume
di vera onestà tempio,
sparito sia come egli avesse piume
per nostro eterno scempio. 20
 Or chi sia mai che a pieno
dica quanto si duol, che l'aureo nome,
nome dolce sereno,
tien fisso al cor con gli occhi e con le chiome
e col celeste seno? 25
 Chiunque l'Arbia onora
e i celebrati suoi bei colli ha in pregio
te pianse, Aurelia, e ancora
ogni spirto gentil di nome egregio
che in terra oggi dimora. 30
 Ma che? Mentre che in pianto
stiam qui per te che al cielo or sei salita
altri con attrettanto
gioir ti miran sì da Dio gradita
tra festa riso e canto. 35

O qual dolceza e quanta
dal mio dotto Sozin, Sozino illustre
gusta quella alma santa
ch'or per te par che più risplenda e lustre
e le tue lodi canta. 40
 Ma quale stile o ingegno
potrà mostrar l'alta ineffabil gioia
d'Alceo, pastor sì degno,
che punto ora per te non sente noia
nel vero eterno regno. 45
 Il degno Alceo che intese
a far le tue virtù sì chiare al mondo
con sue rime, che intese
furon per quanto Apollo gira a tondo,
che Amore, Amor l'accese. 50
 Or seco lieta vai
ragionando pe' bei campi celesti
e de' tuoi dolci rai,
non men qua giù che fra le stelle onesti,
ogn'or più vago il fai. 55
 Mentre ch'or di dolceza
m'empiva io già stando la suso in cielo
ecco che d'allegreza
donna mi priva accolta in mesto velo
e m'ingombra d'aspreza. 60
 Questa è l'afflitta Madre
tua, non Vittoria più, ché se pria vinse
aspre fortune et acre,
il tuo morire ogni valor l'estinse
e par che il cor le squadre. 65
 Ma quai Donne vegio io
seco venire in negra veste involte?
Vince il lor pianto il mio.
Son tue sorelle a pianger te raccolte,
ch'han' di morte or desio. 70
 Ah, non vogliate or voi
perir piangendo, ah ch'a mortal non lice

e par che il cielo annoi
il troppo lacrimar, né mai felice
fe' il pianto alcun fra noi. 75
 Tace, ecco ancor, mia Musa,
ché il Re del tutto or meco non s'adiri,
e chi contender usa
col gran Signor ch'è nei celesti giri
stolto ciascun l'accusa.[45] 80

On the Death of Lady Aurelia Petrucci: An Ode

Weave a black wreath, / Muse, around your head, and then your
lyre / Crown with cypress boughs, / Don a dark gown, and sigh
with me; / Sigh, and sadly play. // Joy is not forever / For us
mortals, in fact all earthly laughter / Has wings for sudden flight; /
Most of the time mankind, infirm and frail, / Has tears upon its
face. // She, whom you did sing / Just yesterday with wonder
unsurpassed, / By death has been purloined / And her black
eyes, so charming chaste, are closed, / Rivals of holy love. //
Oh, that a rare example / Of beauty, thought, of morals high
and good, / A temple of true virtue / Should disappear, as if
it sprouted wings, / To our eternal loss. // Now who can ever
fully / Proclaim his pain, who keeps the golden name, / Sweet
halcyon name, / Fixed in his heart along with her eyes and hair /
And her celestial breast? // All those who honor Arbia / And
hold in great esteem her famous hills, / Wept, Aurelia, for you /
As did all gentle souls of high renown / Who dwell today on
earth. // What now? While we shed tears, / For you who have
ascended into heaven, / Others, with just as much / Delight,
admire you, so dear to God, / In feast and mirth and song. //
Oh, what delight abundant / From my Sozin so wise, revered
Sozino, / That holy spirit savors; / He now, through you, seems
brighter than before / And sings your praises high. // But what
great style or wit / Could ever tell the gladness beyond words /
Of Alcaeus, worthy shepherd, / Who now, because of you, /
suffers no pain / In that eternal realm. // The worthy Alcaeus

sought / To make your virtues known to all the world /
With poems that then were heard / As far around the globe
as Apollo rides, / For Love, Love kindled him. // Now gladly
you go with him / Conversing through the fair celestial fields /
And with your pleasant rays, / Among the stars just as you did
down here, / You make him fall in love. // While I was filling
up / With sweet delight from being in heaven with you, /
Suddenly a woman / Draped in a mourning veil denies my joy /
Encumbering me with woe. // This is your grieving mother, /
Vittoria now no longer, for if before / She parried Fortune's
blows / Your death has crushed the valor that she had / And
seems to break her heart. // Who are those women coming /
Along with her enshrouded in black gowns? / Their weeping
conquers mine. / They are your sisters, weeping here together, /
Wishing for their death. // Ah, do not now wish / To cry
yourselves to death, it's not allowed, / And too much crying
seems / To bother heaven, nor ever on this earth / Did weeping
make one glad. // My muse as well falls silent / So that the King
of all won't be upset / And [because] those who will contend /
With that great Lord who dwells in heaven on high / Are
deemed to be fools by all.

While the work may not constitute great poetry, it is of interest to us be-
cause of several biographical elements it contributes to our knowledge
of Aurelia Petrucci. It alludes, for example, to unspecified adversities
that her mother, Vittoria Todeschini Piccolomini, had to overcome—
"vinse / aspre fortune et acre" (vv. 62–63). The poet's choice of words
is telling: *fortune* suggests the Machiavellian reversals typical of the ruling
elite, *aspre* means "bitter," but with connotations of harshness and vio-
lence, while *acre* means "acrimonious," with connotations of malevo-
lence, spite, and malice. This seems to support our understanding that,
at Borghese's precipitous flight from Siena in 1515, the wife and four
daughters who were left behind by the fleeing Petrucci men were basi-
cally abandoned to their fate *(fortuna)* and obliged to fend for them-
selves in the bitter *(aspro)* and acrimonious *(acre)* political upheavals of
the time. If the reader should detect an element of rancor in the poet,

this may not be surprising if the attribution we advance in the next paragraph is correct.

The ode also mentions by name two previously deceased Sienese men whom Aurelia knew quite well and who now greet her upon her arrival in Paradise (vv. 40–55). The first is the jurist and professor Alessandro Sozzini il Giovane (1509–41), who had passed away the previous year while teaching at the University of Macerata. He was Aurelia's brother-in-law, having married her widowed sister Agnese in 1538.[46] Since the poet refers to him as "my" and gives him pride of place in the list, we might safely assume that the author is Agnese herself. This ode would then constitute the only extant poem by Agnese Petrucci and would add one more occasional woman poet to our list.

The ode also speaks of the close family ties that must have existed between Aurelia and her sister's marital family, the Sozzini (or Socini). These are fascinating ties because nearly all the men in the Sozzini family were suspected of harboring heretical beliefs. Two, in particular, were obliged to flee across the Alps because of their religious views: one was Alessandro's younger brother, Lelio Sozzini (1525–62), who died very young while an exile in Geneva, and the other was the son of Alessandro and Agnese herself, Fausto Sozzini (1539–1604), the anti-Trinitarian theologian who eventually fled as far as Poland because his views were anathema in both Italian- and German-speaking areas. While there is no indication that Aurelia might have shared her Sozzini relatives' heterodox religious views, we should not discount the possibility that she would have had plenty of occasions to discuss such views with them, whether she agreed with them or not. Such discussions would fit well with the lively and inquisitive religious climate of Siena in those decades when figures such as Bernardino Ochino and Aonio Paleario, not to mention the Sozzini themselves, were present in the city. As we shall see in the chapter on Laudomia Forteguerri, women did engage, at least within their private homes, in theological discussions that courted heretical views.

The second individual mentioned in the ode is a certain "Alceo," an otherwise unidentified male admirer of Aurelia. We may assume that "Alceo" was his poetic persona when writing poetry for Aurelia or for other Sienese women. Because his poems have not survived (or at

least have not yet been located), I am not able to identify him at this time. His name and his affection for Aurelia do, however, reinforce what we had noticed earlier in the context of the "Tombaide"—pastoral motifs and settings were current in literary circles in Siena and entailed the active involvement of local women in this fantasy.

Alessandro Piccolomini's Eulogy for Aurelia's Death

One of the male Sienese poets who engaged in such pastoral reveries and composed verses in praise of local women was the scholar Alessandro Piccolomini, whom we have already met in chapter 1. At Aurelia's death, Piccolomini was temporarily in Bologna. He quickly composed a long, elegant eulogy that runs to over fifty printed pages and on 28 November 1542 sent it to Aurelia's sister, Giulia Petrucci, with the suggestion that she might read it as if it had been delivered at Aurelia's funeral in the Church of Sant'Agostino in Siena. By its very premise, the eulogy is thus an imagined event, a literary construct, and not an actual funeral oration delivered publicly in front of a grieving group of relatives and friends. It circulated in manuscript form and was not published until 1771, 230 years later.[47]

In the oration, Piccolomini mourned Aurelia's passing as a loss for the entire city. He sang her praises first by summarizing her illustrious parentage, then by listing her wealth of virtues, and finally by celebrating her beauty, charm, and intelligence. The work is an extended paean to the deceased woman and, by extension, to her family and her city. In it, Piccolomini was not only voicing his praises of a distant relative (Aurelia was a Piccolomini on her mother's side) but also glorifying the clan and the city that had given birth to such a wonder.

The oration is addressed to the *Popolo,* the people of Siena, and begins by explaining that in ancient Greece and Rome it was the practice to honor with a funeral oration men and women who excelled "in great deeds, or profound prudence, or immense *virtù*" (p. 1). This, Piccolomini points out, was done not only to glorify the deceased but also to inspire the living to emulate them. Aurelia Petrucci, so Piccolomini says, merits such an oration for a number of reasons. First of all, she brought

prestige to her native city by the example of her life and the "majesty" of her "face, virtue, counsel, religion" that made even the city walls happy (p. 3). Already from the start we see that hyperbole will be Piccolomini's primary rhetorical device. After an obligatory remark about his own inadequacies and the fact that Aurelia merited a far better orator than he, Piccolomini informs the audience of his proposed plan for the oration and begs them to withhold their tears until he is finished.

After saying that merit derives from action, not from birth (p. 4), Piccolomini ignores his own statement and proceeds to praise Aurelia's physical appearance, character, and genealogy. Although an Aristotelian by training, Piccolomini slips temporarily into a Neoplatonic mode by pointing out that a beautiful soul naturally resides in a beautiful body and leads the bearer to perform beautiful deeds. He adds that God himself generously bestowed upon Aurelia so many natural gifts that rarely one finds the gifts of Fortune, Nature, and Intellect so abundant in any one individual. Fortune granted her nobility, wealth, friends, and fame (pp. 4–5). This leads Piccolomini to speak of the nobility of her native city, the beauty of the Sienese countryside, and the nobility of Aurelia's families, both paternal and maternal, which she more than matched in her own right (pp. 5–9). He speaks of her wealth, pointing out that it was not what she owned but how she used it that was important—she was generous but not a spendthrift, charitable toward all but especially toward the poor. She had many friends, both male and female, but in particular she enjoyed the friendship of a select group of women who loved her dearly and now lament her death. Her fame extended well beyond Siena to reach all of Italy, where she was known for her beauty, demeanor, manners, counsel, intelligence, prudence, eloquence, honesty, and religious faith. Fortune blessed her with two noble husbands who loved her dearly and with four wonderful children. Nature blessed her also with physical beauty, eloquence, intellect, and fine judgment (pp. 9–18).

At this point, Piccolomini questions the regulations that prohibit women from holding office by pointing out that Aurelia could have been of great benefit to Siena had she been allowed to serve in public office. This is because, although she was a woman, she did not suffer from a woman's deficiencies. As Piccolomini explains, "So, one can say in a word that if there is any part in a woman that is not good, that part was

not in her: and all those important parts that are well in a man, they were so well wrought in her that, lacking the imperfection of woman and abounding in the perfection of man, she became, as we saw, most exceptional in the world."[48] Though a student at the university famous throughout Europe for its Aristotelianism, Piccolomini is challenging the accepted science of his time to argue that Aurelia, though a woman, was not an imperfect male (as Aristotle would have it) but a perfect male who just happened to have a woman's body—much as Queen Elisabeth I of England would argue four decades later when, haranguing her troops, she would tell them that, though she had the body of a woman, she had the "heart and stomach" of a king and could certainly lead them into battle.[49] Since Aurelia was the oldest direct descendant of the Magnifico Pandolfo Petrucci, Piccolomini may well be suggesting that she should have inherited the Petrucci mantle and governed Siena like her grandfather and father before her. Though women as rulers were not uncommon in Renaissance Italy—one thinks immediately of Queen Giovanna I of Naples or Duchess Caterina Sforza—they held power only in hereditary states, not in republics such as Siena. Piccolomini's comment is thus rather unexpected and quite unusual, well worth further consideration: Was he serious about proposing a woman as *signore* of Siena, or was he merely carried away by his own hyperboles?

Having enumerated Aurelia's "natural" gifts, Piccolomini proceeds to enumerate her accomplishments so as to argue that she was an *eroe* (hero) or *semideo* (demigod), not a mere mortal (p. 21). His use of the masculine forms for both these categories is worth noting, for it seems to refer back to his previous comment on Aurelia's "manly" nature (that is, to her lack of womanly weaknesses). Piccolomini's promised enumeration of her "deeds" does not, however, proceed with a listing of "manly" actions and accomplishments; instead, it follows an outline based on the traditional cardinal and theological virtues—fortitude, temperance, prudence, justice, faith, hope, and charity—pointing out that Aurelia lived her life in accordance with them (pp. 21–25). This is not quite the listing we would have expected, but a catalogue of ethical standards derived from classical and Christian morality. The fact may well be that Piccolomini was at a loss in trying to list what one normally classifies as "accomplishments" for a young noblewoman who was, by

all indications, the focus of much gallant attention for her beauty and charm but not someone who "did" anything spectacular. Piccolomini thus resorts to a conventional (and rather medieval) enumeration of "wholesome" merits that render Aurelia worthy of note. He concludes this review of Aurelia's "accomplishments" with the affirmation that she is now among the seraphim, that is, with the highest order of angels, one that is traditionally associated with love and thus imagined to be closer to God than any of the other eight orders of angels.

A call to tears ensues ("Shall we not cry?"), followed fast by an apostrophe to Death ("O Death, o Death, how much more damage have you wrought upon the world in one single day, than you have ever wrought before?"; p. 26). The apostrophes continue in rapid succession, with a second to her three surviving sisters (pp. 27–28), a third to her surviving husband, a fourth to her children (pp. 28–29), and then, finally, a fifth to her mother who, the previous May, upon hearing of her daughter's illness, had immediately left Rome to rush to her bedside in Siena (pp. 29–30). With these apostrophes and the call for tears Piccolomini moves toward an emotional conclusion and raises the tone so as to turn the oration into a lamentation.

As others cry, he explains that Aurelia was not the type to cry. Even on her deathbed she maintained her composure and kept her courage. When everyone in Siena was concerned for her health, Aurelia remained strong and set an example for those around her. At her death, Siena itself grieved her passing and felt an enormous loss, for it had lost an exceptional person—Aurelia had surpassed the beauty of Helen of Troy, the faithfulness of Penelope, the learning of Sappho, the modesty of Lucretia, and the prudence of Cornelia. Piccolomini imagines Siena saying that "if today's Italy has the holiness and divinity of the Marquise of Pescara [Vittoria Colonna], I, happier than all the others, had Aurelia, who was most beautiful, most eloquent, most chaste, most religious, more than a mortal woman ever could be" (p. 34). The comparison with famous women from antiquity and with one contemporary woman universally reputed to be exceptional draws Aurelia into history by making her part of the catalogue of "famous women" so popular in both the Middle Ages and the Renaissance.

As the oration draws toward a close, Piccolomini asks why God would want to take such a wonderful person away and concludes that,

because we cannot fathom God's reasons, we must simply accept his will and believe that it was for the best. In doing so, we draw comfort from the knowledge that Aurelia is now in heaven. At this point, Piccolomini apostrophizes Aurelia herself, addressing her not only as one would address a saint in paradise but in terms more appropriate to the Virgin Mary herself—he calls her spotless, pure, completely sincere (p. 37). Knowing that she is in heaven, the appropriate response to her passing is not weeping but rejoicing. Siena and all her citizens should be happy in the knowledge that their beloved Aurelia is among the blessed, where, if they follow her example, they will one day see her again.

The oration ends with a sonnet by Piccolomini on Aurelia's death. In it, he laments her passing as the loss of a model for people to emulate and asks her to shed light on this world so as to allow people to follow in her footsteps. The poem then ends, like the oration, with a lamentation, this time poetically punctuated with a series of sighs.

Ne la morte di Madonna Aurelia Petrucci

> Dunque, Aurelia, sì tosto al divin coro
> V'ha Dio chiamata in così verde etade?
> Ben a ragion, ché vostr'alta bontade
> Star non deve u' può sol la frode e l'oro.
>
> Ben piangiam noi, che ad ogni bel lavoro
> Tolto l'esempio ver, chiuse le strade
> Ci ha, nel fuggir con Voi, quella beltade
> Ch'amai presente, or sì di lungi adoro.
>
> Deh, se degnate or più volgervi a basso,
> Scend' un dei vostri raggi, onde scorgiamo
> Vostr' orme sì, che non se n'esca un passo.
>
> O mondo or vil, pur or cotanto adorno,
> O ch'avem ieri, o che non oggi aviamo,
> O infelice ora, o sempre acerbo giorno.[50]

———

On the Death of Lady Aurelia Petrucci

So, Aurelia, so soon to the heavenly choir / God called you in the freshness of your years? / And right he was, for your high

goodness must / Not dwell where only fraud and gold have
power. // But well we weep, for fleeing away with you / That
beauty, which I loved up close and now from far away / Adore,
has taken every true example / Away with her, and closed down
every road. // Alas, if you still deign to look down here, / Send
down one of your rays so we might see / Your footsteps and
not falter on our way. // Oh world, now base, but till now
so adorned, / Oh what we had, that today have no more, /
Oh hour unhappy, oh day forever bitter.

The sonnet is not especially interesting, but it does recapitulate one of
the primary themes in the oration: while on earth Aurelia served as a
model to be followed, in heaven she serves as a shining light on the
path to salvation. The concept is not original and finds its roots in the
poetry of Dante, Petrarch, and many sixteenth-century poets. Piccolo-
mini is merely following a well-established tradition.

————

As we can see, then, the image of Aurelia Petrucci that we can discern
from these various contemporary references to her is fairly standard
but also somewhat unusual. We see the required faithful servant of the
family clan, marrying at a tender age to advance her paternal family's po-
litical agenda, bearing children, remarrying when left a widow, and bear-
ing still more children. We also see the idealized noble lady of Italian
literature, the angelic woman who inspires men to do and to achieve.
At the same time, however, we see glimpses of a woman who comes
of age as the daughter of a deposed and exiled ruler but who, probably
because of her mother and the involvement of the maternal clan, re-
mains very much part of the sociopolitical network in her native city,
even as her paternal and marital kin are exiled and excluded. We see a
woman who serves not as an inspiration but as a model, and not for
fellow women but for fellow "refined intellects." We discover a noble-
woman engaged in "demanding studies" but one who lacks sufficient
fluency in Latin to read the texts in their original language. We see a
woman whose poetry is not about love and its pains but about the po-

litical situation in her homeland. Admittedly, all but one of these viewpoints come from male perspectives and clearly have their own agendas to advance; however, taken as a whole and with a grain of salt, what Aurelia's admirers tell us about her provides us with a fascinating portrait of someone who was clearly an engaging human being. This, in turn, gives us a unique insight into the complex cultural world of a literate noblewoman in sixteenth-century Italy.

Laudomia Forteguerri
Constructions of a Woman

I arrived at Siena the iiijth of September. This citie standethe upon hilles
as the citie of Roome did in the olde time. It is counted vj miles compasse
abowt the walles. The countrey abowt verie frutefull. The people are much
given to entertaine strangers gentlie. Most of the women are well learned and
write excellentlie well bothe in prose and verse, emong whom Laudomia
Fortiguerra and Virginia Salvi did excell for good wittes.
—Sir Thomas Hoby, *The Travels and Life of Sir Thomas Hoby*

One of the most fascinating and possibly controversial women poets
of Siena was Laudomia Forteguerri. She was born in 1515 into an old
and prestigious Sienese noble family. She married twice, bore three chil-
dren, composed a number of sonnets, and disappeared from the records
around 1555. In the late 1530s she appears as a speaker in a theologi-
cally dangerous dialogue by the Sienese erudite Marc'Antonio Piccolo-
mini. Then, in 1541, in a lecture delivered in Padua and published within
a few months in Bologna, the young scholar Alessandro Piccolomini
"outed" Laudomia as a woman who loved another woman. In the 1550s,
the Venetian polygraph Giuseppe Betussi da Bassano praised her as one
of the thirteen most beautiful women in Italy and made her an emblem
of *vera fama,* "true fame." And to this day in Siena, Laudomia is reputed

to be one of the three courageous "women of Siena" who, during the preparations for the expected attack from Imperial forces, organized and led a troop of three thousand women to work in defense of their city. A wife, mother, poet, lover, lesbian, beauty, and leader Laudomia Forteguerri remains, in many ways, a complex and mysterious figure.

Part of the mystery comes from the dearth of reliable information about her, but part also comes from previous scholars who tried to fill the lacunae with their imaginings rather than with facts. For this reason, previous scholarship on Forteguerri needs to be read with great caution. Scholars from the seventeenth to the nineteenth centuries repeated a few basic fragments of information and sequentially enlarged upon them. In the twentieth century scholars have tried to be more responsible, but previous grievous errors have persisted and a few new ones have been introduced into the mix. My hope in this chapter is to provide more reliable information on Forteguerri, to correct at least some of the misconceptions that have crept into her story, to analyze her poetry, and to present a woman who, even in her own time, was clearly seen as a complex and multifaceted figure.

The only archival information discovered so far for the historical Laudomia Forteguerri is her baptismal record, the baptismal records of her three children, and the contract for her second marriage. It seems that Laudomia hardly left a trace of her historical self as she passed through this world, even though she was born into one of the oldest noble families of Siena, married into two other powerful clans of the old feudal nobility, corresponded with an Imperial princess, was the toast of contemporary poets and academicians, had a number of books dedicated to her, and gained lasting fame not only in Italy but also in France for her patriotic deeds during a time of extreme political and military tension in Siena. In place of the "historical" Laudomia we have, instead, an "imagined" Laudomia, one that is more a construct than a true likeness of the individual in question. This, in itself, is indicative of cultural and historical factors that worked, both during and after her time, to erase the historical person and replace it with an imaginary figure designed to suit the needs and ideals of the men who wrote about her. Before we consider the different portraits that emerge, it would be advisable to try to capture at least part of the "historical" Laudomia by focusing on the few surviving archival records that refer to her.

The Historical Laudomia Forteguerri

Laudomia Forteguerri was born in Siena on, or just before, 3 June 1515, the daughter of Alessandro di Niccodemo Forteguerri and his second wife, Virginia di Giulio Pecci. On 3 June she was baptized Laudomia Barthalomea Maria, and her godfather was the Abbot Federico della Rosa.[1] A marginal note in a later sixteenth-century hand in the margin of the baptismal record recalls that she was exceptional, "unique in the world and of rare beauty" (Unica al mondo e di bellezza rara).

The Forteguerri were one of the old noble families of Siena, long-time natives of the city, and closely tied to the interests of the feudal class to which they belonged. They are not to be confused with the Forteguerra family (spelled with a final "a"), recently immigrated from Pistoia, who had been granted Sienese citizenship only in the mid-fifteenth century and were, by the standards of the time, "newcomers" with a lower social status than the "native" nobility. Laudomia's birth family belonged to the Forteguerri, Antolini, and Bisdomini clan that is invariably described as one of the *grandi* of Siena and as members of the Monte del Gentiluomo. They were also members of the Noveschi, the group of about one hundred Guelph families that had run Siena between 1286 and 1355 and had ever since continued to be a powerful force in the city's politics. Though Guelph, the Forteguerri were also feudal lords with castles and properties in the Sienese *contado*. As *signori* of Balignano they owned the castles of San Giovanni d'Asso and of Avena, the fortress of Ripa in Val d'Orcia, and the strategic tower of Posterlia in Siena.[2] Built in 1147, the tower stands to this day on the homonymous piazza at the top of via di Città, in the oldest section of Siena, and is both a Sienese landmark and a symbol of the military strength of the old feudal nobility. An indication of the prestige and reputation the Forteguerri enjoyed is the fact that they had the right to install the bishops (later, archbishops) of Siena in their see.[3]

As early as the twelfth century, male members of the Forteguerri family had held some of the most important magistracies in the city. Iacomo d'Aldobrandino d'Antolino, consul in 1193, was the family's first *risieduto*, that is, the first of his family to hold a senior administrative position in the city government. Among some of the family's more eminent members prior to Laudomia's birth were also important

members of the clergy: the Blessed Paola di Ser Ghino Forteguerri, a nun in the convent of Sant'Abbondio in Siena, and the Dominican friar Niccolò, ordained by St. Dominic himself and considered, by some, blessed. A feudal family would not be worth its salt without its military men, so the Forteguerri were proud of their Ghino, captain of the Sienese army in 1302; of their Pietro Filippo, captain of a troop of three hundred horsemen at the service of the Sienese Republic (1346), who also served as *capitano del popolo* in Perugia; and of another Pietro (who may possibly have been the Pietro Filippo just mentioned) who was *connessabile de' cavalli* in Mantua in 1383. And, of course, men from this family staffed the republic's civil service, serving as ambassadors to other governments, or as *podestà* in a number of different Italian towns.[4]

The Forteguerri could also boast of blood ties with the powerful Piccolomini clan and, through them, claim a pope in their extended family. Pius II was born of Vittoria Forteguerri, wife of Silvio Piccolomini. At their death, Pius II had his parents laid to rest in the sanctuary of the Church of San Francesco in Siena and erected a classicizing white marble plaque on the wall bearing their effigies and, below it, the inscription "I, Silvio, lie here, my wife Victoria is with me. My son, Pope Pius, laid this marble [plaque]" (Sylvius hic iaceo, coniux Victoria mecum est. Filius hoc posuit marmore Papa Pius).

Laudomia could claim distinguished and long-standing noble ancestry not only on her paternal but also on her maternal side. Like the Forteguerri, the Pecci were also Noveschi. The first of their men to hold supreme office in Siena was Ventura (called Peccia) di Giovanni Pecci, in 1313; many others followed suit and were active participants in government and diplomacy.[5] Giovanni di Bartolomeo Pecci (d. 1426) was bishop of Grosseto but is better known today for the splendid bronze tomb slab in the Cathedral of Siena that was cast for him by Donatello (1427). By the fifteenth century the family had established itself so well that Tommaso Pecci was able to purchase the old Palazzo del Capitano and turn it into a prestigious residence that hosted a number of eminent houseguests, among them Cardinal Juan de Torquemada (1460), King Alfonso II of Naples with his new bride Ippolita Sforza (1465), and Eleanor of Aragon (1473).[6] The Pecci were also noble, being lords and counts of Percena Castello, near Buonconvento, and firmly part of the inner circle of Siena's master, Pandolfo Petrucci.

```
BRATTLE BOOK SHOP
1-800-447-9595
www.brattlebookshop.com
WE BUY AND SELL GOOD  BOOKS
DATE 09/03/2020 THU   TIME 09:41

SALE BOOK TAX    T1      $1.00
TAX1                     $0.06
TOTAL                    $1.06
CASH                     $1.06
THANK YOU!
CLERK 1          000001  00001
```

BRATTLE BOOK SHOP
1-800-447-9595
www.brattlebookshop.com
WE BUY AND SELL GOOD BOOKS
DATE 08/03/2020 THU TIME 09:41

SALE BOOK TAX T1 $1.00
TAX1 $0.06
TOTAL $1.06
CASH $1.06
THANK YOU!
CLERK 1 000001 000001

Laudomia had several siblings. The only one to rival her in fame is her half brother Niccodemo (bapt. 14 November 1509), born of Alessandro Forteguerri and his first wife, Francesca d'Angelo d'Azzolino Ugurgieri.[7] Niccodemo later became a valiant captain and political leader in Siena. In 1537 he married Girolama di Cristofano Palmieri and had seven children with her, the first of whom, Alessandro, continued the family line. Laudomia also had two older half sisters, Calidonia (bapt. 25 September 1510) and Laudomia (bapt. 13 September 1511), both of whom appear to have died in infancy or possibly even at birth.[8] In 1513 her father Alessandro remarried. His first wife, Francesca Ugurgieri, had died sometime after September 1511, perhaps in childbirth or from complications following the birth of the first Laudomia. Alessandro's second wife, Virginia di Giulio di Benvenuto Pecci, brought a dowry of 1,500 florins, a sum that was respectable but slightly lower than that of Alessandro's first wife Francesca (who had brought 1,700 florins). This difference may be an indication either of the lower social status of the Pecci with respect to the Ugurgieri, or of Virginia's own age/beauty/health factors, or of Alessandro's own situation as a thirty-four-year-old man with an orphaned four-year-old son and one or two young daughters.

Just over a year after their marriage, Alessandro and Virginia had a baby girl whom they named Laudomia Bartholomea Maria—exactly the same names that had been given two years earlier to Alessandro's last daughter by his previous wife. Though the offspring of a new wife, this child was clearly meant to replace, at least with her names, the daughter Niccolò had lost. By repeating so closely the names of his deceased child, Alessandro may have wished to repeat some previous gesture of respect toward family members or personal patrons implicit in naming a child after them. Alessandro and Virginia had at least seven other children: Cassandra Theodora Maria (bapt. 1 April 1517), Sulpitia Bartolomea Maria (bapt. 30 May 1518), Giovan Francesco Pavolo Bartolomeo (bapt. 26 January 1522/23), Silvio Giovanni Quirico Benedetto (bapt. 21 March 1524/25), Salustio Zeffirino Maria (bapt. 26 August 1526), and Iuditta Caterina Bartolomea (bapt. 28 November 1527).[9] In spite of this large brood, which included three male children, only the first-born, Niccodemo, appears to have continued the family name into the next generation.

Sometime before 1535 Laudomia married Giulio Cesare di Alessandro Colombini (b. 1507), the scion of a noble Noveschi family.[10] The couple had three children: Olimpia Antonia (b. 13 October 1535), Antonia Anna (b. 27 July 1537), and Alessandro Antonio (b. 30 August 1539).[11] There is no further information on the two daughters, but the son, Alessandro, reappears in 1562 when he marries Caterina di Girolamo Tolomei, with whom he had at least eleven children.[12] One of these would be Giulio Cesare Colombini (b. 1576), a namesake of Laudomia's husband and the last of her direct male descendants. In the early 1600s Giulio Cesare the Younger held administrative positions in the *contado* of Siena (he was *podestà* of Asciano, for example), and, as a man of letters, corresponded assiduously with the Sienese *letterato* Belissario Bulgarini (1537/38–1621). He was also a member of at least two literary academies in Siena, where he was known as "lo Stabile" (among the Intronati) and as "Testardo Umeroso" (among the Filomati). He appears not to have married or sired children and to have been consistently short of money.[13]

Sometime around 1542 Laudomia was widowed. On 9 December 1544, she remarried with Petruccio Petrucci (1513–92), a captain in the Sienese forces and later with the Florentines. Petruccio was a scion, through the lateral San Martino branch, of the powerful Petrucci clan.[14] The new couple had no children together and lived childless. The 1553 and 1554 censuses record that Petruccio Petrucci resided in the parish of San Martino with "his wife, his servant woman, and a young male servant" (la donna, una serva, et il garzone) for a total of four people ("4 bocche")[15]—there is no mention of any children in the house because, in line with contemporary practice, when Laudomia remarried she would have had to leave her three very young Colombini children in the care of their paternal family.

At this point, the "historical" Laudomia Forteguerri disappears from the archival records, probably a victim of the war with Florence or the subsequent siege of Siena (January 1554–April 1555). To know more about her, one is obliged to change course and follow her through the literary record, where, as we will see, she appears in a variety of guises over quite a number of years.

Laudomia Forteguerri as a Heterodox Thinker

The first to mention Laudomia Forteguerri in one of his works was the Sienese intellectual Marc'Antonio Piccolomini (1505–79), a cousin of Alessandro Piccolomini (whom we met in chapter 1). In a 1538 dialogue on "whether one is to believe that a woman perfect in all her parts, both physical and spiritual, that one might wish for, is produced by Nature by chance or by design," Marc'Antonio used Laudomia as one of his three female interlocutors.[16] The work is supposedly a retelling of a conversation between Laudomia Forteguerri and Girolama Carli Piccolomini, who was the dedicatee of Aldobrando Cerretani's translation of *Aeneid* 5 (see above, chapter 1). The dialogue is set in Siena on All Saints' Day, 1 November 1537, and imagines that the two women have run into each other that morning at the Duomo. After a brief conversation, Girolama suggests they forego the service for All Saints and go instead to her house, the Palazzo Piccolomini, to chat, an invitation that Laudomia gladly accepts. Once they are at the palazzo and settled in, Girolama engages Laudomia in a conversation on how beauty comes into being. The subject may seem frivolous today, but it was profoundly serious in sixteenth-century Italy because, as Rita Belladonna points out, the topic touched on questions that moved from an aesthetic and then philosophical discussion on beauty to a theological discussion on predestination.[17]

As the discussion opens, Laudomia claims that Nature does not have a plan and therefore that beauty occurs by chance. Girolama responds by claiming that Nature is a providential agent that governs all natural phenomena and keeps the world in equilibrium according to an overarching plan determined by a universal First Cause, that is, by God. Laudomia concedes Girolama's point but adds that this universal plan is evident in what Nature produces normally; when, however, she produces something rare and unusual, such as perfect beauty, this is a result of chance and not part of the normal process of Nature. Girolama responds by distinguishing between chance and fortune, pointing out that chance does occur in Nature but that human actions are governed by fortune, and concluding that chance occurs only when an effect does not correspond to a cause. Having made this point, however, Girolama

affirms that the First Mover does guide Nature toward perfection, so that perfection is a normal result of the master plan. Laudomia now accepts the view that a perfect woman (and here they use Eufrasia or Frasia Marzi as their example of feminine perfection) is an example not of chance but of God's plan and Nature's drive to attain perfection. At this point Laudomia suggests that whatever does not follow this master plan and thus does not attain the perfection desired by God and aspired to by Nature is, in fact, a monster. Girolama responds by indicating that Nature's drive toward perfection can be inhibited by matter. With this declaration of blame laid at the feet of the usual culprit, matter, the discussion changes direction and moves toward questions more closely tied to theology. Laudomia admits her surprise at Girolama's observation that Nature rarely reaches or attains perfection and wonders why so many impediments should frustrate the Master Plan. Girolama responds by suggesting that all causes are connected together and that the closer matter is to God the more perfect it will be; vice versa, the further it is from God the less perfect it will be. Laudomia objects to this and says that such a theory implies that God's will can be blocked or altered by matter and that God, therefore, is not omnipotent. Girolama responds by having recourse to free will, pointing out that if God's will were immutable then there would be no free will and mankind itself would not be free. When Laudomia suggests that human action is irrelevant and only God's will matters and that salvation is a result of grace (God's will) and not good works (human action), Girolama responds by reaffirming human free will, claiming that God's gift was to allow mankind to reach salvation on its own. She then pokes fun at Laudomia by gently chiding her for listening too much to Friar Agostino Museo, who preached the Lenten sermons in Siena earlier that year and caused a controversy to arise over the question of free will and predestination. At this point, the beautiful Frasia Marzi arrives and joins the two discussants as they turn their attention to the question of purgatory. Girolama claims that souls need to undergo a purification process before returning to heaven, but Laudomia wonders why such purification is necessary in the wake of Christ's redeeming sacrifice and whether the concept of purgatory fits with orthodox Christian teaching. Girolama responds by reaffirming the need for such purification and by referring

back to the comments of an unnamed houseguest of hers from the past summer, probably the reformer Aonio Paleario.

As the dialogue unfolds, the character of Girolama Carli Piccolomini affirms the providential aspect of Nature, the existence of free will, and the Neoplatonic belief in the perfectibility of the individual, while the character of Laudomia Forteguerri advances arguments solidly grounded in Aristotelian determinism and denies a human contribution to the achievement of perfection. Laudomia's views are tantamount to supporting predestination, a rather risky stand in post-1517 Catholic Europe and especially in dogmatically turbulent Siena, home to crypto-reformers such as Bernardino Ochino, Aonio Paleario, and Fausto and Lelio Sozzini, all of whom would later be declared to be heretics. At this point, Marc'Antonio must bring the discussion to an acceptable conclusion and somehow rehabilitate the erring Laudomia, who not only has presented heterodox views but also has admitted to having attended the Lenten sermons of a friar who, she admits, is known to hold some heretical views. Marc'Antonio does this by having Laudomia abandon her earlier views and return to the true Catholic path, forsaking her determinist opinions and espousing the belief in free will voiced by Girolama Carli Piccolomini. The fictive Laudomia is thus redeemed, and, one would think, so is the reputation of the "real" Laudomia.

Belladonna points out quite convincingly that the entire dialogue may have been a "coded text" in which Girolama Carli Piccolomini was meant to represent the voice of the Piccolomini clan and the learned academy of the Intronati, at that time under suspicion of heterodoxy, while young and inexperienced Laudomia Forteguerri was meant to represent the views of the more extremist wing of Sienese Spirituali and reformers, at that time fairly active in Siena. In Belladonna's view, Marc'Antonio Piccolomini is defending his clan and his intellectual confrères from spurious but dangerous accusations of heterodoxy by having Girolama Carli Piccolomini not only espouse orthodox views on providence, perfection, and purgation but also convert an erring Laudomia Forteguerri to more orthodox views.

In 1538, when this dialogue was composed, Laudomia was twenty-three years old and married—a young and respectable woman from good Sienese society. Surely, this dialogue on sensitive theological

issues was not the vehicle through which a young wife and mother would have liked to make her debut as a literary figure in contemporary Sienese intellectual circles. So why did Marc'Antonio choose Laudomia to be the voice of heterodoxy? There is no clear answer at the moment, though one might imagine that in the young and inexperienced Laudomia Marc'Antonio found a completely "safe" and "innocent" character, that is, a young person who came from a solidly reputable family, a woman who may have been intellectually curious but could be excused (and corrected) for any erroneous views on account of her age and her gender. Had Laudomia or her family really been rumored to adhere to heterodox views, Marc'Antonio's decision to cast her as the errant figure in the dialogue could certainly have had dangerous implications for the young woman and for her two families—both paternal and marital.

Laudomia Forteguerri as a Student of Astronomy

In August 1539, a year after Marc'Antonio's dialogue, his cousin Alessandro Piccolomini dedicated one of his own works to Laudomia Forteguerri, a scientific compendium of astronomical information in two parts entitled *De la sfera del mondo . . . De le stelle fisse (On the Sphere of the World . . . On the Fixed Stars)*. Although this is a compendium assembled by someone who was not an astronomer but an Aristotelian moral philosopher, it is nonetheless an important work in the history of astronomy because it marks the first time that maps of all forty-eight constellations then known to science were published together and the first time that the relative luminosity of each star in each constellation was indicated by letters of the alphabet, starting with A for the most brilliant and then proceeding with the other letters for decreasing orders of brilliance. Our interest in the compendium, however, lies not in its scientific contribution to the advancement of astronomy but in what it tells us in the dedicatory letter about Forteguerri's interests and activities.

Piccolomini wrote that letter from the villa outside Padua where he was spending the summer months. In it he mentions that he has heard how, that previous springtime, Laudomia spent a sunny afternoon chat-

ting with other noblewomen in her garden in Siena. The women formed a circle in the shade of a laurel tree and engaged in "beautiful and most learned and philological discourses." Turning eventually to "things divine," they talked at length of the beauty and splendor of the heavenly bodies, their marvelous order, and other similar matters. At which point, Alessandro says, Laudomia lamented that she had been born a woman, for had she been born a man she would have dedicated herself "to some worthy study and honored science." What most pained her was "that she had not been able to feast her spirit on matters of Astronomy, to which she felt inclined more than to any other science." Ever the attentive admirer, Alessandro seizes the opportunity to advance his standing in her eyes and to alleviate her unhappiness: he decides to assist her in learning more about the heavenly bodies by gathering astronomical information from a variety of scientific sources and then placing it at her disposal in this volume, which, as he explains, he composed in Italian, not in Latin, so that she may understand it fully. He then continues by claiming that he was inspired to carry out such work also by the knowledge that Laudomia was well versed in Dante's *Divine Comedy* and by the memory of an earlier occasion when he had heard her publicly comment some cantos of Dante's *Paradiso* "so subtly that [he] marveled at it every time [he] thought of it." A compendium of astronomical information, he suggests, would thus help his beloved in her study of Dante's *Paradiso.* Piccolomini concludes the letter with the usual praises and salutations and dates it 10 August 1539, from the villa in Valsanzibio.[18]

Though admittedly a male writer's construct, the Laudomia Forteguerri depicted in this preface is quite unlike the women of contemporary Italian literature. She is not the flirty Boccaccesque beauty who delights her male and female companions in pleasant gardens by narrating fictional stories, singing, or dancing for them. Nor is she Castiglione's courtly lady who entertains the men of the court by charming them with her elegance and by asking questions that will allow them to stay up all night expounding their male perspectives on anything and everything. Instead, with no men around her, Forteguerri engages her female companions in discussions on the nature and physical movement of the heavenly bodies. We note that her interest in the heavens

is not at all mythological (the stars as divinities) or astrological (the stars as horoscope)—it is, instead, thoroughly scientific (the nature and movements of the stars). In the same vein, Forteguerri's interest in the heavens has nothing to do with the Christian heaven of salvation and beatitude, and everything to do with the workings of the physical cosmos—the universe as a mechanical system that can be studied scientifically.

Forteguerri's "scientific" inclination can be detected also in her interest in Dante's *Divine Comedy* (something we, today, may not at first realize). Laudomia's reading of Dante's epic poem is focused not on the *Inferno* or the *Purgatorio* but on the *Paradiso,* a point that Piccolomini is keen to make and that he reiterates seven months later in his dedicatory letter to *De la institutione,*[19] when he notes that "this past autumn, when I was in my garden and had read a short time before Canto XXXI of Dante's *Paradiso,* in which he talks about the highest happiness, which canto, as you will well remember, you once interpreted for me to my great amazement, I turned my thoughts completely to the beautiful things you had explained to me in a most learned way about human and angelic happiness. And, remembering first one and then another of the things you had said, I began, with even more amazement, to marvel at your judgment than I did that day when I listened to you."[20]

What Piccolomini is underlining in these two dedicatory letters, and what we ought to appreciate more fully, is that Laudomia is interested, not in the two canticles of the *Comedy* that are set in the otherworldly regions imagined and created by Dante's poetic fantasy (the *Inferno* and *Purgatorio*), but in the one canticle, the *Paradiso,* that is set in the firm and scientifically "real" cosmos of contemporary science, that is, in the "heavenly" spheres of the Ptolemaic universe that had been the accepted scientific model for the cosmos for at least a millennium and a half. We should also note that Laudomia is interested, not in the two canticles that deal with sin and its consequences—the two topics that are the usual interest of the devout layperson—but rather in the canticle that deals with philosophy and the higher sciences. Her Dante is Dante the philosopher, the scientist, the voyager through the very real cosmos of Ptolemaic astrophysics. As Virginia Cox points out in analyzing Matteo Bandello's comment in the proem to his *Novelle* (1554), where he describes how Ippolita Sforza Bentivoglio was an acute liter-

ary critic who could explicate some texts "profoundly and with great subtlety," what is "notable here is the mention of an audience: this is not a court lady meekly listening to the disquisitions of her male peers but an authoritative critic herself, and a highly articulate one, quite capable of assuming a quasi-magisterial role."[21]

Piccolomini's dedicatory letter to *La sfera del mondo* also highlights an important point about the condition of learned women in sixteenth-century Italy. Laudomia's lament for having been born a woman gives us a very different perspective from what we usually encounter in literary sources. In sixteenth-century learned comedies, for example, women complain about lack of security as a woman in a male world (Santilla in Bernardo Dovizi's *La Calandria* 2.1), about their submission to "man's tyranny" and their marriages to much older men (Madonna Oretta in Giovan Maria Cecchi's *L'Assiuolo* 4.3), about the way they are used and manipulated by their male relatives and even their confessors (Lucrezia in Niccolò Machiavelli's *La Mandragola* 5.4), or about the way they must submit to their husband's or lover's sexual exploitation (Lena in Ludovico Ariosto's *La Lena* 5.11). To these complaints we ought to add the inability to travel freely, which we encountered in Virginia Martini Salvi's poem for the "Tombaide" (chapter 1) and which is implicit in the cross-dressing of certain female characters in comedies (Santilla in *La Calandria* or Oretta in *L'Assiuolo*). Laudomia, on the other hand, is complaining not about women's personal restrictions or their subservience to men but about a woman's lack of opportunity to pursue scientific studies. This gendered obstacle to furthering a woman's education is not unlike Aurelia Petrucci's own difficulties in advancing her Latin skills (see above, chapter 2). It is also something that was noted more recently by Virginia Cox when she pointed out that in Piccolomini's dedications to Forteguerri, "Forteguerri functions as the embodiment of a potential vernacular audience for science or moral philosophy, qualified by natural acumen and intellectual curiosity but excluded from pursuing its interest by an ignorance of Latin: the same audience that Dante and Cavalcanti had reached out to in their vernacular philosophical writings some two centuries earlier."[22]

If this is even an approximate portrait of the historical Laudomia Forteguerri, we can appreciate why she would have been depicted by Marc'Antonio Piccolomini as a figure with heterodox views on Nature

and God's plan, or why his cousin Alessandro Piccolomini would have chosen her as the dedicatee for his astronomical compendia—Laudomia was a woman who broke from the usual gendered expectations in sixteenth-century Italy and pursued her own path to self-fulfillment, not only in matters theological and scientific, but perhaps even in matters sexual, as we are about to describe.

Laudomia as a "Lesbian"

At the time Alessandro Piccolomini was dedicating his works to Laudomia Forteguerri and claiming her as his poetic muse, he was also fully aware that she was not interested in him at all.[23] In fact, Laudomia had developed a strong affection for someone else, a woman, and was writing poems of yearning for her.[24] Although there are earlier examples of poetry expressing same-sex affection between women in France, for example in the works of the thirteenth-century *trobairitz* Bieiris de Romans, there are no previous such examples in Italy, so Laudomia may well be seen as the first "lesbian" poet in the Italian vernacular tradition. Similarly, although same-sex female affection had already been treated in Italian literature, most notably in the Bradamante and Fiordispina episode from Ariosto's *Orlando furioso,* it had not yet received as positive an evaluation as it now did with Piccolomini. As Deanna Shemek points out, the episode with Bradamante and Fiordispina was an "anecdote of doubling and desire, of desire that must be undoubled and re-sorted according to viable social institutions, [that] foreshadows Bradamante's obligation to halt the suspension of her gender identity in order to fulfill her social and reproductive destiny as matriarch of the Este dynasty."[25] No such attempt to re-sort a same-sex affection in order to make it adhere to societal expectations about women's reproductive role is present in Piccolomini's description of Laudomia's love for Margaret of Austria.

Laudomia's affection for another woman did not, in fact, seem to worry Piccolomini. On the contrary, he spoke openly and proudly of Laudomia's "pure love" for Margaret of Austria, most famously in a public lecture he delivered on Sunday, 6 February 1541, at the renowned literary academy of the Infiammati in Padua, where he analyzed and

expounded on Laudomia's sonnet "Ora ten' vai superbo, or corri al-
tiero" (Now you go proudly, now you run haughtily)—the first time a
woman's poetry had been discussed publicly at a meeting of a learned
academy.[26] After the lecture, a copy of this talk came somehow into the
hands of the Bolognese printers Bartolomeo Bonardo and Marc'Antonio
da Carpi, who published it in July of that same year (possibly capitaliz-
ing on the fact that by now Piccolomini had become the *principe* or
head of the Infiammati and had thereby acquired a cachet that could
be commercially advantageous for a publisher).[27] In a letter to the Flor-
entine erudite and personal friend Benedetto Varchi, dated 20 August
1541, Piccolomini claims not to be responsible for this publication and
asks Varchi to "defend" him from any criticism that might be leveled
against him for the incompleteness and superficiality of his work. He
then asks Varchi to let it be known that he, Alessandro, had nothing to
do with this unauthorized publication (though we might take this claim
with a bit of salt). In a not-so-subtle way, Piccolomini implies that the
blame should be placed instead on Leone Orsini, the previous *principe*
of the academy, to whom he earlier sent a copy of the lecture:

> I had forgotten to tell you, Messer Benedetto, that when Messer
> Celso Sozini passed through Bologna he found something that
> came as an unpleasant surprise to me,[28] and that is that in Bologna
> they have printed my lecture on Madonna Laudomia's sonnet, which
> certainly has given me and continues to give me great aggravation
> for an infinite number of reasons. When I asked Messer Celso
> whether he knew how those booksellers had obtained it, he told me
> that he knew for certain that it had come from Ancona, where per-
> haps it may have arrived from Rome. He says "perhaps" because al-
> ready before February, when Mons. [Leone] Orsini asked to see it
> I sent it to him. Whatever the case, I beg you, Messer Benedetto,
> if you should have the opportunity, please defend me saying that
> [this edition] can be nothing but corrupt and faulty because it was
> done without my knowledge. I regret this even more because it car-
> ries the name of the Academy [of the Infiammati of Padua], whose
> greatness deserves something else altogether and not this thing or
> things like it. Patience.[29]

What we have, then, is an apparently unauthorized publication of what had originally been an oral presentation delivered at a closed meeting of a learned academy.[30] Given this context, one might well believe that Piccolomini's description of Laudomia and Margaret's relationship enjoys the benefit of intimacy and immediacy and, consequently, that the unauthorized version published in Bologna has not been toned down or made more circumspect because of its imminent appearance in print. This intimacy and immediacy is perhaps what caught the imagination of other poets and erudites who, as we shall shortly see, picked up the story and referred to it in their own writings.

In the introduction to his lecture, Alessandro Piccolomini informed his listeners that Laudomia had met Margaret in 1536, when the emperor's daughter had passed through Siena on her journey from Naples to Florence.[31] Piccolomini is wrong about the date and circumstances of their first meeting because, when Margaret traveled from Naples to Florence in the spring of 1536, she sailed from Naples directly to Pisa and then went overland along the Arno to the Medici villa at Poggio a Caiano and thence to Florence.[32] She did not stop in Siena because it was significantly out of her way and also because it would not have made much sense — Siena was not in Florentine territory, so there was no reason for Margaret to make a lateral detour to "another country" while making her "nuptial progress" to Florence. What Piccolomini may be remembering, instead, is that in April 1533, on her voyage from the Netherlands, where she was born, to Naples, where she was going to be educated in preparation for her marriage with Alessandro de' Medici, Margaret did stop in Siena because this time she took an overland route from Florence to Rome and thence to Naples. On that voyage, she left Florence on 27 April and arrived in Rome nine days later on 6 May; this indicates that she stayed in Siena for a few days at the end of April 1533, which would give us a much more probable date for her first meeting with Laudomia. At the alleged encounter in 1536, Laudomia would have been twenty years old and Margaret thirteen; if the encounter took place in 1533, as I suggest, they would have been seventeen and ten years old respectively.

Piccolomini recounts how Forteguerri had been attending a *festa* in honor of Margaret when, "as soon as Laudomia saw Madama [Mar-

garet of Austria], and was seen by her, suddenly with the most ardent flames of Love each burned for the other, and the most manifest sign of this was that they went to visit each other many times."[33] Their affection, Piccolomini adds, was rekindled two years later (five, according to my revised dating of the first encounter), in October 1538,[34] when Margaret, now a sixteen-year-old widow, passed once again through Siena, this time on her return journey from Florence to Rome. Piccolomini's description of this second encounter is worth noting. He says: "And when this great Madama passed once again through Siena, two years ago, on her journey to Rome, they renewed most happily their sweet Loves and today, more than ever, with notes from one to the other they warmly maintain them."[35]

Piccolomini then takes great pains to point out that these "sweet loves" of theirs are not something low, vile, and sexual but rather something high, refined, and spiritual. He explains that "love is not a low desire, a vile and unbounded urge, as perhaps those who denigrate it would think, but the most happy acquisition of a virtuous spirit. The aim of the most perfect love, . . . consists in nothing else but the possession of the virtuous spirit of one's beloved, that is, in being loved by her. . . . If a man truly loves and contemplates his beloved constantly, either from nearby or from afar, it is impossible for him not to live happily, imbibing with his mind's eyes a certain hidden sweetness that could never be understood by anyone who has not experienced it."[36] Piccolomini's words are not new to anyone who has worked on medieval and Renaissance love theories or has read Dante or Petrarch. In fact, there are clear echoes of Dante, to whom Piccolomini refers directly, and also of earlier Italian love poetry, especially the works of the thirteenth-century poet Guido Guinizelli and the Sweet New Style poets of the 1290s to 1320s. What is relatively new, however, is that these theories on love are applied to the affection existing between two women, not to the affection of a man for a woman.

This novelty does not, however, seem to dampen Piccolomini's affection for Laudomia. In fact, in his sonnet to Laudomia appended at the end of the published version of the lecture Piccolomini praises this same-sex affection and claims that, by loving Margaret, Laudomia will come to appreciate the love that he, Alessandro, bears for her.

Donna, che con eterno alto lavoro
Drizzate il Tebro al Ciel, per dritto calle,
Rime tessendo sì, ch' ancor' odralle
Forse il Greco, e l'Ispan, l'Arabo, e 'l Moro:
 Le Dee de l'Arbia, il crin mentre d'alloro
Cingonvi, e al vecchio colle ambe le spalle
Pingon verdi, e vermiglie, e bianche e gialle
Gli smeraldi, e i rubin, le perle, e l'oro.
 O' come ho car, che sì gran Donna il core
Vi stempri, e omai v'insegni a creder parte
Di qual prov'io nel petto interno ardore.
 Che già so ben, quanto mal puossi in carte
Porsi 'l poter del Signor nostro Amore,
Che fede acquisti, a chì no 'l sente in parte.[37]

Lady, with your eternal, lofty work / You point the Tiber straight
to heaven's gate, / Weaving such rhymes that might perhaps be
heard / By Greeks and Spaniards, Arabs and Moors, // While
Arbia's goddesses do crown your locks / With laurel leaves and
color green and red / And white and yellow both the old hill's
slopes / With emeralds and rubies, pearls and gold. // Oh, how
I love that such a lady great / Should melt your heart and teach
you to believe / The burning that I feel deep in my heart, //
For I well know it's hard to put in words / The power that Love,
our lord, does wield, so that / Someone who does not love might
then believe.

The poem was republished by Domenichi in his *Rime* (1546),
where it follows immediately upon Forteguerri's "Ora ten' vai superbo"
(pp. 246–47), thus reconfirming the opinion of their contemporaries
that, at least in this instance, Laudomia and Alessandro were to be read
as a pair. Piccolomini's supportive attitude toward Laudomia's love
for Margaret is echoed in the second congratulatory poem included
as an appendix to the *Lettura,* a sonnet by the Genoese poet Emanuele
Grimaldi, who was Alessandro's fellow student at the University of
Padua and a fellow member of the Infiammati.

Donna gentil, che con purgato inchiostro
Scrivendo alzate in questa parte e in quella
I vivi rai dell'amorosa stella
Scesa fra noi dal più beato chiostro,
 O, com'ornate alteramente il nostro
Secolo, poi che così saggia e bella
L'antica etade o pur l'età novella
Non ebbe od ha nè stile uguale al vostro.
 Deh, se v'inspiri ogni'or celesti odori
Dal ricco sen' nel petto onesto e raro
La bella Donna che cotanto amate,
 Degnate ch' io con nuove carte onori,
Laudomia, il nome vostro, ond'oggi è chiaro
Si 'l suon, ch' adoro anch' io vostra beltade.[38]

Gentle Lady, you write with ink refined / And raise both here
and there the shining rays / Of that so loving star who has come
down / Among us from that cloister much more blessed. // Oh,
how you do adorn our times so well, / For neither ancient time
nor our new age / Has had someone as wise and fair as you / Or
someone with a style that equals yours. // Come now, if that fair
woman you adore / Inspires your heart, so honest and so rare, /
With those celestial perfumes from her breast, // Allow that I
should honor with new poems / Your name, Laudomia, whose
sound today / Is so clear that I, as well, adore your beauty.

The third contributor to this chorus of congratulatory sonnets is
the Florentine poet Benedetto Varchi, who praises Laudomia for her
poetic skills as well as for her love of Margaret and then puns on his
and Laudomia's surnames, thus creating a complimentary link between
himself and the Sienese poet.

Donna leggiadra, al cui valor divino,
Che 'n tante parti e così chiaro suona,
Col cor, che sol di voi pensa e ragiona,
Per tanto spatio umilemente inchino.

Poscia che l'empio avaro mio destino
Lungi mi tien dove 'l desio mi sprona,
La strada che 'l vil secolo abandona
Di costì ne scorgete e 'l ver camino,
 Ond'io, che in questo uman, cieco e fallace
Laberinto d'error gran tempo errai,
Per voi ritruovi il varco e vegga ond'esca.
 Così del fallir mio Donna v'incresca,
Com'io cerco acquistar più ch' altri mai
Con Forteguerra dolce eterna pace.[39]

———

Delightful Lady, let me take this time / To humbly bend my heart,
that thinks and speaks / Of you alone, to your merits divine /
That in so many places clearly sound. // Because my cruel fate
so niggardly / Keeps me afar from where my heart would go, /
Show me from there the path the vulgar crowd / Has left
abandoned, show me the true path, // So that, in this erroneous,
blind, and human / Labyrinth, where I have long digressed, /
I might locate through you the passage [varco] out. // And so have
pity, Lady, of my erring / As I, more than all others, seek to gain /
With war that's fierce [forte guerra] a sweet, eternal peace.

Varchi's sonnet is not one of his best and seems to be somewhat stilted.
There are several possible reasons for this, not the least of which might
be haste in composing it or his wish to include at all costs a pun on his
and Laudomia's names. Another (and much more fascinating) reason
might be that Varchi was being deliberately obscure and writing to Lau-
domia in code because his message to her was controversial: he might
well be asking Laudomia, a woman who loves another woman and has,
by all accounts, found an acceptable way of doing so, to help him find
the right path *(strada)* for his own same-sex inclinations and his well-
known sexual interest in young men. The *varco* on which he puns may
thus be the "way out" from this "erroneous, blind, and human laby-
rinth" that is same-sex sexual desire; but, as he suggests, Varchi is un-
able to find a way to raise his physical attraction for young men to the
spiritual level that contemporary Neoplatonist theories describe and
Laudomia achieves. If he were to find the "way out" *(varco)* he would

"find" (that is, "save") himself *(Varchi)*. In the meantime, however, all he can hope for, more than anyone else, is that his bitter struggle *(forte guerra)* will lead him to "sweet, eternal peace."

This interpretation of Varchi's sonnet may not be as improbable as might at first appear. The same-sex love described and analyzed by Piccolomini in his *Lettura* caught the imagination of several of his contemporaries who used Piccolomini's "outing" of Laudomia and Margaret as "lesbian" lovers for their own purposes. One of these was the Vallambrosian monk Agnolo Firenzuola (1493–1543), who, in his dialogue *On the Beauty of Women,* composed in 1541 but not published until 1548, picked up on Piccolomini's comments and used them as supporting evidence in his discussion of the Platonic myth of the androgyne. Through the voice of Celso, the only male discussant in the dialogue, Firenzuola explains to a group of four women gathered in the garden of the abbey of Grignano in Prato:

> Those who were male in both halves, or are descended from those who were, wishing to return to their original state, seek their other half, which was another male. They thus love and admire each other's beauty, some virtuously, as Socrates loved the handsome Alcibiades, or as Achilles loved Patroclus, or Nisus loved Euryalus; and some unchastely as certain wicked men, more unworthy of any name or fame than that man who, in order to gain fame, set fire to the temple of the Ephesian goddess. And all these men, both the virtuous and the wicked, generally flee the company of you ladies. And I know very well that you are familiar with some of these even in our own day.
>
> Those who were female in both halves, or are descended from those who were, love each other's beauty, some in purity and holiness, as the elegant Laudomia Forteguerri loves the most illustrious Margaret of Austria, some lasciviously, as in ancient times Sappho from Lesbos and in our own times in Rome the great prostitute Cecilia Venetiana. This type of woman by nature spurns marriage and flees from intimate conversation with us men.[40]

With these comments Firenzuola contextualizes Laudomia's love for another woman within a creation mythology and a philosophical

tradition that were both very ancient and very much *au courant*. Laudomia becomes not only living proof in support of Aristophanes' myth of the androgyne but also a fellow lover in the category that includes the likes of Socrates, Achilles, and Nisus. She is, furthermore, the only woman, either ancient or modern, that is their peer—and this is no small achievement. She does, admittedly, belong to another gender group, but the parallel with the men is evident and speaks loudly to Laudomia's credit. This is because the contrast in the categories Firenzuola outlines is based not so much on gender distinctions (though these are obviously present) as on the nature of the lover's quest to reunite with the beloved "other half": on one side stands the love that is virtuous (in the case of men) or pure and holy (in the case of women), while on the other side stands the love that is "unchaste" (in the case of men) or "lascivious" (in the case of women). The gendered difference lies in the choice of words—men love in a masculine way based on the Renaissance concept of *virtù,* while women love in a feminine way based on the traditional Renaissance concepts of female chastity and purity. When they transgress, men love unchastely, which is a fairly neutral way of finding fault with them, while women, on the other hand, love "lasciviously," which harkens back to medieval and Renaissance concepts about women's allegedly insatiable hunger for sex.

Not surprisingly, then, the contemporary reference to a woman who loves other women lasciviously is to a Roman prostitute, Cecilia Venetiana, a figure as unsavory as she is mysterious. The 1526 Roman census records two women by this name, but it does not give their occupation.[41] She does, however, appear in the literature of the time. The *Ragionamento del Zoppino,* attributed to Francisco Delicado, reports that "at the age of twenty Cicilia the Venetian (for she passes by this name, even though she is Friulian) was still Jewish; she had herself baptized, took some fool for a husband, ran away from him, and came to Rome with a glutton of a priest who was sent to the galleys for his virtues; she then began to frequent a Sienese teller, who put her back up on her feet."[42] Although a literary construct typical of the genre and its misogynist traditions, Cecilia may well recall one or more figures of professional prostitutes encountered by Firenzuola and his friends among the literate but also worldly circles of Leonine and Clementine Rome (and

from whom he caught the syphilis that laid him out for several years and forced him to retire to a quieter life in Prato). His Cecilia Venetiana may well be based on personal knowledge of a specific woman whom his readers, and especially his circle of male friends, would have recognized. She could also be a composite of various Roman prostitutes and courtesans.

Cecilia was certainly not the only prostitute with a female lover. In his "Discours sur les Dames qui font l'amour et leurs maris cocus," the French historian and biographer Pierre de Bourdeille, Seigneur de Brantôme (ca. 1540–1614), personally recalled a courtesan in Rome who had a lesbian relationship with another woman.[43] Speaking later of sexual acts between women, Brantôme added that "courtesans, who still have plenty of men available to them all the time, indulge in this rubbing [*fricarelles*], and seek and love each other, as I have heard it said in Italy and in Spain."[44] On the other hand, the reference to lesbian courtesans and their sexual activities with each other may be nothing more than a male sexual fantasy akin to lesbian pornography for consumption by heterosexual men, and as such it may have little basis in fact. Whatever the case, in Firenzuola's narrative Cecilia Venetiana represents, by virtue of both her "lasciviousness" and her profession, the unsavory, that is, carnal, aspect of same-sex female attraction and activity.

Margaret of Austria's Alleged Sexual Misconduct

The "lascivious" aspect of same-sex affection implied in Firenzuola's reference to Sappho and to Cecilia Venetiana was not, however, completely absent from the case of Laudomia and Margaret. While Laudomia herself was never suspected of "lasciviousness," such was not the case with Margaret. In the late 1530s and early 1540s, Margaret became the subject of constant unsavory rumors touching on her alleged sexual practices. Although these rumors were eventually to die out in Italy, they persisted for several more decades across the Alps.

The late 1530s had been difficult years for Margaret. We do not know, exactly, what the fifteen-year-old duchess felt for her first husband, the womanizing twenty-seven-year-old Alessandro de' Medici,

but we do know that she very much liked Florence and that after she was suddenly widowed she wished to remain there, possibly even as wife to the attractive new eighteen-year-old duke Cosimo I de' Medici, who was keen to marry her.[45] This, however, was not to be, for Margaret's father, Emperor Charles V, was already planning to use her once again to advance his political agenda, this time by marrying her to the new pope's fourteen-year-old grandson, Ottavio Farnese (b. 9 October 1524). Margaret, for her part, did not like the young man or the thought of marrying him. She arrived in Rome on 3 November 1538 dressed in full mourning for her deceased husband Alessandro de' Medici. The following day, at her wedding with Ottavio, Margaret still wore black and spoke so faintly that she could barely be heard. Later, she would claim never to have pronounced the fateful yes.[46] For several years after the marriage Margaret refused to consummate the union. On her father's orders she agreed to sleep in the same bed with her young husband, but she would not allow him to have sex with her.[47]

Margaret's stubborn refusal to consummate the marriage became public knowledge and provided plenty of grist for the Roman gossip mill, and especially for Pasquino, the ancient statue by Piazza Navona on which contemporary Romans anonymously posted their satirical poems and barbs. Many of the "pasquinades" from these years lampooned, in both Italian and Latin, the young couple's marital problems, advancing various reasons for the wife's unwillingness to have sex with her husband.[48] Most suggested she was too busy engaging in sodomitical sex with her father-in-law Pier Luigi Farnese or with his father (her grandfather-in-law) Pope Paul III Farnese and thus she had no time for her husband. Others suggested that Ottavio was simply too young and his penis too small for her interests. A Latin quatrain datable to 1539 reads:

AD DUCISSAM FLORENTIAE DESPONSATAM
OCTAVIO NEPOTI PAULI, PUERO XV ANNORUM

O tu, quae nimium iuveni male iuncta marito es,
quid facis in solo nocte silenti thoro?
Ut reor ipse, doles, quod sit tua messis in herba,
et cruciat mentem mentula parva tuam.[49]

To the Duchess of Florence Married to Ottavio,
Nephew of Paul, a Fifteen-Year-Old Youth

O you, who are badly joined to a husband far too young, /
What do you do in the quiet night in your lonely bed? / I think
you grieve that your harvest is still grass / And the little penis
torments your mind.

In all of these pasquinades both Margaret and her father-in-law Pier
Luigi Farnese were called mules, clearly in reference to their illegiti-
mate births.

Eventually Margaret relented, not because of pressure from her fa-
ther, her in-laws, or anyone in particular, but because she came to terms
with the fact that she was now a Farnese, because in the Rome of Pope
Paul III Farnese she was able to build for herself a court and develop a
sphere of influence that were not negligible, and because she realized
that she had an unavoidable dynastic duty to perform. In June 1543,
when her husband, now twenty-two years old and well out of his awk-
ward pubescent stage, returned home after a long period of absence
in Spain, where he had been serving in Charles V's military, she met him
at Pavia and then proceeded with him to Rome. The meeting in Pavia
went very well. The historian and bishop Paolo Giovio, who had been
present as part of Margaret's retinue, immediately wrote to his friends
to spread the good news. He opened his letter to Nicola Renzi and
Girolamo Angleria (or d'Angera) with the enthusiastic statement that
"on his first night in Pavia, the handsome Duke Ottavio fucked his
Madama four times, and then he came here [in Rome to attend to the
pope], and thus he got rid of the bad reputation he had."[50] This happy
union was not a one-time event. The couple clearly had intercourse
again, for two years later, in August 1545, Margaret finally gave birth—
to the twins Alessandro and Carlo.[51] Having fulfilled her dynastic duty,
Margaret soon distanced herself from her husband and returned once
again to living on her own and tending to her own affairs.[52]

Renato Lefevre, a contemporary local historian in Penne, Mar-
garet's duchy in the Abruzzi region of Italy, attributes her obstinacy
against marrying Ottavio Farnese and consummating the marriage to

her desire to remain in Florence and marry Duke Cosimo.[53] That may well be true, but one could argue just as well that Margaret's obstinacy was motivated by a lack of interest in Ottavio or even in a husband. Lefevre admits as much when he makes a virtue out of Margaret's apparent lack of interest in sex and men by saying: "Her good reputation as a woman is without question. After all the fuss she made against her second marriage, not one of the scandalous rumors so frequent at that time touched her. If anything, one could say the contrary about her: that she was or became prematurely deaf to physical love, that men were of no interest to her as such."[54] Aside from the fact that scandalous rumors did, very much, touch and even badger Margaret (as we have seen in the pasquinades), Lefevre's view that Margaret's lack of interest in sex revealed her lack of interest in men and that this was a sign of a woman's honor is no longer tenable—Lefevre is, in fact, adhering to heteronormative assumptions and refusing to accept an alternative reading that could just as easily propose that Margaret's lack of interest in sex with men was a sign of her interest in sex with women.

Although no Italian sources suggest that Margaret and Laudomia actually had sex, this is not the case with French sources. Commenting on Firenzuola's text from the dialogue *On the Beauty of Women,* Brantôme blatantly declared that Margaret used Laudomia for her sexual gratification. In so doing, the French historian reversed Firenzuola's comment and stated that Margaret loved Laudomia (not vice versa). He then added fuel to the fire by saying that his friend Louis de Bérenger, Seigneur du Guast, did not believe Firenzuola's claim that this was pure love between two women:

> At this point Monsieur Du Guast rebutted the author [Firenzuola], saying that it was false that this Margaret loved that beautiful lady purely and with holy love; because the fact that she had set her love on this woman, rather than on another just as beautiful and virtuous, led one to assume that she did so to use her for her pleasures, no more and no less than others; and to cover up her own lasciviousness, she said publicly that she loved her in a holy way, just as we see many like her do who cover up their lustful loves with such words. // That's what Monsieur Du Guast said to me; and if anyone wants to discuss this further, it can be done.[55]

By reporting du Guast's views, Brantôme cast doubts on the purity of the affection that bound Margaret and Laudomia. Such views, which amount to pure gossip, must not, however, be given credence. First of all, Brantôme's charge may simply be an attempt to deny Firenzuola's suggestion that women are capable of pure love, that is, of contemplating beauty spiritually. Although contemporary Neoplatonic thinking accepted that in theory women could love purely, it did not actually believe that such pure love on the part of women was possible in practice. The Aristotelian discourse that equated men with the spiritual and women with the physical, men with strength and women with weakness, was simply too prevailing for people to accept the possibility that women were as capable as men of contemplating beauty in a pure and spiritual way. Their innate weakness, a sixteenth-century Aristotelian would argue, would inevitably lead them to fall from the spiritual into the physical, from contemplation into gratification.[56]

There are other hidden agendas in Brantôme's words. For one, his "Discours" had a clear misogynist point to make—that women can cuckold their husbands even without the assistance of a man. Margaret's love for Laudomia had to be presented as a physical, sexual love to provide the evidence required by the argument. Furthermore, the fact that Brantôme unilaterally reversed the direction of love (from Laudomia for Margaret to Margaret for Laudomia) and then used this to suggest an abuse of power on Margaret's part reveals a rather cavalier attitude to precision. His reversal may have been dictated by a Neoplatonic understanding of sexual roles, one that saw the socially superior partner (the equivalent to the "older man") as the lover and the socially inferior partner (the equivalent to the "young boy") as the beloved; in this case, Margaret, the emperor's daughter, had to be the active partner while Laudomia, the Sienese noblewoman, had to be the passive one, simply because of their social position vis-à-vis each other. Finally, one should not discount the possibility that the French Brantôme may have wished to cast aspersions on the half sister of the current Spanish monarch, thereby denigrating the rival Habsburg family and indirectly elevating the French royal house.

In defense of Margaret and Laudomia, it should also be noted that the "Discours" was composed at least forty years after the fact and that since Firenzuola's *Dialogue* had appeared (1548) hardly anyone had

mentioned the two women's love for each other. Perhaps there was nothing to say, or perhaps a prudish silence had descended on the entire affair, at least in Italy. In his short biographical entry for Laudomia Forteguerri, for example, the seventeenth-century Sienese historian Isidoro Ugurgieri Azzolini does not mention her love for Margaret and focuses, instead, on Alessandro Piccolomini's "tender love" for her, saying: "Laudomia Forteguerri, of the Grandees of Siena, was tenderly loved by the great Alessandro Piccolomini, of whom we spoke at entries 5, 17, 18, not just for her beauty, as much as for the similarity in their research interests, for both were great students of moral philosophy, and Piccolomini dedicated to her a book entitled *The Organization of the Entire Life of a Man Born Noble and in a Free City,* divided into ten books, which was printed in Venice in 1540."[57] This prudish silence continued well into the twentieth century and was not broken until recent scholarship, in the wake of feminist and other studies, allowed for the possibility of engaging in a scholarly manner with same-sex affection in early modern Europe.[58]

Laudomia as Poet and Lover

No documents have yet been discovered that might give us an insight into Margaret's feelings for Laudomia Forteguerri, but Laudomia's own expression of love for Margaret is evidenced in five of her six surviving sonnets.[59] The first to be published was the one discussed by Alessandro Piccolomini at the Academy of the Infiammati in February 1541:

> Ora ten' vai superbo, or corri altiero
> Pingendo di bei fiori ambe le sponde
> Antico Tebro, or ben purgate l'onde
> Rendon l'imago a un sol più chiaro e vero,
> Ora porti lo scettro, ora hai l'impero
> Dei più famosi, or averai tu donde
> Verdeggian più che mai liete e feconde
> Le belle rive, or hai l'essere intero.

> Poi ch'egli è teco il vago almo mio sole,
> Non or lungi or vicin, ma sempre appresso,
> E bagni il lembo dell'altiera gonna.
>> Ch'arte, natura, e 'l ciel, e così vuole
>> Chi 'l tutto può, mostran pur oggi espresso,
>> Che star ben pote al mondo immortal donna.[60]

Now you go proudly, now you run haughtily / Adorning both your banks with flowers / Ancient Tiber, now well purged your waves reflect / The image of a brighter, truer sun, // Now you hold the scepter, now you command / Over more famous ones, now you have what makes / Your beautiful banks more verdantly happy / And fecund, now you are completely fulfilled. // For my fair and spotless sun is now with you, / Not distant now or near, but always next to you, / And you flow past the hem of that noble gown. // For art, nature, and Heaven wish it, and he / Who can do all, today they clearly show that / An immortal woman can dwell in this world.

In this sonnet, Laudomia's love for Margaret is articulated along the lines of traditional Italian lyric poetry. The poem is addressed to the river Tiber that flows proudly because the poet's "noble, graceful sun" stands by its shores. In line with Petrarchan poetry, the poet describes the effect the beloved has on the nature that surrounds her. The images that follow are not unusual—with her mere presence the beloved delights and replenishes all of nature around her and, in so doing, reveals that she is a creature of heaven descended to earth. Dante and Petrarch had said as much when they described Beatrice or Laura.[61] These are also standard images of sixteenth-century Petrarchism.

What is unusual, however, is that both the beloved and the poet are women, thus turning these simple verses into a poem of affection by a woman for a woman. Admittedly, were it not for the name of the author, the reader would not be able to identify the lover/poet as female— the language is carefully constructed so as to avoid any gender-specific indicators for the poet. This leads the naive reader to assume that the usual male lover/poet is lamenting the fact that his usual female beloved

is far away. The knowing reader, on the other hand, is aware that both the lover/poet and the beloved are women and is thus made cognizant of same-sex desire expressed in terms and structures typical of contemporary Petrarchan poetry.

The same images and conceits recur in the other published poems by Forteguerri. The sonnet "Felice pianta, in ciel tanto gradita" unabashedly reveals that the beloved is "my goddess, the Marguerite of Austria." In fact, editors have printed this sonnet with the indication of its dedicatee as its title.

A Margherita d'Austria

> Felice pianta, in ciel tanto gradita,
> Ove ogni estremo suo natura pose
> Quando crear tanta beltà dispose,
> Dico mia diva, d'Austria Margherita.
> So ben che mai di ciel non fe' partita,
> Ma per mostrarne le divine cose,
> Scolpilla Dio e di sua man compose
> Questa a Lui tanto accetta e favorita.
> S'a noi fu largo Dio di tanto dono,
> Di mostrarne la gloria del suo regno,
> Non vi sdegnate a me mostrarla in parte.
> E s'io del petto v'ho lasciato un pegno,
> In cambio un vostro ritratto con arte
> Mandare appresso ove i miei occhi sono.[62]

––––––––

To Margaret of Austria

Happy plant, so cherished in heaven, / Where nature placed all its most perfect things / When it set out to create so much beauty, / I speak of my goddess, Marguerite of Austria. // I know well that she departed from heaven / Only in order to show us divine things, / God sculpted her and with his own hand crafted / This woman so beloved by him, and favored. // If God was so generous to us with his gift, / With showing us the glory of his

kingdom, / Do not disdain to show her somehow to me. // And
if I have left you a token of my heart, / In return send a portrait
of yourself, / Skillfully made, here to me, where my eyes are.

The poem is addressed to Margaret of Austria, apostrophized in
the opening words with the epithet "Happy plant." This is, first and
foremost, a pun on her name, since Margherita (the Italian version of
Margaret) also means "marguerite," that is, daisy. The opening words
are, however, more than just a charming pun on a flower: they are a
brilliant and subtle reference to the well-known epithet *Felix Austria*
(Happy Austria) used in reference to that country. The epithet speaks
of the uncanny ability of the Habsburg family to expand their territo-
rial holdings by marriage rather than by war and comes directly from
a distich that King Matthias I Corvinus of Hungary (1443–90) is said
to have composed on the occasion of the marriage of Emperor Maxi-
milian I of Austria and Mary of Burgundy (1477), great-grandparents
of Margaret of Austria:

> Bella gerant alii, tu felix Austria nube.
> Nam quae Mars aliis, dat tibi diva Venus.
>
> ———
>
> Let others wage war, you, happy Austria, marry. / For what
> Mars gives to others, you receive from Venus.

Forteguerri's subtle reference to *Felix Austria* thus connects the
"happy plant" (marguerite) to the happy country (Austria) and the coun-
try, in turn, back to Margaret, who carries the appellative "of Austria"
in her official name. Although Margaret had been born out of wed-
lock, her father, Emperor Charles V, had officially recognized her as his
daughter and had decreed that she be known as Margaret of Austria,
thereby including her fully and unconditionally in the Habsburg family,
archdukes of Austria. Forteguerri's double pun unfolds itself and re-
veals its object in line 4 where the beloved is identified as "mia diva
d'Austria Margherita" ("my goddess, Margaret of Austria" or "the mar-
guerite of Austria"). The verbal punning does not stop there, for in
early modern Italian the word *margherita* could also mean "pearl," and so

Margaret becomes not only the scion of the archducal Habsburg family, or the flower of Austria, but also the pearl of her country. With this multilayered image, Forteguerri is clearly displaying her poetic bravura.

In the second quatrain, Forteguerri reveals that Margaret is special not only because she is the flower or pearl that comes from *felix Austria* but also because she is a gift from heaven—and here the opening epithet "felice" is expanded to include connotations of "fortunate" or "blessed." Using images drawn from the Sweet New Style poets, Forteguerri thus describes Margaret as a heavenly being descended to earth to grant mortals a glimpse of divine beauty. Both Dante and Petrarch, not to mention a myriad of subsequent poets, had attributed similar origins and purposes to their beloveds (see, for example, Alessandro Piccolomini's sonnet for Aurelia Petrucci, which we discussed in chapter 2), so the image is neither original nor noteworthy.

In the concluding tercet, Forteguerri points out that she has offered her beloved a token of herself, that is, a poem expressing her love for Margaret, so now she asks Margaret to reciprocate by sending back a small portrait of herself for Laudomia to keep as a visual memento of her beauty. Although not a direct borrowing from Petrarch, Forteguerri's request for a portrait on which to feast her eyes does recall Petrarch's description of his long, one-sided conversations with the portrait of Laura he had commissioned from Simone Martini.[63]

The rest of the sonnets addressed to Margaret are very similar to these two poems in both themes and imagery. The third, "Or trionfante, e più che mai superba" (Triumphant now, and more than ever proud; see Appendix), describes how "Ancient Rome" glories and how the banks of the Tiber are richly adorned with emeralds and rubies because "All the good that Heaven and Nature gave us," that is, Margaret, is with them. If, on the other hand, the beloved were to remove herself from the Eternal City and come to Siena where her lover lived, the flowers and grass of Rome would cease to be cheerful, while the poet and the river Arbia (which runs next to Siena) would rejoice. In the fourth sonnet, "A che il tuo Febo, col mio Sol contende" (Why does your Phoebus contend with my sun; see Appendix), Forteguerri tells "proud heaven" to hide its sun in the forest or under the sea while her own sun is about, for while the sun in the heavens can be obscured by a

little cloud, the sun that is Margaret of Austria shines even brighter when obscured by clouds or fog—a reference to the distance that paradoxically removes the beloved from sight but makes her brighter still in the poet's mind. Continuing with the image of the sun, the fifth sonnet, "Lasso, che 'l mio bel Sole i santi rai" (Alas, for my beautiful sun will not turn; see Appendix), is a lament occasioned by the fact that the beloved will not turn to, or return to, the lover. The poet thus calls on "cruel Fortune," asking why the lover's body cannot go to where the heart flies. In the final tercets the poet asks Fortune to look favorably upon her request and to grant her the wish to be with her beloved. And here the poet drops her carefully contrived gender ambiguity and makes it absolutely clear that both the beloved and the lover are women.

Though the images in Laudomia's sonnets for Margaret are clear, what is not clear is the depth of the emotion behind them. In these very same years (1530s–40s) Michelangelo's love poetry for the handsome Roman nobleman Tommaso Cavalieri clearly revealed his tortured attempts to sublimate the physical attraction he felt for the heterosexual young man into a Neoplatonic ascent to the divine through contemplation of the beloved's beauty,[64] but no attempt at such a philosophical rationalization is evident in Forteguerri's sonnets. If anything, her laments for the beloved's absence are unfettered declarations of simple affection expressed in thoroughly Petrarchan terms, elegantly calm and possibly even playful or contrived. Even the fifth sonnet, with its appeal to fortune (herself a feminine image), reflects more the exasperation of women unable to travel or relocate themselves than any deeply felt anxiety precipitated by contradictions inherent in a specific love situation. There is no deep internal anguish in Forteguerri's poetry, no need to resolve a profound emotional crux, and so no guilt and no sublimation. Compared to Michelangelo's tense and labored verses, Forteguerri's poetic articulations of same-sex desire are quite relaxed. This may indicate either a lack of real passion for Margaret or a personal interior balance that allowed Forteguerri to deal well with her attraction for another woman. Whatever the case, perhaps it was specifically because of their nontortured and nonchallenging nature that Forteguerri's poems could circulate openly among the literati and find their way into anthologies published at the time.

Was It Love or Was It Politics?

What is also not clear in Forteguerri's poetry for Margaret of Austria is the motivation behind it. Can we be certain that it was love, or even simple affection, that motivated the twenty-three-year-old married Sienese noblewoman, mother to two girls and soon to give birth to a boy, or was it something else? Marie-Françoise Piéjus suggests that it might have been a "community of spiritual and religious interests" that drew the two young women together and points to Margaret's interest in Bernardino Ochino while she was in Prato in 1537–38, and her close ties with Caterina Cibo and with Victoria Colonna during her early years in Rome, and couples these with Laudomia's ambivalent role in Marc'Antonio Piccolomini's dialogue on whether Nature creates beauty by chance or by design.[65] The possibility is interesting and worth pursuing further, but it does not exclude other possibilities. One of these is the possibility of a calculated effort on Laudomia's part to attract Imperial favor and gain support for the Forteguerri clan and their Noveschi political faction in Siena. By complimenting the young Habsburg duchess and somehow drawing her closer to Siena through a declaration of profound love for her, Laudomia may well have been part of a subtle maneuver on the part of the Noveschi to ingratiate the Imperial family to their cause. Virginia Cox points out a similar dynamic when she notes that "female education [was used] as a means of family 'ennoblement.'" In the Forteguerri case, Laudomia's poetry for Margaret could, in fact, be seen as a way of "ennobling" the Forteguerri clan and the Noveschi. Similarly, and still following Cox's schema, Laudomia's poetry for Margaret could be seen as a way to mediate an approach to a much more powerful male (the emperor) through the "gilded subordinate" (Margaret), a dynamic that "allowed dynastic women to serve as flattering proxy figures for male courtier [in our case the Noveschi], simultaneously graced by proximity to power and excluded from its direct exercise."[66] Such declarations of affection for the emperor's daughter might have been seen as inappropriate if coming from a male Sienese, but not if coming from a young noblewoman of impeccable credentials close in age to Margaret, especially if couched in Petrarchan terms.

The Petrucci, whom we have already met, were closely linked with the Spanish crown and Emperor Charles V. Already in the late 1520s the

emperor had expressed his tacit support of them when he obliged the Sienese government to readmit the banned Noveschi, headed by Francesco Petrucci, back into the city and its political structures. The official rationale at that time had been that civil peace was unattainable without the active participation of a major political and social group such as the Noveschi. Imperial support of the Noveschi in general and of the Petrucci in particular was an important element of Spanish politics. After all, in the 1510s Aurelia's father, Borghese Petrucci, had aligned himself and Siena with Spain in an effort to counterbalance the pro-French orientation of the Medici rulers in Florence and Rome. It was thus only natural for Charles V to preserve such a long-standing relationship with the Petrucci and their Noveschi partners. The relationship was not only official but also personal—when he visited Siena in April 1536, Charles V was a houseguest of Anton Maria Petrucci at the palazzo on via del Capitano at the corner with the Piazza del Duomo;[67] and it was here that his daughter, Margaret of Austria, also lodged when she passed through Siena in 1533 and 1538.[68]

The magnate Forteguerri family owned the tower of Posterla at the end of that same street and had its power base in the nearby area of San Pietro di Castelvecchio.[69] Having intermarried with the Piccolomini, they were related to the Todeschini Piccolomini branch of the family that included the dukes of Amalfi, vassals of the crown of Naples (held at this time by Charles V of Spain) and the Pieri Piccolomini d'Aragona branch. Not surprisingly, then, the Forteguerri had vested interests in maintaining and even cultivating closer connections with Naples, Spain, and the Habsburgs, politically, socially, and even personally.

Laudomia was not the only member of the family who enjoyed a personal friendship with an eminent figure from the Imperial camp. Her older half brother Niccodemo had a personal friendship with Charles V's great admiral, Andrea Doria, *signore* of Genoa, an important consideration when, in 1545–46, the Sienese Republic sent him to be their ambassador to Doria. Although personally connected with eminent figures in the Imperial camp, Niccodemo remained very much a loyal Sienese and served the republic both diplomatically and militarily with honor. In 1553, as the threat of an Imperial attack against Siena was mounting, he was selected as one of the four captains for the Terzo di Città, the city "third" where the Forteguerri lived and wielded power.

In 1554 he was chosen as one of the six Sienese captains to direct the defense of the city. In March 1555 he was sent on a diplomatic mission to Piedmont to determine whether French forces under the command of Marshal Charles de Cossé, Count of Brisac, were in fact on their way to help the Sienese. Then, in 1555, when the republic was about to fall, he was stationed in Montalcino to replace the deceased *commissario della repubblica,* Giulio Cacciaguerra. After the fall and during the period of the "Republic of Siena Withdrawn to Montalcino" (1555–59), he served as Sienese ambassador in Rome. After the eventual demise of the republic and its complete incorporation into the Medici state, Niccodemo continued to serve Siena both militarily as a captain and politically in a variety of posts (he was, for example, *gonfaloniere* in 1573), this time working closely with the Medici government in Florence, though always with the interest of Siena in mind.[70]

Although it is not possible to determine with certainty what Laudomia's motivation might have been when she composed her sonnets of affection for Margaret of Austria, one should take into account her family's politics and aspirations and not discount the possibility that her works were motivated by more than just love for another person. Alessandro Piccolomini, himself the scion of a pro-Imperial family, does not suggest a political motivation behind Laudomia's poetry—it would have been counterproductive for him to do so. He simply focuses on the bond of love and, in other venues, on Laudomia's beauty and intelligence. In fact, when Laudomia was composing her sonnets for Margaret in about 1538–39 she had already begun to appear in the works of contemporary writers as a beautiful, charming, and intelligent woman who moved easily within the social and intellectual circles of contemporary Siena and whose fame spread throughout the Italian peninsula—as we have seen in the works of Marc'Antonio and Alessandro Piccolomini discussed earlier in this chapter. With Alessandro's next work inspired by Laudomia, her public persona developed further and acquired still greater depth.

Laudomia as a Wife and Mother

With the birth of her third child, a much-awaited boy, Laudomia fulfilled her social responsibility of providing a male heir to the Colom-

bini family and fortune. The birth of Alessandro Antonio Maria di Giulio d'Alessandro Colombini on 30 August 1539 sealed her reputation as an exemplary woman and wife. In celebration of the event, Alessandro Piccolomini composed an extensive treatise, *On the Organization of the Entire Life of a Man Born Noble and in a Free City,* a work of moral philosophy that, as the author explains in his long-winded title, "both Peripatetically and Platonically, with matters drawn from the *Ethics,* the *Oeconomicon,* and part of the *Politics,* gathers together all the information on what can contribute to make the life of such a man most perfect and happy." The title goes on to explain that the work is "for the benefit of the most noble child Alessandro Colombini, born just a few days ago, son of the immortal Lady Laudomia Forteguerri, to which child (having held him at baptism), the author, as is the custom with godparents, donates these books."[71]

In his dedicatory letter to Laudomia, dated New Year's Day 1540, Piccolomini recalls how one day the previous fall he was sitting in his garden under an ivy-covered pergola reading canto 31 of Dante's *Paradiso* and thinking back to the time when Laudomia had explicated this canto to him and had discussed it with him, expounding with great learning on human and heavenly happiness.[72] Just then, Piccolomini received a letter from Laudomia's brother, Niccodemo Forteguerri, informing him that she had given birth to a baby boy and had named him Alessandro in honor of her father.[73] Piccolomini's joy grew when he found out that he had been chosen by the child's parents and by his uncle, Niccodemo, to be godfather by proxy at the child's baptism. Thinking at length about what might constitute an appropriate gift for his godson, Piccolomini eventually decided to give him a compilation of information drawn mostly from Aristotle and Plato on how best to live one's life and attain the highest happiness.

So, starting "last December [1539], as soon as the Anatomy holidays arrived," says Piccolomini, he began to work on his new book project, taking advantage of the university's winter holidays, which normally extended from St. Thomas's Day on 21 December to March. With Aristotle and Plato in front of him, he seems to have foregone the "Anatomia," the public dissections that would have been conducted in December, January, and February in a temporary anatomical theater built for the occasion. These were very popular events that attracted

not only students in medicine but also a general public of interested and/or curious people. That winter, the professor of anatomy and surgery at the university was none other than Andreas Vesalius (1514–64), who taught in Padua from the fall of 1537 to 1543 and attracted large crowds at his annual dissections during the "Anatomy holidays."[74]

Piccolomini, however, did not go to see Vesalius conduct a dissection. He stayed home instead and focused on gathering all he could from Aristotle and Plato on the topic of how one should conduct himself in life. He then arranged it into a volume written in the vernacular and laid out in fifteen chapter (or "books"), of which, as he explains later, only ten were at that moment ready for presentation (and, in fact, only ten were printed in 1542). Piccolomini focused on the moral disciplines and in particular on ethics, economics, and politics because he thought that these were the disciplines most needed, and least taught, at that time. Piccolomini confesses that this exercise has allowed him to retract what he said earlier in his *La Raffaella,* a rather lively and at times racy "dialogue on the good manners of women," which he wrote "more for entertainment than for any serious reason." He then adds that since the boy is, for the moment, too young to understand, he has decided to dedicate the work to the boy's mother, at least until such a time as the child might be old enough to read and appreciate the work. So in the first three books Piccolomini addresses himself to Laudomia and then, in the following seven books, to little Alessandro Colombini.

At this point in the dedicatory letter there is a brief digression in which Piccolomini explains that he knows that Forteguerri would like him to write something else for her—the missing fourth book to Leone Ebreo's *Dialoghi d'amore,* the one where Philo and Sophia discuss the effects of love (in the first three they discussed the nature, the origin, and the ubiquity of love). Alessandro temporarily declines this invitation, explaining that he is not up to the task and suggests that one should "wait a few months" to see if, by chance, the missing dialogue may not be found. He promises that if, in the end, the fourth dialogue is not found, he will then write it for her, something that he previously refused to do for the Spanish orator in Venice, Don Diego de Mendoza, when the latter asked him the same favor.[75]

This brief digression on Leone Ebreo's popular dialogue, inserted as it is in Piccolomini's dedicatory letter to a work of moral philosophy, is of interest to us for at least two reasons. First, it reveals that there was, in Siena as well as in Venice, in Italian as well as in Spanish circles, a keen interest in locating (or in providing an alternative for) the missing fourth and final dialogue of Leone Ebreo's Neoplatonic discussion of love. This ties in with our earlier discussions of Aurelia Petrucci's "sponsorship" of the first edition of this work and with our references to Laudomia Forteguerri's "platonic love" for Margaret of Austria. Second, the reference to Don Diego de Mendoza is couched in positive terms, reflecting the good reputation the Spanish diplomat and intellectual enjoyed at this time among certain Sienese elements, especially among the pro-Imperial Piccolomini and Forteguerri clans. It was a reputation that would not survive his term of duty as Spanish governor in Siena (October 1547–August 1552) and his ill-fated decision to build a fortress to house the Spanish garrison (the infamous Cittadella). In 1540, however, Don Diego was still viewed in very positive terms as a learned and cultured man. He was, in fact, the generous patron of the Venetian printer Aldo Manuzio, an avid collector of Greek texts, and a polyglot who, aside from a variety of European languages, also read Hebrew and Arabic (one of his childhood languages). Mendoza's interest in completing Leone Ebreo's dialogue either by finding the missing fourth book or by replacing it with a suitable alternative is thus indicative of his humanist interest in lost or rare texts, in Neoplatonism, in Hebrew culture, and in the works of a fellow Iberian intellectual. Piccolomini's comment that he turned down Don Diego but would not turn down Laudomia not only reveals the existence of a personal connection between the Sienese student and the Spanish diplomat but also reinforces our earlier observation of a strong bond between the Piccolomini and the Spanish crown.

With book 4 of his *De la institutione di tutta la vita* Piccolomini begins to address himself to the young child, Alessandro Colombini. In the subsection on what to look for in an ideal wife (10.2), he takes Laudomia as his example and tells the boy:

This is not the time nor the place to discuss what to look for, specifically, in the physical beauty of a woman; however, I will say

that if it were, there would be no need to tell you because, even if I had a thousand years at my disposal, I could not match with my style what Mother Nature and Almighty God have done in creating the most virtuous Lady Laudomia, your mother. She is such that all other women who are to be deemed beautiful should be like her, and those who are not like her in whatever part can never be said to be beautiful. You should turn to her, therefore (Alessandro), and taking her as your model you cannot fail to choose as wife a perfectly formed woman, for your divine mother is a most beautiful woman, born from a most beautiful and most virtuous mother, brought up and nurtured most wisely, most upright in her manners, tall and well formed in her person, full of divine majesty, most sweet, most comely to look at, most honest in every action and word, full of modesty, grace, gentility, gravity, and, to conclude with three words, all divine, all celestial, all immortal. If your good fortune should grant you a wife like her, there would be no happier man than you, now or ever. And this should suffice regarding the choice of consort you should take.[76]

The passage is fairly standard and does not add much more to our knowledge of Laudomia, but its placement in the book is fascinating. It constitutes the final section of a chapter entitled "On the Choice of a Wife and Whether She May Love Another Lover besides Her Husband." In it, Piccolomini argues that a good wife can certainly love another man because there are many different and not mutually exclusive types of love. Love that is the union of two souls is a higher and nobler emotion than marital love, which is merely an earthly contract, so a wife (or husband) can give that higher love to someone else while, at the same time, giving to the consort the earthly love that is due "by law." Piccolomini thus distinguishes between marital expectations, such as the conjugal debt or the contractual agreement to cherish and support one another, and the union of souls that is typical of Neoplatonic discussions on love. As long as husband and wife understand that love exists at many levels and appreciate the fact that this fundamental difference between earthly and spiritual love is not mutually exclusive, each of them can take an extramarital lover. Problems arise, Piccolomini points out, when a wife suspects that her husband's love for another

woman goes beyond *(trapassa)* what is honest, which is to love only the other woman's beauty and virtue, and that he is sharing with her what "by law" is due to the wife. Similarly, problems arise when a beloved begins to fear that her lover is sharing with his wife that love "that should be hers," that is, the union of souls. In arguing the case, Piccolomini thus clarifies his love for Forteguerri while, at the same time, acquitting her from any possible suspicion of infidelity. Although he does not mention it (and may not even be aware of it), he is also providing Laudomia with a valid rationale for her own same-sex love for Margaret of Austria, which Piccolomini would describe and expound at the Accademia degli Infiammati little more than a year later (6 February 1541).

Sometime after the publication of Piccolomini's *De la institutione di tutta la vita* (1542) Laudomia's first husband, Giulio Cesare Colombini, died. In December 1544 she married Petruccio di Niccolò di Benedetto Petrucci (b. 1513),[77] a military captain and the scion of a different Petrucci family tree from that of the Magnifico Pandolfo and Aurelia. In an interlinear note to Laudomia's baptismal record, a later, sixteenth-century hand inserted a cross-reference to the baptismal record for Petruccio Petrucci and described him as "her lover and her husband" in that order—a rather intriguing description, especially in light of Alessandro Piccolomini's discussion on lovers and consorts.[78] Tellingly enough, in 1901 Alessandro Lisini reversed the order and transcribed the marginal note as "her husband and lover," thereby revealing more about himself and his own times than he could have imagined.[79]

With her marriage to her "lover" Petruccio Petrucci, Laudomia Forteguerri lost her other "lover," Alessandro Piccolomini, who never again dedicated any of his works to her or mentioned her in his writings. In his introduction to the 1901 edition of Forteguerri's poems, Alessandro Lisini says that Piccolomini was taken aback by Laudomia's remarriage, which took place while he was away in Rome. Lisini then transcribes two sonnets from Piccolomini to Vittoria di Ascanio Colonna (niece of the much more famous Vittoria Colonna, Marquise of Pescara) in which the rejected lover laments this "betrayal."[80] One of these is sonnet 30 from Piccolomini's *Cento sonetti* (1549), in which the poet does, in fact, bitterly accuse his beloved of having betrayed him while he was briefly away:

Ad una Donna inconstante, e pergiura e senza fede alcuna.

Coi raggi suoi la Luna, alta e lucente,
Splendea da 'l ciel; (pur' a pensarlo aggiaccio)
Quando, piangendo, con le luci intente
Nel volto mio, postomi al collo il braccio,
 Giurasti, aimè, che per me pria che spente
Fosser tue fiamme, arso sarebbe il ghiaccio;
Nè son poi stato a pena un mese assente,
Che rott'hai di tua fè, perfida, il laccio.
 Chi sia non so, che me scacciato ha fuora
Del rio tuo petto, e a tue parole infide
Cred'or' altiero, e non n'ha fatto 'l saggio,
 Ma sia chi vuole, o bello, o dotto, o saggio:
Se ben tec'or del mal mio canta e ride,
Piangerà tosto, e io riderone allora.[81]

———

To a Woman Inconstant, False, and Completely Faithless

The moon shone high and bright up in the heavens / With all
her rays (I turn cold at the thought) / When full of tears, your
eyes fixed hard / Upon my face, your arm around my neck, //
You swore, alas, that ere your flame for me / Should be put
out, cold ice itself would burn; / But then, barely a month after
I left, / You, wicked woman, broke your word. // I do not
know who chased me from your heart / And proudly now
believes in your unfaithful / Words, and has not yet had time
to learn, // But be he who he may, handsome, learned, / Wise,
if he now laughs with you of me, / He soon will cry and then
I'll laugh at him.

Although it would serve Lisini's argument well to date this poem to
1544 or early 1545 and to relate it to Forteguerri's marriage to Petrucci,
there really is no hard evidence to support this dating—no contem-
porary manuscript or printed version connects this poem to Laudomia
or her marriage, so Lisini's suggestion remains unfounded. The poem

could just as easily be lamenting any other perceived "betrayal" on the part of any other beloved. And, in fact, there are several such poems in Piccolomini's *Cento sonetti* that lament a beloved's perfidy or cruelty— for example, sonnet 10 ("To a noble woman who constantly looks at herself in a mirror"), sonnet 62 ("To a very cruel woman"), and sonnet 75 ("To an ungrateful and haughty gentle woman")—any of which could apply to any beloved. As sonnet 43, addressed to the Abbot Bernardino Brisegno and entitled "When the author fell in love a second time," clearly indicates, Piccolomini was not a "one-woman man."

The other poem Lisini proposes as evidence of Piccolomini's reaction to the unexpected wedding is sonnet 3 from the same collection. This work is much more applicable to our purpose because it does clearly refer to Laudomia Forteguerri and reveals that Onorata Tancredi Pecci told Piccolomini that Vittoria di Ascanio Colonna had read the books he had dedicated to Laudomia Forteguerri and had been moved to pity by them.

A la Illustriss. S. la Sig. D. Vittoria Colonna, figlia de
l'Eccellentissimo S. Ascanio, havendo ella letti i libri
composti a Mad. Laudomia Forteguerri, secondo che referì
la Nobilissima Mad. Honorata Tancredi.

> Donna, la cui virtù luce sì bella
> Manda lontan per i belli occhi fuore,
> Che 'l mondo illustra e qual benigna stella
> Ciò che tocca co 'l raggio empie d'amore,
> Mentre che i libri miei, l'empie quadrella
> Vi mostra, ch'entr'al cor mandommi Amore,
> Pietà v'assal, se 'l ver mi dice quella
> Cui 'l nome fa, conforme ai fatti, onore.
> Amai, gliè ver, ma sdegno e crudeltade
> Fer sì, ch'a consolar l'afflitta mente
> Fu poi sin'ora ogni remedio vano.
> Ben la consola or sì, vostra pietade,
> Ch'Invidia or può (chi fia che 'l creda?) il dente
> Volger, dov'ha Pietà l'ochio e la mano.[82]

To the Most Illustrious Signora, Lady Vittoria Colonna,
Daughter of the Most Excellent Signor Ascanio, on Her Having
Read the Books Composed for Madonna Laudomia Forteguerri,
as Reported by the Most Noble Madonna Onorata Tancredi

Lady, whose virtue sends such lovely light / So far away, from
out your lovely eyes / That it enlightens the world and like a
star / Benign, imbues with love all that it strikes, // While all my
books make manifest to you / The wicked web that Love spun
in my heart / Your heart is moved to pity, as I hear / From her
whose name conforms to honest deeds. // I loved, it's true,
but cruelty and disdain / Did such, that to console my grieving
mind / All remedies have been till now in vain. // But now your
pity does console it so / That Envy turns (hard to believe) its
teeth / Away, where Pity sets its eyes and hands.

It does not seem feasible that Piccolomini's writings on astronomy
(De la sfera del mondo) or on the proper life of a noble citizen *(De la insti-
tutione di tutta la vita)* might have elicited such a response from Vitto-
ria Colonna, or, for that matter, his *Lettura* of Forteguerri's sonnet of
affection for Margaret of Austria. Piccolomini may, instead, be refer-
ring to some of his poetry, not his books ("i libri miei") for Laudomia.
Whatever the case, Vittoria Colonna does lend a "heart" and thus be-
comes the well-disposed dedicatee of Piccolomini's collected poetry,
the *Cento sonetti* (1549).

While there is not much evidence to support Alessandro Lisini's
claims that Piccolomini's interest in Laudomia faded when, on his re-
turn to Siena from Rome, he discovered that she had remarried, it is true
that after the 1543 re-edition of his *Institutione* Piccolomini did not ded-
icate any more books to her. By 1545, when he published his *Della no-
biltà et eccellentia delle donne,* an oration he had first delivered at the Academy
of the Intronati in Siena and an ideal place in which to sing the praises
of his beloved, Piccolomini was conspicuously silent about Laudomia.
In the oration he never mentions her name, not even in the section dedi-
cated to the women of Siena or to the praise of his beloved, who re-
mains strangely anonymous. Nevertheless, by this time his love for Lau-

domia had become general knowledge among his contemporaries and, if he did not refer to it, other writers and poets did.

Laudomia as Poetic Muse and Beloved

One of these contemporary writers was Alessandro's friend Benedetto Varchi, who encouraged Piccolomini to pursue his poetic interest in Laudomia by drawing a parallel that normally would seem preposterous, were it not for the natural inclination to grandiose claims typical of the mid–sixteenth century: he compared his friend's beloved to Dante's Beatrice and Petrarch's Laura.

> Alessandro, se mai tanto da terra
> Lungo studio o destin, non proprio ingegno,
> M'alzaran, ch'io non sia del tutto indegno
> Scriver d'Amor, che 'l varco al ciel diserra,
> Alhor di quella dolce e forte guerra,
> Ch'Amor vi diede, (e 'n tutto 'l suo bel Regno,
> Trovar soggetto non potea più degno)
> Dirò, quel ch'hor temenza entr'al Cor serra.
> Ma voi, ch'alta ventura e senno pria
> Guidò per tutti i cerchi a l'alte stelle,
> Poscia u' si fa la pioggia e nasce l'aura:
> Cantar dovete in voci altiere e belle,
> Che s'Arno hebbe già Bice e Sorga Laura,
> Tien' oggi l'Arbia la gran Laudomia.[83]

Alessandro, if studies long or destiny, / and not my intellect, will ever raise me so high from earth that I won't be unworthy / to write of love, which opens heaven's gate [a pun on Varchi]: // Then, of that sweet and fierce war, [a pun on Forteguerri] / that Love conferred on you (in all his realm / he could not find a subject more deserving) / I'll say what fear now keeps within my heart. // But you, whom fortune [a pun on Venturi] high and intellect / first guided through the circles to the stars, / beyond where rain is made or wind is born, // you should sing out in

lofty verses fair / that if Arno had Bice and Sorgue had Laura, / today the Arbia holds the great Laudomia.

Aside from urging Alessandro to continue praising Laudomia, Varchi may well be poking fun at his friend, or at least teasing him, when, at lines 8–9, he reminds him that previously the young Sienese poet was led by *ventura* (fortune) and by *senno* (intellect)—the implication being that now that he loves Laudomia he is neither lucky nor wise. Varchi is also reminding Piccolomini of his earlier flame, Eufrasia Venturi (see above, chapter 1), by punning on her name. The camaraderie evident in this double jab and in the suggestion that emotion has taken over from intellect suggests that Varchi was being more jocular than sincere, an interpretation that is further supported by the self-deprecating comments in lines 1–4, the puns on Varchi's and Forteguerri's names at lines 4–5, the allusion to previous love excesses on Piccolomini's part at lines 8–10, the astonishing comparison of Laudomia with Beatrice and Laura at line 13, and the final preposterous *reductio* of the Arno and the Sorgue (both rather large rivers) to the Arbia (a rather small brook).

Piccolomini responds *per le rime,* picking up not only Varchi's rhyme scheme but also the rhyme words his friend used in his original sonnet.

> Varchi mio, ch'a gran volo alto da terra
> Gite su l'ali del bel vostro ingegno
> Tal ch'ove fu di gire ogni altro indegno,
> Vostra virtute il Varco apre e diserra;
> Gliè ver che dolce, grata, e forte guerra
> Sostenut' ho molt'Anni entr' al bel Regno
> D'Amor, ma non però mi veggio degno
> Di cantar quel che 'l Cor' asconde e serra.
> Ma voi col vostro stil, dove non pria
> Orma fu d'uom, vicin' a l'alte stelle,
> Ove non nasce o neve, o pioggia, o d'aura,
> Portate nuova, com' honeste e belle,
> S'Arno ebbe seco Bice e Sorga Laura,
> Seco hoggi ha l'Arbia la gran Laodomia.[84]

My Varchi, high above the earth you soar / on the wings of your
splendid intellect, / so that where others, unworthy, need to go /
your talent opens and unlocks the gate [a pun on Varchi]; //
It's true, a sweet, desired, and fierce war [a pun on Forteguerri] /
I've waged for many years in Love's fair land, / but in my view
this does not make me fit / to sing what locked and veiled lies in
my heart. // But you, with your high style, where ne'er before /
a man did tread, next to the highest stars, / where no snow
blows, or rain, or any wind, // bring news that just as Arno had
his Bice / And Sorgue his Laura, both beautiful and chaste, /
Today the Arbia has the great Laudomia.

As we can see, Piccolomini's response is equally ambiguous. He
catches and reuses the puns on Varchi's and Forteguerri's names (but
not on Venturi's) and the images his friend has employed, but he seems
not to capitalize at first on the irony present in his friend's poem (could
Piccolomini have failed to catch it?). On first reading, Piccolomini seems
to limit himself to complimenting Varchi on his poetic skills and then
throwing the ball back in Varchi's court by suggesting that he, Varchi,
ought to be the one to tell the world that Laudomia is the new Beatrice
and the new Laura. This last suggestion may, admittedly, be proof that
Piccolomini has, indeed, caught the humor of his friend's jab and the
silliness of comparing Laudomia with Beatrice and Laura, or the Arbia
with the Arno and the Sorgue. Whatever the case, it is clear that the two
friends were indulging in hyperbole and letting their poetic fantasy run
wild with fanciful mutual compliments and absurd suggestions. These
excessive mutual compliments were, in fact, the norm in many episto-
lary exchanges of the time, as is evident in the sonnets Piccolomini ex-
changed with the various Sienese women who participated in the *tenzone*
on his visit to Petrarch's tomb at Arquà (see above, chapter 1).

The same year this poetic exchange between Varchi and Piccolomini
was published in the *Cento sonetti* (1549), another friend and correspon-
dent of Piccolomini's, the Piacentine polymath Lodovico Domenichi,
published a treatise on the nobility of women *(La nobiltà delle donne)*
in which he referred to Laudomia as the wife of Petruccio Petrucci
and then, after saying that she was known in the entire world for her

"divine beauty and heavenly virtue," continued by mentioning that she had been blessed by heaven with such an eminent writer to sing her praises as Alessandro Piccolomini. When, however, we try to identify the poems that Piccolomini composed in praise of Forteguerri and that would have given her such fame, we find that they are very few indeed. In his dedicatory letter to the *Lettura* of 1541, Piccolomini said that he intended to bring "LX stanze" to Laudomia, but they seem not to have survived, at least, not integrally.[85] Among Piccolomini's published poems, only two seem to spring from his affection for Laudomia, and they both come from the preliminary materials to two of the publications he dedicated to her: one is the sonnet "Gl'alti trofei dei primi illustri eroi," first published in his *De la sfera del mondo* of 1540, and the other the sonnet "Donna, che con eterno alto lavoro," first published in his *Lettura* of 1541.

We can safely assume that a number of the poems Piccolomini published in his collection *Cento sonetti* (1549) must have been inspired by his love for Forteguerri, but since they do not contain explicit references to her (as was the case in the sonnet exchange with Varchi), it is not possible to determine which ones they might be. If we assume that, when it came to poetry, Piccolomini was a serial monogamist, then the love poetry written in 1539–44, and especially the poems composed while he was a student in Padua, could conceivably have been inspired by his affection for Laudomia. We could then include in the list of poems for Laudomia such works as "Qual spirto eletto suol dà caldo, e santo" (*Cento sonetti,* son. 92), composed in Padua and lamenting the distance that separates him from his beloved, and "A' pie' de l'Apennin, novo pastore," a "pastoral poem on the distance from his beloved composed while in Bologna" probably during a brief visit or passage to/from Padua (*Cento sonetti,* son. 67). Another possible poem inspired by Laudomia Forteguerri might be the sonnet "Tredici volte ha per me compita" (*Cento sonetti,* son. 19), composed on the thirteenth anniversary of "the day when he first saw his Lady and received, as a favor from her, a small bracelet." To assign it to his love for Forteguerri, we would need to assume that the only woman who could have attracted Alessandro's affection for so many years prior to 1549 must have been Laudomia, given that his interest in Eufrasia Placidi Venturi was quite short-lived

(ca. 1538–39) and that no other beloved is mentioned in any of his poetry or dedications. The poem dates Alessandro's *innamoramento* to 1533, when he was twenty-five years old (v. 9); if the woman with whom he fell in love was Laudomia Forteguerri, this would make her eighteen years old at that time—a perfect coincidence with Dante's Beatrice, who also was eighteen years old when Dante fell head over heels in love with her (*Vita nuova*, ch. 1). The only problem, however, is that this would date the composition of the poem to 1546 (thirteen years after 1533), and by this time Piccolomini had apparently stopped loving Laudomia because she had "betrayed" him by remarrying in December 1544. One way to circumvent this problem might be to postulate that, though upset at her, in 1546 Piccolomini was still fondly remembering his past love for her.

If the assumptions I just made are valid, the sonnet "A che pur' osi dir lingua sfrenata" (*Cento sonetti,* son. 66) would also date from 1546, because in it Alessandro says that after thirteen years of loving her, his beloved finally deigned to clasp his hand (v. 3). By the same logic, the sonnet "Perch' a voi quei due volti, onde sfavilla" (*Cento sonetti,* son. 46), addressed to his cousin Marc'Antonio Piccolomini, would be dated to 1544 because Alessandro says that he has been in love for eleven years. In the summer of 1544 Piccolomini was in Rome, so a number of poems composed in/from Rome could also be included in our list. The most obvious is sonnet 54, "Prima, se punto 'l Signor mio dispone" (*Cento sonetti,* son. 54), which is addressed to the Friulian humanist Romolo Amaseo (1489–1552) and describes the life Piccolomini was leading in Rome. In it, Alessandro mentions that he has been in love for eleven years, which would lead us to confirm 1544 as the date of composition and Laudomia as the beloved. A couple more sonnets composed in/from Rome could be assigned to the same date and inspiration. One is "La Vergin, cui servì la prima gente," addressed to the Venetian scholar and printer Ottaviano Scoto. The poem is based on a dream the poet had while sick in Rome that August.[86] In it, Alessandro describes how his beloved, whom he identifies by the pastoral name "Flori," appeared to him in a vision resplendent like the Moon goddess Diana. Another poem is the sonnet "Per gir' ognihor' in più securo loco" (*Cento sonetti,* son. 77), whose heading in the 1549 edition says that

it was composed on the poet's return from Rome to Siena and whose verses describe how Alessandro missed his beloved while he was away.

In the "Tombaide" of 1540, Piccolomini had mentioned "Flori" in his responses to three different participants in that sonnet exchange. In all three cases Piccolomini, who was writing from Padua, was expressing his heartfelt wish to be back in Siena and in the company of his female friends, including Flori. Working within the "Tombaide" it was impossible for us to identify Flori, but by drawing on Domenichi's *Rime* and Piccolomini's *Cento sonetti* we can now propose that this is the pastoral name for Laudomia Forteguerri. This attribution seems to be supported by a curious editorial revision in the publication record for the sonnet "La Vergin, cui servì la prima gente." When the poem first appeared in Domenichi's *Rime* of 1546, line 10 read "Flori inanzi m'apparue" ("Flori appeared before me"), while three years later, when it was republished in Piccolomini's own *Cento sonetti* as sonnet 91, the author removed the reference to Flori and revised the verse to read "La Donna mia m'apparue" ("My Lady appeared before me"). This revision suggests that Piccolomini may well have been consciously editing Forteguerri out of his *canzoniere*, an indication that his affection for her had subsided and that he was now trying to make his love poetry, originally composed specifically for her, more generic. However, by the time his *Cento sonetti* appeared in print in 1549, the damage had been done: his friends, correspondents, and fellow writers were all firmly of the opinion that Laudomia was Alessandro's beloved, and they said as much in their works.

One of these was Bernardo Tasso, father of the much more famous Torquato. In his epic poem *L'Amadigi* (1560), which he dedicated to King Philip II of Spain, he includes Forteguerri in a list of female worthies and says that a great writer will immortalize her (a clear allusion to Piccolomini):

Una, di cui copre le dorate chiome
Crespo, e candido uelo, e sia cantata;
E posta in molta stima, in molto pregio
Da penna di Scrittore alto, & egregio,
 Sarà Laodomia Forteguerri detta.[87]

One, whose golden curls will be concealed / by a white and
pleated veil and will be praised / And placed in high esteem and
great regard / By the pen of a writer, fine and eminent // Will be
called Laudomia Forteguerri.

Subsequent writers and scholars would continue to connect Forte-
guerri with Piccolomini, either as his beloved or as the dedicatee of
several of his works.

Laudomia as the Incarnation of Heavenly Fame

One of the contemporaries who continued to view Forteguerri and
Piccolomini as a matched pair was the Venetian polygraph Giuseppe
Betussi from Bassano (ca. 1512–ca. 1573). In his dialogue on love, *La
Leonora* (1552), Betussi praises Laudomia, saying that "he has always
observed and observes that in regal and afflicted Siena, home to all the
graces, all virtues, all rare habits and all beauties, the illustrious and im-
mortal Lady Laudomia Forteguerra Petrucci, whose life, whose works,
and whose virtuous actions can inflame anyone who has even a simple
knowledge of virtue and true beauty, let alone those who, like you, have
heard her discuss, debate, and give reasons and causes for all things."[88]
Only a few years later, in his *Le imagini del tempio della Signora Giovanna
Aragona* (1556), an extended literary conceit in praise of Giovanna
d'Aragona Colonna (1502–77), mother of the Vittoria d'Ascanio Co-
lonna we just met, Betussi includes Laudomia Forteguerri in his list of
the thirteen most beautiful and virtuous women in all of Italy and iden-
tifies Alessandro Piccolomini as the poet who, with his lyrics, immor-
talizes her beauty. In the architecture of the conceit, Alessandro is the
pedestal on which Laudomia's image rests.[89]

As the allegorical characters Fame and Truth move down the tem-
ple toward the high altar with the image of Giovanna d'Aragona on it,
they point to the images of twelve beautiful Italian women that stand
in the twelve side chapels along the nave. After pointing to women such
as Gostanza Borromea from Milan, who stands there as a symbol of

Grace, Ippolita Gonzaga Carafa from Mantua (actually, from Guastalla) as a symbol of Hope, Leonarda d'Este Bentivoglio from Ferrara as a symbol of Faith, Ginevra Bentivoglio Novata from Bologna as a symbol of Beauty, Alda Torella Lunata from Pavia as a symbol of Chastity, and so forth, Fame stops and points to Laudomia Forteguerri, saying:

> See, among all the others, Laodomia Forteguerri Petrucci, nearly an oracle in the world, filled with every rare habit, full of every clear virtue, endowed with extreme honesty. Look upon this woman, toward whom should incline all who know what virtue and beauty are. Even someone who has had but the smallest inkling of her virtues should admire her. I will never believe that anyone could be such a barbarian and so harsh toward the freedom of her motherland that, if he should but once hear her speak in defense of her city, would not have bowed [to her words], humble and meek, such is the majesty of her bearing, such the richness of her speech, such the quickness of her intellect.[90]

Truth agrees and proposes that Laudomia should be the symbol of Fame, at which point the character of Fame in the dialogue objects, fearing for herself. Truth responds by indicating that there are two Fames, one earthly (which at times conveys false information and can grant fame even to wicked people, such as the man who set fire to the temple of Diana at Ephesus), the other heavenly (which conveys only truth and grants fame only to those who seek to rise to heaven and thus become immortal)—Laudomia is a symbol of the latter. Fame agrees and concedes that henceforth she will take her lead from Laudomia, who has indeed surpassed her. At this point Truth recites a sonnet in praise of Laudomia.

> Degna d'eterna, et gloriosa FAMA,
> Ch'il nome vostro in ogni luogo porte;
> Sì bella e cara spoglia aveste in sorte
> Dal ciel, che sempre a sè v'invita e chiama.
> Ben è ragion, s'ogn'un v'honora e ama,
> Che ne' begli occhi avete vita e morte;

Ne par, che 'l mondo in altri si conforte,
Che sol la gratia vostra, e più non brama.
 Quando più vide il Sol girando intorno
Simile al vostro peregrino ingegno
Di tante rare qualitadi adorno?
 Quando ebbe Amor mai più securo regno
Del vostro viso; onde hanno invidia, e scorno
L'altre, come a divin celeste pegno?[91]

————

You're worthy of eternal, glorious FAME, / That brings your
name to sound in every place; / From heaven you drew such fair
and lovely form / That it now always bids you to draw near. //
It's right that all should love and honor you, / For in your eyes
you have both life and death, / Nor does it seem the world takes
comfort from / Or wishes for anything but for your grace. //
When did the turning sun ever behold / An intellect as precious as
is yours / So richly adorned with qualities so rare? // And when
did Love enjoy a kingdom more secure / Than your fair face,
whence all the rest are envious / Of this celestial token, so divine?

After Truth has described the "idol," Fame points out that its pedestal
is none other than Alessandro Piccolomini, "who has described her so
wonderfully that time will not wear away their two names."[92] So, as late
as 1556, the admiration Piccolomini had expressed more than a decade
earlier for Laudomia Forteguerri was still current tender in literary and
courtly circles of Italy, and it would remain so, as Fame rightly pointed
out, for centuries to come.

Laudomia as Leader and Patriot

When Betussi's literary conceit was composed (apparently in 1555–56),
Laudomia Forteguerri's life had reached a crucial moment. Betussi al-
ludes to this in the comments he makes immediately before his praises
of her. Political instability caused by Spanish and Florentine military ac-
tion against Siena was threatening the independence and survival of the

republic. Betussi does not mention Forteguerri's actions just before the siege, but other writers do. Already in 1553 the historian Marco Guazzo (1496?–1556) devoted a page of his *Cronica* to "the valiant women of Siena" and their actions in defense of the city. The passage is long, but it is worth citing it in full because it served as a basis for later references to this event, both in Italy and abroad. Speaking of the Sienese preparations in anticipation of an attack by the Imperial army, Guazzo writes:

> I would be worthy of not a little reproach from those who know about it if I did not make known to the world the valor of certain Sienese gentlewomen worthy of eternal praise. One should thus know that this year, 1553, in order to prepare to defend themselves against the Imperial army that was being assembled in order to attack them, they divided their city into three parts under three leaders who had experience and authority, each with his own flag. On 17 January, the feast day of St. Anthony, three great ladies of this city appeared with their flags and drums. One was Signora Forteguerra, dressed in purple, with her flag of the same color and the motto "As long as it is the truth." And the hem of her dress was raised four inches above her foot and revealed her leg. The second was Signora Fausta Piccolomini, all dressed in red, with a red flag divided in four by a white cross and with a motto that read: "As long as I do not throw it [away]." The third was Signora Livia Fausta, dressed in white, with a white flag in which there was a palm and the motto: "As long as I might have it." These great ladies were all dressed like most respectable nymphs and had with them about three thousand gentlewomen and artisan women. This was such a beautiful and marvelous thing that the Cardinal of Ferrara [Ippolito II d'Este], Monsieur [Paul de La Barthe, Seigneur] de Thermes, and all the men who saw them were amazed. The women went throughout Siena calling out. "France! France!" and each of them carried a faggot to a fort that was being built. They set such an example that all the gentlemen in town began to do the same, and every day some of them went with their flags and mottos just like these honorable, prudent, wise, and valiant ladies. And not only the gentlemen were moved to do this, but on the 29th of the said

month, which was a Sunday, the priests went with their archbishop and, on their return from the fort, they ran into a company of damsels that were going with some matrons accompanied by men of a certain age, singing lauds in honor of the ever glorious mother and always Virgin Mary, their advocate. The archbishop [Francesco Bandini] and all the priests joined up with them, and when they arrived in the piazza near the palazzo of the Signoria, where in a prominent place there was a very beautiful image of the Queen of Heaven, they all stopped. The archbishop lined up the maidens as if for battle, making them go up in turn toward that figure and singing some lauds with such a sweet voice that all those who heard it had tears in their eyes on account of how sweet it was and out of tenderness. And when this was done, all the women knelt in front of the archbishop and of the cardinal [Ippolito II d'Este], who was also there, and having received a blessing from each of them, they stood up and, bowing beautifully, returned to their houses.[93]

Siena was preparing for a battle that it knew would be difficult and possibly final. All the citizenry, including women and the clergy, were mobilized for the war effort. The women's contribution was such that the fort they helped to construct just a short distance down the city walls from Porta Camollia is known, to this day, as the "Fortino delle donne," the women's fort, and bears a plaque laid in 1928 commemorating them.

Guazzo's description is the absolute primary source for this event, but it is based on secondhand information, so it is both realistic and imagined, and perhaps even a little confused. The identity of the three women, for example, is not clear—it is generally agreed that Livia Fausta does not correspond to any historical person from that time.[94] Fausta Piccolomini might and should be easy to identify, but she does not appear in the Todeschini or Pieri branches of the Piccolomini family tree. The Piccolomini, however, were a large clan, so it is conceivable that she may yet be identified with a specific member of that *casato*. The Signora Forteguerri, who is mentioned first, is not identified by baptismal name, probably because everyone at the time knew who she was. Traditionally, she has been identified with Laudomia Forteguerri, a feasible assumption given what we know about this versatile and unconventional

woman and given that she was, at that time, married to a military man from the Petrucci family. Organizing a group of women and leading them on a task in support of their men and their city would most probably not be out of character for her. Furthermore, no other Forteguerri woman seems to appear in the chronicles or other literary records of this time to challenge Laudomia's place in this event. One doubt does, however, arise.

The three groups of women were clearly organized along the administrative division of Siena into *terzi* (thirds), complete with the colors and flags of their sectors—Città, San Martino, Camollia. One would then assume that each of the three women mentioned by name would be leading the women from her own *terzo* of the city. Laudomia Forteguerri, whose family's power base was in Castelvecchio, should logically be leading the women from the *terzo di Città* and carrying the red flag with the white cross that is the symbol of this *terzo*. That is not, however, what Guazzo reports: his Signora Forteguerri wears purple and carries the flag of the *terzo di San Martino,* while Fausta Piccolomini wears the red of the *terzo di Città,* though the Palazzo Piccolomini and the family's original power base were in the *terzo di San Martino.* It would seem that Guazzo, who was not a Sienese and was not present at the event, mixed up the two women's *terzi* and colors. Subsequent chroniclers and historians have, unfortunately, assumed that Guazzo was correct and have thus perpetrated what is probably an inaccuracy.[95]

Alessandro Sozzini, who lived through these difficult times, does not mention this episode in his *Diario* for 1550–55. Admittedly, Sozzini wrote his narrative of the fall of Siena more than thirty years later, in 1587, "to pass the time and flee idleness," but he did provide subsequent historians with a very detailed narrative that is based, as he says in the preface, both on verbal testimony from participants and on original documents he was able to consult. It is surprising, therefore, that such an iconic moment in Sienese history should not be reported by a Sienese who actually lived through it.

Another contemporary Sienese who lived through these years was the canon Angiolo Bardi, who mentions the participation of women in the preparations for the siege, but his narrative is significantly different from Guazzo's. Bardi does not mention specific women, nor does he

mention only women—he recalls instead that when news arrived that the Imperial army was moving toward Siena, Paul de La Barthe, Seigneur Thermes, King Henri II's lieutenant in central Italy, and Ippolito II d'Este, cardinal of Ferrara, moved promptly to shore up the city's defenses by tearing down buildings just outside the city walls and constructing three forts to defend the city.

> The city undertook to build these three forts at its own expense so as not to give the agents of the king [of France] too much expense because the buildings were large and so was the expense. Each *terzo* undertook its part. The Terzo di Città undertook to build [the fort] at the Punta del Prato, which comes toward the citadel and looks down toward the bottom, that is, the Valley of Pescaia, and went as far as the middle of the knoll in the Prato. The Terzo di S. Martino carried on with the other fort, from the other half of the knoll as far as the Church of St. Anthony outside the gate, which church went many *braccia* inside the fort itself. The third fort fell to Camollia, and it stood just outside the gate to the right and looked over the entire valley of Malizia. As we said, the entire city set itself to working with great resolve on these fortifications, with citizens, shopkeepers, the old, the young, the women going every day to work in admirable numbers, and making all the faggots. The *contrade* went with their standards and in order. And the cardinal [Ippolito II d'Este] went many times to make and carry the faggots with all his court, and the archbishop of Siena [Francesco Bandini] with the entire clergy of priests, and the friars with their white standard with the Assumption of Our Lady painted on it. It was a delight to see the construction of these fortifications, a triumph, a feast, for the entire city was there constantly working on them, so much so that it was a marvelous thing to behold.[96]

Bardi indicates that the entire city mobilized and what was amazing was that everybody helped out by carrying construction materials. He does not single out the women but includes them in a list that comprises everyone, young and old, lay and clerical, noble or working class, local and foreigner, male or female.

The participation of women was picked up and singled out, instead, by foreign historians, first by the French historian Guillaume Paradin (d. 1590), who took it from Guazzo, and then by the French marechal Blaise de Monluc (ca. 1500–1577), who took it from Paradin and rendered it famous.[97] In the second half of the sixteenth century, Italian historians, such as Ascanio Centorio degli Ortensi, would also pick up the episode from Guazzo,[98] but their successors would not and, strangely enough, referred only to Monluc. For example, in his *Pompe sanesi* of 1649 Isidoro Ugurgieri Azzolini transcribed Monluc's narrative right after entries 37 to 39 dedicated to the three valiant women of Siena.[99] Not surprisingly, the Frenchman's narrative became the basic reference for the event, so much so that his entire narrative of the defense and fall of Siena became a standard text, to the point that in the twentieth century it was twice translated into Italian and enjoyed three different editions, while Guazzo's *Cronica,* which was the original source for both Paradin's and Monluc's narratives, never appeared in print again after the sixteenth century.[100]

Such dependence on Blaise de Monluc is understandable, given that Monluc was the officer in charge of the defense of Siena in 1554–55 and described it from direct personal knowledge of the events. When it comes to the "women of Siena" episode, however, Monluc's knowledge of the events was, like Guazzo's, also based on secondhand sources— Monluc arrived in Siena a full year and a half after the event, in June 1554.[101] He did not see the event but heard about it from another French officer, Paul de Thermes. His information is not only derivative but also fairly removed in time from the actual event. As Monluc himself admits, "Monsieur de Thermes, who told me this story (for I had not yet arrived), has assured me that he had never seen, in his entire life, a more beautiful sight. I later saw their banners. They had composed a song in praise of France [that they sang] as they walked to their fort; I would have given my best horse to have it so I could transcribe here."[102]

Though not present at the event in January 1553, Monluc was so taken by it that he declared: "Never will it be, Sienese ladies, that I do not immortalize your name as long as Monluc's book will live; for, truly, you are worthy of immortal praise, if ever women were."[103] He then retells what he heard from Paul de Thermes:

The moment these people [the Sienese] took the noble decision to defend their liberty, all the ladies in the city of Siena divided themselves into three groups: the first was led by the Signora Forteguerri, who was dressed in violet, like all the women who followed her; her dress was short and looked like that of a nymph, leaving her small boots uncovered. The second was the Signora Piccolomini, dressed in flesh-colored satin, and her group was all dressed in the same manner; the third, the Signora Livia Fausti, was dressed all in white like her troop, and she had a white banner. Their flags bore fine mottos; who knows what I would give to remember them. These three squadrons were composed of three thousand women, both noble and burgher; their weapons were picks, shovels, baskets, and faggots. It was in this uniform that they paraded when they went to start building the fortifications.[104]

Much as Monluc may have wished to praise the women of Siena, his comments and views were severely limited by his own cultural assumptions. He did not explain what, exactly, the patriotic Sienese women did in defense of their city that should have won them such immortal praise, besides carrying picks, shovels, baskets, and faggots to the ramparts. He did, however, wax eloquent in describing to his readers the women's dresses and their banners and even picked up from Guazzo the suggestion that with their short tunics that left their ankles exposed to view the women seemed to be nymphs. The sexual frisson evident in Monluc's narrative is present in other narratives as well. It would eventually lead to Brantôme's appropriation of the story in his *Les sept discours touchant les dames galantes,* where, in the third discourse dedicated to the beauty and power of a beautiful leg ("la beauté de la belle jambe et la vertu qu'elle a"), after briefly narrating the episode and pointing out that the Sienese women "had exposed in full sight their beautiful legs and beautiful calves" ("à plein elles monstroyent la belle jambe et belle grève"), he explains:

I mention this story here, where I speak of generous women, because it touches on one of the most beautiful features that ever was among gallant ladies. To make this point, I will limit myself to

saying that I have heard many gentlemen and soldiers, both French and foreign, tell, even to some people in town, that there never was a more beautiful thing seen in the world, on account of the fact that these were all great ladies and principal citizens of the town, one more beautiful than the other, and as one knows there is no lack of feminine beauty in this town [Siena]. But if it was fine to see their beautiful faces, it was even better to see and admire their beautiful legs and calves, with their pretty shoes so tight and set, as they well knew how to do; they also had their gowns quite short, like nymphs, so as to walk more easily, which tempted and warmed up even the coldest and limpest [men]; and what delighted the onlookers just as much was that, though their faces are in clear view and can be seen every day, this is not so with their beautiful legs and calves. And it was not without reason that they devised this form of dress like nymphs, for it looked very good and attracted many looks, for if its accoutrement was short, it was also slashed at the side, as we see in certain beautiful antiques from Rome, and this very much increases the lascivious gaze.[105]

Clearly, for Brantôme (as for Guazzo, Monluc, and subsequent male historians who mentioned this episode in their own works), Laudomia Forteguerri and the women of Siena were valiant defenders of their city's liberty but also, and perhaps primarily, sexual objects that attracted the male gaze and erotic fantasy. Even as they were breaking out of their traditional molds as noblewomen, chaste wives, and reputable citizens, they were entering into another, male-constructed mold—that of nymphs scurrying around in short sexy dresses.

The tragic irony is that many of those nymphs lost their lives in the siege. According to a later scholar, Laudomia Forteguerri was one of these.[106] The suggestion is tempting, but we ought to withhold judgment for the moment until better documentation is found on when and where Laudomia Forteguerri died. In Giuseppe Betussi's *Imagini del tempio della Signora Donna Giovanna d'Aragona*, published in May 1556 and probably composed in 1555–56, references to Laudomia Forteguerri indicate that she was still alive at that time—in fact, it would have been awkward for Betussi to present a deceased woman as one of the thirteen most beautiful women in Italy at that time. No contemporary source has yet been

found that mentions her passing, and this is surprising, given all the attention Forteguerri had attracted in the previous decade and a half.

Laudomia as a Bore

Most of the attention Laudomia Forteguerri received was positive. The Venetian publisher Ottavio Scoto, who produced Piccolomini's *De la institutione di tutta la vita* and contributed a preface to it, was so intrigued by Forteguerri's reputation that in the fall of 1541, as he passed through Siena, he made a point of meeting her, which he did thanks to the good graces of the jurist Giovan Battista Piccolomini. Scoto writes that he has never seen a more beautiful woman and expresses his regret at not having the opportunity to hear her "discuss."[107] When the English scholar, diplomat, and traveler Sir Thomas Hoby (1530–66) visited Siena in September 1549 he noted in his diary that the Sienese very much liked to entertain visitors from abroad and that "most of the women are well learned and write excellentlie well bothe in prose and verse, emong whom Laudomia Fortiguerra and Virginia Salvi did excell for good wittes."[108] It seems that Cardinal Alessandro Farnese (1520–89) was also fascinated with Laudomia Forteguerri's "good wittes," so much so that in September 1541 he prolonged his stay in Siena longer than expected (it is tempting to think that they might have discussed Laudomia's love for his nephew's wife, Margaret of Austria, who at that time was supposedly still refusing to pay her husband the conjugal debt).

Some of the attention she received, however, was not complimentary. A distinguished member of Cardinal Farnese's retinue, for example, was not impressed by Forteguerri. The Lombard bishop and historian Paolo Giovio was rather blunt in his assessment of Laudomia and her conversation. In a letter to Cardinal Farnese dated 4 September 1541, Giovio lamented that he and the cardinal's retinue had been left idle and without orders in the small Tuscan town of Poggibonsi, halfway between Florence and Siena, while the cardinal lingered in Siena, enjoying Laudomia's company: "We will be left to Lady Fortune, seeing that Your Most Reverend Lordship, occupied by the cogitations, not to say by the deflation of underwear that is the Forteguerri [woman], is forgetting to tell us when to depart."[109] The sexual innuendoes and vulgar

humor are crystal clear—Giovio did not have a high opinion of Lau-
domia's intellect and referred to her conversation as a sexual turn-off.
Given the lighthearted tone of the letter, Bishop Giovio's assessment
of Laudomia Forteguerri and of her conversation is not necessarily to
be taken seriously.

———

What *is* to be taken seriously is that Laudomia Forteguerri was depicted
by the men of her time as a woman outside the norm—dogmatically
suspect, sexually liberated, intellectually curious, poetically gifted, coura-
geously patriotic, and, by some, quite boring. The complexity of her
persona is evident in the manner her story has been told and the pur-
poses it has been made to serve. In the sixteenth century, Forteguerri
was seen primarily as Alessandro Piccolomini's poetic love object and as
a woman of great beauty and intelligence. In the seventeenth and eigh-
teenth centuries she was remembered as the dedicatee of various scien-
tific and educational works. In the nineteenth century, as Italian patriot-
ism spread throughout the peninsula and Italians struggled to become a
nation, she became an emblem of national spirit and the struggle for
freedom, so much so that her actions in organizing women to assist with
the manual work required to bring construction materials to the city
walls were transformed into a valiant defense of the city, fighting from
the ramparts with weapons in hand. In his painting *The Women of Siena
during the Siege of 1554* (1878), the Tuscan painter Pietro Aldi (1852–88)
depicts a group of women, among whom is a figure in purple that one
assumes to be Laudomia; the premise may be historically correct, but
the depiction is fully in line with nineteenth-century Italian nationalist
sentiments and the historical revisionism popular at the time.[110] Earlier
in the century, the historian Carlo Botta (d. 1837), in his multivolume
continuation of Francesco Guicciardini's history of Italy, drew on Mon-
luc's narrative, which he cited at length, but he then added a comment
that would kindle the imagination of later scholars: he described the
women of Siena as "nearly new Telesillas," a reference to the ancient
Greek woman who, when the Spartans slew all the men of Argos able
to bear arms, dressed as a man and successfully led a troop of women in
battle against the enemy and won.[111]

At the beginning of the twentieth century, Anna Baia took Botta's allusion and turned it into fact, writing that "after [Piero] Strozzi lost the Battle of Marciano, even the women, led by Laudomia Forteguerri and Faustina Piccolomini, fought for the motherland." The porters had become combatants. In 1960 Florindo Cerreta brought this Romantic fantasy to its inevitable conclusion when he wrote (with no document to support him) that Laudomia Forteguerri "had met her death fighting for the freedom of her motherland during the siege of Siena." The combatants had become martyrs. Two years later, in 1962, Roberto Cantagalli referred to the women as a "kind of a women's militarized corps." He, too, did not provide any evidence to support his claim. Every army needs recruits, so in 2007 Diana Robin had Laudomia Forteguerri "recruit and train a company of women [and] enter the war in 1554 as their captain against the overwhelming forces of Cosimo I and the emperor Charles V."[112] The combatant had become a captain. In short, in the case of the episode of "the women of Siena" myth has clearly triumphed over fact. The next version must obviously be the Hollywood action movie complete with love story (straight and gay).

While the various constructs others have created around Laudomia Forteguerri are certainly fascinating, for they tells us much about myth building and male fantasy, the image that Laudomia herself left for us in her own writings is equally intriguing. Her few surviving sonnets show us a talented poet who expressed her affection for another woman in the calm language and well-established images of traditional Petrarchan poetry. They suggest that she was not at all troubled by her feelings for another woman; in fact, she appears to have been emotionally rather well adjusted to this same-sex attraction. In the end, one is left wishing for more works from her pen and wondering where all her letters to Margaret of Austria could be. If they were ever to be found, they would shed greater light on the internal life of an exceptional sixteenth-century woman, on the nature and depth of the affection that bound her to another woman, to her family, and to her country, thus giving us a better insight into the workings of the heart and mind of a woman who may be the first "lesbian" poet in the Italian vernacular tradition.

Virginia Martini Salvi
An Indomitable Woman

. . . je veux dire, que je serais tousjours plus asseuré de deffendre
Sienne n'ayant que les femmes Siennoises avec moi pour combattre,
que non pas deffendre Rome avec les Romains qui y sont.
—Blaise de Monluc, *Commentaires*

In previous chapters we met two Sienese women who were both poets and patriots. One was the politically perceptive Aurelia Petrucci, who spoke out against the internecine struggles that were weakening Siena and laying it open to foreign intervention; the other was the determined Laudomia Forteguerri, whose actions in a time of political and military crisis proved beyond a doubt the extent of her personal commitment to her city. In this chapter we will meet a third Sienese woman whose writings and actions reveal a strong political engagement and a determined *prise de position* in support of her family, clan, and city. She was also a controversial figure who took sides decisively and even forcefully. Her name was Virginia Martini Casolani Salvi, and her story is a tale of struggle and defeat.

Clearing Up the Biography of Virginia Martini Salvi

We know very little about Virginia Martini Salvi's life. We do not know when she was born or when she died. From a legal document by which

165

she tried to protect her dowry from her husband's creditors, we know that she was married in 1534 or 1535.[1] Such a marriage date suggests that she was born in the early 1510s. Given that she published a poem on the Battle of Lepanto (October 1571), we know that she was still alive in late 1571. Her life, therefore, extends for about sixty years from the early 1510s to sometime after 1571.

The lack of biographical information on Virginia Salvi has been aggravated over the centuries by confusion over her identity, a problem that plagued even the very first editor of her poetry, the Florentine *letterato* Lodovico Domenichi. Although Domenichi was her contemporary and presumably had access to her or to her correspondents, he gave conflicting information about her and thus began to muddy the waters of her biography. In his 1549 treatise *La nobiltà delle donne (On the Dignity of Women),* Domenichi referred to her as "Madonna Virginia Venturi, wife of Messer Matteo Salvi"; then, ten years later, in his groundbreaking collection of poetry by Italian women, *Rime diverse d'alcune nobilissime, et virtuosissime donne* (Venice, 1559), he referred to her as "Madonna Virginia Martini de' Salvi." Domenichi's first reference is factually incorrect—there was no Virginia Venturi Salvi in Siena, and Matteo Salvi's wife was a Casolani by birth, not a Venturi. His second reference is correct but misleading—there was a Virginia Martini married to a Matteo Salvi, but by adding a *de'* to her name Domenichi implied incorrectly that Martini was her paternal surname and Salvi her married name. Martini, however, was part of her baptismal name; her paternal name was Casolani.

Domenichi's confusion is understandable because the situation was complicated by the fact that at that time in Siena there were two women named Virginia who were married into the Salvi family: one was the wife of Matteo Salvi and the other the wife of Achille Salvi. The two women were sisters-in-law, and they both wrote poetry. In 1540 they both took part in the *tenzone* with Alessandro Piccolomini on the occasion of his visit to Petrarch's tomb in Arquà (see above, chapter 1). However, while Virginia Luti Salvi appears as a poet only that one time and seems to have composed only the one sonnet for the *tenzone,* her namesake Virginia Martini Casolani Salvi went on to become a very prolific poet who composed with ease on a variety of topics and saw

her works published extensively both in Domenichi's *Rime* of 1559 and in other collections.

Domenichi's error was repeated (incorrectly, at that!) by the eighteenth-century erudite Giovan Antonio Pecci, who explicitly stated that "Salvi Verginia, married Martini, flourished about 1559," thus reversing her paternal and marital families.[2] By the mid–seventeenth century, the confusion surrounding Virginia Salvi's name was aggravated by the Sienese erudite and local historian Isidoro Ugurgieri Azzolini, who wrote that Virginia Luti, wife of Achille Salvi, was a prolific poet and did not say anything at all about Virginia Martini Salvi, overlooking her completely.[3] By the end of the eighteenth century, Ugurgieri Azzolini's misinformation confused the bibliographer and erudite Francesco Saverio Quadrio, who made matters worse by saying that there were actually three women poets by that name at that time.[4] The confusion continued when Alessandro Lisini, in the first significant piece of modern scholarship on these Sienese women poets, erroneously claimed that "in the Sienese documents there is only one *ricordo* of a Virginia who was the daughter of Cristoforo Luti and who in 1533 married Achille di Giovan Francesco Salvi, and she alone must be the one who dedicated herself to the muses."[5] In 1930 the Sienese historian Aldo Lusini was finally able to identify positively Virginia Martini, daughter of the jurist Giovanni Battista Casolani, as the wife of Matteo Salvi and as the prolific poet who used her poetic skills for political purposes, and this finally clarified the situation. Lusini was able to do this thanks, in part, to a set of interrogation records from 1546 that he had discovered in the State Archive in Siena. Having identified the correct woman, we can now try to flesh out her biography.

Virginia Martini Casolani was born in Siena sometime between 1510 and 1513, the daughter of the *giuriconsulto* Giovanni Battista Casolani (or Casolano). Her paternal family belonged to the Monte del Popolo, that is, to the political faction that favored a more widely based and liberal form of government. In the first decades of the sixteenth century the Monte del Popolo generally opposed the oligarchic regimes of Pandolfo Petrucci and his descendants, who were, in turn, strongly supported by the Monte dei Nove and the Monte dei Gentiluomini, the two political groups that included some of the oldest and richest magnate families in

the city. The Casolani owned a palazzo in the town of Càsole d'Elsa, where, as we shall see, Virginia would be confined in 1546–47.

In 1534 or 1535 Virginia married the widower Matteo di Giovan Francesco Salvi (b. 1503), who already had at least two children from his first wife, Elena Della Ciaia. Virginia and Matteo had at least one child together, Propertio Austino (b. 1535).[6]

Lusini's suggestion that Matteo was old and incapable is both unkind and unfounded—in the 1530s Matteo was in his thirties, the prime of his life.[7] Along with his siblings, Matteo was one of the scourges of Siena because of the brothers' violent character and disorderly ways. His oldest sibling, Giulio (b. 1502), was actively involved in many of the political and military events of his day, serving the republic in various offices but also fomenting dissent and trouble on several fronts. When Emperor Charles V entered Siena on 24 April 1536, Giulio was *gonfaloniere* for the Terzo di Camollia and participated as such in the formal entry ceremonies.[8] After the Spanish were expelled from Siena in July 1552 and the French brought in to replace them, Giulio, who had long been a supporter of the Gallic faction, was made *capitano del popolo* (in December 1552), an honor that he had very much desired and for which he was prepared to circumvent the law. He did so as follows: when it came time to fill the political posts in Siena in accordance to the new model of government devised by the Sienese and their French protectors, Giulio realized that if the new *bossolo* (that is, the election drum with the names of those eligible to vote and to be elected) was going to be used, the post of *capitano del popolo* would have to go to someone from the Terzo di Camollia and he would be excluded from the running, but if the old *bossolo* was used then the post would go to someone from the Monte del Popolo and he would stand a good chance of getting the nod. Giulio argued with such insistence in favor of using the old *bossolo* and the new model of government that he managed to convince Cardinal Ippolito II d'Este, plenipotentiary for King Henri II in Siena, to do so, a stratagem that then allowed Salvi to win the prestigious post of *capitano del popolo*. The honor, however, turned to harm when, just before his six-month term was over, Giulio fell under suspicion of having been "corrupted" by Leone Ricasoli, the Florentine *oratore* in Siena, who allegedly had convinced him to renounce the French and betray the re-

public. Giulio was arrested on 10 May 1553 while at dinner, tried for sedition, and decapitated on 11 June. His younger brother, Ottaviano (b. 1511), a canon in the cathedral of Siena, also fell under the same suspicion and became a victim of the same justice. Arrested a few days earlier, on 7 May, in the Duomo while mass was being sung, Ottaviano was tried, defrocked, and decapitated alongside his brother Giulio. It seems strange that when Ottaviano was arrested on 7 May Giulio should not have assessed the situation and taken precautions to save himself by escaping or otherwise averting his own arrest. Perhaps he assumed that the charges against Ottaviano would be proven false and so did not consider them enough of a threat to warrant drastic countermeasures; or perhaps he thought that his office as *capitano del popolo* would protect him and place him above the law. Whatever the case, Giulio Salvi misjudged the situation and paid for it dearly with his life.

The other Salvi brothers also had their run-ins with the law, though not with such irrevocable consequences. The historian Roberto Cantagalli describes them as "seven ambitious brothers, all to various degrees turbulent and dauntless *[avventurieri]*."[9] And so they were. In 1527 Achille Salvi (b. 1504) assassinated Girolamo Petrucci, a Sienese *fuoruscito;* in 1530 he was arrested by the Imperial agent Don Ferrante Gonzaga and held for some time in the tower in the small village of Cuna on account of his insolence; and in 1541 he was exiled *(confinato)* to the countryside by Nicolas Perrenot de Granvelle (1484–1550), Emperor Charles V's minister for Italian affairs, in Siena at that time. Not surprisingly, Achille was popularly known as "il Mattana" (the Irritable One),[10] and he is often indicated by this moniker in contemporary chronicles such as that of Giugurta Tommasi.[11]

Though not a Salvi by birth, Virginia seems to have appropriated the Salvi penchant for scrapes with the law. In 1546 she was arrested on charges of sedition when some of her sonnets critical of the government began to circulate anonymously in the city. As we will see below, Virginia risked a summary sentence and was saved only by Imperial intervention. In light of such a violent family history, Virginia must be seen not as the talented young wife of a weak old man, as Lusini would have it, but as an active participant in a dynamic family politic that did not eschew the sword or fear justice. But what was the Salvi political

dynamic? To understand it better and to situate Virginia's poetry within her times, we need to know more about her marital family's involvement in Sienese politics during these troubled decades.

The Salvi Family and Its Politics

In the 1530s the Salvi had been central to secret negotiations carried out by Luigi dell'Armi on behalf of King Francis I and aimed at drawing Siena into the French political sphere and away from its long-standing alliance with the Spanish.[12] In 1537, in the wake of the accession to the throne of Florence of the young Cosimo de' Medici, the Salvi developed a close friendship with the Florentine expatriate Piero Strozzi (ca. 1510–58), who had come to Siena supposedly to pay his respects to the widowed Margaret of Austria when she stopped briefly in the city while on her way to Rome (12–21 October 1538).[13] Strozzi's real purpose, however, was to advance the French cause in Siena and, at the same time, to curry favor with the Sienese for his own personal plans against Duke Cosimo I of Florence. Strozzi's youthful good looks, his liberality, and his charm endeared him to the Sienese. This, in turn, aroused the suspicion of the pro-Imperial faction in Siena on two accounts: first, the Imperialists feared that Strozzi's opposition to the pro-Spanish Duke of Florence would lead Siena to realign itself with France (as, in fact, it did) and, second, they feared that his close friendship with the Salvi family, which was held in high regard in Siena for its military reputation, might lead to armed conflict within the city (as it also did). Emperor Charles V was warned of these threatening possibilities by none other than Cosimo I, who stood to be the victim of Strozzi's plotting. Worried about the situation, Charles V sent an operative to Siena, who was able first to advise the city to be more careful in its dealings with the Florentine *fuorusciti* and then to get Piero Strozzi to leave town voluntarily. The eighteenth-century Sienese erudite Giovanni Antonio Pecci describes the situation as follows:

> Piero Strozzi never stopped working as much as he could to increase his forces and gain friends. Having come to Siena on the

excuse of being related [to her] and speaking continually with the widowed duchess [Margaret of Austria], he cultivated the Sienese youths, and, because he was generous and affable, he and his brother Roberto were well viewed by everyone, especially by the Salvi brothers. These goings-on raised some suspicion among the Imperialists, who feared that they [the Strozzi] might turn the city in favor of the French so as to facilitate their own undertaking with Florence. This fear was constantly growing because in Siena no family had a greater reputation in matters of arms than the Salvi, and because they were poor there was a growing suspicion that they could be bought. So because the Imperialists suspected this and because they had been warned by Duke Cosimo, they sent a certain Sifonte from Rome to Siena, who, once he arrived, used the pretext of gathering troops to bring to Milan as an excuse to stay a few days, residing in the house of Girolamo Mandoli Piccolomini; and he warned the Duke of Amalfi,[14] and he told the officers of the Balìa that the presence of the Strozzi [brothers] in Siena was viewed with suspicion by the Imperialists, so that it would be a good thing to take measures to send them away. But the Strozzi, having learned of the Imperialists' plans, without further warning left voluntarily on their own.[15]

Strozzi's departure was, however, only temporary. He would return some years later as marechal of France (1554) to take a leading role in the city's defense against the besieging Florentine forces. In the intervening years, the Salvi and other Sienese who did not favor a Spanish protectorate in Siena continued to foment dissension in the city, and Virginia herself played a part in this by putting her poetic skills to the service of her marital family's politics.

The Trial against Virginia Martini Salvi

In 1546, shortly after the constitutional revisions that set up and installed the new government of the Ten Priors (1545–48), Virginia Martini Salvi's poetry got her into serious trouble. When certain quatrains,

sonnets, and other poetical works critical of the recently deceased *capitano del popolo,* Francesco Savini, and full of allusions to the sale of "cose pubbliche" (public things) began to circulate anonymously in the city, suspicion quickly fell on Virginia Salvi.[16] In June 1546 a dozen individuals were interrogated, and they all attested to having read or to having seen people read these poems. Giulio di Troylo Zondadari, a Sienese citizen, reported under oath that "he had seen the sonnets composed in the past few days, publicly and privately insulting the public trust, in the hands of Taviano Taviani, and that Messer Carlo Massaini heard that [Sano di Ser Lattantio Granari] the *maestro* of Cavalier Severini copied them from an original that he had received, as far as he had heard, from Girolamo Capacci and that he heard it said publicly around town that they had been composed by Madonna Virginia, wife of Matteo Salvi." Later in his testimony, Giulio Zondadari added that some days earlier his wife had gone for dinner at the house of Cavaliere Saverini, that "there the master [of the house] of the *cavaliere* showed her eight or ten *stanze* or sonnets about these sales, much to the public and private dishonor, and that this *maestro* had received them from Girolamo Capacci, who had told him to copy them and had said he had received them from Madonna Virginia, wife of Matteo Salvi, and that it is publicly known and acknowledged that she had composed them." That same day Sano Granari was brought in front of the court and also testified under oath that "about thirty days earlier Girolamo Capacci had given him nine stanzas in the form of *strambotti* [satirical love poems] that, in the form of an oration, contained matters of public dishonor, and they began: 'Deh Signor mio, se mai prego mortale . . .' [Alas, my Lord, if ever mortal prayers . . .], and he copied them and returned the originals to the said Girolamo, from whom he did not hear whose [poems] they were, and he said that he could give the copy expressly to the Ten [the Conservatori di Libertà], even though this *maestro* Sano said to Girolamo that, as far as he knew, the stanzas were by Madonna Virginia Salvi, and Girolamo said no."[17] The other witnesses also testified that public opinion held Virginia Martini Salvi to be the author of these mocking and insulting poems, many of which cast aspersions on the recently deceased *capitano del popolo.*

The matter came to a head in August. First, on Sunday, 15 August, a magnificent hunt that had been organized in the Piazza del Campo in

honor of the Assumption turned political when, at its conclusion, the cheering crowd began to shout "Imperio! Imperio!" and then, in the evening, when the *contrada* of Aquila (the Eagle) paraded through town loudly praising the Imperial camp.[18] Aquila had been favored by Emperor Charles V himself during his visit to Siena in April 1536, when he gave it permission to use the double-headed Habsburg eagle as its emblem and to title itself "Nobile," so its cries in praise of the empire and the emperor might well have been understandable. However, the situation in the city was already tense, and the government was not at all comforted by the *contrada*'s excessive cheers and noisy evening parade.

In the days that followed, a number of letters from Sienese *fuorusciti* to citizens still in the city were intercepted, as well as "certain sonnets" composed by Virginia Salvi. On Wednesday,18 August, the Conservatori di Libertà met and examined the letters, including some "from Messer Niccolò Spannocchi in Milan to Giulio Bargagli and Orlando Malavolti and from Buoncompagno di Marco Antonio [Agazzari] to Madonna Virginia Martini, wife of Matteo Salvi, and some sonnets composed by her, and letters addressed to the said Buoncompagno." Concluding that the letters and poems constituted sedition against the state, the ten *conservatori* ordered that the three local addressees be arrested and their houses searched. The next day, 19 August, the Bargello's militia moved against the alleged culprits. The historian and scholar Orlando di Bernardo Malavolti (1515–96) was seized and jailed, and his house was searched, but no incriminating evidence was found. The nobleman Giulio di Girolamo Bargagli managed to flee from Siena and avoid capture;[19] his house was also searched, and once again nothing incriminating was found.

When it came to the arrest of Virginia Salvi, the situation took some rather strange turns and became potentially explosive. Virginia's husband, Matteo Salvi, denied the soldiers entry into his house and stood with drawn sword ready to defend his wife. The men of the Bargello withdrew, but Matteo was ordered to appear in front of the council under pain of a five-hundred-ducat fine and jail time. The council then quickly ordered all the city gates shut. Matteo went to the Palazzo Pubblico to explain himself, but his reasons for defending his wife did not convince the council, which immediately threatened him with a fine of

a thousand scudi "if before the hour of vespers he did not provide guarantees" and then locked him in a cell in the Palazzo Pubblico until his wife would be brought before the council. After Adriano Franci offered to be Matteo's guarantor, the council released him from the cell above the stairwell where they had locked him, but they still ordered him not to leave the Palazzo Pubblico on pain of a thousand-scudi fine.[20] On Friday, 20 August, Matteo, who was still under "palazzo" arrest, was granted another two days to have his wife brought to the council. During this impasse, a number of suspected accomplices were interrogated, including the accused scholar Orlando Malavolti, who, on orders from the council, was spared from torture—but not from threat of it! On 24 August he was questioned by the captain of justice and by the three interrogators appointed by the council while tied up ready for the *strappado.* Though physical torture was not administered, psychological torture clearly was.[21]

On Friday, 27 August, nine days after the order to arrest Virginia Salvi had been issued, an agreement was reached, and she surrendered peacefully to the authorities. She was interrogated by two members of the Conservatori di Libertà, Messer Giovambattista Piccolomini and Alberto Luti. Asked whether, since the previous 8 February, she had been in correspondence with any of the *fuorusciti* from the Noveschi faction, she answered that three months earlier she had received a letter from Buoncompagno Agazzari at the Imperial court and that the letter had been delivered by a *maestro* who "stays" with the said Agazzari and with Scipione Borghesi, "who is now in prison." In response to well-focused questions, Salvi informed the two interrogators that in his letter Agazzari had not mentioned anything about politics ("le cose dello stato") but had asked her to compose something for a comedy they wished to mount at court, so in her response she had sent him some of her works, but she could not remember anything more specific about her response to Agazzari. Questioned about the works she had sent, she replied that they were two sonnets, one addressed to Emperor Charles V and the other to his minister for Italian affairs, Antoine Perrenot de Granvelle. In response to further questions she said she had not corresponded with other Noveschi expatriates. Asked about any other poems she might have composed "since the *tumulto,*" she responded

that she had written certain stanzas addressed to Christ describing the disturbances and praying him to put an end to these troubles and to bring peace to Siena;[22] she then added that she had not sent these stanzas to anyone and had not made a copy of them. Asked about who had helped her with the sonnets, she responded that no one had, she had composed them herself and had not given copies of them to anyone except for the two she had sent to Buoncompagno Agazzari at the Imperial court. Questioned whether she had written anything that might help the *fuorusciti* and bring them back to power in Siena, and whether she wished for such a thing, she denied both charges, saying that she "cares for nothing but the common good." When confronted with a letter she had sent to Buoncompagno dated the previous 27 June, in which she mentioned three, not two sonnets, she claimed not to remember clearly how many sonnets she had sent and suggested there might have been two sonnets to the emperor and one to Granvelle, or vice versa. Asked to explain the tone of the intercepted letter, which revealed "passion and disdain against those inside [the city] and affection for those outside," and asked why earlier she had claimed the contrary, Salvi responded that she had expressed affection for Buoncompagno "and his people" so as to seem *amica* and *benevola* toward them; as for the "disdain" for those inside the city, she excused it saying that she had just cause for it because she had been the object of a number of despicable sonnets composed by a *popolare* who had distributed them widely and unjustly. When she was shown the three sonnets that had been intercepted, she acknowledged having composed them and said they were in her hand. Asked who had encouraged her to compose them, she responded that it had been a whim *(capriccio)* of hers and that they were not intended to wreak damage or bring shame on anyone. She then added that they had been composed many days before she actually wrote to Buoncompagno. Asked about how she sent her letters, she responded, via the Ballati Bank. Asked, once again, whether she had written or spoken against the city or the current government, she denied ever having done so and added that she would never have dreamt of doing so. Salvi concluded her testimony by saying that "what she said and wrote [to Buoncompagno] was said and written to make these members of the Noveschi happy and thus feed them with this air and

smoke, but she would never have done anything that might have come back in disservice or damage to the state, because she was from the Popolari, was the wife of a *popolare,* and had in-laws who were *popolari.*" The interrogation thus came to an end. The process seems to have unfolded respectfully, without the use or even the threat of torture.[23]

Although Virginia Salvi consistently denied any wrongdoing and strongly affirmed her loyalty to the state, she was not found to be innocent. Nor, for that matter, was she found to be guilty. Uncertain about how to deal with her and wary lest higher powers be upset by her arrest, the government confined her to the Monastery of San Lorenzo under practical but genteel arrest. The situation must, in fact, have been delicate, for the government felt obliged to send explanatory letters to Emperor Charles V, to his minister Granvelle, and to Ambrogio Nuti, Siena's ambassador *(oratore)* at the Imperial court, informing all of them of the arrests and taking pains to underline the "fair" treatment that had been given to the alleged traitors. Something, however, was clearly brewing behind the scenes at the Imperial court, because a message quickly came back ordering the Sienese government to release immediately the accused scholar and the noblewoman and absolutely not to harm them. Virginia was thus set free but was ordered to spend a year at her paternal family's estate in Càsole d'Elsa, an ancient Etruscan town on the border of the Sienese territory with Volterra, where in the fifteenth and sixteenth centuries the Casolani owned lands and had a palazzo in town. There she was to be in the care and under the supervision of her brothers.

The entire episode remains shrouded in mystery. The Ten were obviously keen to distance Salvi from her marital family, at least for a while, and were also careful not to offend anyone by arresting and prosecuting either the gentlewoman or the scholar. Virginia's contacts with Sienese *fuorusciti* gravitating around the Imperial court were clearly viewed as a threat to internal stability, as were also her poetic compositions that made the rounds in Siena at all levels of society and seem to have provided some amusement for their readers. It is unfortunate that neither the poems sent to Agazzari nor those that were so eagerly copied and circulated in town have been preserved, for they would have provided us with a revealing insight into Virginia's political opinions at that time.

The Sienese political situation was, in fact, rather volatile and unpredictable in those years; political forces were jockeying for position both inside and outside the city walls, turning Siena into a pawn in an international power game that was being played out thousands of miles away in languages other than Italian.

The Arrival of the French

The government of the Ten Priors lasted only three years. By 1548 it had been replaced by an outright Spanish dictatorship under the rule of Don Diego de Mendoza (1504–75), who had just finished his mandate as Spanish ambassador to the Republic of Venice and as Spanish representative at the Council of Trent. In spite of his excellent education and fine scholarly credentials, not to mention personal connections with some Sienese such as Alessandro Piccolomini, Don Diego lacked both the tact and the good judgment necessary to govern a troubled city such as Siena. This, plus his single-minded determination to carry out Charles V's decision to build a commanding Spanish fortress at the northern edge of town with funds raised from the local population itself, so infuriated the Sienese that they finally found something to unite them against a common enemy. On 27 July 1552, a popular insurrection forced the Spanish to abandon the city center and seek refuge in their still-unfinished fortress. The extent of popular support this uprising enjoyed is evident in the narratives of the events penned by subsequent Sienese chroniclers and historians. They speak not only of the military maneuvers of that day but also of the active participation of the Sienese population, pointing out that the women first helped the Sienese cause by signaling with large white sheets from the rooftops of their houses to the troops assembled by Sienese expatriates advancing in the countryside and that, when the Spanish troops that had assembled in the Campo retreated through the narrow streets toward the citadel next to Porta Camollia, the women pelted them from the windows of their houses with stones and other objects.

The Sienese chronicler Giacinto Nini (fl. 1630) gives us a lively narrative of these events. He describes how the Spanish soldiers assembled

in the Campo and were trying to put pressure on the Sienese Signoria in the council chamber in the Palazzo Pubblico, how the forces of the Sienese *fuorusciti* were entering through the southern gates of Porta Tufi and Porta Romana and moving cautiously toward the Campo, and how the Florentines, for their part, were rushing into the city through Porta Camollia at the north end of town in an effort to shore up their Spanish allies:

> If the Sienese were afraid, [the Spanish and Florentine commanders] Álava and Montauto were no less afraid as they saw their enemies divided into two formations ready to attack them,[24] and they did not know their number or abilities, and they knew that Count [Nicola] da Pitigliano was already drawing near with soldiers on horseback and on foot in order to attack them, and rumor had it that the Duke of Urbino was coming in long day's marches with sixteen thousand foot soldiers to help out the Sienese. Seeing themselves battered with stones by women at the windows around the piazza [del Campo], and wounded and killed by harquebuses, and fearing that they might be assaulted and cut to pieces, they decided to abandon the piazza because it was a vulnerable location and to barricade themselves in Camollia. The Florentines were the first to leave [the piazza]; they were followed by the four Savi, who, by long-established habit, always stayed with the guard of the piazza, and then by the Spanish as a rear guard. Their intention was to barricade themselves in the Terzo di Camollia and there to defend themselves, but then, seeing that this was useless and that such a defense was dangerous, they retreated into the Citadel.
>
> When the Spanish gave up the piazza the Sienese entered it, and [Enea] Piccolomini and [Mario] Sforza went up into the palazzo and congratulated the Signoria. Those Spaniards who had shut themselves in the tower [del Mangia] surrendered to the Signoria. The *signori* immediately sounded the alarm on the great bell, and at this sound the people, numbering some six thousand, seized what arms they could find and ran boldly to the palazzo, shouting, "Libertà." This frightened the Imperialists, who abandoned the piazza and scattered up the Poggio de' Malavolti, where they occu-

pied the house of the Landi and all the houses nearby all the way to [the Church of] Sant'Andrea. Here they blockaded the street and reinforced themselves with an entrenchment against the onslaught of the Sienese, and with another blockade they closed off the street that went up to the palazzo of the Malavolti between the house of the Francesconi and the palazzo of the Buoninsegni. The Florentines, however, withdrew to the Poggio di Campansi, where the Sienese caught up with them and attacked them, forcing some of them to flee into the Citadel and some to retreat in the [Church of] San Domenico, and many fled out of the city, and the Sienese, who had already captured Porta Camollia, readily granted them permission to leave.[25]

The Sienese had thus managed to scatter, capture, or besiege the Spanish garrison in Siena and its Florentine allies and to gain control once again of their own city, but their independence was short-lived. Two days later, on 30 July 1552, a French contingent of twelve thousand men arrived in Siena and was welcomed by the Sienese as if it were a liberating army. Over the course of the next few days Louis de Saint Gelais, Seigneur de Lanssac, the representative of King Henri II, brokered an agreement with Duke Cosimo I for the safe passage of the Florentine forces and the Spanish garrison out of the fortress and for the return of the Citadel and of all captured territory to Sienese control. On 5 August the Florentine and Spanish forces left Siena without incident. Sozzini recalls that, as the Spanish and Florentine troops filed out, Don Francés de Álava was the last one to leave the Citadel. Seeing a number of young Sienese men "with whom he had, nonetheless, had a good relationship while in Siena, he bowed to them and said: 'You, valiant Sienese, have struck a fine blow *[bellissimo colpo]*, but be careful for the future, for you have offended too great a man.'" Once the Spanish had left the citadel, Lanssac formally handed the fortress over to the Sienese, who, undaunted by Álava's warning, immediately began to tear it down with picks and shovels "while all the citizenry cried for happiness and sang out in praise of freedom and France." In town, someone posted on the loggia of the Ufficiali a sonnet eulogizing the eviction of the Spanish and urging the Sienese to overcome their differences.[26]

On 6 August, the day after the departure of the Spanish, the Sienese government sent an official letter of gratitude to King Henri II for having restored the city's freedom, and Henri answered them just a week later, on 14 August. As these events unfolded, the French moved to secure their position by stationing thousands of troops in the city and in the countryside. On 11 August, the French general Paul de La Barthe (1482–1562), Seigneur de Thermes, arrived with 2,400 more French troops. At this point Lanssac, the able diplomat, left town, and Siena found itself under the command of a career French soldier. One occupier had clearly been replaced by another, but in the optimism of the moment the Sienese were not fully aware that they had merely changed masters. For the Salvi family and the pro-French party in Siena, their years of being on the political fringe seemed to be over, and they eagerly awaited the recognition and rewards they felt they justly merited for their many long years of anti-Spanish and pro-French politicking.

Salvi's Praises of Henri II

In the days and months that followed, pro-French sentiments were openly expressed in Siena with an exuberance that knew no bounds. They found their poetic voice in Virginia Martini Salvi, who composed a number of poems in praise of Henri II. In the sonnet "Ride tutta l'Italia e per te spera" (All Italy rejoices and hopes through you), datable to the heady moments immediately following the anti-Spanish insurrection and pro-French realignment, Virginia addressed the French king, saying:

> Ride tutta l'Italia e per te spera,
> Enrico invitto, far quel che fatto hai
> Nell'alma Patria mia colma di guai,
> Che lieta la ritorni ove prima era.
> Ha spento il Gallo tuo l'Aquila altera
> Che dar ne procacciava interni lai
> E con la luce de' tuoi santi rai
> Scorgi il camin di sua salute vera.

O santo Re, che dalle irate mani
E dallo ingiusto giogo il gregge umano
Hai tolto e posto in libertà sì cara,
 Stìan dunque, tua merciè, sempre lontani
Mostri sì rei e la regal tua mano
Lungi ne tenga a vita tanto amara.[27]

All Italy rejoices and hopes through you, / Invincible Henry, to do what you have done / In my noble Homeland, once full of woe, / Whom you returned to joy, as she once was. // Your Rooster has killed the haughty Eagle / That had sought to give us internal anguish / And with the light of your holy rays / You show the path of its true salvation. // O holy King, you have removed / This human fold from wrathful hands / and placed it in liberty, so dear. // By your mercy, then, let such evil monsters / Always stay far away, and may your royal hand / Keep us far from such a bitter life.

In this sonnet, Virginia thanks the king for having freed Siena from Imperial domination and informs him that all of Italy now looks to him as the savior who will liberate the peninsula from the Spanish/ Habsburg yoke. Using two rather colorful ornithological images whose meaning would have been clear to everyone, she points out that the Gallic Rooster has overcome the Imperial Eagle, a reference to the Valois/Habsburg rivalry and to the recent Sienese switch in alliances. With her reference to the "human fold" *(gregge umano)* Virginia adds a third animal image, the sheep, thus suggesting that the Sienese and, by extension, Italians as a whole are a flock meant to be guided and protected by Henri II. In introducing the idea of a flock Virginia's poetic intention is clearly to extend the animal metaphor but also to reinforce the Christological motif already present in the poem by associating Henri II with the Good Shepherd. The imagery may be unusual, but it is effective and well developed. It also ties nicely with the traditional belief that the king of France had thaumaturgical powers and could cure certain diseases (in particular scrofula) by the mere touch of his hands. Henri II is thus seen not only as a liberator and a savior but also

a healer, so his entry into Sienese political life is seen as an intervention that will free, redeem, and heal the city.

A second sonnet by Virginia Martini Salvi, "Quai dotti scritti, o quai trofei sien degni" (What learned writings, what trophies will be worthy), is datable to the same period and interprets the recent Sienese political realignment as an example of how a true king conquers new lands and gains his subjects' affection—by love, and not by force.

> Quai dotti scritti, o quai trofei sien degni,
> Signor, del merto di vostre opre sante
> Poscia ch'il valor d'esse a tutte innante
> Passa e fa muti i più sublimi ingegni?
> Così sue si de' far le Patrie e i regni,
> Non con l'inique crudeltà cotante.
> Deh, ferma, sacro Re, tue sante piante
> Entro alla Città mia colma di sdegni.
> Sia la mia patria a tutte l'altre esempio,
> Nè più d'Aquila infida alcun si fidi,
> Che troppo face di noi crudo scempio,
> Ma da l'un mare a l'altro al Ciel si gridi
> "Enrico invitto" e al vostro santo tempio
> Faciam de' nostri cuori eterni nidi.[28]

What learned writings, what trophies will be worthy, / Lord, of [singing] the merits of your holy works, / Since these far outstrip the value of those / And leave the most sublime wits speechless. // This is how one should gain lands and kingdoms, / Not with so much wicked cruelty. / Come, sacred King, stay your holy feet / Inside my city, so full of wrath, // Let my homeland be an example to all, / And let no one trust the faithless Eagle again, / For it wreaked far too much havoc upon us, // Instead, from one sea to the other let the cry rise to heaven / "Invincible Henry!" and in your holy temple / Let us make eternal nests of our hearts.

Salvi is probably not at all thinking of Machiavelli's question from *The Prince* on whether it is better for a ruler to be loved or to be feared,

but her sonnet does speak to the question because it is clearly a critique of the oppressive methods previously used by the Spanish governor, Don Diego de Mendoza. The French had, in fact, sought to distance themselves from such methods and had gone out of their way to show the Sienese a kindlier face. The first two French generals to arrive in town immediately after the expulsion of the Spanish operated with exceptional respect for the local system and openly deferred to the Sienese government on matters political. The example had been set by Lanssac, who had entered Siena with a troop of about twelve thousand men on 30 July but had not needed to use this powerful military contingent to resolve the tricky situation of the besieged Florentine and Spanish garrison, for he gained possession of the Citadel thanks to his diplomatic skills and without loss of life. Once in possession of the fortress, Lanssac handed it over to the Sienese, who immediately began to tear it down. Lanssac's "kindlier face" was continued by his successor, Paul de La Barthe, Seigneur de Thermes, who, when he arrived a week later with reinforcements that bolstered the French contingent in Siena to fifteen thousand men—a rather sizable force for a city of twenty to twenty-five thousand souls and clearly a threat to the city's political independence—immediately dispersed the troops throughout the territory so as to reduce the impact (but, clearly, also to secure the territory).[29] De Thermes also went out of his way to let the Sienese understand that he was interested only in military security, not in political matters. He thus gained the trust of the Sienese and received, in return, honors and recompense. Such restraint on the part of the French contrasted starkly with the manners and methods used by Don Diego de Mendoza and may well lie behind Virginia Martini Salvi's poem on how a ruler should conquer hearts and lands.

Aside from praising Henri for having managed to gain Siena's support without force of arms, in this sonnet Virginia Salvi encourages the French king to enter the city and remain there—a clear invitation to invade and occupy. Were this to happen, Siena would become an example of good government and peace for all of Italy to follow, so much so that, from one shore of the peninsula to the other, everyone would sing Henri's praises, their hearts at peace in the security and comfort of his "'holy temple,'" that is, of his royal body politic. The Christological imagery we had noted in the previous sonnet continues to be

present in this sonnet in expressions such as "sacred King," "holy feet" (v. 7), and "holy temple" (v. 13).

In a third sonnet, Virginia's overwhelming praises of Henri II move from the Christological to the heroic and no longer involve passionate invitations to come, conquer, and rule. It describes Henri rising to the heavens and being crowned with stars in an apotheosis that sheds light upon the darkest souls and tames even the most bellicose men.

Al Re di Francia

> Invitto Re, che le moderne carte,
> Mercè de le vostre opre altiere e belle,
> Fate d'eterni onor vergar con quelle
> Virtù ch'ogni alma vil tiene in disparte,
> V'alzate sì che Voi giugnete in parte
> Ove vi cingon le maggiori stelle
> Et fassi un nuovo giorno a le rubelle
> Menti e a chi segue il furibondo Marte.
> A Voi consacra ogni bella alma il core,
> Spinta d'alto desio, ch'altro non brama
> Che godersi il divin vostro splendore.
> Toscana "Enrico," Italia "Enrico" chiama:
> L'Adria v'inchina, e 'l fero Scita onore
> Vi rende, e il ciel vi favorisce et ama.[30]

———

To the King of France

Invincible King, modern pages are filled, / thanks to your lofty and beautiful works, / to their eternal honor with those / virtues that vile souls keep at a distance, // you rise so [high] that you reach that place / where you are crowned by the most important stars / and a new day dawns upon rebellious / minds and on those who follow furious Mars. // Every beautiful soul consecrates its heart to you, / prompted by lofty desire, and desires nothing else / but to enjoy your divine splendor. // Tuscany "Henri," Italy "Henri" calls, / Adria bows to you, and the wild Scythian / honors you, and Heaven favors you and loves you.

Not everybody, however, was as keen a supporter of Henri II and his intervention into Sienese politics as Virginia Martini Salvi. Latent dissatisfaction in Siena and even political opposition to the pro-French realignment induced Salvi to compose a sonnet in which she harshly reprimands the critics, saying:

> Impio pensier, da cui troppo impio effetto
> Nascer devea se 'l gran potere eterno
> Non troncava il cammin ch'a un certo inferno
> Ne conducea, pur senza altrui difetto.
>
> M'empie il timor di meraviglia il petto
> Né so trovar cagion ch'a tanto interno
> Mal nel guidasse, o santo alto governo,
> Che rallumi l'uman basso intelletto.
>
> Ministri scellerati, orrendi mostri,
> Pena non è ch'al vostro merto eguale
> Si possi dar, sì son le colpe gravi.
>
> Enrico invitto i tanti danni nostri
> N'ha tolti e tronco al fier nemico l'ale.
> Voi cercate tradirlo, ingrati e pravi.[31]

Ungodly thought, from which a much more cruel effect / Would have arisen, if the great eternal power / Had not cut the path that was leading us / to certain hell, though not because of another's fault. // Fear fills my breast with amazement, / Nor can I find a reason why so much internal / Evil was guiding us, oh high and holy Lord, / Who enlightens lowly human intellect. // Wicked ministers, horrendous monsters, / There is no punishment fit to match / What you deserve, so grave your faults. // Invincible Henry has taken away / Our many ills and clipped the enemy's wings. / You, ingrates and wicked, seek to betray him.

The sonnet seems to be set at a time when the situation in Siena had clearly not yet stabilized into a solid and unified pro-French realignment. In it, Virginia expresses her strong criticism of lingering pro-Spanish sentiments, which she sees as expressions of a dissension that could tear apart the fabric of the nation. Echoing in part what Aurelia

Petrucci has already said, Salvi points to self-created internal dissension as the cause of Siena's downward spiral (v. 4), but unlike Petrucci she is not able to rise above strident partisan politics; instead, she lashes out at the opposition in terms that admit no compromise (vv. 8–10, 14). Her references to God (vv. 2, 7) and to King Henri II (v. 12) suggest that Henri is God's agent on earth and that the opposition are evil beings rebellious to the divine will. With this, Virginia is raising Henri II to the status of God's agent on earth, a glorification of the monarch that easily translates into an apotheosis, as in fact it was seen by other readers.

One such reader was the Roman nobleman Leone Orsini, who read Salvi's poems in praise of Henri II and eagerly complimented the author, saying that the French monarch need not envy any hero's apotheosis now that he had Virginia to raise him to the heavens on the wings of her poetry.

> Voi che del grande Enrico opre sì belle
> Scrivete in stil così pregiato e caro,
> Ch'ei non invidia il più famoso e chiaro
> Eroe che splenda in ciel cinto di stelle,
> A sormontar cercate ognior con quelle
> Doti che vi fan fido alto riparo
> Al secondo morir, tal ch'ogni raro
> Spirto convien che sol di voi favelle.
> Scrivete, or che suggetto avete eguale,
> Virginia, ai vostri sì leggiadri carmi
> Che vi fanno qua giù viva immortale,
> Ché l'invitto mio re già veder parmi,
> Portato al ciel del vostro stil con l'ale,
> Sprezzare archi, trofei, metalli e marmi.[32]

By writing of great Henri's beautiful works / In a manner so esteemed and dear, / So that he does not envy the most famous and eminent / Hero shining in the heavens crowned with stars, // You seek forever to rise above with those / Talents that provide you with trusted and lofty protection / Against a second death, so that every rare / Spirit must speak only of you. // Write, now

that you have a subject equal, / Virginia, to your so delightful poems, / That make you immortal while living down here, // For I already seem to see my invincible king, / Raised to the heavens on the wings of your style, / Disregard arches, trophies, metals, and marble.

Orsini's sonnet seems to be directly inspired by Salvi's "Invitto Re, che le moderne carte" as it picks up on some of Salvi's rhyme words *(belle, quelle, stelle),* her description of Henri II as *invitto,* and her comment that poetry now has a fit subject to immortalize, which leads Orsini to encourage Virginia to continue composing poems in praise of Henri II. This was a familiar theme for both Virginia Salvi and Leone Orsini, who had both encountered it in Alessandro Piccolomini's *Tombaide* of 1540. However, while in Piccolomini's case poetry served to immortalize the poet Petrarch, in Salvi's and Orsini's case poetry returns to its original scope, as suggested by Petrarch in his *Rerum vulgarium fragmenta* (henceforth, *RVF)* 187, of immortalizing the deeds of great warriors (*pace* the disappointing military career of Henri II). Orsini can be forgiven, however, for idolizing Henri II because he was, after all, bishop of Fréjus, a town and diocese on the southern coast of France, and owed much to the French crown, so much so that in his sonnet he refers to Henri II as "my king" (v. 12).[33]

Orsini corresponded with a number of Tuscan writers, such as Alessandro Piccolomini, Benedetto Varchi, and Ugolino Martelli, whom he had come to know in Padua when he founded and then headed the Academy of the Infiammati (1540). If he did not receive copies of Salvi's poems directly from Virginia, he must have received them from one of his fellow academicians. Whatever the case, his response to Salvi's poems indicates that her works were circulating in manuscript among Italian literati, some of whom not only praised the Sienese poet but also offered moral support to the Sienese in general in their attempt to be rid of Spanish domination.

One such moral supporter was the Perugian noble Francesco Coppetta Beccuti (1509–53), who composed a sonnet in praise of the 1552 rebellion of the Sienese against their Spanish overlords and their realignment with France.

L'ardita lupa, che da' fieri artigli
de l'aquila rapace ha scosso il dorso
e tronco il duro e insopportabil morso
che l'avea posta in tanti aspri perigli,
 tutta sanguigna e lieta ai cari figli
dicea rivolta:—Ecco finito il corso
de le miserie nostre, ecco il soccorso
che sì fido ne dan gli aurati gigli;
 guardate come dagli acuti ed empi
morsi ne toglie de l'augel nimico
che tante piaghe nel mio corpo impresse.
 Ergansi dunque a questo altari e tempi
dove scritto si legga: "Il grande Enrico,
liberator de le cittadi oppresse."[34]

———

The daring she-wolf, who has shaken the harsh claws / of
the rapacious eagle from its back / and broken the hard and
unbearable bit / that had placed it in so many severe dangers, //
turning, sanguine and happy, to her dear children, / said: "The
course / of our miseries is now ended, here is the sure help /
that the golden lilies give us. // Look how they release us / from
the sharp evil beak of the enemy bird / that inflicted so many
wounds upon my body. // Let altars and temples, therefore,
be raised to him / where these words can be read: "The great
Henri / liberator of oppressed cities."

Coppetta's sonnet seems to respond to Salvi's own poems, picking up
on some of the animal imagery she used and, as in Salvi's case, present-
ing Henri II as a liberator of oppressed cities.

Salvi's Poems to Cardinal Ippolito II d'Este

On 1 October 1552, just two months after the French had taken over
Siena, King Henri II named Cardinal Ippolito II d'Este his plenipoten-
tiary in Siena.[35] As "cardinal protector" of French interests in Rome,
Ippolito was already accustomed to advancing Henri's interests not

only at the papal court but throughout Italy. This was, for him, very much a family matter because his brother, Duke Ercole II of Ferrara, had married Renée of France, sister of the deceased King Francis I and aunt to the current king, Henri II. Both Ippolito and his brother Ercole II were therefore firmly pro-French in their politics and preferences. On 1 November 1552, just a month after his appointment, Ippolito d'Este arrived in Siena with a personal guard of three hundred mounted soldiers and a baggage train of one hundred mules. He installed himself in the palazzo of Anton Maria Petrucci, a place closely associated with the Spanish crown, having hosted in previous years both Emperor Charles V and his daughter Margaret of Austria. While the cardinal occupied himself with political matters, the French marshall Paul de La Barthe, Seigneur de Thermes, oversaw military matters.[36]

Not surprisingly, Virginia Martini Salvi was quick to compose congratulatory sonnets to the newly arrived cardinal. She praised him in particular for the "advice" he was giving to the Sienese and thanked Henri, through the cardinal, for the help the king had provided, help that had made the Sienese as strong as a fortress and ready to take up arms to destroy the enemy.

> Ha fatto la ragione un forte al cuore
> Con l'alta insegna delli aurati gigli,
> Che de l'ingord' Augel li acuti artigli
> Sprezza la patria mia, Sacro Signore.
>
> L'interna cortesia, quel gran valore
> Del grande Enrico, e' vostri alti consigli
> L'hanno fondato e i suoi devoti figli
> 'l fanno invitto e colmo d'ogni onore.
>
> Liberi Iddio ne fe', liberi Enrico
> Di servi n'ha tornati, onde or la mano
> Contra el nemico ardita el ferro prende.
>
> Così sia 'l Cielo a' bei desiri amico.
> La fiera spoglia del rio mostro ispano
> Riporterà, ch'ei desiosa attende.[37]

Reason has made a fort for our hearts / With the lofty emblem of the golden lilies / [So] that [now] my homeland spurns / The

claws of the gluttonous bird, sacred Lord. // The innate courtesy, that great valor / Of the great Henri, and your lofty advice / Are its foundation, and its devoted children / Render it invincible and fill it with every honor. // God made us free, Henri freed us again / From our servitude, so that the daring hand / Now raises its sword against the enemy. // May Heaven smile upon this beautiful wish. / He will return with the grim corpse / Of the evil Spanish monster, which he eagerly awaits.

In this sonnet to the cardinal, Salvi returns once again to the Christological imagery we have noted in previous poems. In this case Henri restores the Sienese to the liberty that God himself gave them and thereby gives them the strength to fight against their enemy, much as Christ redeemed mankind from the servitude of sin and gave it the strength to fight Satan.

While the poems may be triumphalist in their imagery, in their context they reveal that Virginia Martini Salvi clearly misunderstood the political situation. Salvi still dreamt of a free Republic of Siena or of an Italian peninsula governed by its own people under the benevolent protection of the French, but that was simply not in the cards. Her invitation to Henri to come to Italy and free the peninsula from the Spanish yoke ignores the internal divisions present within Sienese and Italian society and exposes her own political naïveté. Aurelia Petrucci had expressed a much more savvy political view when she implored her fellow citizens to find an internal solution so as to avoid a foreign intervention (see above, chapter 2), but her voice had gone unheard and her prediction had come to pass. It would not, however, be the French or the Spanish that would eventually invade and conquer Siena or, I should add, finally bring peace to the troubled city. The conquering peacemaker would be someone much closer to home and much more committed to the security and tranquillity of the region.

The Siege Narratives

Less than three years after the French arrived in Siena and were so enthusiastically received as its liberators, they were forced to leave when

the city was conquered by the forces of the pro-Spanish Duke of Florence, Cosimo I. The long and bitter siege that marked the end of the Republic of Siena (January 1554–April 1555) not only revealed the heroism and determination of the Sienese in the defense of their city but also exposed the brutality of their determination when, on at least two occasions, they cast from the city the so-called "useless mouths" *(bocche inutili)*—women, children, the elderly—leaving them to fend for themselves in hostile territory and knowing full well that they would most probably die of hunger, exhaustion, or violence at the hands of the equally brutal besieging forces. In spite of all their determination, heroism, sacrifice, and brutality, the Sienese were eventually forced to surrender. With their capitulation, the city returned to the orbit of the Spanish Empire, this time under the direct rule of the new king of Spain, Philip II (1555–57). Two years later, Siena was obliged to face the humiliation of being sold outright, like merchandise, by King Philip to Duke Cosimo I of Florence (1557), who added it to his duchy and thus fulfilled his territorial dream. With the Treaty of Cateau-Cambrésis (3 April 1559) and the final surrender of the "Republic of Siena Withdrawn to Montalcino" (4 August 1559), the republic ceased to exist as a political entity and was incorporated into the new dual duchy of Florence and Siena, soon to be raised to the status of grand duchy (1569).

As the final chapter of Siena's history as an independent republic begins to unfold in the early months of 1553, Virginia Martini Salvi suddenly disappears from the records. For all her political meddling and all her writings in praise of France, she is conspicuously absent from any of the narratives about the preparations for war or about the siege, as well as from the iconic episode of the "women of Siena" (see chapter 3). In her place, instead, we find three women whom we really did not expect to see there: "la Signora Forteguerra, . . . la Signora Fausta Piccolhuomini . . . la Signora Livia Fausta."[38] At least two of them came from clearly pro-Spanish and pro-Imperial families, yet they took an active part in the defense of their city against the Spanish. The third woman remains unidentified.[39] Their heroic deeds were narrated as early as 1553 by the Italian historian Marco Guazzo (1496?–1556) and were then picked up by several other contemporary historians (the French Guillaume Paradin and Blaise de Monluc, and the Italian Ascanio Centorio degli Ortensi in particular), quickly becoming part of

Sienese mythology even to this day (see above, chapter 3). Virginia Martini Salvi is absent from this narrative. Her absence is even more surprising given that, when the women of Siena were carrying out their heroic deeds, Virginia's brother-in-law, Giulio Salvi, was *capitano del popolo* (elected December 1552). With the pro-French Giulio Salvi in such an eminent position of authority and command, one would naturally expect to see the leading female members of his family, and especially the politically engaged and strongly pro-French Virginia, at the forefront of an event that epitomized so clearly the indomitable spirit of the Sienese in their struggle against the Spanish. If even women from such Noveschi families as the Forteguerri and Piccolomini were helping to build a bastion to protect the city from the Spanish, whom the Noveschi had long supported, why were the women from a pro-French family from the Monte del Popolo, such as the Salvi, not involved?

The question is intriguing and suggests that the supposed unity brought about by the French "liberation" of the city may not, in fact, have been universal. Judith Hook points out that "those who had been prominent in government in the recent past did not exactly welcome the rebels, but urged them to go away, and, when this request was refused, took suitable avoiding action—concealment, flight, and in the case of several of the *Riformatori,* enlistment with the Spanish forces."[40] Some people may well have kept themselves away from the heroic efforts under way in the city, though such an attitude is difficult to imagine either for a city that so wholeheartedly closed ranks against the enemy or for the strongly anti-Spanish Salvi. On the other hand, Virginia's conspicuous absence from the women's efforts may indicate that the Salvi were already in the process of switching sides and were heeding the siren call of Florentine promises, a call that, a few months later, would lead Giulio and Ottaviano Salvi to the chopping block. A third and more likely explanation for Virginia's absence may be connected to her move to Rome (perhaps to be dated to sometime shortly after the Salvi brothers' drastic reversal of fortune in May 1553)[41] and a subsequent *damnatio memoriae* on the part of contemporary chroniclers— even if Virginia had participated in the February efforts by the women of Siena, Sienese revisionist history in the wake of the Salvi's spectacular fall from grace may have written her out of the narrative, especially

if, shortly after the Salvi debacle, she abandoned turbulent Siena for the safe haven of Rome.

We do not know when, exactly, Virginia left Siena. We do know that by 1556 she was living in Rome as a political exile, but this date is late and not surprising. What might be more surprising, instead, is the reputation Virginia enjoyed throughout Italy in spite of a conjectured Sienese *damnatio memoriae*. In his *Imagini del tempio della Signora Donna Giovanna Aragona* (1556), the Friulian erudite Giuseppe Betussi da Bassano (ca. 1512–73) provides us with a fascinating thumbnail sketch of the exiled Virginia: "Here is the beautiful, wise, magnanimous, noble, and learned Virginia Salvi. See with what greatness of spirit, unable to suffer the sight of her *patria* reduced to being a servant, she has made proud Rome her *patria*."[42] Betussi's words indicate that Virginia was seen as a patriot whose "greatness of spirit" had compelled her to choose exile over servitude—a rather romanticized view of the situation that we would expect more from a nineteenth-century nationalist than from a sixteenth-century erudite. Betussi's words are also an indication that, already in the immediate aftermath of the final defeat, the myth of Siena was finding its voice and its exponents even among writers from as far away as Friuli. Both suggestions, however, remain marginal to our narrative because Virginia Salvi, though a passionate voice from exile, failed completely to motivate a resurgence of interest for the independence of Siena—in spite of her indefatigable epistolary efforts.

An Attempt at a Return

Although a passionate defender of Sienese liberty, Virginia Martini Salvi eventually had to face the facts. In the wake of the French/Spanish settlement of the Italian conflicts in the Treaty of Cateau-Cambrésis (2–3 April 1559) and the surrender of the Republic of Siena Withdrawn to Montalcino (4 August 1559), Salvi came to terms with reality. On 5 August 1559, the day after the capitulation of Montalcino, she wrote to Duke Cosimo I from her exile in Rome. In a gesture of goodwill toward his new Sienese subjects, Cosimo I had granted a general amnesty and allowed restitution for those exiles who were prepared to return to Siena

and reintegrate peacefully into the city. Realizing that with Cateau-Cambrésis and the end of the Republic of Siena Withdrawn to Montalcino there was no further hope for an independent Sienese state, Virginia came to the conclusion that she, too, had to accept Cosimo as the new master. She thus seized the opportunity offered by his amnesty to make a first gesture of goodwill toward the duke. She wrote to him as follows:

> My Most Illustrious, Excellent, and Respected Signore,
> I thank God's goodness that after our long troubles he chose to give us rest by providing us with secure peace and by giving us as a prince and master someone who loves virtue and justice such as Your Excellency, which makes me extremely happy, and I hope that through your valor my homeland, once dead, might return to a most happy life, and though I am unable at the moment to enjoy it [my homeland] because of other obligations, I nonetheless firmly hope, with Your Excellency's assistance, to regain what was mine and has been kept from me, and then to come to serve you, as is my duty. In the meantime, with every humble reverence I recommend myself to you and pray God for your happiness.
> From Rome, the 5th day of August 1559.
> Your Excellency's most humble servant,
> Virginia Martini de' Salvi.[43]

The letter is written in a clear and large italic hand, typical of literate sixteenth-century writers. Virginia uses the standard salutations and terms of homage appropriate when addressing one's superior, and especially one's lord. In it, she pays homage to Cosimo, recognizes him as her *signore,* professes her obedience to him, and declares herself ready to go to him and serve him as soon as she reacquires "el mio tenutomi fin hora"—a somewhat unclear phrase, but one that seems to indicate that she wishes to return to Siena with the full enjoyment of the status and properties she considers to be hers. In other words, she wishes to return with full dignity. Perhaps for this reason Cosimo seems not to have responded to her or granted her permission. On the original letter, still preserved at the State Archive of Florence, there is no marginal comment or instruction from Cosimo to his staff telling them what to do (as

he was in the practice of doing). This silence suggests that he chose to do nothing. Virginia Martini Salvi was probably not someone Cosimo cared to allow back into his duchy.

The Appeals to Catherine de' Medici and Margaret of France

Cosimo's resistance may have been predicated by Virginia's actions over the previous ten or more years, when she did not hesitate, as we saw above, to sing the praises of King Henri II of France and to encourage him to invade and govern Italy. After the fall of Siena and during her stay in Rome, Virginia continued to compose sonnets in praise of the Valois. One, in particular, must have annoyed Cosimo to no end. In the sonnet "Afflitti e mesti intorno a l'alte sponde," addressed to Henri's wife, Queen Catherine de' Medici, Virginia begins with a lament for the Sienese exiles in Rome but then turns her attention to Florence and asks Catherine to cast her eyes on this, the most dejected of all cities, and to save it (supposedly from the usurper):

> Afflitti e mesti intorno a l'alte sponde
> Del Tebro altiero i cari figli vanno
> De la mia Patria, e 'l grave acerbo affanno
> Ciascun nel petto suo dolente asconde.
> Miran lungi il bel Colle, ove s'infonde
> Ira, sdegno, furor, rapina, e danno
> Del famelico Augello, in cui si stanno
> Ingorde voglie a null'altre seconde.
> Spargon per l'aria alti sospiri ardenti;
> Versan dagli occhi largo pianto ogn'ora;
> Muovono i sassi i lor giusti lamenti.
> Piange, Reina mia, la vostra Flora,
> Più di tutt'altre mesta; e son possenti
> I vostri rai far, che di duol non mora.[44]

———

Mournful and downcast beside the high banks / Of proud Tiber, the dear sons of my homeland / Wander, and the bitter, grave

distress / Each in his heart with aching pain does hide. // From
far away they spy the wondrous hill / Where wrath, disdain, fury,
theft, and harm / Come pouring out from the ravenous Bird /
Whose gluttonous cravings are second to none. // They heave
through the air sharp, burning sighs; / They pour from their eyes
a constant flow of tears; / Their righteous lamentations move
the stones. // Your Flora, my Queen, is also weeping, / More
sorrowful than the rest; but your glance / Has the power to let
her not die of grief.

The image of the rapacious bird (a reference to the Habsburg
eagle) wreaking havoc in Siena suggests that the sonnet was composed
when King Philip II of Spain governed the city directly (1555–57). As
we know from the case of the Spanish Netherlands, Philip II did not
enjoy the reputation of being a mild and benevolent ruler, so Virginia's
strong words in the second quatrain may well refer to Philip's auto-
cratic and ruthless modus operandi rather than to Cosimo's much more
benevolent approach. In fact, when Cosimo acquired the city in 1557,
he made it a point of being respectful of local governing structures
and of allowing Siena to exist as a separate entity on par with Florence
in his (now) dual duchy, even letting Siena retain its own constitution
(though with some small revisions), the Signoria, the office of the *capi-
tano del popolo,* the political factions of the four Monti, and its various
magistracies. Cosimo's "good start" was such that Siena never rebelled
against him or his heirs in three centuries of Medicean and then Habs-
burg rule that followed (1557–1859).

 This, however, is not how Virginia Salvi saw Cosimo I. In her eyes,
he was a tyrant and a usurper. The underlying suggestion in her sonnet
is that Catherine should claim Florence for herself and free it from the
tyrant's yoke. Salvi is not far off the mark in suggesting that Cather-
ine take Florence because, in fact, the daughter of Lorenzo di Piero di
Lorenzo de' Medici had a much more direct dynastic claim to the ducal
crown of Florence than her distant cousin Cosimo—who was a direct
descendant of Lorenzo the Magnificent not by the male line, like Cath-
erine, but by the female line (his maternal grandmother was Lorenzo's
daughter, Lucrezia). In making her suggestion, Salvi is also exploiting
Catherine's personal dislike of her young relative, whom she consid-

ered an upstart. However, given the circumstances surrounding the creation of the duchy by Imperial fiat in 1532, the establishment of a line of succession that excluded women from inheriting the state, and then, in 1537, the exclusion of the senior Medici branch from the line of succession in the wake of the assassination of Duke Alessandro by Lorenzino de' Medici, Catherine was unable, three times over, to make a legitimate claim for her rights to the city.

In a much longer poem, "L'ardente amor, la pura, e viva fede" (The burning love, the pure and lively faith), a canzone consisting of ten stanzas and 104 lines, Virginia again writes to Catherine, calling her "my lofty queen" (v. 12) and urging her to take action to reclaim the city that is rightfully hers (see Appendix).[45] Salvi repeatedly declares her loyalty and that of her fellow Sienese to the French, but she also reminds Catherine that France failed Siena in its moment of need ("indarno sperai"; v. 9). Virginia refers to herself as an exile with a child at her breast, deprived of honor and wealth (vv. 45–47), and then appeals to Catherine to intercede with her "royal consort" to reawaken in him the desire to free the Sienese from the Spanish yoke (vv. 67–70). The reference to the consort dates the poem to before July 1559, when Henri II died as a result of a jousting accident. Virginia pours scorn on the Spanish, referring to the claws of the enemy bird (vv. 17–19, 26), a comment that allows us to date the poem even more precisely to the two years when King Philip II of Spain ruled the city directly (1555–57). As the canzone draws toward a close, Salvi describes how she wanders around the seven hills of Rome looking for vestiges of Catherine's stay in that city (Catherine was educated there during the papacy of her uncle, Clement VII) and admiring the work of her "noble shepherds, now immortal" (probably a reference to the contributions to the urban fabric of Rome made by the two Medici popes). As she does so, her soul takes flight toward Catherine and leaves her body behind (vv. 89–96). In spite of this suggestive ending, the tone of the entire poem is disheartened and pessimistic. Salvi's pessimism may have been due in part to Henri II's inaction and perhaps even loss of interest in Siena in the wake of the city's surrender to Cosimo I's army.

Salvi's sonnet "Non sia cagion l'altrui maligno Inperio" (Let not another's evil rule be reason) is also probably datable to this postconquest period when Siena was governed directly by King Philip II of

Spain (1555–57). In it, Salvi appeals to Henri not to forget her city and its plight; she distances herself and her fellow Sienese who still believe in a free Siena aligned with the French crown from their straying counterparts who support the new Spanish overlords; and she closes by appealing to Henri's "courtesy," reminding him (in a rather courtly manner, one should note) that a higher "Lady" expects him to put his "courtesy" into action (see Appendix).

Henri II and Catherine de' Medici were not the only members of the Valois family to whom Virginia Salvi appealed on behalf of the Sienese exiles and the city of Siena. Salvi also wrote to Margaret of France, Duchess of Berry (1523–74), sister to Henri II and (future) wife to Emanuele Filiberto, Duke of Savoy, whom she married in 1559 as part of the agreements of the Treaty of Cateau-Cambrésis. In the sonnet "Se Voi Donna Immortal, volete ch'io" (If you, immortal Lady, wish me), Virginia asks Margaret of France to turn her eyes to Virginia and her plight so that, inspired by her benevolent gaze, Virginia may sing of Margaret's lofty valor (see Appendix). The poem is somewhat superficial and could easily pass as simply a complimentary sonnet to a noblewoman; however, given Virginia's incessant appeals to the French royal house for intervention in Sienese politics, it is clearly to be read in a political sense.

One might wonder whether King Henri II, Catherine de' Medici, and Margaret of France ever received Virginia's poems and what their responses might have been. Unfortunately, such responses, if they ever existed, have not yet been discovered. We do know, however, that the poems circulated, especially among pro-French literati such as Leone Orsini, whose own sonnet encouraging Virginia to sing the praises of Henri II we discussed above.

Cardinal Connections

The various members of French royal house were not the only recipients of Virginia Salvi's poetry. Another important group was a network of powerful cardinals closely connected to the papal throne. They were the influential Cardinal Ippolito II d'Este of Ferrara, protector of French

interests in Rome and past political governor of Siena for Henri II; Cardinal Alessandro Farnese, nephew to the previous Pope Paul III Farnese, an adamant supporter of French interests in the peninsula; Cardinal Girolamo Verallo, who served the papacy on missions to Venice, to the emperor, and to the king of France; the gifted Cardinal Alfonso Carafa of Naples, who died at the young age of twenty-five; Cardinal Vitellozzo Vitelli, a personal friend of the Cardinal Nephew Carlo Carafa; and the learned Cardinal Antonio Trivulzio, bishop of Toulon, nuncio to France and papal legate to King Henri II.

What is fascinating about Salvi's epistolary poetry to these powerful princes of the Church is that, in their case, she steers a conscious course away from politics and toward expressions of friendship, respect, and even religious faith. The sentiments may be sincere, but one should not rule out an ulterior motive. By striking up and maintaining a good personal relationship with influential figures at the papal court and in the papal administration, Salvi may well be ensuring that the cause of the Sienese exiles is not forgotten in Rome. A good case in point is a group of sonnets addressed to cardinals Alfonso Carafa, Vitellozzo Vitelli, and Antonio Trivulzio, all elevated to the purple by Pope Paul IV Carafa on 15 March 1557. Though occasioned by this particular event and probably motivated by Salvi's desire to flatter and gain patronage, the sonnets reveal Salvi's excellent command of the language of salutation, civility, and flattery, as well as a spiritual sensibility that should not be dismissed.

The young Cardinal Carafa is the only prelate to receive two sonnets, the first probably at his elevation, the second at an undetermined date (see Appendix). The poems are addressed to "the cardinal of Naples," which at this time could refer to two different cardinals, Carlo Carafa and Alfonso Carafa. It is highly unlikely, however, that the recipient of such lofty and sensitive verses would be the powerful Cardinal Nephew Carlo Carafa (1517–61), one of the most disreputable members of that family. A man with no religious vocation but an enormous sense of his own career possibilities, Carlo knew how to take advantage of a situation: when his uncle Gian Pietro Carafa was elected Pope Paul IV (23 May 1555), Carlo immediately abandoned the soldiering life he had followed for some time in Italy, Flanders, and Germany

and became a Roman cleric, thus making himself eligible for the cardinal's hat his uncle bestowed upon him on 7 June 1555, just two weeks after his election to the papal throne. Paul IV did this to place a trusted member of his family in charge of the daily running of the state while he himself turned to the question of church reform. A man of disordered life and innumerable failings, Carlo eventually offended even his uncle, who changed his opinion of him and removed him from office and from Rome in early 1559. The banishment was short-lived, however, because Carlo returned to Rome a few months later to participate in the conclave that followed his uncle's death (September–December 1559) and elected Giovanni Angelo de' Medici (1499–1565) as Pope Pius IV. The new pontiff, brother to the *condottiere* Gian Giacomo de' Medici who had captured Siena for Cosimo I, had Carlo arrested in June 1560, locked up in the Castel Sant'Angelo, tried for a variety of crimes and heresies, found guilty, deposed, and then strangled ignominiously in prison (4 March 1561). The following pope, Pius V Ghislieri, tried to rehabilitate Carlo at least in part by ordering a reexamination of the trial so as to expose irregularities in the process, but if the process had been tainted so also was the accused, and little could be done to restore his reputation. If Virginia's poems were addressed to this rather unsavory figure, there clearly was a major discrepancy between the historical individual and the poetic persona she created for him. We cannot assume ignorance on her part: the historical person was certainly known to her because, while still a soldier, Carlo had served as a captain in the army of Pietro Strozzi during the siege of Siena, and, as we already know, Strozzi and the Salvi were very close. Clearly, then, Virginia must have come to know Carlo Carafa when he was a soldier in Siena and must have been fully aware that this was not a man given to Neoplatonic thoughts and visions of God.

It is more likely that when Virginia composed these sonnets she had the other Carafa cardinal in mind—Carlo's seventeen-year-old nephew, Alfonso Carafa. The complete opposite of his disreputable uncle, Alfonso (1540–65) was an educated young man who had studied Latin, Greek, and Italian literature under Giovan Paolo Flavio, "a man of great doctrine and much eloquence."[46] The only one of the Carafa suspects to survive Pius IV's revenge against Carlo and his cronies in

1560, Alfonso was fully rehabilitated and would probably have enjoyed a brilliant ecclesiastical career had he not died unexpectedly of a fever on 29 August 1565 at the tender age of twenty-five.

Another eminent cardinal whom Virginia Salvi complimented on his elevation that 15 March 1557 was Vitellozzo Vitelli (1531–68). Bishop of his native Città di Castello, Vitelli was a close friend of the powerful Cardinal Nephew Carlo Carafa, whom he followed in disgrace at the latter's downfall but managed to survive. In the conclave of 1559 Vitelli was a strong supporter of Cardinal Giovanni Angelo de' Medici (Pius IV), who rehabilitated him and gave him several important posts. A man with a passion for music, he was a patron of Giovanni Pierluigi da Palestrina and other musicians and artists of his time. Together with the Milanese Cardinal Carlo Borromeo, Vitelli headed a Tridentine commission to revise church music and personally oversaw musical reform in Rome in the 1560s. It is perhaps this highly refined aspect of Vitelli's personality, seriously committed to musical culture and to church reform, that attracted Virginia Salvi's interest in him when she addressed her sonnet to him (see Appendix). In it, Salvi compliments Vitelli's intellect and flatters him with the suggestion that he is *papabile*. She also credits him for her own efforts at literary fame by saying that he inspires her to write in a more lofty (and perhaps religious) tone. The reference to Vitelli's victory over the Hydra may well be a reference to his work against heresy and in favor of Catholic reform at Trent and in Rome.

A third recipient of Salvi's congratulatory sonnets was the Milanese cardinal Antonio Trivulzio the Younger (ca. 1514–59), bishop of Toulon (France), also raised to the purple by Pope Paul IV Carafa on 15 March 1557. Trivulzio served as governor of Perugia, prefect of the Segnatura, nuncio to France and to Venice, and legate *a latere* to King Henri II in an attempt to bring about peace between France and Spain. In her sonnet to him, Salvi praises not only his lofty mind and strong faith but also his family's eminent ancestry (see Appendix).

We have found no document (yet) that might tell us how these epistolary poems were received by the three new princes of the Church. The new cardinals must have had far greater and far more powerful figures to respond to than a Sienese woman living in exile in Rome, noble, learned, and talented though she might be. The only answers

Virginia ever received for her epistolary poetry were penned not by politicians or high prelates but by fellow literati: the Sienese count Annibal d'Elci, the Sienese nobleman Cav. Orazio Saracini, the Sienese erudite Lattanzio Benucci, the members of the Florentine Academy, and the Venetian poet and arbiter of language Pietro Bembo. Salvi's poems to these literati were concerned not with matters political or religious but with questions of love and Petrarchan affections. They were firmly grounded either in the tradition of complimentary poetry of mutual praise and respect or in the Petrarchan tradition of unrequited love and plaintive laments for the beloved's absence.

Petrarchan Verses

Virginia Salvi was, in fact, a competent composer of Petrarchan verse, a genre much favored by the literati of her time. To be admired and successful, a poet had to display both excellent technical competence and a solid knowledge of Italian poetic tradition, especially as it emerged from the love poetry of Dante and, most of all, Petrarch. Sincerity was a bonus but not a necessity. Given these criteria, Salvi certainly was seen as a successful Petrarchan poet, much admired by her contemporaries, so much so that already before 1551 she was praised by the members of the Accademia Fiorentina in a sonnet that was then published by the young Ercole Bottrigari (1531–1612), soon to become a noted *literato,* musical theorist, and composer:

> Donna immortal, che albergo chiaro et fido
> Sete di senno e di valore, e tanti
> Altri doni infiniti avete quanti
> Dar ne posson Parnaso, Delfi, o Gnido.
> Questi soli dal mondo errante e 'nfido
> Vi ponno allontanar, onde si vanti
> Siena di aver di cui si parli o canti
> Viè più che già di Penelope e Dido.
> Et non color a cui mentre volete
> Dar lode eterna in dolce alta armonia
> De le pregiate vostre rime accorte,

A voi fama acquistate e lor scorgete
Verso il Ciel per spedita e dritta via,
O di quelli e di voi felice scorte.[47]

———

Immortal woman, you are the clear and trusted home / Of
wisdom and worth, and you have / As many other infinite gifts /
As Parnassus, Delphi, or Knidos can bestow. // These alone,
from this errant and treacherous world / Can distance you, so let
Siena take pride / In having someone that is talked about and
sung / Much more than ever Penelope or Dido were. // And not
for those whom you seek to give / Eternal fame in sweet and
lofty harmony / With your worthy and discerning rhymes, //
[But] for yourself you gain fame, and them you guide / Toward
heaven along the quick and straight path, / O happy retinue for
them and for you.

Admittedly an "academic" sonnet, perhaps even composed by com-
mittee, the poem by the members of the Florentine Academy sings Vir-
ginia's praises not only for her poetry (with their references to Parnas-
sus and Delphi, both places sacred to Apollo) but also for her beauty
(through their reference to Knidos, sacred to Aphrodite/Venus). Mov-
ing abruptly from the ancient world to contemporary Siena, the acade-
micians suggest that Salvi's native city should be proud to claim a
woman more talked about than Penelope and Dido—two rather con-
fusing allusions, for although Penelope had always been seen as a para-
gon of wifely fidelity and chastity, Dido certainly had not, especially
after Dante placed her in hell in the circle of the lustful because she had
broken faith with her deceased husband (*Inf.* 5.85). Perhaps the Floren-
tine academicians were thinking not of Dido's moral faults but of her
regal virtues, thus pointing out that Virginia could be a queen that ruled
her people; or perhaps they were simply in need of a rhyme. In either
case, what the academicians were clearly trying to do was to praise Siena
through Salvi. In fact, as Virginia Cox points out, there are plenty of ex-
amples of "literate women serving as cultural figureheads for their
cities" or as "embodiments of civic cultural excellence."[48] The academi-
cians redeemed themselves, in part, in the sextet, where they alluded to
the power of poetry not only to immortalize great figures but also to

point the way to heaven. At this point Virginia's poetic persona sheds its previous classical allusions and becomes the *donna angelicata* of late medieval Italian tradition pointing (in this case, escorting) human beings to heaven.

Not to seem ungrateful or be outdone, Salvi responded *per le rime* with a sonnet of her own in which she asked the Florentine academicians to look kindly upon her and thus allow her to be remembered and become immortal because of their poetic attention:

Agli Accademici de Fiorenza

> Onor del Tosco e ben gradito lido,
> Saggi, leggiadri e valorosi Amanti
> Ch' in dolci rime i martir vostri e i santi
> Pensieri alzate al ciel con lieto grido,
> De la stessa virtù vi fate nido
> E vi togliete a questi amari pianti
> Del mal' oprato tempo, ove cotanti
> Sepolti sono e ove anch'io m'annido,
> Deh, mercè vostra, un raggio rivolgete
> De' vostri alti pensier ne l'alma mia,
> Acciò mi furi al Tempo et a la Morte.
> Pregio fra chiari spirti eterno avrete
> Di sì bell'opra, et ella non desia
> Altro per gire al ciel che vostre scorte.[49]

To the Academicians of Florence

Honor of the Tuscan and much welcomed land, / Wise, graceful, and valiant lovers / Who in sweet rhymes your sufferings and holy / Thoughts you raise to heaven with joyful cry, // You make a nest of your own virtue / And remove yourselves from these bitter tears / Of ill-spent time, in which so many / Are buried and where I, too, make my home, // Alas, out of pity, turn a ray / Of your lofty intellects toward my soul, / So that I may steal myself from Time and Death. // You will gain eternal merit among

eminent spirits / For such a beautiful work, and your soul wishes /
For nothing else in order to rise to heaven but your company.

The poem and the exchange are exercises in reciprocal flattery and
rather facile rhyming, but they do reflect discussions in contemporary
literary circles on the power of poetry to immortalize great beauty and
great deeds—a topic that was at the core of Alessandro Piccolomini's
sonnet on his pilgrimage to Petrarch's tomb. Virginia Martini Salvi now
adopts this topic and, in a passive, even submissive, feminine voice, begs
the male literati of the Accademia Fiorentina to grant her poetic im-
mortality. Although neither side mentions it, there is a clear allusion to
Alexander the Great's anguish and tears when, as he stood at Achilles'
tomb, he realized that to be immortalized he needed a great poet to sing
his praises—something that Achilles had in Homer but that he, Alex-
ander, lacked. Similarly, Virginia needs the approval of the Florentine
Academy to be immortalized as a poet.

Another, much more important *letterato* who exchanged verses with
Virginia Salvi was Pietro Bembo, who was instrumental not only in es-
tablishing the Tuscan idiom as the national language of the peninsula
but also in refining Petrarchan poetry to the point that the poetic and
linguistic movement he led took its name from him, *bembismo*.[50] Some-
time before 1547 and perhaps even before 1539, Salvi addressed a can-
zone to him, "Mentre che 'l mio pensier dai santi lumi" (While my
thoughts were resting / On those holy lights), in which she tells Bembo
(who has gone away on a mission) how much she misses him and would
like to see him again (see Appendix).[51] To drive the point home, Salvi
ends each of the five stanzas and the final *envoi* with the verse "Che 'l
mio cor lasso ogn'altra vista sprezza" (For my weary heart despises any
other sight), using it as a refrain to her lament. In the opening stanza she
tells Bembo how she wishes to be with him, as her thoughts are. In the
second she discloses that the "fair group" of "dear souls" she frequents
is a bore to her without him. In the third she describes how she wan-
ders along the meadows where he once walked, looking for his foot-
prints and asking the local nymphs and shepherds whether they have
any news of him. In the fourth she admits that there is no point in look-
ing for reflections of him in other people because he far surpasses all of

them. In the fifth she acknowledges that her beloved has had to depart in order to pursue "more praiseworthy deeds" and accepts this fact, even wishing him success in his battle against the enemy, but she remains unhappy and inconsolable at the separation. In the *envoi* Salvi turns to the canzone itself and invites it to "fly past the mountains / And quickly go to my beautiful, clear sun / And say this to him: / "'CINZIA dwells in such bitterness far from you / That her weary heart despises every other sight'" (vv. 56–60).[52] A declaration of this sort to a cardinal might perhaps seem inappropriate, but in truth Salvi does not mention love in the canzone; she seems instead to suggest that she is bound to Bembo by an intellectual or spiritual bond, not a physical or emotional one. In this meeting of minds Bembo is her inspiration and guide, far surpassing the other "minds" left in town. Given that the poem must be dated to before 1547, and thus written at a time when Salvi was still residing in Siena, we assume that Virginia must be referring to Bembo's departure from Siena (not Rome) and that the other nymphs and shepherds must refer to the *literati* in Siena. And, in fact, the canzone does seem to indicate a direct personal knowledge of each other. For the moment we have not been able to determine precisely when Bembo and Salvi might have met, but perhaps it was in Siena in 1539 when Bembo stopped there on his way to Rome to receive the red hat from Pope Paul III Farnese.

In his response to Salvi, "Almo mio Sol, i cui fulgenti lumi" (see Appendix), Pietro Bembo repeats her rhymes and her refrain. He calls her Cinzia, asks her, "Why do you still wear yourself down with tears?" (v. 4), and consoles her by telling her that his thoughts travel easily back to her and that this gives him much pleasure. He excuses his absence by saying that it is caused by his "desire for lofty deeds, / which should please you" (vv. 46–47) and then encourages her to "Temper, therefore, every sigh / CINZIA my sweet, and break off your pain already" (vv. 53–54). In the *envoi* Bembo tells the canzone to "go back over the mountains / and piteously say to my beautiful sun / these four words: / Live, gentle CINZIA, without any bitterness, / For my unfortunate heart despises any other sight" (vv. 56–60). Bembo's canzone is thus an elegant and polite response to an admirer's flattery, a compliment to her by virtue of his reprise of her rhymes, thoughts, and refrain. The affec-

tion voiced in both poems is not love, Petrarchan or otherwise, but a genteel expression of admiration and respect couched in a pastoral poetic language that, more than anything else, speaks of communal membership in a society of "nymphs and shepherds"—the poetic and intellectual network of contemporary vernacular *literati*.

Salvi and Music

Salvi belonged in this network not only because she had an extensive poetic output and many learned connections but also because she knew how to speak the language of Petrarchan poetry and how to play with it. In the octave sequence "Da fuoco così bel nasce il mio ardore" (My passion is born of such beautiful fire; see Appendix) she displays both her imagination and her facility in manipulating the tradition by composing a fourteen-octave sequence that systematically mines Petrarch's sonnet "Pace non trovo e non ho da far guerra" (*RVF* 134)—each of her octaves ends with the next verse from Petrarch's sonnet, thus incorporating a full reprise of Petrarch's poem inside her own poem.[53] By thus mining Petrarch's sonnet, Salvi demonstrates not only her command of the tradition and her poetic skills but also her familiarity with the Spanish technique of the *glosa* (gloss), which was becoming popular in Italy, with a number of Italian poets "glossing" not only Petrarch's lyrics from the *Rerum vulgarium fragmenta* but also Ariosto's octaves from the *Orlando furioso*.[54] Maria Luisa Cerrón Puga points out not only that this was a poetic development that ran contrary to the usual flow of influence (it went from Spain to Italy and not vice versa) but also that it was closely connected to musical circles on the Italian peninsula.[55]

And in fact Salvi's gloss of Petrarch's *RVF* 134 was set to music by the most famous Roman composer of the time, Giovanni Pierluigi da Palestrina (1525/26–94), who arranged her fourteen octaves as a set of fourteen madrigals for four voices.[56] Like the poetic text on which it is based, Palestrina's work is deeply indebted to a predecessor, in his case Ivo Barry (fl. 1525–50), a French singer and composer at the court of popes Clement VII and Paul III. In the music for each final line of Salvi's fourteen octaves, where Salvi cites directly and sequentially each

of the fourteen verses from Petrarch's sonnet, Palestrina cites directly the music from Barry's own setting of *RVF* 134.[57] Mary S. Lewis refers to Palestrina's setting as "monumental," and James Haar calls it an "exceptional effort," pointing out that while "Palestrina is famous for his parody technique in the Mass; as yet not many examples of this technique applied in other genres are known."[58] Maria Luisa Cerrón Puga calls Salvi's poem a most eminent *(más relevante)* example of a gloss in Italian and then points out that Palestrina's musical setting of that gloss is not only unusual (given that he composed mainly sacred music), but also exceptional, even within the context of his secular music production, because, although he composed many madrigals based on texts by Petrarch, Bembo, Ariosto, Boccaccio, and other Italian poets,

> none of his compositions displays the complexity of this fourteen-part madrigal cycle that anticipates the dramatic forms that will be developed in subsequent years and will culminate in Monteverdi's *Orfeo,* the first modern opera, mounted in Mantua in 1607. This complexity derives from the fact that he used the technique of the *glosa a la española* in the text (Virginia Salvi remakes Petrarch's sonnet), and that of the *parodia* in the music (Palestrina remakes Ivo's madrigal); the exercise reveals, furthermore, [Palestrina's] effort to find a musical equivalent for verbal antitheses, an indication that Palestrina had appropriated the humanist principle of a necessary fit between text and music that characterizes the Italian madrigal in its maturity.[59]

Not surprisingly Palestrina's setting of Salvi's *glosa* met with great success. The work was published twice by the Venetian printer Antonio Guardano, first in 1557 and then in 1571, as an added piece in *Il secondo libro de' madregali a quatro voci,* a collection of madrigals by the Flemish composer Cipriano de Rore, active in Florence and Parma in the 1540s. In 1569 it was published by the organist and composer turned publisher Claudio Merulo da Correggio (1533–1604).[60]

The young Giovanni Pierluigi had arrived in Rome in 1551 when Pope Julius III Del Monte took him from Palestrina and appointed him chapel master at the Cappella Giulia, the papal choir at St. Peter's

Basilica. Other similar appointments quickly followed at St. John's Lateran and Santa Maria Maggiore, thus making the young composer not only extremely successful but also immensely popular and influential. His musical rendition of Salvi's octave sequence can be dated between 1551 and 1557, possibly more toward the later than the earlier year.[61] His setting of the poem leads us to believe that Virginia Salvi's poetry was circulating in Rome in the 1550s and that Salvi herself may have known Palestrina personally, perhaps through mutual contacts such as Cardinal Vitellozzo Vitelli, a great patron of music and of Palestrina in particular, or because of shared cultural interests.[62]

Palestrina was not the only sixteenth-century composer to set Salvi's poem to music — the Flemish composer Jean de Turnhout (ca. 1550–1614) set at least one of the fourteen octaves from Salvi's "Da fuoco così bel nasce il mio amore" to music (the twelfth, "Misero stato degli amanti in quante") and published it in Antwerp in his *Il primo libro de' madrigali a sei voci* (1589), which he dedicated to Alessandro Farnese (the son of Margaret of Austria), then governor of the Spanish Netherlands.[63] Because of his position as singing master *(maître de chant)* at the royal chapel in Bruxelles and his connections with the Spanish court, Jean de Turnhout was, for more than twenty years, the foremost musician in the Spanish Netherlands. In the words of his recent biographer, he may not have been one of the greatest musicians of his time, but he was nonetheless "a capable contrapuntist, even if not always inspired. An enlightened technician and a man with a structured mind both in overall composition and in refinement of the details."[64] Both Cipriano de Rore and Jean de Turnhout were Flemish composers in the service of the Farnese — Rore served as chapel master for Margaret of Austria first in the Netherlands and then in Parma, while Turnhout served in the same capacity for her son, Alessandro Farnese, in Bruxelles. It is tempting to imagine a Salvi connection with the two Flemish composers through Margaret of Austria (who was born in Flanders), but unfortunately no documentation has yet been found to support it. Nonetheless, the Flemish/Farnese connection should not be dismissed, for there are other tantalizing indicators to support it. Cerrón Puga points out that there were good contacts between Italian and Spanish musicians, thanks, in part, to the constant travels in Europe of Emperor

Charles V, who was always accompanied by his *ministriles,* or instrumentalists;[65] so it is not unfeasible that when his daughter Margaret of Austria and his grandson Alessandro Farnese served as governors of the Netherlands they would have continued to foster such musical contacts, leading, as they did, to de Turnhout's setting of an octave by Virginia Salvi.

Palestrina and Turnhout were not, apparently, the only musicians to set Virginia Salvi's poetry to music. In his *Dialogo della musica* (1544), which is set in Piacenza the previous year, the Florentine literato Anton Francesco Doni describes how, during the second day of discussions, Count Ottavio Landi of Piacenza asked for permission to speak of Virginia Salvi, "a beautiful and virtuous woman," and then did so by singing his own improvised musical rendition of an eight-octave sequence composed by Salvi while accompanying himself on the *viuola,* a bowed string instrument (though it is not clear whether this would have been a viola da gamba, a viola da brazzo, or a vielle). Doni does not provide the music for the octave sequence, as he does for most of the other pieces performed in the dialogue, which suggests that Landi extemporized his musical rendition of Salvi's poem on the spur of the moment. The octave sequence begins with the lines "Mentre che i dolci lumi onesti e santi / Rivolge in me la cara vita mia" (While he, who is my life, turns / his sweet, holy, honest eyes toward me; see Appendix) and is replete with Petrarchan words and phrases, the most prominent being "l'infinita bellezza e poca fede" (the infinite beauty and little faith), a reprise of *RVF* 203, v. 5, which Salvi uses as the recurring final line for every octave in the sequence and which she also picks up, in brief, for the first line of octaves 2 and 3.

Ottavio Landi, who proposed Salvi's poem and sang it impromptu, was an amateur musician and professional diplomat/soldier. He came from one of the four most important noble families of Piacenza, a city that in 1544 was part of the Papal States but that, in 1545, was separated from them by Pope Paul III Farnese so that it might be turned into a duchy for his son Pierluigi. While not everyone in Piacenza was happy with Farnese rule, Ottavio Landi seems to have been a loyal subject of the new dukes and to have maintained a close connection with the ruling family, eventually serving as a captain in Flanders under the

leadership of Alessandro Farnese (1580s)—even though one of his own relatives, Ortensio Landi, had taken an active part in the assassination of Alessandro's father, Duke Pierluigi Farnese (1547).

Doni's *Dialogo della musica* is of interest to us because it provides further confirmation that Virginia Salvi's poetry circulated widely in Italy. It also offers a suggestion of how her poetry might have moved from Italy in 1544 to the Spanish Netherlands in the 1580s: by way of Margaret of Austria, her son Alessandro Farnese, or Ottavio Landi himself, all of whom are closely connected with both regions. All three can be situated in Bruxelles in the 1580s when Jean de Turnhout was chapel master at the Spanish vice-regal court. Doni's dialogue also reveals that Salvi's poetry was set to music not only by professional musicians, such as Giovanni Pierluigi da Palestrina in Rome, who may have been her personal friend, and Jean de Turnhout in Bruxelles, whom Salvi most probably never met, but also by amateurs such as Count Ottavio Landi in Piacenza. While Palestrina's and de Turnhout's settings were carefully planned musical compositions, Landi's was probably an improvised rendition similar to the one Doni mentions a little later in the dialogue when he says that Selvaggia, the only woman participating in the discussions, asked Landi to accompany her on his instrument while she extemporized a musical rendition of four sonnets in praise of Madonna Isabetta Guasca.[66]

The Dissemination Networks for Salvi's Poetry

While the printing press clearly contributed to Virginia Martini Salvi's fame as a poet, especially in the wake of her participation in Lodovico Domenichi's anthology of 1559, the success that her octave sequence, in particular, enjoyed in Italy and the Spanish Netherlands suggests that a network of personal contacts was still the most effective way for her poetry to move past the city walls of Siena (and later, Rome) to reach the literati and musicians who consumed it. The poetic exchanges we have already discussed between Alessandro Piccolomini and the five Sienese women who responded to his sonnet on Petrarch's tomb, or between Benedetto Varchi and Emanuele Grimaldi, or Virginia Salvi and

Pietro Bembo, attest to the practice of sharing and circulating the works of friends. The community of cultural operators not only passed these works to one another but also discussed them publicly, as we saw with Piccolomini's presentation at the Academy of the Infiammati in Padua of Laudomia Forteguerri's sonnet "Ora ten vai superbo, or corri altiero."

With Virginia Salvi, we can observe a similar network of personal contacts operating to disseminate her poetry throughout Italy and beyond. In the case of the extemporaneous singing of her poems at a soirée in Piacenza, we can hypothesize an interesting transmission trail from the author in Siena to Doni in Piacenza. The path would start with Salvi and her fellow Sienese, Alessandro Piccolomini, who, while a student at the University of Padua, was receiving and responding to Salvi's sonnets, as we saw in chapter 1. From Piccolomini the trail would lead to Lodovico Domenichi (b. 1515), a fellow student in Padua, who was there to study law but spent much of his time with *literati* such as Alessandro Piccolomini and other future members of the Accademia degli Infiammati. On his graduation and return to his native Piacenza, where he began to practice as a notary (1539–43), Domenichi continued to nurture his literary interests by founding the Accademia degli Ortolani (the Gardeners), very much modeled on its counterpart in Padua. One of the first members of the academy was the Florentine Anton Francesco Doni, who was in Piacenza at that time to study law. "Il Semenza" (the Seed), as Doni was known among the Ortolani, had befriended local cultural leaders such as the notary Domenichi, the nobleman Ottavio Landi, and the organist Claudio Veggio (b. ca. 1505). Eager to demonstrate his intellectual and cultural qualifications, Doni composed the *Dialogo della musica,* which featured these prominent local figures as interlocutors but also highlighted the poetic and musical works of artists from further away. One of them was the Sienese Virginia Salvi, who as yet was little known in literary circles in Italy but who may not have been completely unknown to the members of the Academy of the Ortolani, thanks, in part, to their connections with the Infiammati of Padua.[67]

While Piccolomini might have been the first node in these fairly linear three degrees of separation from Salvi to Doni, and thus the essential first promoter of her poetry (excluding Salvi herself), Domenichi was certainly her most influential advocate. Not only did Domenichi

probably serve as the link that transferred her work from Padua to Piacenza, but he also provided Salvi with the broad platform that would spring her into a much larger arena—the *Rime diverse d'alcune nobilissime, et virtuosissime donne* (Lucca, 1559). His groundbreaking anthology of women poets brought Salvi's poetry to the attention of the wider Italian reading public and illustrated both the quantity and the versatility of her output. Of the fifty-two women represented in the anthology, Virginia Salvi tops the list of contributors with forty-five original works, an amazing number considering that the average contribution per person is a mere six poems. What is equally surprising is that well-known contemporary women poets, whose works would have been readily available to Domenichi and therefore could have been easily included in the anthology, do not come even close to the number of contributions from Salvi's pen: Vittoria Colonna, for example, by far the best-known and most respected woman poet of that century, is represented by twenty-five poems, a small fraction of her works available in print and in manuscript at the time; Veronica Gambara, another prolific poet, has only twenty-two works in the anthology; and Gaspara Stampa, author of a *canzoniere* with 311 poems (1554), is represented by only five poems. Marie-Françoise Piéjus suggests that Domenichi's extraordinary focus on Salvi's poetry, "the only important and coherent subgroup" in the collection, reflects the high esteem he had for her work and her poetic abilities.[68] Or perhaps, as Diana Robin suggests, Domenichi was much more interested in presenting his readers with new poetic voices, thus giving previously unpublished women poets an opportunity to appear in print and see their work disseminated to a wider reading public.[69] Vittoria Colonna, with eight solo editions of her poetry published before 1559, certainly did not need to be introduced to the reading public, so a small sampling of her many poems was more than sufficient for Domenichi's purpose. Lesser-known women poets, on the other hand, needed exposure, which is what Domenichi's anthology offered them. And Domenichi certainly did this, introducing an astonishing number of previously unknown, or little-known women poets to the larger reading public. Still, the amount of poetry by these new voices that Domenichi presents does not even approach the sheer volume of poetry by Virginia Salvi. Domenichi's effort on behalf of Virginia Salvi must have paid off, for Salvi's poems continued to appear in print both in

the sixteenth century and, periodically, in the collections of Cinquecento verse that were published in the centuries that followed.

———

In her time, Virginia Martini Salvi's poetry crossed the Apennines and the Alps to reach Rome, Piacenza, Paris, and Bruxelles, where it was read and performed in literary circles and possibly even at court. Her works attracted the attention not only of fellow literati who complimented her on her skills but also of political figures who found her writings to be both subversive and dangerous. Her Petrarchan poetry inspired at least two professional musicians and one amateur to set it to music in compositions that were in some cases spontaneous improvisations and in other cases carefully wrought and complex pieces of musical showmanship and virtuosity. In spite of all this contemporary success and recognition, subsequent critical judgment has not been generous with Virginia Martini Salvi. Scholars from the seventeenth to the nineteenth centuries limited themselves to merely mentioning Salvi's name in their catalogues of women writers and to praising her facility with verse in what could easily be interpreted as backhanded compliments. They did not comment specifically on any of her verses or elaborate on her life—a clear indication that Salvi was seen as a curiosity whose time had passed, as an "also ran" in the course of Italian literature. Twentieth-century scholars have also universally ignored Virginia Martini Salvi and her works.[70] This is unfortunate because, although her poetry may not have stood the test of time, it does deserve greater attention from scholars for the various contexts into which her rhymes were set, the technical skill evident in her verses, her obvious interest in experimenting with new poetic forms, and the insights her writings offer into a woman's literary connections and political maneuvering. Salvi's biography and works reveal that not all women poets pined away for unrequited or lost love or composed pleasant and polite *poesia d'occasione*—some were deeply engaged in the current political situation and actively cultivated personal connections with the cultural establishment of their time.

Epilogue

*Non di picciolo biasmo degno io mi farei presso coloro [che]
lo sanno non facendo noto al mondo la valorosita d'alcune
Gentildonne Sanesi meritevoli di eterna lode.*
— Stefano Guazzo, *Cronica* (1553)

———————

The flowering of women poets in Siena in the mid-sixteenth century is both exceptional and exciting. Certainly other Sienese women, in previous times, had contributed to the intellectual life of the city and, in some cases, Italy—the most famous being Caterina Benincasa, better known as Saint Catherine of Siena (1347–80), whose hundreds of letters and *Dialogue of Divine Providence* are among some of the most important literary and religious documents of the late fourteenth century. The sudden appearance on the literary landscape of Siena of an entire group of women who engaged not only with fellow kinswomen but also with male and female literary, political, and ecclesiastical figures is, however, a novelty in the Italian cultural scene. The closest parallel one might draw is with the circle of d'Avalos and Colonna women on the island of Ischia in the 1520s and 1530s, recently studied by Diana Robin in her groundbreaking volume *Publishing Women: Salons, the Presses, and the Counter-Reformation in Sixteenth-Century Italy* (2007).[1] As I had occasion to write before,

215

It was here [on Ischia] that in the 1520s–30s Costanza d'Avalos, duchess of Francavilla (d. 1541), established a salon frequented by learned men and intelligent women that fostered the intellectual growth and development of four incredible young women closely related to one another—the sisters Giovanna d'Aragona Colonna (1502–75) and Maria d'Aragona d'Avalos (1503–68) and their sisters-in-law Vittoria Colonna d'Avalos (1490–1547) and Giulia Gonzaga Colonna (1513–66). Costanza's salon was also the catalyst that in the 1530s–40s spawned five different salons in cities such as Naples, Rome, Viterbo, Ferrara, and Milan/Pavia, each directed by one of the founding d'Avalos/Colonna women and each thoroughly engaged in the cultural, religious, philosophical and political debates of the time. Each of these salons also served as a cell for the dissemination throughout Italy of religious reformist ideas drawn primarily from Juan de Valdés, but also, to a lesser degree, from transalpine reformers such as Jean Calvin or Martin Luther, ideas that the Roman Church soon declared heretical.[2]

Influential and groundbreaking as these "salons" (to use Diana Robin's word) might have been, they served primarily as incubators and catalysts for the intellectual and spiritual development of their participants; they did not inspire their female members to engage poetically with their male counterparts and thus to produce their own corpus of poetry—except, of course, in the case of Vittoria Colonna, who, alone of the four women, did compose poetry and did see it circulate widely in her own time. Vittoria's poetic works were published as a collection first in 1538 and then twelve more times before her death in 1547, on each occasion apparently without her authorization.[3] Vittoria is thus an exception in that network of women emanating from Costanza d'Avalos's "salon" on Ischia, so she remains a unique case among the other female participants in that special Neapolitan moment.

The case for Siena is different. Admittedly, the Sienese women did serve as catalysts for men's projects, such as the group translation of Virgil's *Aeneid* 1–6, and as participants in male-authored dialogues, such as Marc'Antonio Piccolomini's "Se è da credersi che una donna . . ."; but, for the most part, they remained firmly anchored to their traditional role as muses for men's poetry and as dedicatees of men's writings. At the

same time, however, we note that some of these Sienese women contributed in a new and significant manner to the cultural life of their city by participating, firsthand and with unusual energy, in the literary process, composing verses of their own and sharing them with their male counterparts. So we find in Siena the emergence of a poetic dialogue between men and women, and between the women themselves, that was not present on Ischia or, as far as we can tell at this time, elsewhere on the peninsula. What becomes clear, then, is that in Siena we are dealing not with a virtual "salon," as Diana Robin has described for Ischia, but with a virtual "academy" of women. Forteguerri's circle of women listening to her expositions of Dante's *Paradiso* could certainly be compared to the circle of men at the Academy of the Infiammati in Padua listening to her fellow countryman and admirer Alessandro Piccolomini expounding on poetry. And certainly the variety of interests and pursuits evident among the women of this virtual Sienese "academy" also reflects the variety of interests evident in the Paduan or Florentine organizations, from Aurelia Petrucci's interest in Leone Ebreo's Platonic philosophy to Laudomia Forteguerri's interest in astronomy; from Virginia Martini Salvi's interest in current Sienese politics to her kinswoman Virginia Luti Salvi's (possible) interest in religious reform; from Camilla Piccolomini de' Petroni's interest in pastoral imagery to Girolama Biringucci de' Piccolomini's interest in the restorative powers of poetry. The diversity of interests evident within this small group of women is, in fact, quite astonishing.

Sarah Gwyneth Ross has recently pointed out that, for looking at early modern women, the "older interpretive models are proving intractable, especially the argument that early modern women writers were considered 'exceptional' and transgressive figures, whom society consigned to the margins." As she then comments, "This is the moment to reassess that claim. Within the last year (as I write), several studies focusing on the sixteenth century have demonstrated that women writers, far from being marginalized, in fact played authoritative roles in contemporary 'salons' and 'literary circles'—a defining characteristic of which was the collaboration of male and female colleagues."[4] My examination of Sienese women writers is part of this new perspective on early modern women. Although the women I examine were, indeed, "exceptional" because of their social background and their accomplishments, and although some of them were clearly "transgressive"

because of their actions against the state or their (supposed) choice of love interests, they were certainly not "marginalized" by their male peers or their society. Laudomia Forteguerri, for example, who should have been a prime candidate for marginalization on several counts, was never ostracized, ignored, or discounted, but was in fact constantly praised by her male contemporaries and given a leadership role by her female contemporaries. The Sienese women examined in this volume were, by virtue of their intelligence, talent, and social class, clearly "exceptional," and some, by virtue of their actions, were also clearly "transgressive," but they were also fully integrated in their society, and as part of that society they participated in, and contributed to current discussions on such exalted topics as poetic fame and in such critical debates as those concerning the politics of the time. The personal *engagement* of Virginia Martini Salvi, for one, in the dirty business of politics would have made Jean-Paul Sartre proud.

Inevitable restrictions of time, space, and resources have obliged me to focus my study primarily on one emblematic episode (the *Tombaide* of 1540) and on three very special women whom I have chosen as representative of their wider group (Aurelia Petrucci, Laudomia Forteguerri, and Virginia Martini Casolani Salvi). This, however, has been to the disadvantage of the other women composing poetry in Siena at this time.

Cassandra Petrucci

First and foremost among these other women is Aurelia's kinswoman Cassandra Petrucci, a prolific poet and an elusive woman. Fourteen of her poems were published in Lodovico Domenichi's collection of 1559—twelve sonnets, one madrigal, and one sestina (see a sample in the Appendix).[5] They reveal that she was a poet with a fine poetic sensibility and good poetic technique. Many of her works are love sonnets addressed to men and are firmly based on the standard images and motifs of current Petrarchist poetry. Her sestina "Spargete a terra omai le smorte fronde" (Scatter on the ground your withered leaves) displays a fine command of language and technique, while her madrigal "Com'esser può che quel ch'io più vorrei" (How can it be that what I most desire) plays on sounds and rhythms that cry out for a musical setting.

The difficulties with Cassandra are to be found not in her poetry but in her biography—as I indicated in chapter 2, at that time in Siena there were five different women by that name, and it is not possible, at this moment, to determine which one might have been our poet (assuming that only one of the five Cassandras wrote poetry, which may not in fact be the case). Establishing Cassandra's biography is, therefore, a difficult problem that has stumped previous and present scholars but perhaps will be resolved by future ones.

Lucrezia Figliucci

Another woman worthy of further note is Lucrezia Figliucci. Six of her poems were published in Domenichi's collection of 1559 and a seventh in the *Parnaso italiano* of 1847 (see a sample in the Appendix).[6] All are sonnets that conform to contemporary Petrarchist tastes. Nothing is currently known about Lucrezia, not even her birth or marriage information. The Figliucci belonged to the Monte del Popolo and counted several important men in their number in the sixteenth century, among them Figliuccio Figliucci, a protégé of Pope Paul III Farnese, who made him bishop of Chiusi (r. 1554–58); Felice Figliucci (1518–95), a humanist, theologian, and man of letters who, in 1556, entered the Dominican order at San Marco in Florence and assumed the name of fra Alessio; and his nephew Fabio (or Flavio) Figliucci, a member of the Sienese Accademia degli Accesi and a middling *letterato* in late sixteenth-century Siena. We do know that Lucrezia addressed one of her sonnets to Cassandra Petrucci, who responded to her rhyme for rhyme, so there clearly were personal connections between the two Sienese women that might be examined further.[7]

Francesca B.

Domenichi's collection also included four sonnets by Francesca B. (see Appendix), a woman whose identity was kept hidden behind her initial. The eighteenth-century scholar Francesco Saverio Quadrio speculated that the anonymous poet might be Francesca di Agostino Dardi, who married Giambattista Baldi and was praised by Ludovico Domenichi in

his *Nobiltà delle donne* (1549) as a clear crystal mirror that gives light to all who look at it because, in gazing upon her, one sees a chaste soul contained in a beautiful body.[8] Quadrio's compliment was directed not only at Francesca but at two other women, Atalanta Donati and Lisabetta Capacci, and does not really contribute much to furthering our knowledge of this elusive and mysterious Sienese poet.

Atalanta Donati

Of the two other women complimented by Quadrio, Lisabetta Capacci apparently did not compose any poetry, but Atalanta Donati did. Two extant sonnets are attributed to Atalanta, one in Domenichi's collection of 1559, and a second still unpublished in a manuscript in Siena (see Appendix).[9]

Like Francesca B., Atalanta remains a mysterious figure. In some collections she is identified as "Atalanta Donati," while in others she is known only as "Atalanta sanese." Archival and antiquarian sources tell us that Atalanta Donati was born in 1530, the daughter of Bartolomeo Donati; she married Daniele di Benedetto Vieri in 1558 and died in 1588.[10] The seventeenth-century Sienese antiquarian Isidoro Ugurgieri Azzolini says that "she was given to the world as an object of wonder and amazement, so richly was she endowed with a most lofty wit and adorned with very beautiful virtue; when she spoke, she stole people's hearts; and those praises that mythical writers bestowed on [the ancient Greek maiden] Atalanta who surpassed everyone else in a race well and truly could be bestowed on her [the Sienese Atalanta], who with the flight of her sublime understanding surpassed every other [woman]."[11] In the eighteenth century Giovan Antonio Pecci said that Atalanta composed Tuscan verses with fine style and graceful naturalness.[12] No one, however, has been able to provide a fuller biography for her or a more profound critical analysis of her works.

Silvia Piccolomini

Silvia Piccolomini bears a very famous Sienese name but remains a complete mystery to us, as she was to previous scholars. When Ludovico

Domenichi published her sonnet "Ben' ho del caro oggetto i sensi privi" (My senses are, indeed, deprived of my beloved; see Appendix), there were two different women by that name in Siena. One was Silvia di Pierfrancesco Piccolomini, who was born in 1526 and in 1541 married Innico Piccolomini, Duke of Amalfi; the other was Silvia di Girolamo Carli Piccolomini, who was born in 1542 and in 1572 married Curzio di Giovanni Turamini.[13] Wishing to determine which of the two women composed the sonnet, one might be tempted to assume that it was the thirty-three-year-old Silvia di Pierfrancesco rather than the seventeen-year-old Silvia di Girolamo, but one cannot be sure. In 1847 Francesco Trucchi attributed another sonnet to Silvia Piccolomini, "S'al tronco sol d'una spezzata lancia" (If to the stump, alone, of a broken lance), a poem that supposedly refers to when, in 1527, Francesco Maria della Rovere, Duke of Urbino, was placed in command of the papal armies that were to defend Rome against the advancing Imperial forces led by Charles de Bourbon. This, however, is a very unlikely attribution, given that Silvia di Pierfrancesco would have been only one year old at that time and Silvia di Girolamo was yet to be born.

The one sonnet that is attributed to Silvia Piccolomini as early as Domenichi's 1559 collection, "Ben' ho del caro oggeto i sensi privi," laments the absence of the beloved and speaks of the lover's burning passion for the beloved that, strangely enough, grows stronger with distance. Domenichi's attribution of this sonnet to Silvia Piccolomini is, however, contested. Four years earlier, in the collection *Rime di diversi in morte di Donna Livia Colonna,* the sonnet was published under Flaminio Orsini's name (with some gender variations in the pronouns to suggest a male lover and a female beloved), while a few years later, in Atanagi's *De le rime di diversi nobili poeti toscani* (1565), it was attributed instead to Annibale Caro (where it has generally remained).

Ermellina Arringhieri de' Cerretani

A somewhat better-known Sienese woman poet is Ermellina Arringhieri de' Cerretani, who was born sometime in the late 1510s or early 1520s to Alessandro di Francesco Arringhieri and Cassandra di Jacopo Petrucci, the niece of the Magnifico Pandolfo Petrucci. Through her

mother, Ermellina was thus second cousin to the poet Aurelia Pe-
trucci, whom we met in chapter 2. Ermellina could, conceivably, also
be the daughter of the poet Cassandra Petrucci (whom we have not yet
been able to identify precisely). The Arringhieri belonged to the Monte
del Popolo and came originally from Casole d'Elsa, where they owned a
palazzo on the town's main street, across from the Palazzo Pretorio,
where the town's magistracies had their offices. The family palazzo
was sold to the Casolani—Virginia Martini Salvi's birth family—who
owned it already by the mid–sixteenth century. The palazzo now bears
the Casolani's name, but the Arringhieri crest can still be seen in its
charming inner courtyard dating from the sixteenth century. In 1541
Ermellina married Aldobrando di Pietro Cerretani, bringing with her a
dowry of 2,500 florins. Aldobrando (b. 1511) was an erudite man with
an interest in Latin and Italian letters. We met him in chapter 1 as one
of the men who translated part of Virgil's *Aeneid* into Italian (1540);
Cerretani dedicated his translation of book 5 to the widowed Sienese
noblewoman Girolama Carli Piccolomini (see chapter 1). Aldobrando
and Ermellina had at least three children together: Pietro Maria (b. 1543),
Agnese Girolama (b. 1546), and Mario Girolamo (b. 1547).[14] Although
Giovanni Mario Crescimbeni says that Ermellina wrote "with grace
and charm" (con grazia e leggiadria),[15] we have only one poem by her, a
thirteen-verse madrigal "Già per morir del mortal lume intorno" (Ready
to die, around the deadly light) that describes how a moth suddenly
changes its course toward the fire in order to fly, instead, toward the
poet's brighter *Dea* (goddess), who, however, is accustomed to better
prey—a novel and charming variation on the old theme of a moth's at-
traction to a burning flame (see Appendix).

Pia Bichi

We have only one extant poem from Pia Bichi as well—the sonnet
"O di lagrime mie fida fontana" (Oh faithful fountain of my tears). In
it Bichi laments her weak poetic skills and calls upon the laurel tree to
help her, a young fledgling, in the art of poetry. Bichi's sonnet elicited
a response from the Genoese poet Ortensia Scarpi, who answered

rhyme by rhyme with the sonnet "Da due bei colli una chiara fontana" (From between two beautiful hills a clear fountain), reassuring Pia of her poetic skills and urging her to let her light shine forth upon the hillsides, possibly a reference to the hills of Siena (see Appendix).

Nothing is known about Pia Bichi's life, but the eighteenth-century Sienese erudite Giovan Antonio Pecci says that, because of her noble family's poverty, she was obliged to marry a *speziale* (druggist) from the Restori (or Rettori) family and was thus unable to devote herself to poetry because she was obliged "to work with her hands."[16] As with most of his other information, Pecci does not provide references to his sources, a particularly disappointing lacuna in this case because if we had the original documents we would have at our disposal a fascinating source for a better understanding of how poetry was viewed as a leisure activity for noblewomen but not for "working women." There may be a reference to Bichi's difficult economic situation in the third stanza of Bichi's sonnet, where she laments:

> Minerva al nascer tuo farti felice
> Promise, e Cerer giunse a te in quell'ora,
> Le cui vestigia a te cercar pur lice.
>
> ———
>
> At your birth, Minerva promised to make you / happy, and Ceres came to you at that time, / whose signs you are obliged to seek.

Much as Bichi would like to dedicate herself to the intellectual pursuits patronized by Minerva, goddess of wisdom and poetry, she is obliged instead to follow the interests of Ceres, the Roman goddess of planting and agriculture. In light of this interpretation, Scarpi's response sonnet, replete with references to rich objects—marbles, alabasters, Oriental gems, a golden vase, a beautiful treasure—may appear somewhat insensitive, but it does offer a consoling thought in the suggestion that Bichi's misfortune is but an oversight on the part of Nature:

> Fontana ben ti puoi chiamar felice
> E sol natura a te mancò in quell'ora
> Che stato non ti diè d'imperatrice.

You can rightly call yourself a happy fountain; / the only thing
Nature did not give you at that time / was the rank of empress.

In the early nineteenth century the anonymous editor of *Delle illustri
donne italiane* asserted that Bichi was "a learned and genteel woman, but
her poetry . . . was already showing the vices of the following century
that, infiltrating into Italian letters, damaged its [good] taste and nearly
made them barbarous."[17] The editor may, in fact, be reacting to Bichi's
hermetic imagery and message, which may have been clear to her con-
temporaries who were aware of her precarious economic situation and
its impact on her opportunity to write but were undecipherable for
subsequent generations.

Onorata Tancredi Pecci

Onorata Tancredi Pecci, on the other hand, was blessed by Nature not
only with the leisure time available to wealthy noblewomen but also
with physical beauty, poetic skills, and ready wit. Lodovico Domenichi
recalls how "in a gathering of gentlewomen and worthy gentlemen the
conversation had turned upon a Sienese gentlewoman generally reputed
to be beautiful and very proper, who was praised by everyone as she
deserved; but one man, moved either by a desire to be contrary or by
some rejection he had received from her, charged her with vanity and
frivolity; at which point Madonna Onorata Pecci, who was present, im-
mediately said: 'Now, if you take vanity away from women, what will be
left for them?' (A modest and most virtuous gentlewoman.)"[18]

Onorata was born in 1503 to Girolamo Tancredi and Donaddea di
Mariano Spannocchi. In 1522 she married Benvenuto di Giulio Pecci,
scion of the powerful Sienese family, counts of nearby Percena Castello,
bringing with her a dowry of 2,200 florins.[19] Three years later, in 1525,
the young and aspiring *literato* Agnolo Firenzuola praised her in his
"Epistola in lode delle donne" (Letter in praise of women) addressed
to the Sienese erudite Claudio Tolomei. In it, Firenzuola described Pecci
as a woman of great intellect and profound philosophical understand-

ing, saying: "I also know, Messer Claudio, that you have told me on several occasions that your fellow Sienese Madonna Onorata Pecci discusses so discerningly the most obscure points of philosophy, that the most refined people of that city, aside from enjoying it, are also greatly amazed: nor has anyone ever spoken to me about her (and many people have) without depicting her to me as an equal to my Madonna Gostanza in every sort of virtue."[20]

In spite of what Firenzuola said about her, however, there is no evidence of any philosophical interests in either of Onorata's two surviving poems (see Appendix).[21] They contain, instead, a fairly commonplace appeal to God to turn his eyes upon the poet and thus help her rise above her earthly desires. The first sonnet, "Se la parte miglior vicina al vero" (If my better part, near to the truth), argues that as long as the poet's desires are focused on a mortal delight (supposedly a human beloved) she will be unable to raise her thoughts to God, but if God were to look down and gaze down upon her soul, her affections could then rise happily to him. A similar concept is expressed in Onorata's second sonnet, "Mira, vero Signor, mira quest'alma" (Look, true Lord, look at this soul), where she again asks the Lord to look upon her. This time, however, her appeal is couched in terms of her soul's losing battle against earthly desires. Both poems beg for God's assistance, arguing that without his help the poet will remain mired in earthly desires and consequently in perdition. The appeal to the divinity to enter actively into the poet's life and thereby raise her soul to heaven is reminiscent of some of the mystical poetry by the likes of Vittoria Colonna and Michelangelo. The hint of a *schuldcomplex,* the confession of personal inadequacy, and the expressed desire to be consumed by the burning fire of God's love merely confirm this interpretation. Instead of being remembered as a "philosopher," as Firenzuola and others have suggested, Onorata Tancredi Pecci might better be remembered as a religious, perhaps even a mystical, poet, one whose ardent appeals to God contain the urgency and force typical of a passionate, not a rational, relationship with the Almighty.

One might well wonder, then, why Onorata Tancredi Pecci's contemporaries praised her ready wit and discerning philosophical knowledge when her own works clearly point instead toward a passionate

religious love and a mystical theology. A closer look at Onorata's biography provides an answer.

Neither Domenichi's reference to her ready wit nor Onorata's surviving poems can be dated with precision. The context and atmosphere implied in Domenichi's reference to her witticism about women's vanity do seem to point, however, to the Siena of the 1520s and 1530s and to the *veglie senesi* (Sienese soirées) so vividly recalled by Girolamo Bargagli in his *Dialogo de' giuochi che nelle vegghie sanesi si usano di fare* (1572). Firenzuola's reference to Onorata's discerning philosophical knowledge, on the other hand, can be dated with absolute certainty to 1525, when his "Epistola in lode delle donne" was composed. Connecting the two, we can propose with some confidence that Onorata's intellect and wit caught people's imagination when she was a young (and beautiful) woman in her twenties and participated actively in the private social gatherings of the Sienese nobility and the city's cultural elite. Her two religious sonnets addressed to God are the product not of this time but of a later, more mature and more introspective period that, we can safely propose, should be dated a couple of decades later, to the 1540s and 1550s, when Onorata's interests had taken a different turn and her life had brought her into the service of Duchess Ippolita Gonzaga and, consequently, into contact with Giulia Gonzaga, one of the leading figures of the Italian reform movement. Onorata's spirituality was probably known and evident to her contemporaries, as a marginal note added next to her birth record in the city's register might indicate when it describes her as "holy, wise, gay, honest, and beautiful" (santa, saggia, leggiadra, honesta, e bella).[22]

Onorata's spiritual/mystical "side," so to speak, was probably already evident long before she transferred to Gonzaga's service. As we have had occasion to point out in chapter 1, in the 1530s and 1540s Siena was a hotbed of religious reformist ideas fostered, in no small way, by the presence in the city of popular reformist preachers such as the Capuchin friar Bernardino Ochino, reform-minded humanists such as Aonio Paleario, and theologically inquisitive local intellectuals such as Bartolomeo Carli Piccolomini and the Sozzini men. Given Onorata's exceptional intellectual talent, it is possible that she was drawn to the ideas advanced by these engaged and stimulating minds and began to

turn her thoughts to topics that were, at that time, both current and controversial. Having demonstrated her wit and intelligence in her youth and an interest in reformist religious thought in her mature years, Onorata seems to have been ideally placed to enter into the circle of reform-minded Italian women connected with the Colonna, d'Avalos, and Gonzaga women in Naples. She did so when she was chosen to serve as governess and companion to the young Ippolita Gonzaga, daughter of Ferrante Gonzaga, Duke of Guastalla.

Ippolita was born on 17 June 1535 in Palermo when her father was Spanish viceroy of Sicily. As a young child of less than two years, she was sent to Naples to be raised and educated in the style befitting the daughter of a Spanish viceroy and highly respected Imperial general who not only had participated in the sack of Rome (1527) but had also successfully defended Naples from an attack by the French marechal Odet de Foix, Count of Lautrec (1528), obtained the surrender of Florence and drawn up its terms after a bitter ten-month siege (1530), and fought alongside Emperor Charles V in the capture of Tunis (1535).[23] In short, her father was one of the most brilliant, successful, and well-placed military figures of his time and Ippolita one of the most privileged young women in Italy.

In Naples, the young Ippolita had many occasions to come to know her widowed great-great-aunt Giulia Gonzaga Colonna (1513–66),[24] a fervent disciple of the Spanish friar and writer Juan de Valdés (d. 1541). In the 1540s and 1550s Giulia was directly involved in the publication in Venice and elsewhere of Valdés's writings and consequently was one of the leading lay figures among the Italian Spirituali, the reformed-minded Catholics of the 1530s to 1550s who were seeking to reform the Church from within, both morally and theologically. The Spirituali were not a homogeneous, organized group but a loose network of friends and sympathizers that included the likes of cardinals Gasparo Contarini, Jacopo Sadoleto, and Reginald Pole, as well as laypersons such as the poet Vittoria Colonna d'Avalos and her admirer Michelangelo Buonarroti, not to mention accused heretics such as Bernardino Ochino, Pietro Martire Vermigli, and Pietro Carnesecchi. As we can read from Giulia's correspondence, the great-great-aunt clearly adored her little niece—in a letter of 1 April 1537 to Ferrante Gonzaga, Giulia

writes: "These last few days I enjoyed the company of the lady prin-
cess [Isabella di Capua, Ferrante's wife] and these most delightful chil-
dren and especially of my Donna Ippolita, whom I can never get my fill
of seeing and kissing."[25] Then, just a few days later, she wrote: "I kiss
a thousand times the little child [Cesare] and ten thousand times my
Donna Ippolita, most beautiful and most delightful."[26] Ippolita thus
grew up in an atmosphere of viceregal elegance and manners but also of
strong familial affection, profound spirituality, and inquisitive thinking.

In November 1548, at the tender age of thirteen, Ippolita married
Fabrizio Colonna.[27] Though happy, their marriage was cut short by
Fabrizio's early death of a fever while he was serving in the Imperial
army at the siege of Parma (1551). In the fall of 1554, after three years
of widowhood, Ippolita married Antonio Carafa (1542–78), Prince of
Stigliano and Duke of Rocca Mondragone, seven years her junior. The
marriage, however, was troubled by difficulties from her new father-in-
law that eventually obliged Ippolita to seek refuge with Giulia Gonzaga
in a Neapolitan convent.[28] After some years of barrenness, the couple
eventually had a child, Anna Clarice, born in very early 1563. Shortly
after giving birth, Ippolita suddenly fell ill and on 9 March 1563, after
nine days of illness, passed away, comforted by the loving care of her
great-great-aunt Giulia Gonzaga, who remained at her bedside till the
end. Both her second husband, Antonio Carafa, and her friend the poet
Luigi Tansillo (1510–68) left moving letters describing her last days,
and many of her friends and admirers composed poems that were sub-
sequently published in a memorial volume.[29] Tansillo's two letters on
Ippolita's death are addressed to Onorata Tancredi, who was Ippolita's
governess.

Onorata had entered into service for the Gonzaga household in
late 1548 or very early 1549. At that time Onorata was in her mid- to
late forties, while Ippolita was a young girl and bride of thirteen. Given
Ippolita's age, her husband's inevitable protracted absences because of
his military career, and the wagging tongues of Roman and Neapolitan
society, it was necessary to provide the young girl with a constant com-
panion and tutor who could watch her, educate her, and protect her
from gossip. Tancredi's name had been given to Ippolita's mother, Isa-
bella di Capua, Princess of Molfetta, by the scholar and diplomat Luca
Contile (1505–74). In one of his letters of recommendation dated 1548,

Contile reassures Ippolita's mother, saying: "I have proposed [to you] this noblewoman so full of virtues [abilities] that I could say she has no equals, much to all other [women's] suffering."[30]

In 1548 Contile had just left the service of the Alfonso d'Avalos, Marquis of Vasto, and had accepted a position in the household of Ippolita's father, Ferrante Gonzaga, now Spanish viceroy in Milan. In recommending Tancredi, Contile might have sought to bring Onorata into the same noble household he was serving, an indication, certainly, of his high opinion of Tancredi's abilities but also of his strong friendship with her. Their friendship probably dated back to the mid-1520s, when Contile had spent some time in Siena as a student at the university and had played a part in the founding (1525), and then in the meetings, of the Academy of the Intronati. It had continued in the years that followed, when Contile worked for Cardinal Agostino Trivulzio in Rome in 1527–42, then for Alfonso d'Avalos in 1542–46, and finally, after d'Avalos's death, for his widow, Maria d'Aragona d'Avalos, in 1546–48. In a letter of 6 May 1548 to Onorata, intended not only to ferry news but also to advise her on how best to serve in the household of a great noblewoman, Contile did not mince words about working for Maria d'Aragona: "You can certainly find no greater lady than the Marquess of Vasto; more magnanimous and more fortunate; nonetheless, whoever will serve her, will also need to be able to stand up boldly to her; and for this, let Signora Alessandra Piccolomini, who did not last a full year [in her service], be an example."[31]

In spite of the warning, or perhaps enriched by it, Onorata Tancredi did accept the position of governess to Ippolita Gongaza that was offered to her by the young girl's mother. Ippolita's education and Onorata's contribution to it are described by her eighteenth-century biographer Ireneo Affò, who points out that after the marriage had been celebrated in Milan and Prince Philip of Spain, who had attended the wedding and had remained in the city for much of January 1549, had left for Mantua, the newlyweds remained together "in perfettissima unione d'affetto" (in a most perfect union of affection); at which point,

> The mother, meanwhile, who shortly had to return to her possessions in the Kingdom of Naples, placed at her side a most excellent governess called Onorata Tancredi, to whose worth, praised

by many famous men of the time, one can certainly attribute Ippo-
lita's best development in elegant manners and knowledge. Tancredi
was a most virtuous [accomplished?] noblewoman, full of spirit, as
described in the praises she garnered on various occasions; so that,
having entered into the service of the Gonzaga, she directed her ex-
cellently on the right path, encouraging her to persevere in the study
of worthy sciences, and to esteem learned men, since in this man-
ner she would distinguish herself among her peers, and thanks to
approval of these [men] she would attain that fame that noble souls
have always sought. Far, then, from following the manner of some
women, who see marriage as the conclusion of their education and,
on attaining their new status [of married women], give themselves
over to a life of freedoms and conversations, Ippolita carried on
with her endeavors and did so with so much enthusiasm that, at
only fifteen years of age, she showed herself so well advanced in
the cultivation of her spirit that, reaping praise and wonder, she had
the honor of seeing an elegant coin struck with her portrait on it,
on whose reverse were depicted the symbols and instruments of
Poetry, Music, Astronomy, and such subjects, and the motto NEI-
THER TIME, NOR AGE: as if to say that in the progress she had
made in such rare disciplines she had considerably surpassed ex-
pectations and her age.[32]

Onorata remained with Ippolita for at least seven years (1549–56),
during which time, aside from tending to her charge, she also came into
direct contact with and gained the respect and support of Giulia Gon-
zaga Colonna. When Ippolita ran into difficulties with her father-in-law
in the wake of his second marriage, one of the victims was Onorata Tan-
credi, who was dismissed from service or at least distanced from the
household. At this point the feisty Giulia Gonzaga Colonna wrote to Ip-
polita's father, Don Ferrante, informing him of the situation and defend-
ing Onorata against the accusations of gossiping that had been made
against her:

Some days ago I wrote to Your Excellency regarding the mat-
ters with Signora Donna Ippolita, now I believe the Monsignor of

Otranto [Pietro Antonio di Capua] will have informed you better. I'm sorry that people are talking about this so publicly, and the irony is that, so as not to make Donna Ippolita feel for the departure of Madonna Onorata, they want to make her believe that she is responsible for all the things that are being said, but the prince [Don Luigi Carafa, Prince of Stigliano] will not pull the wool over my eyes, for he knows what I know, I told him before. . . . Onorata arrived, and he also knows from whence I know this, but what great foolishness of theirs to think they can keep secret so many things, for there is no relative nor servant, even down to the dish-washers, who does not talk about the base manners and bad quality and poverty of that house. These things were in part foreseen, and if Your Excellency's time and obligations had not been a factor, they should not have [blank space in the original] let the two persons, that is the Duke [Fabrizio Colonna] and Donna Ippolita stay near Your Excellency and that they should have lived apart, now I think that they will not go first to Basilicata, but to the Rocca [their fief of Mondragone].[33]

With Onorata's departure from Ippolita Gonzaga's service we lose track of the Sienese poet's whereabouts and activities. She may have remained in the service of the Gonzaga family or may have returned to Siena, now firmly in the hands of the Spanish (1555) and then of the Florentines (1557). She was certainly still alive in 1563 and 1564 when the Sienese erudite Lattanzio Benucci (1521–98) dedicated his "Dialogo della lontananza" and his "Osservazioni sopra la Commedia di Dante," both still unpublished, to her.[34]

Whatever the case, it is evident that her years of service in the Gongaza-Carafa household and her daily contact with Ippolita Gonzaga had brought her into direct contact with some of the leading figures of the Spirituali movement in Naples and Italy, some of whom, like Giulia Gonzaga Colonna or Pietro Antonio di Capua, were Ippolita's relatives. Christopher Hare counted Onorata Pecci as one of the "pupils" of Juan de Valdés but did not provide any supporting documentation for the claim; the circumstantial evidence we have presented in the previous pages would certainly support Hare's claim.[35] While in

Gonzaga-Carafa employment Onorata may also have served as a con-
duit to Ippolita. A letter from Pietro Aretino to Onorata dated January
1551, in which he thanks her for having sent him a medal of Ippolita,
suggests that the Sienese governess may also have tended to some of
Ippolita's personal contacts or correspondence, acting perhaps even as
her secretary.[36] Partly for this reason, but also because of her own intel-
lectual and literary skills, Onorata met and corresponded with some of
the major literary figures in Italy at that time, such as the courtier and
poet Bernardo Tasso, father of the more famous Torquato Tasso, who
sang her praises, saying:

> Donna gentil, che con sì bel desio,
> con sì casti pensier rivolta al vero,
> sgombrate l' ombre ond' è chiuso il sentero
> che securi ne mena inanzi a Dio,
> raro ha veduto il mondo cieco e rio
> spirto di raro ben ricco et altero
> tanto inalzar il suo nobil pensero
> ch' ogn' altro paia a par pigro e restio.[37]

————

Noble lady, who with such a beautiful desire, / with such chaste
thoughts turned to the truth, / you scatter the shadows that
cover the path / that leads us safely in front of God, // rarely has
the blind and wicked world seen / a spirit rich in rare and lofty
good / lift its noble thoughts so high / that everyone else, in
comparison, seems lazy and unwilling.

In his sonnet, Bernardo Tasso is clearly referring to Onorata's in-
terest in religious "truth" and to her role as a guide for others on the
path to God. Such comments suggest that Onorata was much more in-
terested and engaged in religious thought and debate than would nor-
mally be the case for a traditional, pious Catholic woman. For our in-
terests, Onorata may well be the link that closes the circle we opened
when discussing Virginia Luti Salvi's sonnet and its subtle message to
the carefree student Alessandro Piccolomini, far more interested in Pe-
trarch and poetry than the good of his eternal soul would warrant (see
above, chapter 1).

In the final analysis, although for the most part Sienese women poets composed verses fully in line with the dominant Petrarchism of the times, it is clear from the example of some of these women that Petrarch and Petrarchism could, and did, offer opportunities for women to engage with the Italian lyric tradition in a novel and, one might suggest, distinctive manner. While the *Tombaide* may well be judged to be nothing more than a gracious exchange of lavish compliments, it does point to a poetic dialogue between men and women that does not, at least this time, depend on pining away for unrequited love or lamenting for deceased beloveds. Instead, the *tenzone* allows the women involved to discuss the topic of poetic fame and, within their own limits, to participate in it. The poetry of women such as Virginia Martini Salvi, Aurelia Petrucci, and Laudomia Forteguerri is both versatile and technically advanced. Some women, such as Virginia Martini Salvi, corresponded actively with poets, prelates, and rulers in verses that reveal a thorough command of the poetic idiom and a profound grasp not only of Petrarchan love motifs but also of the political situation of contemporary Italy. Others, such as Laudomia Forteguerri, pushed the boundaries of love poetry to express either desire for another woman or, possibly, a subtle political agenda couched within a Neoplatonic affection. And still others, like Virginia Luti Salvi or Onorata Tancredi Pecci, used poetry to advance reformed religious thoughts. So while Petrarch offered the women of Siena a vocabulary and a language for the expression of their poetic talents, he also offered some of them the opportunity to move in a different direction and to step onto the Italian literary stage, playing a part that was not, necessarily, the standard feminine role. In Deanna Shemek's wonderful phrase, many of the Sienese women proved themselves to be veritable "ladies errant" in thoughts, words, and deeds.

Having thus met a number of Sienese women poets of the mid–sixteenth century, one is left to wonder why, in the 1530s to 1550s, Siena experienced such a flowering of women poets, a bloom that appeared quite suddenly and faded away just as quickly after the city's capitulation to Florence. A number of factors were clearly in play.

The first and foremost reason for this sudden blossoming probably lies with the presence in Siena of an active and lively cultural-literary

association focused on the vernacular: the Accademia degli Intronati. While only men could be members, women were always either at the center or in the immediate periphery of its work. Not only did the academicians constantly praise Sienese women for their beauty, elegance, charm, and wit, but they also engaged them in discussion, dedicated their works and translations to them, used them as interlocutors in their dialogues (real or imaginary), and spent lively soirées (the famous Sienese *veglie*) playing intellectual/literary parlor games with them. Laudomia Forteguerri, for example, who found her poetic muse in Margaret of Austria, was herself the poetic muse and platonic love object for the Sienese erudite Alessandro Piccolomini. Piccolomini dedicated several works of a moral, scientific, and literary nature to her. His cousin Marc'Antonio Piccolomini cast Laudomia Forteguerri as an interlocutor in his philosophical dialogue on whether Nature creates beauty by chance or by design, a work that plays with some very profound and possibly heretical ideas.

A second reason probably lies in the political tensions present in Siena in those decades. The debates on beauty and love that filled the meeting rooms of the Intronati had their counterparts in the debates on politics, government, and alliances that filled the council chambers in the Palazzo Pubblico, or in the debates on religion that pitted Catholic against reformist theologians and thinkers. Sometimes they all crossed over into each other's camp: one modern scholar, Pasquale Stoppelli, for example, has interpreted Antonio Vignali's scurrilous dialogue *La Cazzaria (The Cockery)* as an extended metaphor for the political infighting in Siena in 1524–25.[38] Another modern scholar, Rita Belladonna, has interpreted Marc'Antonio Piccolomini's dialogue on how Nature creates beauty as an echo of the debates on predestination that took place in Siena in the 1530s.[39] As Pamela Benson has rightly pointed out, in times of crisis, "when the boundary between the political and the domestic broke down," women were able to break away from "traditional female fields," and, as she put it, "male spirit miraculously entered them."[40] My own metaphor would be that in times of crisis, when the fabric of a male-dominated society begins to be torn apart, women appear through the tears in the fabric to reveal, as in a slashed Renaissance sleeve, both their brilliance and their skills.

Still another reason might lie in the nature of Sienese society at that time. Siena had once been a powerful and vibrant city-state, but now it had long passed its economic and political prime; this was a city that had become inward-looking and provincial. With this "closing in" of Sienese culture, local male intellectuals and writers turned to their own small local social circle for support, thus drawing into their discussions and their intellectual pursuits the women that charmed and enlivened their soirées. This was the time of the Sienese *veglie* that Girolamo Bargagli described so eloquently and that, already by the late 1560s when he composed his nostalgic book on the Siena of his youth, had become nothing more than a pleasant memory of a time long ago and of a society at the close of its day. The approaching dusk of evening had blurred distinctions and somehow leveled the playing field; this, in turn, had allowed the talented women of Siena to enter confidently into the fray and to engage with their male companions in a brief but passionate dialogue. The siege of 1555 and the final demise of the republic were to mark the end of that elegant evening of Sienese culture when women, politics, and poetry had been very much the order of the day.

Ermellina Arringhieri de' Cerretani

Già per morir del mortal lume intorno
Il picciolo animal con l'ali tese
Sen gìa, lieto e sovrano,
Ove natura e suo destino il prese,
 Allor che di mia Dea poco lontano
Scorto il volto, la man, l'ardenti luci,
Ch'alle strade del ciel fur sempre duci,
 Congiò vicino a lei subito loco
Bramando ivi morir in più bel foco
O con sorte miglior nelle sue mani;
 Ma fur tai desir vani,
Chè prender più chiare alme ha per costume
Sì bianca mano, e quel celeste lume.

The little animal, happy and sovereign, was already flying with
open wings around the deadly light where nature and his fate
were taking him // when, seeing a short distance away the face,
the hand, the burning lights of my goddess, which were always a
light on the roads to heaven, // he immediately changed place
and drew near to her, craving to die there in a more beautiful fire
or, if he were luckier, at her hands; // but his wishes were in vain,

237

for such a white hand and that heavenly light are accustomed to seizing purer souls.

Madrigral, published in Domenichi, *Rime diverse d'alcune nobilissime, et virtuosissime donne,* p. 33; Bulifon, *Rime,* p. 26; Bergalli, *Componimenti poetici,* vol. 1, p. 130; *Delle donne illustri italiane,* pp. 149–50.

Francesca B.

(1)

Sì come suol drizzar saggio Nocchiero,
Quando gli asconde nuvoloso verno
La Stella scorta sua; con il governo
De la pietra indiana il suo sentiero;
 Così drizza quest'occhi il mio pensiero
Al luogo, ov'è colui, lo qual d'eterno
Laccio mi strigne; e mentre, ch'io 'l discerno
Il cor sottraggo al martir aspro e fiero.
 Questi alquanto dà triegua ai dolor miei
Da Lui lontano; e questi assai men greve
Rende l'incarco de' miei duri omei.
 Ma, se non fusse, che vederlo in breve,
Lasso, pur spero, in pianto mi sfarei,
Sì come a caldo Sol tenera Neve.

———

Just as, when cloudy winter hides the star / that is his guide, a wise helmsman knows / how to direct his course / with the Indian stone [i.e., the compass] // So my thought directs my eyes / to the place where he abides, who binds me / with an eternal rope, and while I see him / I remove my heart from harsh and bitter pain. // This one relieves my pains somewhat / when I am far from him, and this one renders / the weight of my hard sighs less heavy. // But, were it not that I do hope to see him / shortly, I would melt away in tears / like soft snow under the warm sun.

Sonnet, published in Domenichi, *Rime diverse d'alcune nobilissime, et vir-tuosissime donne,* p. 234.

(2)

Risposta a M. Girolamo Popponi

Segui l'alto camin ne' tuoi begli anni,
Nipote e figlio veramente fido
D'Aquila illustre, e da sì raro nido
Rivolti ogn'ora al Sol tien gli occhi i vanni.
Celeste Augel non ti rimova o appanni
Falso splendor, né vil piacer o infido
Ritardi mai sì chiara fama e grido
Con lusingh'empie e con suoi fieri inganni,
Ché vedrem tosto al santo tuo pensiero,
A l'onorata voglia anzi il morire
Render il ciel premio conforme e degno.
Né, qual Icaro, o qual Fetonte altiero,
N'andrai nel corso, ch'il tuo onesto ardire
D'arrivar merta ad ogni nobil segno.

———

Response to Messer Girolamo Popponi

Follow the high path in your young years / Nephew, and true son
of an illustrious Eagle, / and from such an excellent nest keep your
eyes / and wings turned toward the sun. // Heavenly Bird, let not
false splendor / turn your eyes away or cloud them, nor let / a
false friend delay you from your calling / with empty flattery and
bold deceits; // For soon we will see Heaven / bestow its prize on
your holy thoughts / and your honorable wishes before you die. //
Nor will you go on your path like Icarus /or haughty Phaeton, for
your honest desire /deserves to reach each of your noble goals.

Sonnet, published in Domenichi, *Rime diverse d'alcune nobilissime, et vir-tuosissime donne,* p. 234.

(3)

In Risposta

> Alzate al vero sole il cuor sincero
> Et al verbo incarnato oggi attendete,
> Che ne l'aperte sue piaghe potrete
> Scorger di gir al Ciel l'erto sentiero.
> In questo eterno ardor del sommo impero
> Tutti i vostri desir pronti accendete
> E l'ardenti faville indi spargete
> Nel magnanimo vostro petto altero.
> Siate questo a seguir pronto et accorto,
> Ch'al Ciel vi guiderà con quel fervore
> Con il qual non poss'io, che son di vetro.
> Da quel, vita, splendor, speme e conforto
> Prendete, perch'Egli è quel sol Signore
> Che 'l lume vi può dar, che donò a Pietro.

———

In Response [but with no indication to whom]

Raise your sincere heart to the true sun / and tend today to
the Word incarnate / for in his open wounds you will be able /
to see the steep path that leads to heaven. // In this eternal
desire for the highest empire / light all your desires without
hesitation / and then scatter the burning sparks / in your
magnanimous and proud breast. // Be quick and determined
to follow this / for it will guide you to heaven with that fervor /
with which I cannot go, for I am made of glass. // Gather from
it life, splendor, hope, / and comfort; for he is that single Lord /
who can give you the light he gave to Peter.

Sonnet, published in Domenichi, *Rime diverse d'alcune nobilissime, et vir-
tuosissime donne,* p. 235. I have corrected the "hotti" of v. 2 to "oggi."

(4)

Quando primier ardendo il dolce lume,
Nato da quel vivo occhio sfavillante,
Carità sempiterna ed opre sante
Scese nel petto e in quel si fece Nume,

 Cangiossi allor l'alpestre mio costume
E di odioso a sè mi fece amante,
Duro trafisse il cor come diamante,
Indi di giusto pianto nacque un fiume.

 Dentro una fiamma ch'arde folgorando,
Con impeto d'amore i caldi raggi
D'un invisibil foco l'alma e il core,

 Tal che mie forme umane van mancando
E i spirti nel Signor diventar saggi,
Fuggendo l'infernale, eterno onore.

———

When first, burning, that sweet light, / borne from that brightly shining eye, / Eternal charity and holy works, / entered my heart and made itself Lord, // my rough habits then changed / and from disliking him it made me love him, / it pierced my hardened heart like diamond, / then a river of righteous tears did start to flow. // Inside a fire, that dazzles as it burns, / with the force of love its warm rays / [burn?] with invisible fire my soul and heart, // So that my human form is fading away / and my spirit became wise in the Lord, / fled the infernal, [and earned] eternal honor.

Sonnet published in Bergalli, *Componimenti poetici,* vol. 1, p. 212, where she dates it 1560.

Pia Bichi

[To Ortensia Scarpi]

O di lagrime mie fida fontana,
Come nodrisci il desiato alloro
Se di caldi sospiri il bel lavoro,
S'ogni sua pianta il tuo calore spiana?
 Che tua benigna stella, orrenda e strana,
Spenta giacque per te, né suoi fior d'oro
Sparger mai volse, né quel bel tesoro
Che suol felice altrui fare una grana.
 Minerva al nascer tuo farti felice
Promise, e Cerer giunse a te in quell'ora,
Le cui vestigia a te cercar pur lice.
 Pianta felice desiata ancora
Al nuovo augel che cerca tua pendice,
Spargi tuoi rami verdeggianti ogn'ora.

―――――

[To Ortensia Scarpi]

O faithful fountain of my tears, / how can you nourish the
desired laurel, / if your warm sighs destroy the beautiful work, /
if your heat razes every plant to the ground? // For your
beautiful star, dreadful and strange, / lies dead because of you,
nor its golden threads / did it ever want to spread, nor that fine
treasure / that makes others happy // At your birth, Minerva
promised to make you happy, / and Ceres came to you at that
time, / whose traces you are allowed to seek. // Happy plant,
desired even / by the new bird that seeks your branches, /
always spread your verdant boughs.

Sonnet, published in Domenichi, *Rime diverse d'alcune nobilissime, et vir-
tuosissime donne,* p. 75; Bulifon, *Rime,* p. 67; Bergalli, *Componimenti poetici,*
vol. 1, p. 109; *Parnaso italiano* [1851], col. 1386.

Ortensia Scarpi

Risposta di Mad. Ortensia Scarpi

> Da due bei colli una chiara fontana
> Deriva a l'ombra d'un bel verde alloro,
> Di marmi et alabastri, il cui lavoro
> Il cielo elesse e 'l mondo qui lo spiana.
>> Fra gemme orientali una assai strana,
> La qual risiede sopra un vaso d'oro,
> Soave frutto nasce al bel tesoro,
> Onde nulla dolcezza s'allontana.
>> Fontana ben ti puoi chiamar felice
> E sol natura a te mancò in quell'ora
> Che stato non ti diè d'imperatrice.
>> Già non s'asconda la tua luce ancora.
> Spand' i tuoi raggi per ogni pendice,
> Che narrar possan le tue lodi ogn'ora.

———

Response by Ortensia Scarpi

From between two beautiful hills a clear fountain / runs down to
the shade of a beautiful green laurel, / of marbles and alabasters,
whose work / the heavens chose, and the world here reveals. //
Among Oriental gems [is] a very unusual one / that sits upon a
golden vase; / a pleasant fruit is born from the beautiful treasure
/ from which no sweetness ever distances itself. // You can
rightly call yourself a happy fountain; / the only thing Nature
did not give you at that time / was the rank of empress. //
Let not your light be hidden any longer; / spread your rays on
all hillsides / that they might always sing your praises.

Sonnet, published in Domenichi, *Rime diverse d'alcune nobilissime, et vir-
tuosissime donne,* p. 75. Scarpi uses the same rhymes used by Bichi in her
sonnet "O di lacrime mie chiara fontana," which suggests that the latter
might have been addressed to Bichi.

Atalanta Donati

(1)

In lode dell'Accademia degli Accesi

> Pina gentil, ben gloriar ti dei
> E altiera gir di sì rara ventura
> Non sol perché di te mai sempre ha cura
> L'alta immortal gran madre delli dei,
> Ma amor perché sostegno et ombra sei
> In cui s'appoggia e sotto cui secura
> Vive l'Accesa schera, né paura
> Gli fan del tempo o invidia i morsi rei.
> Uguagli i frutti al tuo precioso odore
> Quali ambo stanno in vaga fiamma ascosi
> Tal ch'il mondo ne resta oggi in stupore.
> Dunque, o divini spirti e gloriosi,
> Chiunque brama acquistarsi un vero onore
> Sotto quest'ombra lieto se riposi.

———

In Praise of the Academy of the Accesi

Gentle pinecone, you must be rightly pleased / and proudly go because of your rare fortune / not only because the high immortal mother / of the gods always takes care of you, // but also because you are the support and shade / where the group of the Accesi rests / and lives secure, not fearing / the cruel stings of time or envy. // You are the equal of fruits, with your precious fragrance, that hide inside a fair flame, / so much so that the world is still amazed today. // So, divine and glorious spirits, / whoever wishes to acquire true honor / must happily rest under the shade of the pine.

Sonnet, previously unpublished. Manuscript in SI-BCI, MS Y. II.23, fol. 11r. The pinecone on a fire was the symbol of the Academy of the

Accesi, founded by Belisario Bulgarini at his own home in Siena at the time of the fall of the republic or shortly thereafter.

(2)

Vidi nell'alto mar dubbioso un legno
Che di ragione avea l'albero schietto
E di pensier le vele, e d'intelletto
Era il timone, e i remi eran d'ingegno.

E mirando lontan, vidi il più degno
Splendor che mai facesse umano aspetto,
E 'l più pregiato e più divino obietto
Che facesse natura entro il suo regno.

Ond'ei pensando, che quel lume solo
Lo potesse condur sicuro al porto,
Ratto senza pensar mosse le piante,

Ma fu quel suo sperar fallace e corto
Ché, pensando trovarci un nuovo polo,
Trovò ch'era uno scoglio di diamante.

I saw a ship in peril on the high seas / whose straight mast was reason / and its sails were thoughts, and its rudder / was intellect, and its oars were talent. // And looking far away, I saw the worthiest / splendor that ever human appearance made / and the most esteemed, and the most divine object / that Nature ever made in her kingdom. // And so, thinking that that light alone / could lead it to the safety of the harbor, / the ship quickly, without thinking, moved toward it. // But its hope was mistaken and short-lived, / for thinking that it was finding a new pole / it found it was a rock as hard as diamond.

Sonnet, published in Domenichi, *Rime diverse d'alcune nobilissime, et virtuosissime donne,* p. 77; Bulifon, *Rime,* p. 69; Bergalli, *Componimenti poetici,* vol. 1, p. 163.

Laudomia Forteguerri

(1)

Or trionfante e più che mai superba
Sen va l'antica Roma, ché possiede
Tutto 'l ben che natura e il ciel ne diede.
Essa in se lo raccoglie e lo riserba.

Ma s'a me fosse dolce e a te acerba
La mia nimica, che m'ha sotto il piede,
Te lo togliesse e me ne fesse erede,
Più non ti riderian fioretti e l'erba.

Non sarien più di smeraldi e rubini
Le ricche sponde del gran Tebro ornate,
Pur l'Arbia s'orneria la fronte e 'l seno.

Più non avresti gli esempi divini,
Né godresti l'angelica beltate.
Se questo avvien, son pur felice appieno.

———

Triumphant now, and more than ever proud / Ancient Rome
proceeds along, possessing / All the good that Heaven and
Nature gave us. / She gathers it into herself and keeps it. // But
were my foe, who keeps me underfoot, / To show kindness to
me and grief to you, / If she took it from you to give to me, /
Your flowers and grass would cease to smile for you. // No
longer would the banks of mighty Tiber / Be richly dressed
with emeralds and rubies, / For Arbia's brow and breast they
would adorn. // No longer would you have a form of heaven, /
Nor would you revel in angelic beauty. // Were this to be, I
would be overjoyed.

Sonnet, published in Domenichi, *Rime diverse d'alcune nobilissime, et virtuosissime donne*, p. 103; Bulifon, *Rime*, p. 95; Forteguerri, *Sonetti*, p. 18; in Eisenbichler, "Laudomia Forteguerri," pp. 298–99; Borris, *Same-Sex Desire*, p. 283.

(2)

A che il tuo Febo col mio Sol contende,
Superbo ciel, se il primo onor gli ha tolto?
Torni fra selve o stia nel mar sepolto
Mentre con più bei raggi il mio risplende.

Picciola nube tua gran luce offende
E poca nebbia oscura il suo bel volto;
Il mio fra nubi (ahi, lassa) e nebbie avvolto
Più gran chiarezza e maggior lume rende.

Quando il tuo porta fuor de l'onde il giorno,
Se non squarciasse il vel che l'aria adombra
Non faria di sua vista il mondo adorno.

Il mio non toglie il vel né l'aria sgombra,
Ma somigliando a se ciò c'ha d'intorno
Fiammeggiar fa le nubi e splender l'ombra.

———

Why does your Phoebus contend with my sun, / Proud heaven,
who has stolen its glory? / Let it hide in the woods or in the sea /
While my sun shines forth with far brighter rays. // A little cloud
can injure your great light, / A little fog obscures its lovely face, /
But mine, in clouds (alas) and wrapped in fogs, / Shines with
more brightness and a greater light. // When yours brings forth
the day out from the waves, / Unless it tear the veil that dims
the air / The world would not be graced with the sight of it. //
Mine does not part the veil or clear the air, / But, fitting what
surrounds it to itself, / Makes the clouds burn bright and
darkness shine.

Sonnet, published in Domenichi, *Rime diverse d'alcune nobilissime, et vir-
tuosissime donne,* p. 102; Bulifon, *Rime,* p. 94; *Parnaso italiano* [1851], col.
1010; Forteguerri, *Sonetti,* p. 17; Eisenbichler, "Laudomia Forteguerri,"
pp. 299–300; Borris, *Same-Sex Desire,* p. 283.

(3)

Lasso, che 'l mio bel Sole i santi rai
Ver me non volgerà. Dunque debb'io
Viver senza il mio ben? Non piaccia a Dio,
Che senza questo io viva in terra mai.
 Ahi, fortuna crudel, perché non fai
Che vada il corpo dove va il cor mio?
Perché mi tieni in questo stato rio
Senza speme d'uscire unqua di guai?
 Volgi, lieta e benigna, omai la fronte
A me, ché non è impresa gloriosa
Abbattere una del femineo sesso.
 Odi le mie parole come pronte
In supplicarti. Né voglio altra cosa
Salvo ch'a la mia Dea mi tenga appresso.

———

Alas, for my beautiful sun will not turn / Its holy rays toward me.
Must I therefore / Live without my treasure? May it not please
God / That I should ever live on earth without it. // Ah, cruel
Fortune, why do you not allow / My body to go where my
heart goes? / Why do you keep me in this awful state / With
no hope ever to come out of my misery? // Turn your face
now, considerate and happy, / Toward me, for it is not a glorious
deed / To cut down someone of the feminine sex. // Listen to
my words, how they are ready / To beseech you. Nor do I want
anything else / But that you keep me close to my goddess.

Sonnet, published in Domenichi, *Rime diverse d'alcune nobilissime, et vir-
tuosissime donne,* p. 104; Bulifon, *Rime,* p. 96; Forteguerri, *Sonetti,* p. 19;
Eisenbichler, "Laudomia Forteguerri," p. 300; Borris, *Same-Sex Desire,*
p. 284.

(4)

Alla Signora Alda Torella Lunata

Il maggior don che Dio e la natura
Donasse a noi mortal per abbellire
Il mondo e farlo d'ogni ben gioire
È de la signora Alda la fattura.
 Chi può veder l'angelica figura,
Beato essere in tutto può ben dire.
Chi può le saggie sue parole udire,
Null'altro mai che lei sentir procura.
 Deh, perché a me non è tanto concesso
Da la mia sorte ria, dal fier destino,
Ch'io veder possa l'angelico volto?
 Non sia che vuole, io pur nel petto impresso
Porto per relation quel suo divino
Aspetto e questo mai non mi fia tolto.

———

To the Signora Alda Torella Lunata

The greatest gift that God and Nature gave / To us on earth to
beautify the world / And let us find delight in what is good /
Is the shape and form of Signora Alda. // Whoever her angelic
figure sees / Can truly say he has been richly blessed. / Whoever
her judicious words can hear, / Seeks nothing else but to listen to
her. // Alas, why am I not allowed this much, / By cruel destiny,
by my evil fate, / That I may look on this angelic face? // It will
not let me, yet in my heart I hold / Her divine appearance as
described to me, / And this will never be taken from me.

Sonnet, published in Domenichi, *Rime diverse d'alcune nobilissime, et vir-
tuosissime donne,* p. 104; Bulifon, *Rime,* p. 96; Forteguerri, *Sonetti,* p. 20.

Lucrezia Figliucci

(1)

Troppo alto dono a me, troppo eccellente,
Troppo rara virtù, perfetto ingegno,
E troppo dotto stil, sol di voi degno,
Ingombran la mia bassa e debil mente.

 Pur, col pensier torno a voler sovente
Vostro voler seguir, ma il mio disegno
Ritruovo vano, ond'io meco mi sdegno
Poich'a sì bel disio le forze ho spente.

 Deh, s'io potessi torre un raggio solo
De la vostra divina interna luce,
Che splende in voi sì come in cielo il Sole,

 Potrei con l'ali vostre alzarmi a volo
Sicura, ove ogni gratia in noi riluce
E lodar vostre lode al mondo sole.

Too great a gift, to me, too fine, / too special a skill, perfect talent, / and too refined style, worthy only of you, / clutter my low and weak mind. // Yet, with my thought I often come back / to wish to follow you; but I find that my plan / is vain, and then I get irritated with myself; / for my strength is lacking for such a fine wish. // Alas, if only I could gather one ray at least/ from your divine, internal light, / that shines in you like the sun in the sky, // then with your wings I could raise myself / secure in flight to where every grace reflects in us / and praise your unique praises to the world.

Sonnet, published in Domenichi, *Rime diverse d'alcune nobilissime, et virtuosissime donne,* p. 20.

(2)

Sciolto da tutte qualitate umane
E della terra, il mio Signor sen gia
Verso il cielo e del sol già si vestia
Il bel corpo e di stelle alte e sovrane,

 E salendo pian pian, dalle lontane
Genti già si vedea la gerarchia
Prima venire e l'altre esser in via
Con desiose voglie e sovrumane.

 Da queste furon certi angeli eletti
Che innanzi al carro trionfale in mano
Portasser croci, spine e acuti chiodi,

 E lancie e spugne e dure sferze e nodi
Per mostrar con quali armi 'l mondo insano
Ei vinse ed espugnò gli Stigi tetti.

Released from all human qualities / and from the earth, my
Lord was going / toward heaven, and already he was dressing /
his body with the sun and the high royal stars, // and, rising
slowly, the first rank / of the heavenly crowds could be
seen arriving / and the others on the way / with eager and
superhuman desire. // Among these there were certain elect
angels / who, in front of the triumphal chariot, carried / in their
hands crosses, thorns, and sharp nails, // and spears and sponges
and harsh whips with knots / so as to show with what weapons
he won / the mad world and conquered the Stygian lands.

Sonnet, published in *Parnaso italiano* [1847], p. 1007; *Parnaso italiano*
[1851], col. 1399.

(3.a)

A Mad. Cassandra Petrucci

Quella chiara virtù, che da' primi anni
In voi destò leggiadri e vaghi fiori,
Rende frutti or ch'a' più pregiati allori
Non pure invidia fan, ma scorni e danni.
 Onde, spiegando al ciel sicura i vanni,
Fate che lieto ogniun v'ame et onori.
Così, fregiata de' più degni onori,
Far procacciate a morte oltraggi e inganni.
 Già non posso arrivare al vostro volo,
Ché troppo adombra questa bassa spoglia
Quel bel che l'alma in ciel conobbe prima.
 Pur, con l'esempio vostro i' mi consolo
E cerco alzarmi a l'alta cagion prima,
Ma il sapere aguagliar non può la voglia.

———

To Cassandra Petrucci

That fine skill, that since the earliest years / awoke in you
happy and beautiful flowers / now bears fruits that to the most
esteemed laurels / not only lead to envy but bring scorn and
damage. // So, unfurling your wings securely to the sky, / you
make everyone love and honor you. / Thus, adorned with
the most worthy honors, / you bring death upon insults and
deceits. // I cannot reach as high as your flight / for my lowly
body darkens too much / that beauty that the soul first knew in
heaven. // Yet I console myself with your example / and I seek
to rise up to the First Cause, / but my knowledge cannot match
my desire.

Sonnet, published in Domenichi, *Rime diverse d'alcune nobilissime, et vir-
tuosissime donne,* p. 19; Bulifon, *Rime,* p. 12; *Delle donne illustri italiane,*
pp. 140–41; *Parnaso italiano* [1851], col. 1400.

(3.b)

Risposta di Cassandra Petrucci

Quanto felici in voi sieno i lieti anni,
E quanto meritate i vaghi fiori,
Ora ogniun vede i già pregiati allori
Son sbigottiti pe' veduti danni,
 A tal che lieta co bei vostri vanni
Al ciel salite e di celesti onori
V'ornate sì, che questi bassi cori
Pregiate a vile, e gli tenete inganni.
 Ovunque va l'altiero vostro volo,
Che l'indirizzi l'onorata spoglia,
Sembra quel bel che in ciel si vede prima.
 Ond'io con allegrezza mi consolo
Veder voi con Apollo esser la prima,
Nè brama altro che questo la mia voglia.

———

Response by Cassandra Petrucci

How happy the earliest years are in you / and how much you deserve the fair flowers / everyone now sees, [and] the worthy laurels / are amazed at all the damages they suffer, / so that, happy, with your beautiful wings // you rise to heaven, and with celestial honors / you adorn yourself, for these lowly choirs / you consider vile and hold to be deceits. // Wherever your high flight might go, / what leads your honored body seems to be / that beauty that is first seen in heaven. // And so I console myself with happiness / in seeing you be first with Apollo, / nor does my desire wish for anything else.

Sonnet, published in Domenichi, *Rime diverse d'alcune nobilissime, et virtuosissime donne,* p. 19; Bulifon, *Rime,* p. 12. Petrucci retains the same rhymes used by Figliucci and in all but one verse the very same rhyme word.

Cassandra Petrucci

(1)

Lo stil, che a prova in voi poser gli Dei,
Con la gratia, con che l'alma Natura
V'adornò già quando lucida e pura
Creovvi, e di virtute eguale a Lei,
 Messo han tal freno ai rozi versi miei,
Al vano stile, a la mia mente oscura,
Che, ingombra di viltà, non s'assicura
Dir che del cielo il ben vero è in costei.
 Assicurando poi miei debil spirti,
E fissando le luci al bello stile,
Che ben si mostra di voi esser degno,
 Oso dir solo: "O dilettosi mirti,
O vaghi allori, aveste unqua voi regno
Fra stil dotto, sì alto, e sì gentile?"

————

The style, that the Gods placed in you as a test, / with the grace, with which fair Nature / adorned you when, clear and pure / she created you, and equal in virtue to her, // have reined in my rough verses / and my vain style and my murky mind / that, muddled with faint-heartedness, dares not / say that this woman has truly come down from heaven. // Assuring, then, my weak spirits / and fixing my eyes on the beautiful style / that truly shows itself worthy of being in you // I dare say only: "O delightful myrtles, / O fair laurels, did you ever have till now a kingdom / among the learned style, so high and so refined?"

Sonnet, published in Domenichi, *Rime diverse d'alcune nobilissime, et virtuosissime donne,* p. 23; Bulifon, *Rime,* p. 16.

(2)

Dove tra fresche e rugiadose erbette
Corre un più chiaro e più limpido fiume,
Ivi lieta mi sto, del chiaro lume
Contando le leggiadre parolette.

Amor, che in l'alma il bel desio mi mette,
Meco si sta con le sue lievi piume
Facendomi, per suo dolce costume,
Cercar l'ombre, e le piante leggiadrette.

Non però spero mai l'aura soave
Spenga col chiaro fiume il crudel fuoco
Ove mai sempre mi ritrovo accesa,

Ma sottoposta a così duro gioco,
Dato ad Amor de' pensier miei la chiave,
Lieta mi sto senza più far contesa.

———

Where, among the fresh and dewy grasses / a river runs most
clear and most transparent, / there I linger happily, counting
the delightful / little words of my clear light [love]. // Love,
who places this desire in my soul, / stays with me, with his light
feathers, / making me, as is his habit, / seek among the shadows
and the delightful plants. // Nor do I hope that the sweet air
should ever / put out, with the clear river, the cruel fire / with
which I always find myself burning, // But, subjected to such
a harsh yoke, / having given the key to my thoughts to Love, /
I am happy and struggle no longer.

Sonnet, published in Domenichi, *Rime diverse d'alcune nobilissime, et vir-
tuosissime donne,* p. 23; Bulifon, *Rime,* p. 16; Bergalli, *Componimenti poetici,*
vol. 1, p. 127.

(3)

Maturo, se de' bei rami d'alloro
Desiate giamai degna corona,
O il petto empir de l'onde d'Elicona,
U' sempre i pensier vostri intenti foro,
 Or di costei che non io sola onoro,
Ma quanto è sotto il figlio di Latona,
Col dolce stil, che 'l ciel largo vi dona,
Più caro oggi fra noi che perle et oro,
 Cantate il gran valor d'ogni error casso,
L'opre, la fama, i saggi esempi rari,
L'alte virtuti, e le bellezze sole,
 Ché farete adorare il ricco sasso
E lassarci i gran lumi arder più chiari,
Et abbellire il ciel d'un più bel Sole.

———

Maturo, if you should ever wish to have / the worthy crown
of laurel branches / or to fill your breast with the waves of
Helicon / where your thoughts always are, // this woman, whom
I am not alone in honoring, / but all that is under Latona's son, /
with sweet style, which heaven richly grants you, / dearer today
among us than pearls and gold, // sing the great worth, free from
all error, / the works, the fame, the rare wise examples / the high
virtues, and the unique beauties, // for you will have the precious
stone adored / and let the great lights [eyes] burn more clearly /
and beautify heaven with more than one sun.

Sonnet, published in Domenichi, *Rime diverse d'alcune nobilissime, et virtuosis-
sime donne,* p. 24; Bulifon, *Rime,* p. 17. The reference to the "precious
stone" is not clear; it may refer to a woman by the name of Pietra (stone).

(4)

Com'esser può che quel ch'io più vorrei,
Quel ch'io più bramo, e via più ch'altro ho caro
Ove ogni bene imparo,
Da me discacci? O miei fati empi e rei,
Dunque pensate vui,
Ch'io non sia sempre in lui?
 Deh, non per Dio, più tosto senza vita
Viver potrei, ma se talor mi sforza
Una onesta partita,
Resta seco il pensier con maggior forza.

———

How can it be that what I most desire, / that which I most want,
and hold most dear / whence I learn all that is good / should
flee from me? O my fate, evil and wicked, / do you then think /
that I am not always in him? // Alas, no, by God, rather without
life / I could live, but if perchance I am forced / by an honest
departure, / my thought remains more strongly with him.

Madrigal, published in Domenichi, *Rime diverse d'alcune nobilissime, et vir-
tuosissime donne,* p. 24; Bulifon, *Rime,* p. 17; Bergalli, *Componimenti poetici,*
vol. 1, p. 128; *Parnaso italiano* [1851], col. 1391.

(5)

Spargete a terra omai le smorte frondi,
Annose quercie, e voi languidi fiori
Siate, poich'è con voi sì mesta donna
Qual sono io, che lontan da la mia vita
Vivo senz'alma in questi alpestri monti, 5
Priva d'ogni piacer, colma di doglia.

Ora ho cangiata ogni mia gioia in doglia,
Poiché 'l mio fier destin fra queste frondi
Mi tiene e in sì solinghi oscuri monti,
Né vaghezza di bei leggiadri fiori 10
Potria rasserenar mia scura vita,
Né di me vive più infelice donna.

 Et a ragion vie più d'ogni altra donna
Mi doglio e più d'ogni altra è la mia doglia
Maggior perché in lui vive la mia vita, 15
E tal che più onorate chiome frondi
Non cinser mai e de' suoi vaghi fiori
S'ornano i piani e si fan belli i monti.

 Lassa, ch'io temo, or che da questi monti
È sì lontano, una più bella donna 20
Non gli arda il cuore e più lodati fiori
Non cerchi cor, né curi la mia doglia,
Pur che di più novelle e grate frondi
S'adorne il crine e me privi di vita.

 Dunque esser deve mai che la mia vita, 25
Se ben stessi mai sempre in questi monti,
Nuovo desio di più onorate frondi
O più vaga e gentil cortese donna
Gli ingombri il cor di nuova e dolce doglia
Ancor ch'ei ne sperasse e frutti e fiori? 30

 Io prego il ciel, se più lodati fiori
Han forza il tor da me sì cara vita,
Finisca il viver mio con la mia doglia
Pria che da voi mi parta, altieri monti,
Et ei felice viva e la sua donna 35
Cortese ogn'or gli sia di frutti e frondi.

 Ma spero ancor lasciarvi, o fronde, o fiori,
Innanzi ch'altra donna la mia vita
Mi tolga e gli aspri monti e l'empia doglia. 39

Scatter on the ground your withered leaves, / Most ancient oaks, and you, flowers, languish / For such a woeful woman, as I am, / Is with you. Distant from my life I live / Without my soul among these rugged peaks, / Deprived of every pleasure, full of woe. // Now I have changed my every joy to woe, / For my cruel fate keeps me among these leaves / And on these dark and solitary peaks, / Nor could the beauty of some graceful flowers / Make bright again my dark and sullen life, / There is no woman more forlorn than I. // And rightly more than any other woman / I do lament, and greater is my woe / Than theirs, for my whole life dwells in him. / No leaves did ever gird more noble locks / Than his, and with his wondrous flowers / The mountain peaks and plains adorn themselves. // Alas, I fear that now that he is gone / So far from here a woman prettier still / Might set his heart ablaze and make it seek / More honored flowers, indifferent of my woe, / As long as newer and more welcomed leaves / Adorn his brow and steal my life from me. // Must it then be that ever my dear life, / If I should always stay here on these peaks, / Should wish anew for much more honored leaves / Or should a fair and gentle courtly woman / Oppress his heart with woe so new and sweet / That he might hope to reap its fruits and flowers? // I pray the Heavens, if more praiseworthy flowers / Should have the strength to take my life from me, / Let me then cease to live, much to my woe, / Before I should depart from you, proud peaks, / And let him live in joy and let his woman / Be always gracious to him with both fruits and leaves // But I still hope to leave you, leaves and flowers, / Before another woman takes my life / And these high peaks and this my cruel woe.

Sestina, published in Domenichi, *Rime diverse d'alcune nobilissime, et virtuosissime donne,* pp. 24–26; Bulifon, *Rime,* pp. 18–19.

Silvia Piccolomini

(1)

Ben' ho del caro oggetto i sensi privi,
Ma il veggio, e sento, e ho nell'alma impresso
Come suol egro che da sete oppresso
Ha sempre nel pensier fontane e rivi.

E s'io qui mi consumo e 'l mio Sole ivi
Altrove splende, Amor, digli tu stesso,
Poiché non ho di te più fido messo
La mia gioia e 'l mio duolo, onde derivi.

Digli la mia speranza e 'l mio desio,
Com'io l'aspetto ognor, come l'invoco,
E come senza lui più non sono io.

Digli che non sia mai tempo, nè loco,
Che spenga e scemi più l'incendio mio,
Poich'ardo più quanto più lungi è il fuoco.

———

My senses are, indeed, deprived of my beloved, / but I see him,
hear him, and have him in my soul, / like parched ground that,
consumed by thirst, / is always thinking of fountains and of
brooks. // And if I, here, wither away, and my sun, there, /
shines somewhere else, do tell him, Love, / since I have no
more trusted messenger than you, / whence my joy and sorrow
do derive. // Tell him of my hopes and my desires, / how I
wait for him ever, how I invoke him, / and how without him
I am no longer myself. // Tell him there never will be a time,
or place, / that might put out or dampen my [wild] fire, / for
I burn more the more the fire is distant.

Sonnet, published in Domenichi, *Rime diverse d'alcune nobilissime, et vir-
tuosissime donne,* p. 76; Bergalli, *Componimenti poetici,* vol. 1, p. 124; *Parnaso
italiano* [1847], p. 208; *Parnaso italiano* [1851], col. 1380; Canini, *Libro dell
amore,* p. 23. The sonnet was first attributed, in 1555, to Flaminio Orsini
(*Rime di diversi*) and then, in 1565, 1839, and 1879, to Annibal Caro (Ata-
nagi, *De la rime,* vol. 1, fol. 5v; *Scelta di poesie liriche,* p. 65; *Lirici del secolo
XVI,* p. 214).

(2)

Al duca d'Urbino, nel pigliar il bastone

 "S'al tronco sol d'una spezzata lancia
Oggi cede, Signor, nemica schiera,
Che fia se dritta in su la coscia e intera
L'abbasserai contra di Spagna e Francia?
 Più non arrossirà la bella guancia
Italia mia per vergogna, ché spera
Col tuo braccio e valor tornar qual era,
Di se stessa e d'altrui spada e bilancia."
 Così di speme e d'alto sdegno armata
Roma diceva e in puro marmo e saldo,
Ergendo al nome vostro archi e colossi,
 Scriverà di sua man: "Polver sacrata
Al magnanimo invitto Guid'Ubaldo,
I figli miei di servitù riscossi."

––––––––

To the Duke of Urbino on Taking the Baton

"If to the stump, alone, of a broken lance / The rival band, my
Lord, submits today, / What will ensue when toward France or
Spain / You aim the lowered lance, now straight and whole? //
No longer will my Italy's fair cheek / Turn red with shame,
for with your arm and valor / She can expect to be what she
once was, / The sword and balance of herself and others." //
Thus armed with hope and great disdain / Spoke Rome, and
raising arches and colossi / Of pure and solid marble to your
name // She'll write in her own hand: "This soil is sacred /
To Guidobaldo, noble and unconquered, / Who freed my
children from their servitude."

Sonnet published in Trucchi, *Poesie italiane,* vol. 3, p. 209. The poem is
attributed to Silvia Piccolomini by Scipione Bichi Borghesi in SI-BCI,
MS P. IV.11, fol. 226r and by Trucchi. Trucchi admits that he has no
evidence to support his attribution of the poem to Silvia Piccolomini.

Virginia Martini Casolani Salvi

A complete edition of Salvi's poetry is part of my *L'opera poetica di Virginia Martini Salvi*.

(1)

[To King Henri II of France]

Non sia cagion l'altrui maligno impero,
Enrico pio, che l'alma patria mia
Vi sia men cara, ché voi sol desia,
Voi solo chiama, in voi fisso ha il pensiero.
 Questi inpii, fuor del dritto e bel sentiero,
Non son suoi figli, anzi di fera ria
Son nati, e su dal Ciel grida Maria
Vendetta a chi turbava il suo ben vero.
 La Real cortesia non venga meno,
Ché nel danno maggior di maggior luce
Convien che ne teniate acceso il seno.
 Ecco la Donna nostra, amata duce,
Che l'ascoso venen fa chiaro a pieno,
Onde maggior la gloria vostra luce.

———

[To King Henri II of France]

Let not another's evil rule be reason, / Pious Henri, for my life-giving motherland / To be less dear to you, for you alone it wants, / You alone it calls, in you its thoughts are fixed. // These impious people, off the right and fair path, / Are not her sons, but from a savage wicked beast / Were born. From Heaven on high Mary calls / For vengeance against those who vex her true good. // Let not your royal courtesy diminish, / For in the greater ill you need to keep / A greater light lit in your bosom. // Here is our Lady, our beloved leader, / Who fully exposes the hidden venom, / From this your glory will shine the more.

Sonnet, published in Lisini, "Poetesse senesi degli ultimi anni," p. 141 (but with transcription errors); Eisenbichler, *L'opera poetica,* p. 114. Manuscript in SI-BCI, H. X.7, fol. 37r.

(2)

Alla Reina di Francia [Catherine de' Medici]

<div style="text-align:center">

L'ardente amor, la pura e viva fede,
Il dolce e bel desio
De la cara e amata libertade
Son cagion che 'l mio volo ogni altro eccede
Poiché questa alma vede 5
Oggi a suo danno una aspra crudeltade,
Quand'ella alta pietade
Sperava e 'l fin de suoi dogliosi guai.
Lassa indarno sperai
Poscia ch'oppresso in breve tempo il nido 10
Mio vidi, ond' or piangendo afflitta io grido,
 "Alta Reina mia, chi fia che creda
Quanto fermo il pensiero
Fu de l'alme devote al vostro nome?
Queste morir volean, prima che preda 15
Esser del crudo e fiero
Nemico augel, che di sì gravi some
Oggi ne carca, come
Col suo artiglio n'avesse a forza presi.
O, troppo duri pesi 20
Amaro e rio velen, che non consenti,
Che l'alata speme or sua salute tenti.
 A Voi, come a pia madre, i cari figli,
Che da belva crudele
Sian de l'amato nido tratti fuore 25
Venghiamo, offesi da' rapaci artigli
De l'empio et infedele
Augel, cagion del nostro aspro dolore.
Et anco in mezo al core
Son, mia Reina, i vostri Gigli impressi 30

</div>

Che mai non furon oppressi
Né da lungo penar, né da l'offesa
De la nemica man di rabbia accesa.
　　　Ben so che per pietade io vedrei il viso
Vostro di pianto molle　　　　　　　　　　　　　　35
Se vi fosser presenti i martir nostri
E 'l duol v'avrebbe amaramente anciso
Quando il nemico volle
A forza darne in preda a fieri mostri.
Noi sempre sotto i vostri　　　　　　　　　　　　40
Vanni sperammo alfin sicura aita
E la noiosa vita
Men grave ne parea, sprezzando sempre
Di questo empio crudel l'amare tempre.
　　　Or per gli altrui paesi andiamo errando　　　45
Co' figli afflite in seno,
Prive di tanti onor, di tal ricchezze,
L'amata libertade in van chiamando.
Deh, s'in Voi non è meno
La pietà di cotante altre bellezze,　　　　　　　　50
Queste bell'alme avvezze,
Pur sotto l'ombra de' bei Gigli d'oro,
Non lasciate a coloro
Ch'han posto il giogo a l'alma Patria nostra,
Se non oprate Voi la virtù vostra.　　　　　　　　55
　　　Quali più strane o più selvaggie fere
Fur mai ch'al nostro pari
Sol d'acqua e d'erbe sostenesser l'alma,
Chiamando Enrico invitto, e quelle altiere
Insegne che gli amati　　　　　　　　　　　　　60
Toschi temprasser? Grave e dura salma.
Ahi, lassi, palma a palma
Battere or ne conviene, e 'l volto e 'l crine
Sveller per duolo al fine
Poscia che 'l nostro lungo alto martire　　　　　65
Gioia fu del nimico altrui desire.

Nel regal cor del vostro alto Consorte
Di nuovo raccendete
Quel bel desio di liberare altrui
Dal giogo, che ne dà perpetua morte, 70
Che Voi sola potete
Troncare al fier nemico i lacci sui,
E rischiarare i bui
Abissi nostri, u' sempre il pianto s'ode
Di tante offese e frode, 75
Ch'ei ne procaccia, mentre ogn'or si face
Maggior la nostra guerra e la sua pace.
 Chi mai con maggior fede e duolo interno,
Presago de' suoi danni,
Servò se stesso al vostro grande Enrico? 80
Lassa, che s'io ben dritto il ver discerno,
Nessun simili affanni
Soffrì, e quanto più dirne m'affatico
Il meglio, e più non dico,
Solo per dare a quello eterna fama. 85
Questo oggi anco vi chiama
Al bello acquisto, anzi a la gloria vera
De la città ch'in Voi rimira e spera.
 Io, più d'ogni altra Voi bramando, torno
Ai sette colli e veggio 90
I bei vostri vestigi u' gli occhi giro
E tra me dico: "Qui fece soggiorno,
Qui tenne il suo bel seggio
L'alta Reina mia, per cui sospiro."
E intenta l'opre miro 95
De' vostri almi pastor fatti immortali.
Onde prendendo l'ali
Da così dolce rimembranza, a Voi
Sen' vien quest'alma e qui me lascia poi.
 Canzon nata di pianto, 100
Va afflitta e mesta a la Reina mia
E dille: "A Voi m'invia

Quella, che 'n mezo al cor scolpita tiene
La bella imagin vostra e le sue pene." 104

———

To [Catherine de' Medici,] the Queen of France

The burning love, the pure and lively faith, / the sweet and
beautiful desire / for dear, beloved freedom / are the reasons
why my flights supersede all others, / for today this soul sees, /
first-hand, a bitter cruelty / where she, instead, had hoped /
[to find] lofty piety and an end to her woeful troubles. / Alas,
I had hoped in vain, / after I had seen my home so quickly /
oppressed, so that now, in tears and distress, I cry: // "My lofty
queen, who will [not] believe / how firmly those spirits / devoted
to you kept their mind fixed on your name? / They would sooner
have died than have fallen prey / to the cruel and fierce / enemy
bird, which today weights them down / with such heavy burdens,
as if / it had captured them forcefully with its claws. / Oh,
burdens far too heavy, / a bitter and evil poison, that does not
allow us now / to seek our salvation on the wings of hope. // To
You, as to a merciful mother, your dear children, / who have been
forced from their beloved nest / by a cruel beast / come, injured
by the rapacious claws / of the pitiless and unfaithful / bird, the
source of our bitter pain. / And in the middle of my heart, / my
queen, your lilies are imprinted, / never overpowered / either by
long suffering or by the injury / wrought by the enemy's hand,
burning with rage. // I know well that I would see your face, out
of pity, / wet with tears, if our sufferings were reported to you /
and you would have died of grief / when the enemy wanted / to
give us, by force, to wild monsters. / We always hoped to find, /
under your wings unfailing help / and our troubled life / seemed
less grave to us, always despising / the bitter character of this
cruel foe. // Now we wander though other lands / afflicted, with
children at our breast, / deprived of so many honors, of all our
wealth, / calling in vain for our beloved freedom. / Please, if
pity is not lacking / in You for all these other beauties, do not
abandon these beautiful souls that were accustomed / [to dwell]
under the beautiful golden lilies, / to those who have placed a

yoke on our noble motherland, / [as will happen] if you do not put your skills to work. // What stranger or wilder beasts / were there ever than us, / who sustain our soul only with water and tender grasses, / and call for invincible Henri, and for those proud / ensigns that the beloved / Tuscans tempered? A grave and bitter psalm. / Oh, woe, palm with palm / we now must beat, and our face, and pull out / our hair with grief so that / our long and hard suffering, / a pleasure to our enemy, might inspire someone else to action. // In the royal heart of your lofty consort / rekindle again / that fair desire to free other people / from the yoke that gives them perpetual death, / for You alone will be able / to stop the fierce enemy's looting, / and light up again our dark / depths, where weeping is constantly heard, / on account of the many injuries and frauds / that [the enemy] wreaks upon us, while every moment / our strife increases and [the enemy] extends its control. // Who ever, with greater faithfulness and internal anguish, / foreseeing its losses, / still remained true to your great Henri? / Alas, if I do perceive the truth correctly, /no one suffered similar / woes, and the more I exhaust myself in telling it, / [the more] I cannot speak more highly or better / just to give him eternal fame. / This, too, calls upon you today / to seize the beautiful spoils, that is, the true glory / of the city that looks upon you with hope. // I, more than anyone else, craving for you, return / to the seven hills and see / your beautiful vestiges wherever I turn my eyes / and say to myself: "Here she stayed, / here she had her seat, / my lofty queen, who is my life." / And intently I admire the works / of your noble shepherds, now immortal. / And so, rising on the wings / of such a beautiful memory, my soul / rushes to you and leaves me here alone. // Song, borne from tears, / go, afflicted and somber to my queen / and say to her: "I am sent to you / by her, who keeps imprinted in the middle of her heart, / your beautiful image and her woes."

Canzone, published in Domenichi, *Rime diverse d'alcune nobilissime, et virtuosissime donne,* pp. 199–202; Bulifon, *Rime,* pp. 187–90; Lisini, "Poetesse senesi degli ultimi anni," pp. 36–37 (but only partially); Eisenbichler, *L'opera poetica,* pp. 117–200.

(3)

A Madama Margherita di Francia

Se Voi, Donna Immortal, volete ch'io
Possa cantar il vostro alto valore,
La divina virtù, quel bel splendore,
Che di godervi a pien sprona il desio,
 Volgete un raggio vostro entro al cor mio,
Ch'ei dar puote a quest'alma il vero onore,
Allor mostrerò lieta al mondo fore
Gli alti pensier fuor de l'eterno oblio.
 Ché senza, è il mio aspro terreno asciutto,
Pien di spini e di sterpi e non produce
Per se stesso giamai fior, fronde, o frutto.
 Date, dunque, mio Sol, la vostra luce
Al lasso spirto in pene arso e distrutto,
E siate a me di sì bell'opra duce.

———

[To Margaret of France [also known as Marguerite de Valois]

If you, immortal Lady, wish me / To sing of your lofty worth, /
Your divine virtue, and that beautiful splendor / That urges
desire to enjoy you to the fullest, // Turn your glance into my
heart, / For it can give this soul true honor, // And then I will
gladly show forth to the world / The lofty thoughts that elude
eternal oblivion. // Because without [your glance] my bitter soil
is parched, / Full of thorns and scrubs, so that it never yields /
On its own flowers, leaves, or fruits. // Give, therefore, my sun,
your light / To my tired soul consumed and wracked by pains, /
And be, for me, the captain of such fine work.

Sonnet, published in Domenichi, *Rime diverse d'alcune nobilissime, et vir-
tuosissime donne*, p. 170; Conti, *Rime di diversi autori*, p. 4; Bulifon, *Rime*,
p. 159; Eisenbichler, *L'opera poetica*, p. 134.

(4)

Al Cardinale di Napoli [Alfonso Carafa]

A l'alto merto vostro, al gran valore,
Men non si convenia, ch'ornarvi d'ostro
L'altiera testa, esempio al secol nostro
Di bontà, di virtù, d'eterno onore.
 Voi colmo avete il sen di casto amore,
Pieno d'alti concetti il pensier vostro,
Voi chiaro fate questo oscuro chiostro,
Sì ch'ei non teme il variar de l'ore.
 Sacra pianta gentil, da cui si deve
Sempre frutto sperare eterno e raro,
Ove il tempo non puote, o ingorda morte.
 E quanto al mondo par noioso e greve,
A Voi, che bene oprate, è dolce e caro,
Tal che v'alzate al ciel con queste scorte.

———

To the Cardinal of Naples [Alfonso Carafa]

Given your lofty merit, your great valor, / Nothing was more
fitting than to deck / Your lofty head with purple, a model
for our times / Of goodness, virtue, and everlasting honor. //
Your breast is filled with love most chaste, / Your thoughts with
notions most refined, / You fill with light this cloister dark and
dusky, / So that it does not fear the passing hours. // Sacred,
gentle plant, from which we always can / Expect a yield both rare
and everlasting / That time and greedy death cannot undo. //
Whatever to the world seems heavy and annoying, / To you, who
do good deeds, is sweet and dear, / So that you rise to heaven
with these stores.

Sonnet, published in Domenichi, *Rime diverse d'alcune nobilissime, et virtuosis-
sime donne,* p. 198; Bulifon, *Rime,* p. 186; Eisenbichler, *L'opera poetica,* p. 123.

(5)

Al medesimo [Alfonso Carafa, Cardinal of Naples]

Sì come occhio mortal giunger non puote
A contemplar di Dio la beltà vera,
Fin che, disciolto da la bassa sfera,
Ogni terren pensier da sè non scuote,
 Così le rime mie d'effetto vote
Son, mentre speran vostra virtù intera
Cantare a pien, per giungere anzi sera
Ove che 'l cieco oblio mai non percuote.
 Eguale al merto è il mio desire ardente,
Ma non s'aguaglia al vostro alto valore
La penna mia, nè l'oprar nostro umano
 Perché, congiunto Voi con l'alta mente,
Troppo ardir fora il vostro bel splendore
Fissar con l'occhio e col pensiero invano.

———

To the Same [Cardinal Alfonso Carafa of Naples]

Just as a mortal gaze cannot reach out / To contemplate the true
beauty of God / Until it is released from this low sphere / And
from itself has cast all earthly thoughts, // So too my rhymes are
void of their effect / When they aspire to praise your worth in
full / So as to reach, before the evening falls, / Where blind
oblivion never will offend. // My burning wish is equal to your
merit, / But my pen does not match your lofty worth / Nor do
our human works because, // United as you are with the High
Mind, / It would be far too bold to fix my eyes / Or my vain
thoughts on your brilliance so fair.

Sonnet, published in Domenichi, *Rime diverse d'alcune nobilissime, et virtuosis-
sime donne,* p. 198; Bulifon, *Rime,* p. 186; Eisenbichler, *L'opera poetica,* p. 124.

(6)

Al Cardinal Vitelli

> Signor, ch'a l'Idra il venenoso dente
> Rompete sì che i vostri alti pensieri
> Giungono al fin che fa ch'ogni alma speri
> Vedervi vice de l'eterna mente,
> Quel vostro bel desio, chiaro, et ardente
> D'oprar per l'altrui ben, simile è ai veri
> Effetti del Motore, onde leggieri
> Ite, ove il mortale occhio ir non consente,
> Tal ch'io di me la miglior parte offersi
> A quella gran virtù che in Voi risplende,
> Ornamento immortal del secol nostro.
> O fortunato dì, che gli occhi apersi
> Per veder quel valor ch'ogn'or m'accende
> A farmi eterna con purgato inchiostro.

―――

To Cardinal [Vitellozzo] Vitelli

Signor, the Hydra's poisonous tooth / You break so that your
lofty thoughts / Lead everyone to hope / To see you vicar to
the Eternal Mind, // Your beautiful desire, clear and burning, /
To work for the good of others, is similar to the true / Effects
of the Mover, and so you fly lightly / To where a mortal eye is
not allowed to go, // So that I offered what is best in me / To
that great virtue that in you shines forth, / Immortal ornament
to our times. // Oh fortunate day, when I opened my eyes /
To see that worth that still inspires me / To make myself eternal
with purged ink.

Sonnet, published in Domenichi, *Rime diverse d'alcune nobilissime, et virtuosissime donne,* p. 196; Bulifon, *Rime,* p. 184; Eisenbichler, *L'opera poetica,* p. 122.

(7)

Al Cardinale Trivultio

 Del gran tempio di Dio sostegno fido,
Verace onor di questa nostra etate,
Esempio di virtù, per cui v'ornate
La chioma d'ostro con eterno grido,
 Chiaro Trivultio, albergo e caro nido
De' più santi pensier, Voi sol ne fate
Fede de la divina alma bontate,
Con alta maraviglia, in ogni lido.
 Già non potea da così illustre seme
Nascer frutto, Signor, punto men degno,
Ch'un bel principio il fin lodato attende.
 O de l'anime belle intera speme,
O di salire al ciel sicuro pegno,
Specchio in cui tanto il primo raggio splende.

———

To Cardinal [Antonio] Trivulzio [the Younger of Milan]

Trusted column of God's great temple, / True honor of this
age of ours, / Example of virtue, by which you deck / Your
brow with purple to your eternal fame, // Bright Trivulzio,
lodging and dear home / To most holy thoughts, You alone bear
witness / For us of pure divine goodness, / With great marvel
everywhere. // From such illustrious seed there could not /
Spring but such fruit, Signor, and just as worthy, / For a good
start expects an exalted end. // O abounding hope of beautiful
souls, / O certain token of rising to heaven, / Mirror that reflects
so well the first ray.

Sonnet, published in Domenichi, *Rime diverse d'alcune nobilissime, et virtuosis-
sime donne,* p. 195; Bulifon, *Rime,* p. 183; Eisenbichler, *L'opera poetica,* p. 125.

(8)

Virginia Salvi al S. S.

Da fuoco così bel nasce il mio ardore
Ch'in me si faccia eterno sol desio,
Il laccio, con cui l'alma avvinse Amore
È tal, ch'in piacer volge il martir mio.
Questo sol mi tormenta e affligge il core: 5
Non poter tor d'altrui quel timor rio.
Questo turba il mio dolce e fa ch' in terra,
Pace non trovo e non ho da far guerra.
 Rapace, ingorda, e venenosa fera,
Seme che spegni ogni dolcezza mia, 10
De l'altrui danno sol ti godi e altera
Ten' vai, troncando il ben ch'altri desia.
Felice è chi fuggir tuo velen spera,
O infernal furia, o iniqua Gelosia,
Ch' in te pensando io mi consumo e sfaccio, 15
E temo, e spero, e ardo, e son un ghiaccio.
 Amo, e non nacque dal mio Amor giamai
Questo verme crudel ch'altrui divora,
Amo, quant'amar posso, i santi rai
Del mio bel Sol che nostra etate onora. 20
Nè mai tal doglia nel mio cor gustai
Che tanto altrui, quanto se stesso accora,
E pur Amor sue forze in me disserra
E volo sopra il cielo e giaccio in terra.
 Da l'altrui Gelosia nasce il tormento 25
Che del caro mio ben, lassa, mi priva.
Questa sol mi disface e ha già spento
L'umor che questa spoglia tenea viva.
Ella mi toglie il dolce e bel concento
De le parole ond'io già mi nodriva, 30

Però piangendo io mi consumo e taccio,
E nulla stringo e tutto 'l mondo abbraccio.
 Sì mi vince talor l'aspro martire
Che per minor mio duol corro a la morte.
La ragion poi si desta e prende ardire 35
E a l'empio mio desir serra le porte
Dicendo: "Lassa, vuoi dunque finire
Tua vita in così dura e acerba sorte?"
In così van soccorso il pensiero erra;
Tal m'ha prigion, che non m'apre, né serra. 40
 O affetto rio, ch' il più felice stato
Che goder possa alma d'amore accesa
Co 'l venenoso tuo tosco hai turbato,
Rotta la sua beata et alta impresa.
Avestu ancora il debil fin troncato 45
E questa spoglia a la vil terra resa,
Ch'omai da me la vita odio e discaccio,
Né per sua mi ritien, né scioglie il laccio.
 Amor, non volev'io ch'il mio gioire
Senz' il piacer di te mai fusse eterno; 50
Con la tua aita al Ciel sperai salire,
Ché fuor di te non ho guida o governo;
Onde se sai che tal fu il mio desire,
Perché spargi nel cor tal duolo interno?
Ahi, mia già lieta speme, or sei sotterra, 55
Ché non m'ancide Amore e non mi sferra.
 Non mi sferra il crudele e non m'ancide,
Non mi dà morte e non mi tiene in vita,
Troncar non vuol lo stame e no 'l recide,
Tormenta l'alma e finge darle aita. 60
Del misero mio stato io piango, ei ride
E in così dure tempre a starmi invita,
Ch'io per mille morti il giorno faccio,
Nè mi vuol viva, nè mi trae d'impaccio.
 Poi che la vista del mio chiaro Sole 65
Al mio mal pronta Gelosia m'ha tolto,

Risonano anco in me quelle parole
Che da bassi pensier m'hanno il cor sciolto,
Ne l'alma ho sculte quelle luci sole
Sostegno mio, e 'l vago e 'l dolce volto, 70
E seco del mio mal piango e sorrido,
Veggio senz'occhi, e non ho lingua e grido.
 Senza lingua grid'io, senz'occhi veggio
Quel ben, ch'oggi al mio Sol posseder lice,
Fin ch'ivi ho il mio pensier altro non chieggio, 75
Che 'l possessor di quel troppo è felice.
In tal pensier, fra me stessa vaneggio,
E se godere il ver mi si disdice,
La mente mia col falso tiemmi in vita,
E bramo di perire e chieggio aita. 80
 L'alta cagion del mio fermo pensiero
Mi porge per salire al ciel le scale,
E mi conduce a quell'oggetto vero,
Ov'è l'opra infinita et immortale.
I sensi frali poi da quel sentiero 85
Mi tolgono, ond'io, lassa, vengo a tale
Ch'io fuggo il sole e i chiari raggi sui,
E ho in odio me stessa et amo altrui.
 Misero stato degli amanti, in quante
Morti si vive e in qual tormento e morte? 90
Un dolce riso fa gustar le tante
Amare pene dolci; e se per sorte
Il suo bel sol si vede irato innante
Apre il pianto al dolor le chiuse porte,
Et io, che in queste tempre oggi m'annido 95
Pascomi di dolor, piangendo rido.
 Fuggir devriensi, se fuggir si puote
D'Amor i lacci e le lusinghe amare,
Amare, poi che son di fede vote,
Larghe promesse, e sol d'effetti avare. 100
Per un piacer mille dolor percuote
Entr'al cor lasso. E anco a me fur care

Le lagrime ch'al duol davano uscita.
Or mi spiace egualmente morte e vita.
 Satio del tormentarmi, Amore stassi 105
Lo stato mio mirando interno e fiso,
E vede gli occhi miei di pianger lassi,
E l'imagin di morte entr'al mio viso.
Son questi i merti ch'a' suoi servi dassi,
Amor, poscia c'hai il cor di pene anciso? 110
Io, per men doglia, ir bramo a' regni bui.
In questo stato son, mio ben, per vui. 112

———

Virginia Salvi to S. S.

My passion is born of such beautiful fire / That I only hope
it lasts in me forever, / The tie that Love has used to bind my
soul / Is such that all my woes it turns to bliss. / But this alone
torments and grieves my heart: / I cannot flee the fear of
someone else. / This troubles all my joys so that on earth /
I find no peace and have no war to wage. // Rapacious, greedy,
poisonous wild beast, / The germ that cancels every joy I have, /
You revel only in another's harm / And proudly go, thwarting
another's hopes. / Happy the one who hopes to flee your bane, /
Infernal fury, ungodly Jealousy, / Thinking about you I come
undone and wither, / And fear, and hope, and burn, and turn to
ice. // I love, but my love never did give birth / To this cruel
worm that gnaws away at me. / I love, as much as I can love, the
holy rays / Of my fair sun who honors this our age. / But never
did my heart feel such great pain / That grieves another as it
grieves itself, / And yet Love sets his forces loose in me / And I
fly o'er the sky and lie on earth. // From someone else's jealousy
is born / The torment that deprives me of my good. / It's this,
alone, that breaks me and already / Has dried the humor that
kept me alive. / It takes away the sweet and fine accord / Of
those fine words that once did nourish me, / And so, in tears,
I wear away in silence, / I have but naught and all the world
embrace. // Sometimes the bitter suffering so defeats me / That

for my lesser pain I rush to die, / But reason then awakes and, / gathering strength, / Slams shut the gate upon my sinful wish / And says: "Wretch, do you want to end / Your life in such a harsh and bitter way?" / In these vain paths my thoughts wander about; / Such is the jail that neither frees nor holds me. // O wicked feeling, with your poisonous bane / You have disturbed the happiest of states / A soul enflamed with love might revel in, / And ruined its blessed, lofty enterprise. / If only you had cut the feeble thread / And rendered back these spoils to lowly earth, / For now I hate my life and flee from it, / Nor does he make me his, nor set me free. // My love, I never wished that my delight / Should last forever without joy of you, / For without you I have no guide or rule; / So, if you know that such was my desire, / Why do you fill my heart with inner woe? / Alas, my hope once glad, so buried now, / For Love will neither slay me nor unchain me. // The cruel one will neither free nor slay me, / He will not give me death or keep me living, / He will not cut the thread or break it off, / He grieves my soul and feigns to give it life. / I weep upon my dire straits, he laughs / And bids me to remain in this hard state, / That makes me die each day a thousand times, / Nor does he want me alive, or get me out. // Since Jealousy, so keen to do me harm, / Has taken the sight of my clear sun from me, / Those words that have undone my heart / With vile concerns still echo deep within me, / Those lights that alone sustain me, that fair / And pleasant face are sculpted on my soul, / I cry and smile with her about my woe, / Without my eyes I weep, without a tongue I shout. // Without a tongue I shout, eyeless I see / That good that on this day my sun may have, / I ask no more while here my thoughts remain, / For who possesses this is far too glad. / And if I am denied to see the truth, / My mind keeps me alive with something false / And I crave for my death and ask for help. // The lofty reason for my constant thought / Offers me the stairs to climb to heaven / And guides me on the way to that true object / Where all is without time and without bounds. / But then my feeble senses draw me away / From that path, and I, alas, become such /

That I flee the sun and its clear rays, / And I detest myself and love another. // O, wretched state of lovers, in how many / Deaths one lives and in what pain and death? / A tender smile lets one taste many sweet / And bitter pains; and if by chance one sees / That lovely face irate in front of you, / Tears open up the gates once closed to pain / And I, who dwell today in such a state, / Feed on my pain, and in my tears I laugh. // One should escape, if one could but escape / The ties of love and all its bitter lures, / Bitter, since they are void of trust, / Great promises, but lean in their results. / For one delight he strikes a thousand blows / Inside the weary heart. And I, too, held dear / The tears that were a gateway for my pains. / Now I dislike both life and death the same. // Content with his tormenting me, Love stands / Intently gazing at my inner state / And sees my eyes grown weary from my crying / And death's own image drawn upon my face. / Are these the gifts you give to all your servants, / Love, once you have killed their hearts with grief? / To ease the pain, I crave the dark domain. / I am in such a state, my love, for you.

Octave sequence, published in Arrivabene (1553), fols. 109v–11v; Domenichi, *Rime diverse d'alcune nobilissime, et virtuosissime donne,* pp. 186–90; Ferentilli, *Primo volume della scielta* (1571), pp. 436–40, (1579), pp. 169–73, and (1584), pp. 174–78; Bulifon, *Rime,* pp. 174–78; *Rime di poeti italiani,* pp. 135–38; Eisenbichler, *L'opera poetica,* pp. 103–6. Manuscript in FI-BNCF, Palat. 256, fols. 195r–97r. The last verse of each octave picks up in sequence each of the fourteen verses of Petrarch's poem *RVF* 134, "Pace non trovo e non ho da far guerra," thus creating a *glosa* or gloss. I have based my edition and translation on the 1559 text.

(9.a)

A Pietro Bembo

 Mentre che 'l mio pensier dai santi lumi
Prendea fido riposo,
Ben non vid'io, che al mio ben fosse eguale.
Or che 'l ciel vuol ch'in pace i' mi consumi
E a forza tenga ascoso 5
Il troppo acerbo e doloroso male,
Piacciavi darme l'ale
Così veloce a ritrovarvi poi,
ché sempre vivo in voi,
E ne piglio cotanta e tal dolcezza, 10
Che 'l mio cor lasso ogn'altra vista sprezza.
 M'è a noia, ove ch'io miro, se sembianza
Di voi, ben mio, non veggio,
E se di cari spirti ho sempre intorno
Vago drappel, l'acerba lontananza 15
Fa che col duol vaneggio.
Né gioia, né piacer fa in me soggiorno
Talché a voi sempre torno,
Ch'ivi è la mia ricchezza e 'l mio tesoro,
Ivi le gemme e l'oro 20
Son che cotanto l'alma onora e prezza
Che 'l mio cor lasso ogn'altra vista sprezza.
 Movo talor le piante, ove 'l bel piede
Premendo se ne gìa
Le tenerelle erbette e i vaghi fiori 25
Per veder s'orma almen di quei si vede,
Ma l'alta speme mia
Nulla ritrova fuorché i suoi dolori,
E se Ninfe o Pastori
Veggio, dimando pur se del Sol mio 30
San nulla. E mentre un rio
Fan gli occhi mesti e sono a tale avvezza
Che 'l mio cor lasso ogn'altra vista sprezza.

Ma che spero io trovare in altri mai
Di voi sembianza vera 35
Se l'alma bella e 'l valoroso velo
Fe' senz'eguale il ciel per più miei guai?
Ché dunque 'l cor più spera
Temprar senza voi stesso il caldo e 'l gelo
Che con grave duol celo 40
Fra finto riso e simulato volto?
E dove ch'io mi volto
Non potendo veder vostra bellezza
Il mio cor lasso ogn'altra vista sprezza.
 Se pur altro desio di eterno onore 45
Di più lodate imprese
Vi face star da me, cor mio, lontano,
Benché mi doglio, pur sento 'l valore
Vostro con l'ale stesse
Girsen' poggiando ognor per monte e piano. 50
Veggio la bella mano
Far con la spada al reo nimico danno
E con tema ed affanno
Farlo cattivo, onde sua forza spezza,
E 'l mio cor lasso ogn'altra vista sprezza. 55
 Canzon mia passa i monti
E ratta vanne al chiaro mio bel sole
E di' queste parole:
"CINZIA vive a te lungi in tanta asprezza
Che 'l suo cor lasso ogn'altra vista sprezza." 60

———

To Pietro Bembo

While my thoughts were resting / On those holy lights, / I did not notice the same was true for my beloved. / Now that heaven wants me to wither away in silence / And to keep hidden, by force, / My too bitter and dreadful pain, / May it please you to give me wings / To fly quickly to you / In whom I always live, / And from this I gather so much pleasure / That my weary heart despises any other

sight. // Wherever I look, I find it tedious, if I don't see / A semblance of you, my beloved, / And if I am always surrounded / By a fair group of dear souls, the bitter distance / Makes me rave with pain. / Neither joy nor pleasure dwells in me / Because I always return to you, / For there lies my wealth and my treasure, / There are the jewels and gold / That my soul so honors and values, / For my weary heart despises any other sight. // Sometime I move my feet where the fair foot / Wandered by, pressing / On the tender grass and beautiful flowers / So as to see if any trace of him can still be seen, / But my high hope / Finds nothing but its own aches. / And if I see nymphs or shepherds / I ask them if they know anything / Of my sun. And while a river / Moistens my eyes, I am so used to this / That my weary heart despises any other sight. // But why should I hope ever to find in others / A true semblance of you / If the Heavens made that beautiful soul / And valiant veil without equal, to my greater woe? / Why, then, does my heart hope / To temper, without you, the heat and ice / That, to great woe, I hide / In false laughter and a feigned countenance? / And wherever I turn, / Unable to see your beauty, / My weary heart despises every other sight. // If any other desire for eternal honor / From more praiseworthy deeds / Keeps you, my heart, far away from me, / Although I lament, yet I feel your valor / With open wings / Fly over every hill and plain. / I see your beautiful hand / Wreak damage with your sword on the wicked foe / And to his fear and anguish / Capture him and thus break his strength / And my weary heart despises every other sight. // Song, fly past the mountains / And quickly go to my beautiful, clear sun / And say this to him: / "CINZIA dwells in such bitterness far from you / That her weary heart despises every other sight."

Canzone, published in Bottrigari, *Libro quarto delle rime,* pp. 190–92; Bembo, *Rime* (1753), pp. 174–75; Bembo, *Opere,* vol. 2, pp. 142–43; Tobia, *Fiori di rimatrici italiane,* (1846), pp. 18–21; *Parnasso italiano* [1847], pp. 1015–16 (where, after Salvi's name, the editor has added "(1561)," but this is clearly a typographical error for 1551); Eisenbichler, *L'opera poetica,* pp. 81–83.

(9.b)

Riposta del Bembo

 Almo mio Sole, i cui fulgenti lumi
Fan chiaro e luminoso
Quant'oggi mirar può vista mortale,
Perché più lagrimando ti consumi?
Quantunque il volto ascoso 5
Ti fia, qual chiami in terra senza eguale,
Non sai che i vanni e l'ale
Ha il bel pensier e li viaggi suoi
A CINZIA sono, e poi
Ne tragge una sì estrema e gran dolcezza, 10
Che il mio cor lasso ogn'altra vista sprezza.
 Non può quella benigna alta sembianza,
Qual con la mente veggio
Ed in mezzo dell'alma fa soggiorno,
Amareggia l'acerba lontananza, 15
Ché l'onorato seggio
Ha così bella immago al core intorno,
Il bel sembiante adorno
E la rara beltà che in terra adoro
In cui sol vivo e moro. 20
Gode 'l penser lontan e sì l'apprezza
Che 'l mio cor lasso ogn'altra vista sprezza.
 Quantunque in altro clima io giri il piede,
Non però mi disvia
Amor sì li desir che i primi ardori 25
Smorzi, e la data mia sincera fede.
La viva speme mia
Sempre ha sostegno di tempi migliori.
Muse, Ninfe, e Pastori
Cantan lodando il degno alto disio 30
E mentre il pensier mio
Fermo con l'alma al dolce oggetto avvezza,
Il mio cor lasso ogn'altra vista sprezza.

Però se di lontan gli amati rai
E la bellezza altera, 35
Se la gentil sembianza e 'l chiaro velo
Scorge l'occhio mental più dolce assai
Che la presenza vera,
Perché più ti distempra il caldo o 'l gelo?
Poich'è benigno il cielo, 40
Qual giunge l'alme, rasserena il volto,
Qual fia più grato molto
L'aspettato ritorno alla bellezza,
Che 'l mio cor lasso ogn'altra vista sprezza?
 Non mi scompagna un volontario errore, 45
Ma un desio d'alte imprese,
Che a te deve aggradir, mi fa lontano
Viver, ma vivo in te vive 'l mio core
E le mie voglie accese
Passan mari, alti monti, e largo piano, 50
Ed al bel viso umano
Mille e più volte 'l duol torno fanno
Tempra dunque ogni affanno
CINZIA mia dolce, e 'l duol già rompi e spezza
Che 'l mio cor lasso ogn'altra vista sprezza. 55
 Canzon, ripassa i monti
E dì pietosamente al mio bel Sole
Queste quattro parole:
"Vivi, CINZIA gentil, fuor d'ogni asprezza,
Che 'l mio cor lasso ogn'altra vista sprezza." 60

———

Response from [Pietro] Bembo

My life-giving sun, shining lights / Make clear and brilliant /
Whatever mortal eyes can see today, / So why do you wear
yourself down in tears? / Although my face is hidden from you /
That you deem without equal here on earth, / Don't you know
that beautiful thought / Has feathers and wings, and its path /
Leads to CINZIA, and then it draws / Such great and extreme
sweetness from this / That my weary heart despises every other

sight. // That lofty and benevolent countenance / That I see in
my mind / And that dwells in the middle of my soul, / Cannot
be grieved by cruel distance, / For such an honored place /
Belongs to the beautiful image in my heart, / To the fair adorned
countenance, / And to the rare beauty I adore on earth, / In
which, alone, I live and die. / My distant thought delights in it
and so appreciates it / That my weary heart despises every other
sight. // Even though I wend my way in other climes, / Still
Love does not lead astray / My desires or dim my first passion /
Or the sincere promise I have made. / My fervent hope / Always
trusts in better times. / Muses, nymphs, and shepherds / Sing the
praises of my lofty wish / And while my thought / Firmly, with
my soul, dwells on my beloved, / My weary heart despises every
other sight. // So, if my mind's eye sees from afar / The beloved
rays / And the lofty beauty, the gentle countenance / And
the clear veil, and finds them much sweeter / Than the true
presence, / Why does the heat and ice wear you away? /
Since Heaven is so kind / That it joins souls, restrain your
tears, / For the longed-for return to beauty / Will be much
more appreciated, / For my weary heart despises every other
sight. // It's not a voluntary error that takes me from you, /
But a desire for lofty deeds, / Which should please you. This
makes me live / Far away, but alive in you my heart lives /
And my burning desires / Fly over seas and high mountains
and wide plains / And to the beautiful human countenance /
A thousand and more times bring back pain. / Temper, thus, all
your distress, / My sweet CINZIA, and break and destroy this
pain, / For my weary heart despises every other sight. // Song,
fly back across the mountains / And in pity say to my beautiful
sun / These four words: / "Live, gentle CINZIA, away from
any bitterness, / For my weary heart despises any other sight."

Canzone, published in Bottrigari, *Libro quarto delle rime,* pp. 192–95;
Bembo, *Rime,* pp. 176–78; Bembo, *Opere,* vol. 2, pp. 144–46; Eisenbich-
ler, *L'opera poetica,* pp. 84–85.

(10)

Mentre che i dolci lumi onesti e santi
Rivolge in me la cara vita mia
Do fine ai dolorosi acerbi pianti,
Né più la brama il cor, né più desia,
E da mille pensier ch'aveva inanti 5
Mi toglie Amor e sol mi sprona e avvia
Ivi; ma per mio duol, lassa, no 'l crede
L'infinita bellezza e poca fede.

 O poca fe', bellezza alta infinita,
Senza egual oggi nel mio chiaro sole, 10
Alma nel sen di Dio sola gradita,
Che per esempio suo fra noi ti vole,
Deh, come saria a pien dolce mia vita
Se fe' prestassi a mie vere parole,
Non direi con quel duol, ch'a me sol riede, 15
Infinita bellezza e poca fede.

 Poca fede, infinita alma bellezza
È quella di ch'io parlo e di ch'io scrivo,
E nulla qua giù stima e nulla prezza,
Ch'ogn'un vede a sé vile ed altri ha schivo. 20
Ma a chi degno è mirarlo, tal dolcezza
Dona che lascia il cuor d'ogni duol privo,
N'altro men bello in lui, n'altro si vede,
Ch'infinita bellezza e poca fede.

 Deh, perché eternamente non poss'io 25
Tener quest'occhi fissi e fermi in lui?
Perché saziar non posso quel desio
Ardente in me dei santi lumi sui?
Acciò che 'l fermo e santo pensier mio
Non abbia forza mai volgersi altrui, 30
Né possa il cor mai dir con tal mercede:
Infinita bellezza e poca fede.

 Ogni sua forza in sé natura accolse
Per far un'opra così rara e bella,
E da mille bell'alme elette tolse 35

Il meglio e n'adornò mia chiara stella,
E poscia Iddio suoi santi raggi volse
Pieni d'alte terrene grazie in quella
Alma gentil che tutte l'altre eccede
D'infinita bellezza e poca fede. 40
 E perch'io più vedessi aperto e chiaro
Il bel ch'Iddio gli die' d'altro maggiore,
M'è stato il ciel d'ogni suo dono avaro
Pascendomi di pianto e vano errore.
Or, per tornar dolce il passato amaro, 45
A quest'occhi ha scoperto quel splendore
Che fisso miro e sol quest'alma fiede
Infinita bellezza e poca fede.
 Ma s'egli avien che mai se stesso miri,
Che mi dia fe', senza alcun dubbio spero, 50
Non dico a quei cocenti miei sospiri
Che del cor mostran fuori aperto il vero,
Né tanto ai gravi e tant'aspri martìri
Che 'l fan del mio penar cotanto altiero,
Ma che quel ch'amo, miro e ch'ei possiede, 55
Qual sua beltà infinita fia sua fede.
 Volga dunque in se stesso i lumi ardenti,
E vedrà la cagion ch'amor m'accende,
Non già cagion di pianto o di tormenti,
Anzi di gire al ciel ch'eterno splende. 60
E vedrà poi che con ragione spenti
Ha in me gl'altri desii e che si stende
Il mio pensier in lui, n'altro gli chiede
Ch'eguale a sua beltà mostri la fede. 64

———

While he, who is my life, turns / his sweet, holy, honest eyes
toward me / I put an end to my bitter painful tears / and my
heart no longer longs for him or desires him, / and from the
thousands worries I had before / Love takes me away and only
spurs and leads me / here; but, to my woe, alas, he does not
believe it, the infinite beauty and little faith. // O [you of] little
faith, lofty and infinite beauty / without equals in my clear sun

today; / soul that, alone, is beloved in God's bosom, / who wanted you to be a model of himself among us, / oh, how my life would be full and sweet / if only you believed my truthful words, / I would not say, with that pain that returns upon me, / infinite beauty and little faith. // Little faith, infinite life-giving beauty / is the one I speak and write about; / and he esteems nothing down here and appreciates nothing / for he considers everyone base compared to himself and avoids them. / But to those worthy enough to look upon him he gives / such sweetness that it deprives the heart of every pain / and nothing less beautiful, nothing in him is seen, / but infinite beauty and little faith. // Oh, why can I not forever / keep these eyes fixed and fast on him? / Why can I not satisfy that desire / burning in me for his holy lights? / So that my steady, holy thought / need never have to turn to someone else, / nor my heart need say with so much pleading: / infinite beauty and little faith. // Nature gathered into itself all of its strengths / to create such a rare and beautiful work, / and from a thousand elect souls it took / the best of each and adorned my clear star with it, / and then God turned his holy rays / full of lofty earthly graces toward that / gentle soul, which surpasses all the others / in infinite beauty and little faith. // And so that I might see more openly and clearly / the beauty that God gave him, greater than anyone else's, / Heaven was stingy with me with all its gifts / and feeds me with tears and vain error. / Now, to render sweet the bitter past, / it has revealed to my eyes that splendor / that I fixedly admire, and only this soul is torn by / infinite beauty and little faith. // But should he ever look inside himself, / I hope, without a doubt, he will believe me. / I do not mean [he will believe] my burning sighs, / that openly reveal the truth inside my heart, / or even my many bitter, grievous woes / that make him so disdainful of my sufferings, / but that he should see what I do love and admire and what he possesses, / like his infinite beauty be his faith. // Let him, therefore, turn his burning lights unto himself / and he will see the reason why love burns me / [and is] the cause not of my tears and torments / but of my going to that heaven that is forever radiant. / He will then see that he has, quite rightly, / put

out all other desires in me and that my thoughts / reach out to him alone and ask for nothing else / but that he show his faith to be equal to his beauty.

Octave sequence, published in Doni, *Dialogo della musica* (1544), fols. 35r–36r; (1969), pp. 137–39; Eisenbichler, *L'opera poetica*, p. 75–77.

Onorata Tancredi Pecci

(1)

Se la parte miglior, vicina al Vero,
Fuor de le mortal voglie mi sospinge
E quanto il debil senso al cor dipinge
Gli mostra vano e fuor d'ogni sentiero,
 Donde mio sommo Dio, perfetto e intiero,
Che 'l duro laccio che quest'alma cinge,
A sua voglia mi sforza, volge, e stringe
Tal che l'effetto poi segue al pensiero
 E ben vegg'io che i santi lumi tuoi
Non mi lece mirar mentre ch'intenti
Sono a cosa mortale i miei desiri,
 Non posso io nulla oprar, ma se tu vuoi
Volger ne l'alma i puri raggi ardenti,
Felici al ciel giranno i miei sospiri.

———

If my better part [my soul], near to the truth, / pushes me beyond my mortal wishes / and shows how vain and far from every path / is whatever our weak senses reveal to the heart, // Whence my supreme God, perfect and complete, / forces, turns, and tightens as he wishes / the harsh bond that binds my soul / so that the results then follow the thought, // And though I understand that I am not allowed / to gaze upon your holy lights [eyes] as long as / my desires are fixed upon a mortal thing, // I can do nothing, but if you want / to turn your burning rays toward my soul, / my happy sighs will wend their way to heaven.

Sonnet, published in Domenichi, *Rime diverse d'alcune nobilissime, et vir-tuosissime donne,* p. 72; Bulifon, *Rime,* p. 63; Bergalli, *Componimenti poetici,* vol. 1, p. 177.

<div align="center">(2)</div>

> Mira, vero Signor, mira quest'alma
> Involta ne la fral terrena scorza,
> Come afflitta si duol, poscia ch'a forza
> Vede al basso desio spettar la palma,
> E la chiara virtù celeste et alma
> Che Tu le desti più non si rinforza,
> Poiché sì picciol vento abbatte e smorza
> Sua luce lungi a la bramata salma.
> Senza l'aita tua ben temo ch'ella
> Non resti priva de' tuoi santi lumi,
> E pur, s'a Te non piace, esser non puote.
> Adunque, Signor mio, volgi in me quella
> Pietate ardente che 'l mio cor consumi,
> Né sien le preci mie di merto vote.

––––––

Look, true Lord, look at this soul / wrapped up in its frail earthly husk / how, afflicted, it laments, since it is obliged / to see the palm [of victory] bestowed on low desires // and the clear celestial life-giving virtue / that you gave it no longer able to grow strong / because a little wind brings it down and puts out / its light, far from the desired object. // Without your help, I very much do fear lest she / remain deprived of your holy lights [eyes], / and yet, if you don't wish it, it will not be. // So, my Lord, turn toward me your / burning pity, that it might consume my heart; / nor let my prayers go without reward.

Sonnet, published in Domenichi, *Rime diverse d'alcune nobilissime, et vir-tuosissime donne,* p. 72; Bulifon, *Rime,* p. 63; Bergalli, *Componimenti poetici,* vol. 1, pp. 177–78.

NOTES

Abbreviations Used in the Notes

BN Bibliothèque Nationale, Paris, France

FI-BNCF Biblioteca Nazionale Centrale di Firenze, Florence, Italy

RISM Répertoire international des sources musicales (superscript indicates RISM number from the volume *Recueils imprimés xvie-xviie*)

SI-ASS Archivio di Stato di Siena, Siena, Italy

SI-BCI Biblioteca Municipale degli Intronati di Siena, Siena, Italy

Introduction

1. Dionisotti, *Geografia e storia,* pp. 227–54.

2. V. Cox, *Women's Writing in Italy,* pp. xx–xi. But see also Cox's comment later in her volume: "Even if the 1540s and 1550s in Italy did not constitute quite the isolated great age of women's writing we encounter in Dionisotti's historical construction, it cannot be denied that it was in many ways a breakthrough period for the nascent tradition [of women's writing]" (p. 118). Add to this Marie-Françoise Piéjus's comment that "même si l'écriture féminine n'est pas née en 1538, elle ne devient un phénomène public qu'à cette date, lorsque paraissent les *Rime* de Vittoria Colonna." Piéjus, "Création au féminin" (1994), p. 80.

3. Shemek, *Ladies Errant,* p. 6.

4. Ruggiero, "Marriage, Love, Sex," p. 10.

5. Ross, *Birth of Feminism,* p. 315.

6. "Ma io non posso andar cercando minutamente ogni cosa, e mi conviene perciò passar sotto silenzio più altre che o come coltivatrici della volgar

poesia vengon lodate dagli scrittori di que' tempi, benchè non ce ne siano rimaste rime, o ci hanno lasciata solo scarsa copia di rime." Tiraboschi, *Storia della letteratura italiana* [1805–13], vol. 7, pt. 2, p. 1174. Tiraboschi is incorrect in saying that "none or few of their poems survive"—in fact, there are plenty of manuscript and sixteenth-century editions of their poems.

7. "Che è questo vano cicaleggiare intorno ad amore, e questa seguela monotona e fredda di versi, che sembrano tante proposizioni messe l'una dietro l'altra senza un sentimento? Vuoto: quel vuoto ch'era nell'anima. I medesimi caratteri naturalmente offre la poesia della Brambatti Grumelli piena di sottigliezze e d'immagini oscure e strane, un altro labirinto; e così la poesia di Lucrezia Marcelli che fa descrizioni insipide ed inefficaci, e quella di Virginia Salvi che pare imiti addirittura la già citata Andreini: 'Dolci sdegni e dolc'ire / Soavi tregue e paci / Che dolce fate ogni aspro e rio martire, / O d'amor liete faci, / Che ad ambo il petto ardete / Con così grato foco, / Che m'è caro il penar, la morte gioco . . . / Ci sentite dentro una rilassatezza ed una monotonia, che dovean finire per annoiare loro medesime.'" Magliani, *Storia letteraria delle donne italiane,* pp. 174–75.

8. M. Cox, "Earliest Edition of the 'Rime,'" p. 266. None of the collections of Colonna's poetry published in her lifetime was ever authorized or otherwise approved or checked by her.

9. But see Robin, *Publishing Women,* who does argue for the existence of a virtual salon of literate and literary women in Italy, of which Vittoria Colonna formed a part, on the island of Ischia as early as the 1520s–30s. I would point out, however, that, as Robin herself states, each of the four Colonna-D'Avalos women who formed the nucleus of this salon served more as "an influential patron" to contemporary and future writers (p. 2) than as a producer of cultural wares (except for Vittoria Colonna, who would, in later years, devote herself to poetry).

10. Buonarroti, *Rime,* G.235.

O N E . At Petrarch's Tomb

1. In "Création au féminin" (1994), Piéjus gives 1538 as the year of Piccolomini's visit to Arquà (p. 81), but this is clearly a slip-up; she corrects herself in "Venus bifrons" ([1980], p. 96), coming in line with scholars such as Salza ("Da Valchiusa ad Arquà," p. 755) and Cerreta ("Tombaide," p. 162).

2. "Andando Ms. Alesandro Picc.mi da Padova alla Tomba del Petrarca, che è in Arqua, egli vi fece sopra il presente Sonetto qual'è. / Giunto Alesandro à la famosa Tomba / sopra il quale molte Gentildonne Senesi, et altri belli Spiriti

fecero il rimanente de' Sonetti, et infiniti altri pigliando il soggetto del sonetto allegato, e le proprie rime." SI-BCI, MS H. X.2, fol. 21v. Also: "andando egli a visitare il Sepolcro del Petrarca ad Arquà, luoco vicino a Padova poche miglia, spinto dalla riverenza di quell'ossa, mettesse insieme, prima che d'intorno a quelle si partisse, il nobil sonetto. / *Giunto Alessandro a la famosa tomba / Del gran TOSCAN che 'l vago amato alloro* con quello che seguita. / Et a quei marmi l'affissasse." S. Bargagli, "Orazione," p. 556; Fabiani, *Memorie,* pp. 29–30.

 3. The sonnet survives in manuscript in FI-BNCF, MS Palat. 256, fols. 71v–72r and SI-BCI, MS H. X.2, fol. 65r. It is not transcribed in FI-BNCF, MS Palat. 228, or in SI-BCI, MS H. X.2 (in the first of two sets of transcriptions that starts at fol. 21v), or in SI-BCI, MS H. X.45, which instead carry the responses the sonnet elicited from five Sienese women and Piccolomini's answers to them. The sonnet was published several times in those decades: first in Domenichi, *Rime diverse di molti eccellentiss. auttori* (1546), p. 247, and (1549), p. 247; then in 1549 in A. Piccolomini, *Cento sonetti,* sonnet 86, sign. Giijv, where, however, it displays significant variants from the manuscript records. My edition is based on the FI-BNCF, MS Palat. 256 rendition, which is the version on which the Sienese women based themselves in echoing Piccolomini's rhyme words. Here as elsewhere in this volume I have rectified the punctuation and the u/v, i/j variance in line with modern practice.

 4. Petrarch, *Rerum vulgarium fragmenta,* 187; hereafter cited parenthetically in the text as *RVF.*

 5. Petrarch, *Petrarch's Lyric Poems,* p. 333. The translation is mine.

 6. "E se Alessandro ebbe invidia ad Achille non de' suoi fatti, ma della fortuna che prestato gli avea tanta felicità che le cose sue fossono celebrate da Omero, comprender si po che estimasse più le lettre [sic] d'Omero, che l'arme d'Achille. Qual altro giudice adunque, o qual altra sentenzia aspettate voi della dignità dell'arme e delle lettere, che quella che fu data da un de' più gran capitani che mai sia stato?"; Castiglione, *Libro del Cortegiano* 1.45.

 7. Procaccioli, *Lettere scritte a Pietro Aretino,* letter 116, vol. 2, pp. 130–31; see the transcription below in this chapter.

 8. I take the idea of "patriotic issues" from Virginia Cox's *Women's Writing in Italy,* p. 6.

 9. "E come per a lui gradire spàrtesi di quello d'ognintorno le copie, niun bello spirito nell'ACCADEMIA non rimanesse, nè fuore, nè in quella, od altre nobil città d'Italia, che non dettasse versi sopra il medesimo concetto da lui spiegato, e sopra le da lui medesime rime usate. Perche andarono intanto multiplicando i componimenti presso a tal materia distesi, e d'un tal volume se ne fè conserva, che ne meritò sotto 'l titol de la TOMBAIDE di esser desiderosamente ricevuto dal Mondo." S. Bargagli, "Orazione," p. 556.

10. FI-BNCF, MS Palat. 228, fols. 76v–81r (formerly 65v–70r), includes the sonnets by the five Sienese women and Piccolomini's responses to them but not the original sonnet by Piccolomini or the sonnets by the three men (Orsini, Grimaldi, and Varchi); SI-BCI, MS H. X.2, fols. 21v–25v, includes the sonnets by four of the five Sienese women (it lacks Eufrasia Marzi's— though it does have Piccolomini's response sonnet to her) and Piccolomini's responses but not his original sonnet or those by/to the other men (Orsini, Grimaldi, Varchi); SI-BCI, MS H. X.2, fols. 65r–66r, includes only Piccolomini's original sonnet, Marzi's sonnet, and Piccolomini's response to Marzi's sonnet; SI-BCI, MS H. X.45, fols. 95v–98r, includes the sonnets by all five Sienese women but not Piccolomini's original or those to/by the other three men (Orsini, Grimaldi, Varchi). Orsini's sonnet survives in manuscript in BN, MSS italiens, 1535, fol. 73r, and is published in Flamini, "Canzoniere inedito di Leone Orsini," pp. 652–53, Salza, "Da Valchiusa ad Arquà," p. 757, and Cerreta, *Alessandro Piccolomini,* p. 247. Grimaldi's sonnet has not been located in manuscript and survives in Cerreta, "Tombaide," p. 166, and Cerreta, *Alessandro Piccolomini,* p. 246. Varchi's sonnet also is not extant in manuscript but is published in Cerreta, "Tombaide," p. 166, and Cerreta, *Alessandro Piccolomini,* p. 247.

11. V. Cox, *Women's Writing in Italy,* p. 84.

12. It is not clear which of two different "Eufrasia Venturi" might be the woman in question. In the dedicatory letter to his translation of Xenophon's *La Economica* (8 January 1538/9), Alessandro Piccolomini refers to her as "Eufrasia Placidi de' Venturi," thus indicating that she was born a Placidi and married a Venturi (fol. 2r). The only Eufrasia Placidi at that time was Eufrasia Caterina di Aldello Placidi, who was baptized on 4 April 1507 (SI-ASS, Biccherna 1134, fol. 115v; SI-ASS, MS A 51, fol. 309r). However, there is no record of this Eufrasia Placidi, or any other Placidi woman, marrying into the Venturi family at any time in the first half of the sixteenth century, so one might conclude that Piccolomini was incorrect in identifying her as a Placidi—a rather surprising error, considering that Piccolomini was using her as his muse and dedicating a book to her. If Eufrasia was not a Placidi by birth but a Venturi, she could then be identified with Eufrasia di Girolamo Venturi, who was baptized on 3 November 1514 and who in 1556 married Captain Niccolò Ranuccini (SI-ASS, Biccherna 1134, fol. 230r; SI-ASS, MS A 52, fol. 343r; SI-ASS, MS A 58, fols. 261v and 264r). This second Eufrasia was a sister-in-law to Aurelia Petrucci, who in 1531 had married her older brother Camillo di Girolamo di Ventura (SI-ASS, Biccherna 1134, fol. 230r; SI-ASS, MS A 52, fol. 343r). For our purposes, we will assume that Piccolomini knew Eufrasia Venturi well

enough to know her maiden name, so our working hypothesis for this study will be that we are dealing with Eufrasia Placidi de' Venturi and not with Eufrasia Venturi de' Ranuccini.

13. "VII. Evfrasia Venturi nobil Sanese, fù ventura del suo secolo, che si stimò d'hauer hauuto gran fortuna per hauer dato al mondo così gentile spirito nelle virtuose congregazioni di spiritose Dame, e saggi Caualieri, ch'in Siena si sogliono fare, nelle quali portò più volte il vanto di leggiadra, d'accorta, d'arguta, e di modesta." Ugurgieri Azzolini, *Pompe sanesi,* vol. 2, p. 397.

14. G. Bargagli, *Dialogo de' giuochi,* p. 187.

15. "Di Lucignano di Valdasso, el dì VIII di Genaro, nel XXXVIII." Xenophon, *Economica di Xenofonte* (1540). The 1538 date is to be rectified to 1539 because the Sienese calendar started on 25 March, the feast day of the Annunciation or Incarnation.

16. Piccolomini, dedicatory letter to his translation of *Aeneid* 6 from Virgil, *I sei primi libri del Eneide* (1544), fol. 1v; repr. (2002), p. 230.

17. Fabiani, *Memorie,* p. 37, describes it as "Castello del Sanese, ove erano i suoi beni, e le possessioni patrimoniali." The hamlet lies forty-six kilometers southeast of Siena and thirteen kilometers northwest of Pienza.

18. "Tra le quai virtù, si giudica communemente ch'ella possa havere il vanto, di saper governar felicemente la casa sua." A. Piccolomini, *De la institutione,* fol. 237v.

19. On Eleonora's extensive land holdings and management of her estates, see Edelstein, "Nobildonne napoletane," esp. p. 307; Baia, *Leonora di Toledo,* pp. 62–64; and my critique of Baia in my introduction to Eisenbichler, *Cultural World,* pp. 6–7.

20. There is plenty of evidence in Italy for women managing estates and family businesses, though more often than not this was done on the occasion of a missing husband (abroad, exiled, or deceased). For an examination of a non-Tuscan milieu, see Smith, "Negotiating Absence."

21. Venice: Scoto, 1543 and 1545; Venice: Bonelli, 1552; Venice: Francesco dell'Imperadori, 1559; Venice: Ziletti, 1560, 1569, 1574, 1582, and 1583; Venice: Ugolino, 1594. The work is officially dedicated to the newborn child, Alessandro Colombini, but the dedicatory letter and the text reveal clearly that Piccolomini was addressing himself to the child's mother, Laudomia Forteguerri Colombini, who thus became the true dedicatee of the work, so much so that in the editions published after her death (1555?) Alessandro rededicated the work to his brother, Giovan Battista Piccolomini, a professor of jurisprudence in Macerata, and wrote a new dedicatory letter dated 26 September 1558 that replaced the original one dated 25 March 1540.

22. Laudomia Forteguerri must have visited with Girolama Carli Piccolomini, as is indicated in the dialogue by Marc'Antonio Piccolomini, "Se è da credersi che una donna compiuta in tutte quelle parti così del corpo come dell'animo, che si possino desiderare, sia prodotta da la natura a sorte o pensatamente," which includes the two women as interlocutors; see the edition published by Rita Belladonna ("Gli Intronati, le donne") in 1992.

23. See below, chapter 3, for a more extensive discussion of Laudomia Forteguerri herself and Piccolomini's interest in her.

24. For more information on Virginia Martini Casolani Salvi, see below, chapter 4.

25. See Giannetti, *Lelia's Kiss.*

26. Ricorda, "Travel Writing."

27. FI-BNCF, MS Palat. 228, fol. 76v (formerly 65v); also, with slight variants, in SI-BCI, MS H.X.45, fol. 104v (formerly 95v) and SI-BCI, MS H.X.2, fol. 25r. Published in Lusini, "Virginia Salvi," p. 145, n. 23, Cerreta, "Tombaide," p. 163, and Cerreta, *Alessandro Piccolomini,* p. 241.

28. FI-BNCF, MS Palat. 228, fol. 77r (formerly 66r); also, with slight variants, in SI-BCI, MS H.X.2, fol. 66r; SI-BCI, MS H.X.45, fols. 104v–105r (formerly 95v–96r). The poem is not transcribed in SI-BCI, MS H.X.2, fol. 26r, where the page is left blank. Published in Rossi, "Opere letterarie," p. 50, and Cerreta, *Alessandro Piccolomini,* p. 242.

29. "Sette ambiziosi fratelli, tutti più o meno turbolenti e avventurieri." Cantagalli, "Inedito del 1553," p. 128. Virginia was married to one of these seven brothers, Matteo.

30. Salza, "Da Valchiusa ad Arquà," p. 754, attributes the verses either to Pietro Aretino or to Ercole Bentivoglio; Graf, *Attraverso il Cinquecento,* p. 40, cites vv. 1–6 with slight variants and says that they come from a capitolo variously attributed to Antonfrancesco Doni, Francesco Sansovino, or Giovanni Andrea dell'Anguillara. I have not been able to determine to whom, exactly, the verses ought to be attributed. For pilgrimages to Arquà by the likes of Giovanni Dondo dall'Orologio, a friend of Petrarch's, and Bernardo Bembo, father to the much more famous Pietro Bembo, see Salza, "Da Valchiusa ad Arquà," pp. 749–61; for a much more recent study of pilgrimages to Arquà as well as to Vaucluse, see also Sabbatino, "In pellegrinaggio."

31. Procaccioli, *Lettere scritte a Pietro Aretino,* letter 116, vol. 2, pt. 1, p. 235. The letter is also cited in Salza, "Da Valchiusa ad Arquà," p. 756.

32. "Non le mando alcuni sonetti che mi son venuti di alcune Gentildonne senesi, perchè M. Hemmanuel [Grimaldi?] gli potrà mostrar, che già so gli ha havuti dal Conte Troilo." FI-BNCF, Autografi Palatini, vol. 2, "Lettere al Varchi," no. 66, transcribed in Cerreta, *Alessandro Piccolomini,* p. 265, and cited

in Cerreta, "Tombaide," p. 165. At his father's death in 1547, Troilo II de' Rossi became third Marquis and eighth Count of San Secondo (r. 1547–91) in the duchy of Parma.

33. Virginia Luti was baptized on 10 December 1513; SI-ASS, Biccherna 1134, fol. 231v; see also SI-ASS, MS A 50, fol. 228v.

34. Baptismal records show the birth of the following children of Achille Salvi: Artemisia Maria (1532), Leandra Isabella (1534), Mario Giovanni (1536), Antonino Pio (1537), Pietro Francesco Maria (1539), and Silvia Giovanna (1542); see SI-ASS, MS A 52, fols. 52v–53r. Because the mother's name is not given, we cannot be certain that they were all borne by Virginia Luti, but for the moment we can take this to be a working hypothesis. It is not clear from where Lisini draws the 1533 date for Virginia Luti and Achille Salvi's marriage (Lisini, "Poetesse senesi degli ultimi anni," p. 37 n. 1), and I have not been able to confirm it from archival sources, which leads me to suspect that it may be incorrect.

35. "Verginia Luti nobil Sanese fu moglie d'Achille Salvi, e con l'occasione delle veglie Sanesi dimostrò spirito così sublime, che persuase i più elevati ingegni degli Accademici Sanesi a sciogliere la lingua, e muovere la penna più volte per consagrare con la voce, e con l'inchiostro le rare virtù di lei all'immortalità. Habbiamo vedute molte ottave, e sonetti da lei composti molto vaghi, e numerosi." Ugurgieri Azzolini, *Pompe sanesi,* p. 402. In the eighteenth century, the erudite Francesco Saverio Quadrio aggravates matters by misdating her to the 1570s (*Della storia e della ragion,* vol. 2, pt. 1, p. 259), an error then repeated blindly by the compilers of the two biographical registers *Delle donne illustri italiane,* p. 97, and Buti's *Poetesse e scrittrici,* vol. 1, p. 347.

36. FI-BNCF, MS Palat. 228, fol. 78v (formerly 67v); SI-BCI, MS H.X.2, fol. 23v (but lacking at fols. 65–66); SI-BCI, MS H.X.45, fol. 105v (formerly 96v). Published in Lusini, "Virginia Salvi," p. 145, Cerreta, "Tombaide," p. 164, and Cerreta, *Alessandro Piccolomini,* p. 243.

37. "Sollevando entusiasmi, discussioni, ma anche le prime ostilità." Caponetto, *Aonio Paleario,* p. 60.

38. On Bartolomeo Carli Piccolomini (b. 1503), husband of Girolama Carli Piccolomini, and his connections with reformist religious ideas, see in particular Belladonna's "Bartolomeo Caroli, nobile senese," "Cenni biografici," and "Bartolomeo Carli Piccolomini's Attitudes." For the Sozzini family, the bibliography is vast and readily accessible, so I need not cite it here.

39. Caponetto, *Aonio Paleario,* passim, but esp. pp. 34 and 164–68. On the reformist currents in sixteenth-century Siena, see, among many works, Marchetti, "Formazione dei gruppi ereticali."

40. Marchetti, "Formazione dei gruppi ereticali," p. 117.

41. FI-BNCF, MS Palat. 228, fol. 79r (formerly 68r); SI-BCI, MS H. X.2, fol. 24r (but lacking at fols. 65–66); SI-BCI, MS H. X.45, fol. 1064r (formerly 97r). Published in Rossi, "Opere letterarie," p. 51; Cerreta, *Alessandro Piccolomini,* p. 244.

42. Eufrasia Marzi was baptized on 25 September 1512; SI-ASS, Biccherna 1134, fol. 196v; see also SI-ASS, MS A 32, fol. 212r. In his oration in praise of Eufrasia, Marc'Antonio Piccolomini says she was born "the day of St. Apollonia [i.e., 9 February], in the year of our Redeemer 1515, if I remember well" (SI-BCI, MS P.V.15, fasc. 7, fol. 8v), but his information is contradicted by archival records.

43. "Tutte quelle cose che le fanciulle nobili & tutte le donne devesi sapere . . . la santità del vivere, & gli ornamenti dell'anima, come 'l sonare, 'l cantare, i raccami & l'altr'arte fanciullesche"; SI-BCI, MS P.V.15, fasc. 7, fols. 9v–10r.

44. Piccolomini mentions the sonnet in his "La vita della Nobilissima Madonna Arithea de Marzi" but does not transcribe it; SI-BCI, MS P.V.15, fasc. 7, fol. 11r. I have not been able to locate a copy of the poem elsewhere.

45. The poems are mentioned but not recorded in SI-BCI, MS P.V.15, fasc. 7, fol. 11v; once again, I have not been able to locate a copy elsewhere.

46. SI-ASS, MS A 35, fol. 211r; SI-ASS, MS A 48, fol. 306r.

47. "Eufrasia Marzij consorte di Livia, fu emula cortese della Parente nella poesia Toscana, nella quale hebbe gran felicità, e noi, che habbiamo havuto fortuna di leggere molte sue composizioni poetiche manuscritte, lo potiamo con verità testimoniare." Ugurgieri Azzolini, *Pompe sanesi,* vol. 2, p. 399.

48. "Poetessa, scrittrice e interprete eccezionale di orazioni, poesie e madrigali." Cagliaritano, *Mamma Siena,* p. 272.

49. For a more detailed discussion of this work, see below, chapter 3, and Belladonna, "Gli Intronati, le donne." Marc'Antonio Piccolomini (1505–79) is one of the most interesting and controversial figures of early sixteenth-century Siena and Italy. After having studied law at the University of Pisa, he ran afoul of the law when, in 1545, he was found guilty of homicide. Aside from his appearance as a discussant in Antonio Vignali's scurrilous *Cazzaria,* he appears in Girolamo Bargagli's much more respectable discourse *Dialogo de' giuochi che nelle vegghie sanesi si usano di fare* (1563–64). In 1531 Marc'Antonio contributed some of his own works to a collection of poetry in honor of Aurelia Bellanti on the occasion of her husband's death, a collection gathered by the deceased's close friend and soon-to-be reformer and heretic Aonio Paleario. In spite of this rather checkered past, Marc'Antonio had a successful career as a secretary for several prelates, participated in the last sittings of Council of

Trent, served the Republic of Siena in its final years, was ordained a priest in 1570, and died in Rome in 1579. There is still no monograph study on this eclectic and fascinating figure of sixteenth-century Italy.

50. Belladonna, "Gli Intronati, le donne."

51. The work survives in manuscript in SI-BCI, MS P.V.15, n. 7, and remains unpublished.

52. I have not been able to locate any portrait of Eufrasia Marzi or to identify any of the contemporary artists who might have painted one.

53. FI-BNCF, MS Palat. 228, fol. 77v (formerly 66v); SI-BCI, MS H. X.2, fol. 65v (but lacking at 21v); and SI-BCI, MS H. X.45, fol. 105r (formerly 96v); published in Cerreta, "Tombaide," p. 164, and Cerreta, *Alessandro Piccolomini,* p. 242.

54. SI-BCI, MS H. X.2, fol. 22r; SI-BCI, MS H. X.45, fol. 105r–v (formerly 96r–v); FI-BNCF, MS Palat. 228, fol. 78r (formerly 67r); published in Rossi, "Opere letterarie," p. 51; Cerreta, *Alessandro Piccolomini,* p. 243.

55. Camilla Maria Piccolomini was baptized on 14 August 1506, and her godfather was Ser Bernardino d'Alberto da Casole; SI-ASS, Biccherna 1134, fol. 92v, and SI-ASS, MS A 51, fols. 210v, 211r, 243r, 244v. For her marriage, see SI-ASS, MS A 56, fols. 206r and 293r.

56. SI-BCI, MS H. X.2, fol. 22v; SI-BCI, MS H. X.45, fol. 106r–v (olim 97r–v); FI-BNCF, MS Palat. 228, fol. 79v (formerly 68v); published in Cerreta, "Tombaide," p. 164, and Cerreta, *Alessandro Piccolomini,* p. 244.

57. Ovid, *Fasti* 5.183–212.

58. SI-BCI, MS H. X.2, fol. 23r; SI-BCI, MS H. X.45, fol. 106v (formerly 97v); FI-BNCF, MS Palat. 228, fol. 80r (formerly 69r); published in Rossi, "Opere letterarie," p. 52; Cerreta, *Alessandro Piccolomini,* p. 245.

59. Petrarch, *Petrarch's Lyric Poems,* pp. 246–47; my translation.

60. There is no birth or baptismal record for Girolama Biringucci in Manenti's register (SI-ASS, A 48) or in the Biccherna (1133 and 1134, covering the years 1490–1520). She is recorded in SI-ASS, MS A 56, fol. 289v. Girolama is thus the stepmother of Camilla Piccolomini de' Petroni (b. 1506), whom we met above. She is not to be confused with Girolama Carli Piccolomini, who in 1526 married Bartolomeo Carli Piccolomini (b. 1503) and whose beauty is praised by Phylolauro di Cave in his *Dialogo amoroso* (Siena, 1533).

61. SI-ASS, MS A 51, fols. 246v–248r.

62. SI-BCI, MS H. X.2, fol. 24v; SI-BCI, H. X.45, fols. 106v–107r (formerly 97 v–98r); FI-BNCF, MS Palat. 228, fol. 80v (formerly 69v); published in Cerreta, "Tombaide," pp. 64–65, and Cerreta, *Alessandro Piccolomini,* p. 245. I take the reading of v. 9 from the manuscript at FI-BNCF.

63. SI-BCI, MS H.X.2, fol. 25r; SI-BCI, MS H.X.45, fol. 1074r (formerly 98r); FI-BNCF, MS Palat. 228, fol. 81r (formerly 70r); published in Rossi, "Opere letterarie di Alessandro Piccolomini," p. 52, and Cerreta, *Alessandro Piccolomini,* p. 246.

64. Alongside the question of what the women were reading one might ask who was teaching them to read and to critique. My current research did not provide a clear answer, but the silence and the context seem to indicate that they were not educated by a learned father or sponsored by a "patriarch," as Ross suggests when she says that "the patriarch was complicit in the creation of 'Renaissance feminism'" (*Birth of Feminism,* p. 6, but see also p. 193). Instead, the Sienese women seem to have been encouraged and supported in their literary and intellectual interests by their friends and peers in the wider community of literate people in town.

65. V. Cox, *Women's Writing in Italy,* p. 58.

66. Benson, *Invention of the Renaissance Woman,* p. 5.

T W O . Aurelia Petrucci

1. Aurelia was baptized on 16 December 1511, and her godfather was Francesco Soderini, cardinal of Volterra; SI-ASS, Biccherna 1134, fol. 176r. See also SI-ASS, MS A 51, fol. 222r.

2. "Fu caro al popolo e contribuì largamente allo splendore della sua città." *Enciclopedia italiana,* vol. 27, p. 65.

3. For the marriage of Borghese Petrucci and Vittoria Todeschini Piccolomini, see SI-ASS, MS A 56, fol. 218v; SI-BCI, MS C.VI.9, fol. 30v.

4. Cantagalli, *Guerra di Siena,* lxvi, lxvii.

5. Gattoni, *Leone X,* p. 14 n. 12.

6. SI-BCI, MS A.V.19, fols. 129r–138r, fol. 134v: "1517. Raffaello di Iacomo, Vescovo di Grosseto, nemico di Borghese Petrucci, benchè suo cugino, seguì sempre la parte di Casa Medici, a' quali nella cacciata loro di Fiorenza haveva sovvenuto con le proprie entrate. Fu fatto Prete Cardinale del titolo di S. Susanna, e Castellano di Castel S. Angiolo da Papa Leone X nel 1517, il quale concedette ancora diverse Abbadie, e discacciati di Siena Borghese pred.o e Fabio, l'aiutò a pigliare il governo di quella Città, ed impadronirsene. Fu ancora Legato a Latere di d.o Pontefice a' Sanesi. . . . Morì nel 1522 e fu sepolto nella Chiesa di S. Domenico di Siena." For his burial in S. Domenico on 17 December 1522, see SI-ASS, MS D 14, p. 129.

7. Tommasi, *Dell'historie di Siena,* p. 20.

8. Her daughters were Aurelia (b. 1511), Giulia (b. 1512/13), Agnese (b. 1514), and Pandolfina (b. 1515).

9. Tommasi, *Dell'historie di Siena,* p. 49.

10. Tommasi points out that when Fabio returned to Siena and seized power his brother Borghese remained in Naples because he had lost his mind ("alienato della mente") as a result of his distress at his own misfortunes and at the fall from grace and execution of his brother, Cardinal Alfonso Petrucci, found guilty of conspiring to assassinate Pope Leo X (1517); Tommasi, *Dell'historie di Siena,* p. 41.

11. Tommasi, *Dell'historie di Siena,* p. 182.

12. Agnese and Giovanni had two children, Claudio Desiderio (b. 1532; SI-ASS, MS A 52, fol. 134r) and Flaminia Marfisa (b. 1534; SI-ASS, MS A 52, fol. 134r). Having been left a widow, Agnese married the jurist and university professor Alessandro di Mariano Sozzini (1509–41), with whom she had two more children: Fausto Pauolo, the anti-Trinitarian theologian and heretic (b. 1539; SI-ASS, MS A 52, fol. 134r) and Fillide Petra (b. 1540; SI-ASS, MS A 52, fol. 134r, d. 1568). Having once again been left a widow (1541), by 1546 Agnese was married once again, this time to Ghino di Bartolomeo di Ghino Bandinelli, with whom she had seven more children: Marcello (b. 154?), Aurelia (b. 154?), Iuditta Romula Maria (b. 18 January 1546/47; SI-ASS, Biccherna 1136, fol. 149r), Francesca Dorotea Maria (b. 7 February; SI-ASS, Biccherna 1136, fol. 180v), Pandolfo Romulo Maria (b. 30 April 1550; SI-ASS, Biccherna 1136, fol. 225v), Sofonisba Maria (b. 30 September 1551; SI-ASS, Biccherna 1136, fol. 243r), and Laurentio Romulo Iacomo Maria (b. 27 November 1552; SI-ASS, Biccherna 1136, fol. 256r). With thanks to Philippa Jackson for all the marriage and birth information.

13. "Il est prudent de dire, donc, qu'avec quelque vingt-trois éditions alimentant le marché, les *Dialogues* deviennet durant le XVIe siècle non seulement une oeuvre influente de philosophie lue par des spécialistes, mais aussi une oeuvre d'un intérêt culturel général intéressant de larges secteurs du public éduqué européen." Melczer, "Platonisme et Aristotélisme," p. 294.

14. Angel, "Judah Abrabanel's Philosophy," p. 81.

15. Leone Ebreo, *Diálogos de amor,* vol. 1, p. 341 n.

16. See Novoa, "Mariano Lenzi."

17. "Casto soggetto d'amore à donna casta, che spira amore: pensieri celesti à donna, ch'è ornata di virtu celesti: altissimi intendimenti à donna ripiena d'altissimi concetti"; Leone Ebreo, *Dialoghi d'amore,* sig. Aijv.

18. On the treaty of 1511, see Gattoni, *Pandolfo Petrucci,* and "Politica estera."

19. The dialogue is not available in print. It survives in two manuscript copies (Florence, FI-BNCF, N. A. 1248, and Parma, Biblioteca Palatina, MS Palat. 297). It has been edited and published electronically by James Nelson Novoa (whom I wish to thank for having given me a prepublication copy of his edition) at http://parnaseo.uv.es/Lemir/Textos/Dulpisto.pdf. For a brief introduction to the *Dulpisto,* see Novoa, "Aurelia Petrucci," pp. 540–44.

20. Thurman, "Anatomy Lesson."

21. "Mentre che nell'accademia degli nostri Intronati si attende a scrivere in gloria, et honore, della gratia, et honesta di voi bellissima donna. Ho anchor io, benche membro debolissimo, di essa pensato oprar alcuna cosa in servigio di lei, poi che in desiderio, et obligo di farlo non mi sento inferiore a qual si voglia altro." Vignali, *Dulpisto,* FI-BNCF, N. A. 1248, fol. 1r; Novoa, "Aurelia Petrucci," pp. 541–42.

22. "Quando per altro si troverà libera de' suoi studij piu gravi"; Vignali, *Dulpisto,* FI-BNCF, N. A. 1248, fol. 1r.

23. A. Piccolomini, *De le stelle fisse,* in *De la sfera,* fol. n.n. 2r. See below, chapter 3, for a fuller discussion of this comment.

24. "Le Siennoises de la bonne société jouissaient d'une culture qui leur permettait de s'intéresser aux travaux et discussions des *Intronati* d'une façon qui n'était pas seulement formelle." Piéjus, "Venus bifrons" (1980), p. 93.

25. *Sei primi libri dell'Eneide* (1540). See above, chapter 1, for a fuller discussion of this translation project. There is a rich bibliography of works on this 1540 edition; see in particular Virgil, *Sei primi libri di Vergilio* (2002); Kallendorf, *Bibliography of Renaissance Italian Translations* and *Bibliography of Venetian Editions*; Benci, "Volgarizzamenti antichi"; Borsetto, *Eneida tradotta.*

26. "Dove essa, poi che la fortuna, le interroppe i latini studij troppo per tempo, potrà molto bene col suo singularissimo ingegno conoscere il vero splendore poetico, come al presente desidera, colui legendo, che è (come Dante disse) de gli altri poeti honore, e lume." Virgil, *Sei primi libri del Eneide* (1544), fol. 1v.

27. "A Madonna Aurelia Petrucci. // Non mi curo se io sarò forse tenuto da molti presuntuoso, scrivendo hora a voi, la quale io non ho mai ne conosciuta, ne veduta, perche il nome de le virtu vostre, e de la vostra gentilezza è così grande ch' m'assicura da tutti coloro che mi tenesseno presuntuoso; e piu che mi pare con piu nobil parte che non è l'occhio del corpo havervi gia gran tempo riguardata; conciosia che dopo ch'io pienamente fui de l'alta nobiltà de l'animo vostro fatto accorto, sempre m'è stata dinanzi a gli occhii una viva imagine de le virtu vostre: la quale hora mi sforza, e sia o riverenza questa, o presunzione, madarvi un ritratto di quella nuova poesia Toscana, che pur hora

fa l'anno manifestai a molti miei amici qui in Roma. Voi per la cortesia vostra vi degnarete guardarlo, che certamente non mi terrò piccolo guiderdone de le mie fatiche, ch'egli vi sia in qualche sua particella aggradato. State sana. Di Roma." Tolomei, *De le lettere,* fol. 142r.

28. *Delle donne illustri italiane,* p. 131; Canonici Fachini, *Prospetto biografico* p. 127.

29. Published in Domenichi, *Rime diverse d'alcune nobilissime, et virtuosissime donne,* p. 9; Bulifon, *Rime,* p. 2; Leone Ebreo, *Dialogos de amor,* pp. 445–46; and Novoa, "Aurelia Petrucci," p. 539. Bergalli, *Componimenti poetici,* does not publish this sonnet.

30. The sonnet was first published in Domenichi, *Rime diverse d'alcune nobilissime, et virtuosissime donne,* p. 9, and then in Bulifon, *Rime,* p. 2; Bergalli, *Componimenti poetici,* p. 71; *Parnaso italiano* [1851], col. 771; Lisini, "Poetesse senesi degli ultimi anni," pp. 34–35; Stortoni, *Women Poets,* pp. 42–43; Eisenbichler, "Chant à l'honneur," pp. 94–95, and "Poetesse senesi a metà Cinquecento," p. 98; and Novoa, "Aurelia Petrucci," p. 535; Eisenbichler, *L'opera poetica,* p. 40. I disagree with Stortoni and Lillie's translation of line 5: they translate "all'altrui spese" as "at others' hands," thereby suggesting that Siena is learning, at the hands of others, the consequences of civil discord; this is incorrect because the phrase in question means "At others' expense" (not "hands"), so Aurelia is clearly saying that Siena should learn from the experience of others (not "at the hands of others") what the consequences of civil discord can be.

31. Eisenbichler, "Chant à l'honneur," p. 95, and "Poetesse senesi a metà Cinquecento," p. 98.

32. "Ce l'han calata" is a rare expression; it is used in Sacchetti's *Trecento novelle,* novella 98, to mean "they have made fun of us" or "they have pulled a prank on us."

33. SI-BCI, MS H. X.12, fasc. 10, fol. n.n. 13r. Because the page is ripped, the remainder of the poem has been lost. I have not been able to locate a complete version of the poem. The sonnet does not appear in Domenichi, *Rime diverse d'alcune nobilissime, et virtuosissime donne,* or in any other published volume, so its presence in this current study marks its first appearance in print. My translation of "quel che si piglia" (v. 12) is tentative and the reference remains obscure, as is also the reference to the "party of the gold and the pearls" and to Doccio's daughter (v. 10). Similarly, my translation of what survives of the last verse, "o che cativa" is simply an educated guess based on the verses that precede it.

34. Mauro, "Capitolo del viaggio." Two of the women Mauro points out in the last stanza are probably Eufrasia Venturi (b. 1508 or b. 1514) and Laudomia Forteguerri (b. 1515). The unidentified Spannocchi woman is most

probably either Isifile (b. 1515) or Caterina (b. 1517), both daughters of Federico di Mariano Spannocchi (SI-ASS, MS A 52, fol. 144r). The young woman from the Saracini family is more difficult to identify because there were at least thirteen women born in the family between 1510 and 1521 (SI-ASS, MS A 52, fols. 94v–95r. Silvia is probably not Silvia Piccolomini, who, having been born in 1526, would have been only six years old at the time.

35. G. Bargagli, *Dialogo de' giuochi,* p. 59.

36. "E al tempo mio s'apprezzava tanto, ch'un giuoco succedesse con grazia, che quando occorse la passata del marchese del Vasto e del principe di Salerno, che l'uno e l'altro si fece Intronato, non ci vergognammo d'ordinar fra di noi, un giorno innanzi, quei giuochi che pensavamo di fare alla lor presenza. Non che ci componessimo insieme di quel che puntualmente si avesse a dire, ma ben furono proposti e scelti due o tre giuochi, che di far si disegnava, acciò che ognuno potesse penservi sopra qualche bel capriccio; e di più andando a visitare qualcuna di quelle donne che dovevano a tal vegghia intervenire, averemmo con esse discorso di qualche bella cosa che da loro si fosse potuto dire. Onde nacque che quella sera si sentirono di bei concetti e di spiritose vivezze e le donne con quel poco d'aiuto dissero cose di maraviglia. E da questi primi aiuti cominciarono a fare un abito tale, che all'improvviso e in ogni occasione discorsi, motti e ragionamenti miracolosi si sentivano uscir da loro, donde madonna Aurelia e madonna Giulia Petrucci, madonna Frasia Venturi, la Saracina, la Forteguerra, la Toscana e alcune altre s'acquistarono eterno grido." G. Bargagli, *Dialogo de' giuochi,* pp. 91–92. Alfonso d'Avalos, Marquis of Vasto (1502–46) and Ferrante Sanseverino, Prince of Salerno (1507–68) were inducted into the Accademia degli Intronati in 1525 with the academic names of "il Pomposo" and "l'Ostinato." I gratefully acknowledge the assistance of dott. Enzo Mecacci for this information. See also Sbaragli, "'I Tabelloni' degli Intronati," p. 191.

37. For her death and burial, see SI-BCI, MS C. III.2, fol. 179v, and SI-ASS, MS D 14, p. 147. Her husband's will, dated 2 March 1549/50, is in SI-ASS, Notarile Ante-cosimiano 2350, doc. 161; Cassandra's own will, dated 7 March 1550/51, is in SI-ASS, Notarile Ante-Cosimiano, 2350, doc. 216. With thanks to Philippa Jackson.

38. For her marriage, see SI-BCI, MS A. III.7, fol. 118v, and SI-ASS, Gabella 335, fol. 42r. With thanks to Philippa Jackson. She may be the Cassandra Sozzini who was buried in San Domenico on 26 October 1565; SI-ASS, MS D 14, p. 157.

39. For her baptism, see SI-ASS, Biccherna 1134, fol. 96v, and SI-ASS, MS A 51, fol. 221v. In the Petrucci family tree in SI-BCI, MS A. III.7, fol. 116r, she is not listed as a daughter of Pandolfo, but that is probably because she

was illegitimate. For her marriage, see SI-ASS, Notarile Ante-Cosimiano, 2013, doc. 70. With thanks to Philippa Jackson for all this information.

40. For her baptism, see SI-ASS, Biccherna, 1134, fol. 160v, and SI-ASS, MS A 51, fol. 222r; for her marriage and kin, see SI-BCI, MS A. III.7, fol. 114r (where Verginio is not listed, possibly because he died in infancy). With thanks to Philippa Jackson.

41. For her baptism, see SI-ASS, Biccherna 1135, fol. 68r, and SI-ASS, MS A 51, fol. 22r; for her parentage, SI-BCI, MS A. III.7, fol. 120r; for the marriage, SI-ASS, Notarile Ante-Cosimiano. 2249, doc. 746. With thanks to Philippa Jackson.

42. Domenichi, *Rime diverse d'alcune nobilissime, et virtuosissime donne,* pp. 19, 23–30.

43. Published in Domenichi, *Rime diverse d'alcune nobilissime, et virtuosissime donne,* p. 29, and Bulifon, *Rime,* p. 22.

44. SI-BCI, MS I. XI.49, fol. 12v.

45. SI-BCI, MS H. X.12, fasc. 10, fols. [10r–12v]; SI-BCI, MS I. XI.49, fols. 7r–8r. The work was not previously published. The pun on "aureo nome" and Aurelia at v. 22 is untranslatable in English. The identity of the poet "Alceo" (v. 43) remains a mystery. The author of the ode may be Aurelia's sister, Agnese Petrucci.

46. See above, note 12. Alessandro Sozzini's body was brought back to Siena and buried in the Church of San Domenico on 26 April 1541; see SI-ASS, MS D 14, p. 141.

47. The oration survives in SI-BCI, MS C.VI.9, fols. 29r–37v. For its published edition, see A. Piccolomini, *Orazione.* Further citations to this text are from the published edition and are given parenthetically in the text. Novoa, "Aurelia Petrucci," pp. 544–53, transcribes a number of passages from this oration and provides a brief analysis of what it says about Aurelia.

48. "Però che si può in una parola affemare, che se parte alcuna ha di non buono la Donna, tal parte non fu già in Lei: e tutte quelle parti importanti, che stan bene all'uomo, furono in Essa sì compiutamente, che mancando Lei dell'imperfezion della Donna, ed abbondando della perfezion dell'uomo, singolarissima, qual noi la vedemmo, si rese al mondo" (p. 19).

49. "I know I have the body but of a weak and feeble woman, but I have the heart and stomach of a king, and of a King of England too, and think foul scorn that Parma or Spain, or any Prince of Europe should dare to invade the borders of my realm." Somerset, *Elizabeth I,* p. 591.

50. SI-BCI, MS C.VI.9, fol. 37v. Published in Piccolomini, *Cento sonetti,* son. 95, sig. Gviijr; Piccolomini, *Orazione,* p. 39.

THREE. Laudomia Forteguerri

1. Laudomia's baptismal record from SI-ASS, Biccherna 1134, fol. 253r, reads: "Laudomia bart.a m.a F. di Alix.o forteguerri si bap.o addi 3 di Giug.o fu compare ms federigo della rosa." Next to it, in the right-hand margin, a later sixteenth-century hand has written in an italic script, "Unica al mondo e di bellezze rare" (the phrase has subsequently been scratched out, but it is still faintly visible). The record from the baptismal register from the baptistry of San Giovanni reads: "Laudomia Barthalomea Maria figlola di Alixandro di Nichodemo Forteguerri fu battezzata a dì 3 di giugno a ore 21 in circha, fu compare messer Federicho abbate de la Rosa, che Dio le dia buona ventura." Both records were first reported by Lisini in his introduction to Forteguerri, *Sonetti,* p. 7 n. 1. The identity of Abbot Federico has not been determined; "della Rosa" may well be not his name but the name of the Abbey of Santa Mustiola, popularly known as Santa Maria della Rosa, located just outside Siena's Porta Tufi. The abbey was razed to the ground by the besieging Imperial army in 1554–55. See Repetti, *Dizionario geografico,* vol. 1, p. 191, and Liberati, "Chiese, monasteri, oratori," pp. 69–73.

2. For the Forteguerri possessions, see SI-ASS, MS A 30/II, fol. 268r; SI-BCI, MS A.VI.54, fol. 202r–v; SI-ASS, MS A 2, fol. 12r. See also SI-ASS, MS D 22, pt. 1, bk. 3, fol. 142r.

3. SI-ASS, MS A 15, fol. 150v.

4. SI-ASS, MS A 15, fol. 151v.

5. SI-ASS, MS A 2, fol. 20v: "Pecci, Sig.ri, e Conti di Percena Castello appresso Buonconvento, il primo, che godesse il Supremo Magistrato, fu il Peccia di Ventura nel 1313 a Caleffi." On the Pecci family, see Fumi and Lisini, *Genealogia dei Conti Pecci,* and especially p. 69 for her short biographies of Benvenuto and Pier Antonio Pecci, brothers of Virginia Pecci and uncles to Laudomia Forteguerri.

6. Nievola, *Siena,* pp. 57, 66, 182–83 and passim.

7. SI-ASS, Biccherna 1134, fol. 156r: "Nichodemo barth.o fol. di Alix.o di nichodemo fortiguerri si baptiço addi xiiij di novembre. Compare ms Giuliano di Piero di San Giovanni." For Alessandro and Francesca's marriage, see SI-ASS, MS A 54, fol. 334v.

8. SI-ASS, Biccherna 1134, fol. 163v: "Caladonia sulpitia marina fol. [illeg.] Alex.o forteguerri si baptiço addi xxv di septembre." There is no indication of *compare;* there is a pointing hand in the left margin and, above it, a cross with the word "morta" underneath. Fol. 186r: "Laudomia bart.a m.a fol. di Alix.o forteguerri si baptiço addi xxiij di septembre. Compare nessuno." Then, in the left margin, there is a cross, and above the entry the word "morta."

9. For all these children, see SI-ASS, Biccherna 1134, at dates.

10. The marriage is not listed by Manenti in SI-ASS, MS A 54. On the Colombini, see SI-ASS, MS A 15, fols. 15r, 139r–140v and passim; SI-ASS, MS A 26, fols. 123r–127r; SI-ASS, MS A 30/II, fols. 223r–225r; SI-BCI, MS A.VI.54, fols. 180r–182r.

11. For the baptismal references for Olimpia, see SI-ASS, Biccherna 1135, fol. 348v; for Antonia, see Biccherna 1135, fol. 379v; for Alessandro, see Biccherna 1135, fol. 419r. Scaglioso, "Carte delle Assicurate," p. 24, mistakenly reports the second child as a male, "Antonio."

12. For Alessandro's marriage, see SI-ASS, Gabella 386, Lib. 1 del 1562, fol. 198r, which also records the dowry of 3,750 florins.

13. Some of Giulio Cesare Colombini's poetic works can be found in SI-BCI, Y.II.23. For some of the letters exchanged with Bulgarini, especially in 1597–1609, see SI-BCI, MS D.VI.7, fols. 80–143. Aurieri describes him as "molto erudito in lingua Toscana, ed in Antichità" (SI-ASS, MS A 16, fol. 140r). At his death, Bulgarini composed a sonnet to his memory (SI-BCI, MS P. IV.14, fol. 142r).

14. We have no information on when Laudomia's first husband, Giulio Cesare Colombini, died. Her second husband, Petruccio Romulo Maria, was baptized on 24 September 1513, the son of Niccolò di Benedetto Petrucci; SI-ASS, Biccherna 1134, fol. 217r, see also SI-BCI, MS A. III.7, fols. 113v–114r. For the marriage contract, see SI-ASS, Gabella 386, fol. 54r, and also SI-ASS, Notarile 1928, Ser Mino Belzi, 1543–44, item 39; see also SI-ASS, MS A 54, fol. 337r. Petruccio is not to be confused with Petruccio, called Muzio, di Francesco Petrucci, also a captain in the Sienese and Florentine forces. Laudomia's Petruccio seems not to be directly related to the poets Aurelia Petrucci or Cassandra Petrucci, but further biographical research into the Petrucci clan may eventually shed greater light on this point and on the family ties that linked the various women poets of Siena.

15. SI-ASS, Balìa 952, fol. 26v. The census carried out the following year, in 1554, lists four *bocche* in Petruccio's house but does not detail them; one would assume that they would be the same four individuals; SI-ASS, Balìa 953, fol. 216v.

16. The autograph manuscript in the Biblioteca Comunale degli Intronati di Siena (P.V.15, fasc. 5) is dated 2 May 1538. The work was first published as an appendix to Belladonna, "Gli Intronati," pp. 59–90.

17. Belladonna, "Gli Intronati," p. 53.

18. Piccolomini, *De la sfera del mondo* (1540), fols. n.n. 2r–3v. This may well be the same villa from which, exactly a year later, Piccolomini undertook his pilgrimage to Petrarch's tomb in Arquà; see above, chapter 1.

19. The dedicatory letter to *De la institutione* is dated "Di Padoua, il primo giorno de l'anno. M.D.XL." If Piccolomini is following the Venetian reckoning of the year, the "first day of the year" in Padua would date the latter to 25 December 1539 (current style), but since he is writing to a fellow Sienese residing in Siena he is probably using the Sienese computation of the year, which would then date the letter to 25 March 1540 (current style), a conclusion supported by reference in the letter to "this December past," a phrase that would not make sense if he were using the Venetian calendar.

20. "Mi stava quest'Autunno passato, un dì frà gli altri, si com'ero solito, su 'l mezogiorno di fare, nel giardin mio; sott'una uerdura intessuta d'Edera, in me medesmo raccolto (virtuosissima Madonna LAVDOMIA:) e hauendo poco innanzi letto il XXXI. Canto del Paradiso di Dante; doue de la somma felicità si ragiona: il qual voi già, con gran mio stupore, se ben vi ricordate, m'interpretaste: tutto m'ero col pensiero profondamente riuolto à molte bellissime cose, che voi sopra la Felicità humana e angelica, dottissimamente mi ragionaste. E una cosa dà l'altra sovvenendomi, cominciai con molta più marauiglia, considerando sì belle cose, à stupir del giuditio vostro; che io non feci in quel giorno, che raccontandole voi le raccolsi." Piccolomini, *De la institutione,* fol. iiir.

21. V. Cox, *Women's Writing in Italy,* p. 42.

22. V. Cox, *Women's Writing in Italy,* p. 101.

23. In this section's title I use the term *lesbian* as a convenient short form to indicate those women whose primary emotional and/or sexual focus was on other women, without at all implying that the construction of same-sex desire has remained unchanged through time. This section draws in part from my previously published article "Laudomia Forteguerri," but reaches a less "sexual" and more "political" conclusion.

24. Elena De' Vecchi's claim that Laudomia "wrote patriotic poems" is completely unfounded and undocumented; only six of Laudomia's sonnets have survived, and they are all poems of affection or respect addressed to two women, Margaret of Austria and Alda Torella Lunata. De' Vecchi is also incorrect in dating Piccolomini's *De la sfera del mondo* (1540, not 1539). Finally, her dismissive attitude to Laudomia's poetry is indicative of a profound misreading (if there even was a reading!) of Laudomia's work and of her importance. De' Vecchi, "Alessandro Piccolomini," passim.

25. Shemek, *Ladies Errant,* p. 116.

26. Fabiani says that the lecture was delivered on the first Sunday of February and that the letter to Orsini was written the next day, Monday. Since the letter is dated "Di Padoua, el di VII. di Febraro. M.D. XLI.," the lecture must have been held on 6 February. Fabiani, *Memorie,* p. 26. On this lecture,

see Piéjus, "Lecture académique." On the primacy of this lecture, see Piéjus, "Poétesses siennoises" (1994), p. 322.

27. A. Piccolomini, *Lettura*. Piccolomini was *principe* of the Infiammati from April to September 1541; Cerreta, *Alessandro Piccolomini,* p. 26; Fabiani, *Memorie,* p. 26.

28. Celso Sozzini (1517–70) was the brother of Alessandro Sozzini il Giovane and hence Agnese Petrucci's brother-in-law. He was a professor of law at the University of Bologna and, after the death of his brother Alessandro, an important influence on his orphaned son, Fausto (b. 1539), the future reformer. A member of the Sienese literary academy of the Intronati, where he went by the name of "il Sonnacchioso," Celso founded the Academy of the Sizienti, which discussed only matters juridical and which, in 1554, he transferred from Siena to Bologna. In 1558 Celso underwent a heresy trial (together with his brother Camillo and his young nephew Fausto) and abjured. On Celso, see Grendler, *Universities of the Italian Renaissance,* p. 463 and passim.

29. "Mi ero scordato, M. Benedetto, di dirui come M. Celso Sozini, al passar per Bologna, ha trouate, cosa a me molto discara e marauigliosa, et è che in bologna hanno stampato la mia lettura sopr'l sonetto di Madonna Laudomia; che certo mi ha dato e mi dà per infiniti rispetti assai fastidio; e ricercando io M. Celso se sapeua come quei librari l'hauessero hauuta, mi dice che sa di certo che è venuta d'Ancona, doue forse è andata di Roma; dice forse, perché già prima di Febraro, ricercandomi mons. Orsini di voler vederla, gliela mandai. Come si sia, vi prego M. Benedetto, che occorrendoui, voliatemi difender con dir ch'ella non possa esser senno corrotta e guasta, per esser stata fatta tal cosa senza veder di farmene saper niente. Duolmi ancora tanto più per esserci il nome del'Academia, a la grandezza dela quale si conuiene altra cosa che questa o simili. Patienza." Cerreta, *Alessandro Piccolomini,* p. 273; original in FI-BNCF, Autografi Palatini, vol. 2, "Lettere al Varchi," n. 69.

30. One may well question Piccolomini's claim of innocence in this process and wonder just how much he was involved in this publication, but that is for another venue. On the traits of "orality" still evident in the printed version, see Piéjus, "Lecture académique" (2007), p. 237.

31. A. Piccolomini, *Lettvra,* sig. Bijr. Piccolomini says "l'anno del. XXV," but he is using Sienese dating style, which, rectified to modern style, would be 1536.

32. Belardini, "Margherita d'Austria," p. 31. See also Giorgio Vasari's detailed letter of 3 June 1536 describing Margaret's progress from Livorno to Venice in Vasari, *Opere,* vol. 8, pp. 262–65. Piéjus has also cast doubts on the reliability of Piccolomini's information on this detail; see Piéjus, "Lecture académique" (2007), p. 240, n. 19.

33. "La qual [Laudomia] come prima uidde Madama, e dà quella fù ueduta altresì, subito di ardentissime fiamme d'Amore, l'una de l'altra si accese, di che manifestissimo segno fù, che più uolte da poi con ambasciate si uisitarono." A. Piccolomini, *Lettura,* sig. Biijr.

34. Margaret left the Fortezza da Basso in Florence, where she had sought refuge after Alessandro's assassination, on 10 July 1537 and moved to Prato, where she remained (except for some short stays in Florence, Empoli, and Pisa) until 8 October 1538, at which time she left for Rome; see Belardini, "Quando Margherita d'Austria," pp. 55–57. On the way, she stopped for some days in Siena, where she was met with great respect by her future father-in-law, Pier Luigi Farnese. She remained in Siena until 30 October as a guest in the palazzo of Anton Maria Petrucci, where, some years earlier, her father Emperor Charles V had been lodged. Pecci, *Memorie,* vol. 3, p. 96; SI-ASS, MS D 50, fol. 89r; SI-ASS, MS D 23, col. 730; Morsia, "Da una corte all'altra," p. 61.

35. "Et al passar che fece, questa gran Madama nuouamente per Siena, due anni sono, ne la sua andata di Roma, felicemente i dolcissimi loro Amori rinnouarono, & oggi più che mai, con auisi e da questa parte e da quella caldamente conseruano." A. Piccolomini, *Lettura,* sig. Biijr. I have been unable to locate any of the "notes" Piccolomini claims the two women exchanged.

36. "[Amore] non consiste in un desiderio basso, in una uoglia uile e sfrenata, come forse si pensano [coloro che lo biasimano], ma nel felicissimo acquisto di un'animo uirtuoso. In niente altro consiste (Signori) il fin d'un'Amor perfetto, che nel possedere il uirtuoso animo de l'amata sua, ò uoliam dire, in esser amato dà quella. E questo fine hauerà egli, sempre che gli amará come se gli conuiene, non potendo un uero Amante, secondo il parer d'Aristotele nel VIII de l'Etica, non essere amato, si come afferma ancor Dante nel Vigesimo secondo Canto del Purgatorio. Onde ne segue che amando egli ueramente, e contemplando del continuo ò presente ò lontana l'amata sua, impossibil cosa è, che ei non uiua lieto e felice, beuendosi con gli occhi de la mente una certa occulta dolcezza, che non mai si darebbe ad intendere à chi prouata non l'habbia." A. Piccolomini, *Lettura,* sig. Bijr.

37. A. Piccolomini, *Lettura* (1541), sig. Ei v; Domenichi, *Rime diverse di molti eccellentiss. auttori* (1546), p. 247. The "omai" at v. 10 appears as "amor" in the 1546 edition by Domenichi; this is probably an editorial revision by Domenichi, so I prefer to follow Piccolomini's own version from 1541.

38. A. Piccolomini, *Lettura* (1541), sig. Eiv.

39. A. Piccolomini, *Lettura* (1541), sig. Eijr; Varchi, *De sonetti* (1555), p. 97, and *Opere* (1859), vol. 2, p. 860. Varchi puns on his own name (v. 11) and on Laudomia's (v. 14).

40. Firenzuola, *On the Beauty of Women,* pp. 16–17. Incidentally, the Abbey of Grignano was Margaret of Austria's first residence when she left Florence in July 1537 and settled in Prato. Firenzuola was also a resident at the abbey from at least 1538 and possibly from even slightly earlier, so it is possible that he met Margaret personally during her stay in Prato. This would then add a further dimension to his comments about Laudomia and Margaret.

41. Lee, *Descriptio Urbis,* entries no. 2262 and 3325. This section on Cecilia Venetiana is taken from Eisenbichler, "Laudomia Forteguerri."

42. "Cicilia veneziana (che così si fa chiamar, benché la è furlana), di venti anni la era ancor giudea; battizzossi, e prese marito un certo sgraziato, e da quel si fuggì, e venne a Roma con un prete ghiottone, il qual fu mandato in galea per le sue virtù; prese poi pratica d'un cassier sanese, il qual la drizzò in piedi." Delicato, *Ragionamento del Zoppino,* p. 44. Rendina, *Pasquino statua parlante* (p. 152), cites the poem "Il lamento della cortigiana ferrarese" (ca. 1530) in which Cecilia is mentioned along with other prostitutes.

43. "J'ay cogneu une courtisanne à Rome, vieille et rusée s'il en fut oncq, qui s'appelloit Isabelle de Lune, espagnolle, laquelle prit en telle amitié une courtisane qui s'appelloit la Pandore, l'une des belles pour lors de tout Rome, laquelle vint à estre mariée avec un sommeiller de Monsieur le Cardinal d'Armaignac, sans pourtant se distraire de son premier mestier: mais cette Isabelle l'entretenoit, et couchoit ordinairement avec elle; et, comme debordée et desordonnée, en paroles qu'elle estoit, je luy ay oüy souvent dire qu'elle la rendoit plus putain, et luy faisoit faire des cornes à son mary plus que tous les rufians que jamais elle avoit eu." Brantôme, *Recueil des Dames,* p. 362.

44. "Mesme les courtisannes, qui ont les hommes à commandement et à toutes heures, encor usent-elles de ces fricarelles; s'entrecherchent et s'entr'ayment les unes les autres, comme je l'ay oüy dire à ancunes en Italie et en Espagne." Brantôme, *Recueil des Dames,* p. 364. Jacqueline Murray points out that "the association of courtesans with lesbian sexual preference can be traced to Antiquity" and then gives several references for it in her "Agnolo Firenzuola," p. 210 n. 42.

45. Van Lennep, *Années italiennes,* p. 66–67; Pastor, *History of the Popes,* vol. 11, p. 324.

46. Pastor, *History of the Popes,* vol. 11, p. 325; Morsia, "Da una corte all'altra," pp. 62–63.

47. Vatican Archives, Fondo Borghese, ser. I, 36 fol. 119v, letter of 18 August 1540, cited in van Lennep, *Années italiennes,* p. 145 n. 34. See also Lefevre, "Figura di Margarita d'Austria," pp. 161–62; Pastor, *History of the Popes,* vol. 11, pp. 325–26.

48. Marucci, Marzo, and Romano, *Pasquinate romane,* especially poems 439, 443, 448, 449, 450, 451, 463, 471, 476, 481, 491, 496, 507, 511, 514, 515, 527, 539, 541, 546, and 613.

49. Marucci, *Pasquinate del Cinque e Seicento,* p. 137.

50. "Il bel duca Ottavio chiavò in Pavia quatro volte la prima notte la sua Madama e poi è venuto qua *ad sanctissimos pedes,* e così s'è levata la mala opinione qual si avea;" Giovio, *Lettere,* vol. 1, p. 312. Others claimed the consummation took place earlier, some in 1539, others 1540, etc.; see Pastor, *History of the Popes,* vol. 3, p. 326 n. 2. See also Morsia, "Da una corte all'altra," pp. 63–64.

51. Carlo died in infancy; Alessandro (d. 1592) survived to inherit the duchy of Parma and Piacenza (1586) and to make a name for himself as *el gran Capitan,* famous for his service in the Imperial army in the Netherlands and at the Battle of Lepanto (1571). Like his mother, Margaret of Austria, he also served as governor of the Spanish Netherlands (1578–92). Among the many portraits of him, there is a stunning one by Sofonisba Anguissola that shows him as an elegantly clad sixteen-year-old (1561) and another by Otto Vaenius that shows him as a confident military figure (1585).

52. Ottavio Farnese's other children—Violante (b. 1555), Lavinia (b. 1560), Ersilia (b. 1565), and Isabella (b. 1570)—were sired from various mistresses, not from Margaret.

53. Lefevre, "Figura di Margarita d'Austria," p. 161.

54. Lefevre, "Figura di Margarita d'Austria," p. 164. This is not, however, what the scurrilous Pasquino was saying at the time; see note 48 above for references to the pasquinades touching on Margaret's sex life.

55. "Là dessus Monsieur de Gua reprit l'auteur, disant que cela estoit faux que cette belle Marguerite aymast cette belle Dame de pur et saint amour; car puisqu'elle l'avoir mise plustot sur elle que sur d'autres qui pouvoyent estre aussi belles et vertueuses qu'elle, il estoit à presumer que c'estoit pour s'en servir en delices, ne plus ne moins comme d'autres; et pour en couvrir sa lasciveté, elle disoit et publioit qu'elle l'aymoit saintement, ainsi que nous en voyons plusieurs ses semplables, qui ombragent leurs amours par pareils mots. "Voilà ce qu'en disoit Monsieur du Gua; et qui en voudra outre plus en discourir là dessus, faire se peut." Brantôme, *Recueil des Dames,* pp. 369–70.

56. For a discussion of this point with reference to Firenzuola's words, and for further references on this topic, see Murray, "Agnolo Firenzuola," pp. 203–7.

57. "LAVDOMIA Forteguerri de' Grandi di Siena, fu teneramente amata dal grand'Alessandro Piccolomini, di cui si è parlato ne' titoli 5. 17. 18. non tanto per la bellezza, quanto per la conformità delli studij; perche am-

bidue furono studiosissimi della Filosofia morale, ed il Piccolomini gli dedicò il suo libro intitolato, L'Instituzione di tutta la vita dell'huomo nato nobile, e in Città libera, e distinto in dieci libri, che fù stampato in Venezia l'anno 1540." Ugurgieri Azzolini, *Pompe sanesi,* vol. 2, p. 403. Ugurgieri Azzolini is incorrect about the date of publication; the first edition is dated 1542 in Venice.

 58. See my "Laudomia Forteguerri."

 59. This subsection is also taken for the most part from my article "Laudomia Forteguerri." The sixth sonnet is written to and in praise of the woman poet Alda Torella Lunata, from Pavia. This is a simple poem of admiration and is not particularly noteworthy for our discussion. Betussi presented Lunata in his *Imagini del tempio* (1556), pp. 63–66, as the emblem of chastity. Three of Lunata's poems appeared in Domenichi, *Rime diverse d'alcune nobilissime, et virtuosissime donne,* pp. 236–37. As far as I can tell, no critical attention has been paid to Lunata and her poetry.

 60. A. Piccolomini, *Lettura* (1541), sig. Biiiv, republished in Domenichi, *Rime diverse di molti eccellentiss. auttori* (1546), p. 246, and in its 1549 re-edition, and then in Domenichi, *Rime diverse d'alcune nobilissime, et virtuosissime donne,* p. 102, this time with five other poems by Forteguerri (102–4). It was later included in Bulifon, *Rime,* (pp. 94–96; *Parnaso italiano* [1851], col. 1010; Forteguerri, *Sonetti,* pp. 17–20; Eisenbichler, "Poetesse senesi a metà Cinquecento," p. 101. It is also found, with an English translation, in Eisenbichler, "Laudomia Forteguerri," p. 200, republished in Borris, *Same-Sex Desire,* pp. 283–84.

 61. "E par che sia una cosa venuta / da cielo in terra a miracol mostrare," vv. 7–8 of the sonnet "Tanto gentile e tanto onesta pare," in Dante, *Vita nuova,* p. 97.

 62. First published in Domenichi, *Rime diverse d'alcune nobilissime, et virtuosissime donne,* p. 103, and then in Bulifon in *Rime,* p. 95; Forteguerri, *Sonetti,* p. 19; with an accompanying English translation in Eisenbichler, "Laudomia Forteguerri," pp. 286–87, 298, and republished in Borris, *Same-Sex Desire,* p. 282.

 63. Petrarch, *Rerum vulgarium fragmenta,* 78.

 64. Eisenbichler, "Religious Poetry of Michelangelo."

 65. Piéjus, "Lecture académique" (2007), p. 241.

 66. V. Cox, *Women's Writing in Italy,* esp. pp. 5 and 23. See also pp. 66–68 for Cox's comments on two other women poets whose works may well have closely connected to Spanish interests in Italy, Vittoria Colonna and Veronica Gambara. Speaking of Colonna, for example, Cox notes that "her marriage to Ferrante d'Avalos represented a harmonized union of 'modern' Spanish power and ancient Italian aristocracy, cast here flatteringly as a relationship of equals, he excelling in the field of arms, she in letters. Colonna's verse in

memory of d'Avalos was charged, then, with a series of political and ideological meanings far beyond their already attractive literal sense of a devoted widow's tireless memorialization of her husband."

67. This was originally the palazzo of Giacoppo Petrucci, brother of the Magnifico Pandolfo. It passed to his son, Cardinal Raffaello Petrucci, who governed Siena from it, and then, at his death, to Raffaello's nephew Anton Maria Petrucci.

68. Pecci, *Memorie,* vol. 3, p. 96; SI-ASS, MS D 50, fol. 89r; Tommasi, *Dell'historie di Siena,* vol. 3, p. 235.

69. Nievola, *Siena,* p. 208.

70. There is no biography of Niccodemo Forteguerri available. The tidbits of information on him mentioned above come from Adriani, *Istoria de' suoi tempi,* passim; Sozzini, "Diario," passim; Ugurgieri Azzolini, *Pompe sanesi,* passim; FI-ASF, Mediceo del Principato 2010; SI-ASS, Concistoro 1233; SI-ASS, MSS D 17–21, vol. 19 (1552–53); SI-BCI, MS A.VII.17, p. 1487; SI-BCI, MS D.VII.7, fol. 21r; SI-BCI, MS A.VI.54. Niccodemo was a personal friend of Alessandro Piccolomini, who remembers him in the dedicatory letter and proem to his *De la institutione di tutta la vita.*

71. A. Piccolomini, *De la institutione.*

72. "New Year's Day" would be 25 March 1540 (see note 19 above).

73. Piccolomini's comment should not be taken seriously, since both of the child's grandfathers were named Alessandro so that the choice of name honored both the paternal and maternal branches of the family.

74. For a discussion of the academic calendar and public anatomy/dissection lectures, see Grendler, *Universities of the Italian Renaissance,* pp. 143–44, 329–35.

75. Don Diego de Mendoza, a writer and intellectual, as well as a diplomat and a historian, was Spanish ambassador in Venice in 1539–47; as such, he represented Spain diplomatically at the initial sessions of the Council of Trent (1545–47).

76. "Qual voglia esser poi minutamente la bellezza corporal d'una donna, non è questo il luogo, né il tempo di ragionare. Dirò ben, che quando ben fusse il luogo, a voi nondimeno non bisognaria raccontarlo, essendo che se io dicesse mille anni; non potria arrivar con lo stile a quel, che la madre Natura, e Dio grandissimo appresso; nella virtuosissima vostra madre Madonna Laudomia, ha riposto. Ella è veramente tale, che come lei debban' esser fatte quelle donne che belle chiamar si debbino, e qualunque donna, in qual si voglia parte, non è prodotta simil a lei; in quella tal parte esser bella non potrà mai. A lei dunque (Alessandro) vi rivolgete, e pigliando essempio da essa, non potrete se non

elegger donna compiutamente perfetta: essendo la divina vostra madre, donna bellissima, et di bellissima, e virtuosissima madre nata, e prudentissimamente allevata e nodrita: di costumi ornatissima, di persona alta e ben fatta, e di divina maiestà piena; dolcissima, e vezzosissima in vista; honestissima in ogni attione e parola: piena di modestia, di gratia, di gentilezza, di gravità, e per concludere in tre parole tutta divina, tutta celeste, tutta immortale, a cui simile, se la buona fortuna vostra vi concedesse una moglie; mai non nacque né sia per nascere, huomo di voi più felice. Et questo basti, quanto all'elettione della consorte, che tor dovete." A. Piccolomini, *De la institutione,* fol. 220r–v.

77. The marriage contract is dated 9 December 1544 and is found in SI-ASS, Gabella 386, and in SI-ASS, Notarile 1928, Ser Mino Berzi, 1543–44, item 39. Lisini says Laudomia was widowed for two years (introduction to Forteguerri, "Sonetti," p. 11), but I have not been able to confirm this information.

78. "In questo in fo. 217 Petruccio Petrucci suo amante e suo marito"; SI-ASS, Biccherna 1134, fol. 253 r, col. b. The modern notation for that folio page is 220v. Next to Petruccio's entry someone has added a pointing hand at the left and on the right the note "a Laudomia in questo in fo. 250" (modern foliation, 253 r).

79. Lisini, introduction to Forteguerri, *Sonetti,* p. 8 n. 1.

80. Lisini, introduction to Forteguerri, *Sonetti,* pp. 11–12.

81. A. Piccolomini, *Cento sonetti,* son. 30, sig. Cvijv.

82. A. Piccolomini, *Cento sonetti,* son. 3, sig. Biir.

83. A. Piccolomini, *Cento sonetti,* unnumbered sonnet, sig. Hvr.

84. A. Piccolomini, *Cento sonetti,* son. 79, sig. Fviijr.

85. A. Piccolomini, *Lettura,* sig. Bijv. Later scholars referred to these sixty poems but did not indicate where they were; see Fabiani, *Memorie,* p. 83.

86. The sonnet was first published in Domenichi, *Rime diverse di molti eccellentiss. auttori* (1546), p. 248. Its subsequent publication in the *Cento sonetti* (in 1549) removed the reference to Flori (see below).

87. Tasso, *L'Amadigi,* canto 44, stanzas 115–16, p. 272. Together with Laudomia, Tasso mentions and praises four other Sienese women: Camilla Saracini, Eufrasia Baldini, Eufrasia Venturi, aznd Onorata Tancredi (stanzas 113–14).

88. "Egli [Betussi] sempre ha osservato ed osserva nella reale ed afflitta Siena, nido di tutte le grazie, di tutte le virtù, di tutti i rari costumi e di tutte le bellezze, la chiara ed immortal madonna Laudomia Forteguerra Petrucci, la cui vita, le cui opere e le cui virtuose azioni possono accendere ognuno che cognizione semplice di virtù e di vera bellezza abbia, nonché quelli che

l'hanno, come voi, veduta, udita ragionare, discorrere e render ragioni e cagioni di tutte le cose." Betussi, *Leonora,* p. 344. The statement is made by the character of Capello, and the "egli" refers to Giuseppe Betussi, who is also a discussant in the dialogue. The dialogue was first published in Lucca by Vincenzo Busdrago in 1557 but dates from 1552.

89. Betussi, *Imagini del tempio* (1556), pp. 75–80; (1557), fols. 31r–33r.

90. "Vedi fra tutte l'altre LAODOMIA FORTEGUERRI PETRUCCI quasi oracolo nel mondo, prena d'ogni raro costume, colma d'ogni chiara virtu, dotata d'estrema honestà. Vedi questa, à cui devriano inchinarsi quanti sanno, che sia virtu & bellezza. Devria ammirarla chi pure ha compreso una minima ombra delle sue virtu. Non crederò mai, che spirito alcuno fosse stato sì barbaro, & duro verso la liberta della patria sua; il quale una sola volta havesse sentito lei a pigliare la protettione di quella; che non si fosse piegato, humiliato, & rimesso: tanta è la maestà dell'aspetto, tanta la facondia del dire, & tanta la prontezza delle ragioni." Betussi, *Imagini del tempio* (1556), pp. 75–76.

91. Betussi, *Imagini del tempio* (1556), pp. 78–79.

92. Betussi, *Imagini del tempio* (1556), p. 80.

93. "Non di picciolo biasmo degno io mi farei presso coloro [che] lo sanno non facendo noto al mondo la valorosita d'alcune Gentildonne Sanese meritevole di eterna lode, è dunque da sapere che di quest'anno mille cinquecento cinquantatre [i] Sanesi preparandosi a la difesa loro contra le genti Imperiali, che se mettevano ad ordine per venirli sopra, havendo divisa la citta in tre parti con tre capi di esperienza, e di auttorita [sic] con le loro insegne. A gli diecesette di Genaro giorno solenniggiato in honore di santo Antonio comparsero tre gran Madonne di questa citta con loro insegne, e tamburi, l'una fu la Signora Forteguerra vestita di pavonazzo con l'insegna sua del medesimo colore, con un moto tale. Pur che 'l sia il vero, & era alzata a la rotonda quatro dita di sopra dal piede mostrando la gamba. La seconda fu la Signora Fausta Piccolhuomini, tutta di rosso vestita, con l'insegna rossa quartata con una croce bianca con un moto che diceva. Pur che non lo butto. La terza fu la Signora Livia Fausta vestita di bianco, con l'insegna bianca, ne la qual eravi una palma, & scritto. Pur che l'habbia. Erano tutte tre succinte a guisa di honestissime Ninfe, queste tre gran Madonne che raccolsero con loro tra Gentildonne, & artegiane d'intorno a tremila donne. Fu cosa tanto bella, e tanto meravigliosa che ne rimasero stupidi [sic] il Cardinale di Ferrara, Monsignor di Termes, & quanti huomini le videro, andarono per tutta Siena gridando Franza, Franza, & ciascuna di loro portava una fascina ad un forte che si faceva, essempio tale che tuttti i Gentilhuomini de la citta si misero a fare il medesimo, andando ogni giorno qualch'un di loro con loro insegne, & moti ad imitatione di queste hon-

orate, prudente, savie, & valorose Signore. E non solo i Gentilhuomini a cio fare furono mossi, ma a gli vintinove di detto mese che fu in Domenica vi andarono i Preti con l'Arcivescovo loro, & al ritorno dal forte s'incontrarono in una compagnia di Donzelle ch'andavano con alcune Matrone accompagnate da huomini di qualche eta, cantando laudi in honore de la gloriosissima madre, & sempre Vergine Maria loro avocata, se unì con esse loro l'Arcivescovo con tutti i Preti, & giunti a la piazza dove presso il palagio de la Signoria evi in un luogo eminente una molto bella imagine de la Regina de' Cieli, s'affermarono tutti, l'Arcivescovo ordinando le donzelle in modo di battaglia, facendole salire di mano in mano verso quella figura cantando alcune laudi con tanta suavita di voce, che tutti gli ascoltatori stavano per dolcezza, e per compassione con le lagrime sopra gli occhi, & cio fatto, tutte s'inginocchiarono dinanti a l'Arcivescovo, & al Cardinale che si vi ritrovò, & da questo, & da quello havuta la beneditione levarono in piedi, & fattali un'altra bella riverenza andarono a le case loro." Guazzo, *Cronica,* "Donne valorose di Siena" fol. 433v: The volume is dedicated to Duke Cosimo I of Florence and, although published in Venice, carries a Florentine ducal permission to go to press dated 27 January 1552/53, signed by Lelio Torelli, the duke's secretary, and a papal permission dated 24 March 1553, signed by Paolo Sadoleto, secretary of briefs to princes for Pope Julius III. The pages touching on the siege of Siena constitute the very last gathering of the book (sig. DDDDi-iii) and, as the opening lines of the subsection on the Sienese women indicate, deal with events of the "present year, 1553." Guazzo's description is, therefore, to be dated to the early months of 1553, nearly contemporary with the events described.

94. The seventeenth-century Sienese erudite Giacinto Nini says that "della terza non ritrovo il nome, essendo dalli scrittori, o forestieri, imperiti falsamente nominata Livia Fausta, la qual Famiglia non essendo mai stata in Siena, non è certo chi fosse questa Signora" and concludes that the three women must have come from only two families, the Piccolomini and the Forteguerri; see SI-ASS, MS D 19, vol. 6, p. 112.

95. We find the same division into *terzi* and the same use of colored flags in an earlier, anonymous poem commemorating the Sienese victory over the attacking Florentines at the battle of Camollia (1526); see Mango, *Guerra di Camollia,* octaves 118–20.

96. "Questi tre forti la città s'obbligò a farli a sue spese per non dare tanta spesa all'agenti del re, e per essere la fabbrica grande, e di grande spesa, ogni Terzo prese da fare la sua parte, il Terzo di Città prese di fare della Punta del Prato, che viene di verso la cittadella, e guarda il fondo, o vero la Valle di Pescaia, e tirava infino al mezzo il poggio del Prato; il Terzo di S. Martino

seguì di fare l'altro Forte dall'altra metà del poggio insino alla Chiesa di S. Antonio fuori del Portone la qual chiesa per molte braccia andava dentro del Forte; il terzo Forte toccò a Camullia, che era all'uscire del portone a mano dritta, che guardava tutta quella valle di Malitia. Hor queste fortificationi tutta la città, come si è detto, vi si messe a lavorare con tanta volontà, che i cittadini, bottegari, vecchi, giovani, donne con una frequenza mirabile, andavano tutto il giorno a lavorare, e nell'andare a fare le fascinate, andavano le Contrade con le loro insegne con ordinanza, e vi andò molte volte il Cardinale a fare, e portare le fascine con tutta la sua Corte, l'Arcivescovo di Siena con tutto il Clero de' preti, e frati coll'insegna bianca dell'Assunta di Nostra Donna dipinta. Era il vedere fare queste fortificationi un piacere, un trionfo, una festa, che tutta la città n'era a lavorare con tanta frequenza, che era cosa maravigliosa a vedere." SI-ASS, MS D 50, fols. 288v–89r.

97. For Monluc's enormous debt to Paradin, and Paradin's to Guazzo, see Courteault, *Blaise de Monluc historien,* especially pp. 75–81 for the women of Siena episode and pp. 229–98 for the description of the siege itself.

98. Centorio degli Ortensi, *Seconda parte de' Commentarii,* p. 6.

99. Ugurgieri Azzolini, *Pompe sanesi,* vol. 2, p. 406.

100. Monluc, *Guerra di Siena* and *Blaise de Monluc all'assedio.*

101. Courteault, *Blaise de Monluc historien,* p. 238.

102. "Monsieur de Termes, qui m'en a souvent faict le compte (car je n'estois encor arrivé), m'a assueré n'avoir jamais veu de sa vie chose si belle que celle-là. Je vis leurs enseignes despuis. Elles avoient faict un chant à l'honneur de la France, lorsqu'elles alloient à leur fortification; je voudrois avoir donné le meilleur cheval que j'aye et l'avoir pour le mettre icy." Monluc, *Commentaires,* pp. 106–7. The song, still unidentified, has been attributed either to Laura Civoli or to Virginia Martini Salvi; Lisini, "Poetesse senesi degli ultimi anni," p. 38.

103. "Et il me fust montré par des gentils-hommes sienois un grand nombre de gentil-femmes portans des paniers sur leur teste pleins de terre. Il ne sera jamais, dames siennoises, que je n'immortalize vostre nom tant que le livre de Monluc vivra; car, à la verité, vous estes dignes d'immortelle loüange, si jamais femmes le furent." Monluc, *Commentaires,* p. 106.

104. "Au commencement de la belle resolution que ce peuple fit de deffendre sa liberté, toutes les dames de la ville de Sienne se despartirent en trois bandes: la première estoit conduicte par la signora Forteguerra, qui estoit vestue de violet, et toutes celles qui la suivoient aussi, ayant son accoustrement en façon d'une nymphe, court et monstrant le brodequin; la seconde estoit la signora Picolhuomini, vestue de satin incarnadin, et sa trouppe de mesme livrée; la troisiesme estoit la signora Livia Fausta, vestue toute de blanc, comme aussi

estoit sa suitte, avec son enseigne blanche. Dans leurs enseignes elles avoient de belles devises; je voudrois avoir donné beaucoup et m'en resouvenier. Ces trois escadrons estoient composez de trois mil dames, gentil-femmes ou bourgeoises; leurs armes estoient des pics, des palles, des hotes et des facines. Et en cest equipage firent leur monstre et allèrent commencer les fortifications." Monluc, *Commentaires,* pp. 106–7.

105. "Je mets ce conte ailleurs, où je parle des femmes généreuses: car il touche l'un des plus beaux traits qui fust jamais fait parmy galantes dames. Pour ce coup, je me contenteray de dire que j'ay ouy raconter à plusieurs gentils-hommes et soldats, tant françois qu'estrangers, mesmes à aucuns de la ville, que jamais chose du monde plus belle ne fut veue, à cause qu'elles estoyent toutes grandes dames, et principales citadines de ladicte ville, les unes plus belles que les autres, comme l'on sçait qu'en cette ville la beauté n'y manque point parmy les dames, car elle y est très-commune. Mais, s'il faisoit beau voir leurs beaux visages, il faisoit bien autant beau voir et contempler leurs belles jambes et grèves, par leurs gentiles chaussures tant bien tirées et accommodées, comme elles sçavent trèsbien faire, et aussi qu'elles s'estoyent fait faire leurs robes fort courtes, à la nimphale, afin de plus légèrement marcher; ce qui tentoit et eschauffoit les plus refroidis et mortifiez; et ce qui faisoit bien autant de plaisir aux regardans estoit que les visages estoyent bien veus tousjours et se pouvoyent voir, mais non pas ces belles jambes et grèves; et ne fut sans raison qui inventa cette forme d'habiller à la nimphale: car elle produit beaucoup de bons aspects et belles œillades; car, si l'accoustrement en est court, il est fendu par les costez, ainsi que nous voyons encore par ces belles antiquitez de Rome, qui en augmente davantage la veue lascive." Brantôme, *Dames galantes,* vol. 2, pp. 93–94.

106. Cerreta, *Alessandro Piccolomini,* p. 31 n. 18. Cerreta does not, however, provide a source for this claim. While it is tempting to assume this, one should be careful not to do so blindly and to leave open the possibility that future research might provide us with reliable information on the time and place of Laudomia Forteguerri's death.

107. "Il pregio de la qual donna, quantunque per fama sia notissimo, io nondimeno per veduta ne posso far fede, conciò sia che passando questo Autunno per Siena, e desiderando più che altro vederla, per il mezo del Escellentissimo Dottor di leggi, M. Giovan Battista Piccolomini, mi accade vederla, d'odir ragionarla non già, in che intendo ch'ella è maravigliosa. Parsemi la sua bellezza tale, che io non mi ricordo d'haver veduta mai la maggiore." A. Piccolomini, *De la institutione,* sig. Aiiv.

108. Hoby, *Travels and Life,* p. 19.

109. "Noi andaremo a madonna la ventura, poi che V. S. R.ma, occupata nella cogitazione per non dire sgonfiatura di brachesse della Fortiguerra, si scorda di darci avviso della partenza nostra." Giovio, *Lettere,* vol. 1, p. 268. In this same letter Giovio complains about all the badly cooked marzipan he had to eat in Siena and then pokes fun at a certain Messer Antonino who heaved "twenty-four sighs" on account of his love for Eufrasia Venturi (one assumes he must have composed a number of love lyrics in her honor): "Signor Cardinal, Even though you have murdered your entourage by making them stay in Siena a day and a half eating full meals of badly cooked marzipan, it is nonetheless true that we did draw some pleasure from Messer Antonino's twenty-four sighs dedicated to his love for Madonna Eufrasia Venturi: a thing that moved even Lorenzo da Gaeta, even though Ser Lorenzo was in greater danger, having to sleep with Pierino the citharist . . ."

110. On Pietro Aldi, see the *Dizionario biografico degli italiani,* vol. 2, p. 86; Pignotti, *Pittori senesi,* pp. 182 and 185; Marziali, *Pietro Aldi.* Aldi's painting *The Last Hours of Sienese Freedom* was exhibited at the Musei Capitolini in Rome in 1883 and established his fame. Thieme and Becker indicate that this painting is now in storage at the Musei Capitolini (*Allgemeines Lexikon,* vol. 1, p. 244).

111. Botta, *Storia d'Italia,* vol. 2, p. 175.

112. Baia, *Leonora di Toledo,* p. 5: "Perduta dallo Strozzi la battaglia di Marciano, perfino le donne guidate da Laudomia Forteguerri e da Faustina Piccolomini pugnarono per la patria." Cerreta, *Alessandro Piccolomini,* p. 31 n. 18: "coltissima e distintissima gentildonna senese, che incontrò la morte combattendo per la libertà della patria durante l'assedio di Siena." Cantagalli, *Guerra di Siena,* p. 81 n. 173: "questa specie di corpo militarizzato femminile"; Robin, *Publishing Women,* p. 126, but see also pp. 128, 131, and passim.

FOUR. Virginia Martini Salvi

1. SI-ASS, Giudice Ordinario 254, cited in Lusini, "Virginia Salvi," p. 135 and p. 146 n. 24.

2. "No. 6. Salvi Verginia, maritata in Martini, fiorì circa il 1559." SI-BCI, MS A.VII.36, fol. 85v (formerly p. 166).

3. "XXV. VERGINIA Luti nobil Sanese fu moglie d'Achille Salvi, e con l'occasione delle veglie Sanesi dimostrò spirito così sublime, che persuase i più elevati ingegni degli Accademici Sanesi a sciogliere la lingua, e muovere la penna più volte per consagrare con la voce, e con l'inchiostro le rare virtù di lei all'immortalità. Habbiamo vedute molte ottave, e sonetti da lei composti molto vaghi, e numerosi." Ugurgieri Azzolini, *Pompe sanesi,* vol. 2, p. 402.

4. Quadrio, *Della storia e della ragion,* vol. 2, pt. 1, p. 259.

5. Lisini, "Poetesse senesi degli ultimi anni," p. 37 n.1. The date of marriage is probably incorrect; working backwards from the birth records of his children, it seems most likely that Virginia Luti and Achille Salvi married in 1531. Achille was one of the four "gentili giovani" who carried the light blue standard with "Libertas" inscribed on it during the solemn entry of Emperor Charles V into Siena on 24 April 1536; Vigo, *Carlo V,* p. 17.

6. Matteo had married Elena d'Antonio di Ms Melchiorre Della Ciaia in 1528; their children were Scipione Romulo (b. 1528) and Fulvio Modesto (1530). See SI-ASS, A 57, fol. 66r, for the marriage and A 52, at dates, for the children.

7. Lusini, "Virginia Salvi," p. 135. For Matteo's birth year, see SI-ASS, MS A 52, fol. 51v. In the 1554 census, at the date 5 August, Matteo is listed as having five "mouths" *(bocche)* in the house plus two servants. Presumably the "mouths" indicate him, his wife Virginia, his two children by his previous marriage, and his child by Virginia; see SI-ASS, Balìa 953, fol. 174r.

8. Vigo, *Carlo V,* p. 6.

9. Cantagalli, "Inedito del 1553," p. 128.

10. The *Dizionario Garzanti* defines *mattana* as an outburst, a temper tantrum, a sudden fit of irritability; alternatively, *mattana* could mean a sudden fit of joy, as in the affectionate diminutive *mattaccione* used in Florence to refer to a happy sort of fellow; however, given Achille's character, it seems that the negative connotations were probably the operative ones in his case. Pianigiani, *Vocabolario etimologico,* defines *mattana* as the gloom and irritability of someone who is ready to lose his temper over every little thing *(ad vocem).*

11. Tommasi, *Dell'historie di Siena,* vol. 3, pp. 169 n. 204, 180, et passim. For Achille's birth year, see SI-ASS, MS A 52, fol. 51v.

12. Zeller, *Diplomatie française,* p. 300.

13. Van Lennep writes that Margaret arrived in Siena probably on 12 October *(Années italiennes,* p. 144 n. 7); Pecci reports that she departed from Siena on 21 October 1538 *(Memorie,* vol. 3, pp. 102–3).

14. Don Alfonso Todeschini Piccolomini d'Aragona (ca. 1500–1564/65), Duke of Amalfi, was *capitano del popolo* in Siena in 1528–30 and then again in 1531–41.

15. "Piero Strozzi ancora non restava d'operare quanto potea per accrescere le forze, e procacciarsi degl'amici, per lo che, anch'esso venuto in Siena, e sotto colore di parentado, trattando continuamente colla Duchessa Vedova [Margherita d'Austria] accarezzava i giovani Sanesi, e per essere liberale, e affabile, esso, e Ruberto di lui Fratello erano ben veduti da tutti, e particolarmente da Fratelli de' Salvi. Tali andamenti cagionavano sospetto nell'Imperiali, perche temeano chè non potesse voltarsi la Città a favore de' Francesi per meglio

facilitare l'impresa di Firenze, e tanto più andava crescendo il timore, perchè in Siena non v'era Famiglia, che avesse maggior riputazione nell'armi, di quella de' Salvi, e per esser povera di sostanze molto più cagionava sospetto di potere esser corrotta, onde dubitandone gl'Imperiali, e dal Duca Cosimo resi avvertiti, spedirono da Roma a Siena un tal Sifonte, che arrivatovi sotto pretesto di far gente, e andare alla volta di Milano, vi si fermò molti giorni, alloggiando in Casa di Girolamo Mandoli Piccolomini, e avvertì il Duca d'Amalfi, e agli Offi-ciali di Balia espose, che la stanza degli Strozzi in Siena era sospetta alla faz-zione Imperiale, e però esser bene il provedervi, e scacciargli, ma gli Strozzi accortisi del disegno degl'Imperiali, senza'ltra intimazione da loro stessi vo-lontariamente si partirono." Pecci, *Memorie,* vol. 3, pp. 96–97.

16. This section is completely dependent on Lusini, "Virginia Salvi," be-cause the original documents he presents and transcribes can no longer be lo-cated at the Archivio di Stato in Siena. The bibliographical reference Lusini provides is no longer valid, and recent attempts to find the original trial records have not been successful. I wish to express my gratitude to the staff of the Archivio di Stato as well as to dott.ssa Elena Brizio for their generous help in my bootless quest to find the original documents.

17. Lusini, "Virginia Salvi," p. 147.

18. Cecchino libraio, *Magnifica & honorata Festa,* fol. 506r–v, and SI-BCI, MS R.VIII.011, "La magnifica et honorata festa fatta in Siena per la Madonna d'agosto l'anno 1546." Extensive sections of Cecchino's description are tran-scribed in Cairola, *Siena/Le Contrade,* 43–45.

19. Giulio Bargagli (b. 1512) was the father of Girolamo Bargagli (b. 1537), the author of the *Dialogo de' giuochi,* who was only nine years old at the time of his father's scrape with the law.

20. Adriano Franci held a variety of positions in the Sienese government. Elected to the Concistoro, the highest magistracy in the city, in 1534 for the Monte del Popolo, he went on to serve the republic in various capacities, includ-ing as *regolatore* in 1539, as ambassador to Rome in 1540 and 1546, as a judge in the Tribunale dei Pupilli in 1547, *capitano del popolo* in Grosseto in 1547, and in a variety of posts in the territory. Born around the turn of the sixteenth century, he died sometime between August 1547 and 1549. Though a member of the Academy of the Intronati, where he was known as "il Cupo," Franci was not re-ally a *letterato;* the only creative work attributable to him is a poem of affection for Virginia Salvi in which he vows eternal love for her ("Come possete dir, vivo mio sole," FI-BNCF, MS Palat. 256, fols. 31r–32r). The dialogue *Delle lettere nuo-vamente aggiunte, libro di Adriano Franci da Siena intitolato il Polito,* a work that argues against Giovan Giorgio Trissino's proposed reform of Italian orthography, is

generally attributed to Claudio Tolomei. On Franci, see *Dizionario biografico degli italiani* (1998), vol. 50, pp. 128–30.

21. Lusini, "Virginia Salvi," pp. 149–51.

22. It is not clear to what "disturbances" the interrogators were referring. Perhaps they were thinking of the disturbances in the wake of the death of the *capitano del popolo* Francesco Savini or the clamor made by the *contrada* of Aquila on 15 August.

23. Lusini, "Virginia Salvi," pp. 151–52.

24. Don Francés de Álava y Beamonte (1519–86) was lieutenant in Siena for Don Diego de Mendoza, as well as *maestro di campo* and captain of the Spanish garrison in that city; see Malavolti, *Dell'historia di Siena,* pt. 1, fol. 152r–v; Cantagalli, *Guerra di Siena,* passim; Contini and Volpini, *Istruzioni agli ambasciatori,* p. 196 and passim. After a military career in Germany and Italy for Charles V, Álava served King Philip II as ambassador at the French court (1564–72) and then as a member of the Spanish War Council (1572–86). He was also captain general of the Artillery and an authority on cannons and armaments. Sozzini describes him as a courteous and refined person who, when it came to negotiating, seemed a young woman *(donzella);* Sozzini, *Guerra di Siena,* p. 14, and "Diario delle cose avvenute," pp. 32, 88. There is considerable variation in how his name is given: Franzés, Franzès, Franzese, Francisco, Giovanni Franzesi, de Alaba, de Avila, d'Avila, and so on. "Montauto" is Pierfrancesco (called Signorotto or Otto) Barbolani da Montauto, one of the two Florentine captains sent to reinforce the Spanish garrison in Siena (the other was Menichino da Poggibonsi); see Malavolti, *Dell'historia di Siena,* pt. 1, fol. 152v; Sozzini, *Guerra di Siena,* p. 27, and "Diario delle cose avvenute," p. 78; Bertini, *Feudalità e servizio,* p. 57. Signorotto and his younger brother, Federico, were both captains for Cosimo de' Medici in the war against Siena, but at that time Federico was stationed at Pisa. Signorotto died suddenly a few months later, on 26 September, of an illness. Federico (1513–82) would have a long and prosperous career, eventually serving Cosimo I in Siena as the city's *castellano* (1557–67), *comissario* (1558), and *governatore* (from 1567 until his death in April 1582); see Medici Archive Project, "Barbolani de Montauto."

25. SI-ASS, MS D 19, vol. 5, pp. 250–51. For similar descriptions of these events, see SI-ASS, MS D 23, col. 960, or Pecci, *Memorie,* vol. 3, pp. 263–73; Sozzini, *Guerra di Siena,* pp. 25–31, and "Diario delle cose avvenute," pp. 77–89. For modern scholars' descriptions, see D'Addario, *Problema senese,* pp. 117–55; Cantagalli, *Guerra di Siena,* p. 50; Hook, "Habsburg Imperialism," pp. 286–87.

26. Sozzini, *Guerra di Siena,* p. 30, and "Diario delle cose avvenute" (1987), p. 88; the sonnet is published in Sozzini, "Diario delle cose avvenute" (1842), p. 453, doc. xii.

27. Manuscript copies in SI-BCI, MS I. XI.49, fol. 29v; SI-BCI, MS H. X.2, fol. 69r; published in Lisini, "Poetesse senesi degli ultimi anni," p. 35; Eisenbichler, "Poetesse senesi a metà Cinquecento," p. 96, "Chant à l'honneur," pp. 89–90, and *L'opera poetica,* p. 89. The poem is not published in Domenichi, *Rime diverse d'alcune nobilissime, et virtuosissime donne,* Bulifon, *Rime,* or Bergalli, *Componimenti poetici.*

28. Manuscript copies in SI-BCI, MS I. XI.49, fol. 29v, and MS H. X.2, fol. 70r; published in Lisini, "Poetesse senesi degli ultimi anni," p. 36; Eisenbichler, "Poetesse senesi a metà Cinquecento," 97, "Chant à l'honneur," pp. 90–91, and *L'opera poetica,* p. 91. The poem is not published in Domenichi, *Rime diverse d'alcune nobilissime, et virtuosissime donne,* Bulifon, *Rime,* or Bergalli, *Componimenti poetici.*

29. D'Addario, *Problema senese,* p. 122. The figure of 40,000 for the population of Siena just before the siege is given by more or less contemporary writers and picked up by later historians (Douglas, *History of Siena,* p. 262; Baia, *Leonora di Toledo,* p. 5); modern historians however, consider it to be grossly exaggerated. Ottolenghi, "Studi demografici," p. 302, suggests, instead, a figure of 24,000 to 25,000 before the siege; he then gives a figure of 10,500 for 1557 and shows a small but steady rise to 20,590 in 1580. Pardi, "Popolazione di Siena," p. 115, says that "Dei 22.500 abitanti della città e Masse (quest'ultimi si erano rifugiati pure dentro le mura) ne sarebbero scomparsi più di 11.600, o morti di ferite, o periti di malattie causate in gran parte dal cibo insufficiente e cattivo, o andati ad abitare altrove, ne sarebbero rimasti meno di 11.000. Difatti, in una descrizione eseguita nell'Agosto del 1556, si contarono nella città 10.271 *anime* . . . Anche il Segni, Storico abbastanza coscienzioso, scrive che i Senesi dopo la capitolazione si ridussero (in cifra tonda) a 10.000."

30. Published in Domenichi, *Rime diverse d'alcune nobilissime, et virtuosissime donne,* p. 196; Bulifon, *Rime,* p. 184; and Eisenbichler, *L'opera poetica,* p. 162. It is not included in Bergalli, *Componimenti poetici.*

31. SI-BCI, MS H. X.7, fol. 36v, where it is headed by the title "Di M.a Verginia Salvi." The poem was published with some significant transcription errors in Lusini, "Virginia Salvi," p. 140 (for example, Lusini twice transcribes "impio" as "empio" at v. 1 and misreads "un certo" as "incerto" at v. 3). See also Eisenbichler, *L'opera poetica,* p. 93.

32. Paris, BN, MSS Italiens 1325, fol. 90r. Published in Flamini, "Canzoniere inedito di Leone Orsini," p. 652; Eisenbichler, *L'opera poetica,* p. 195.

33. Salvi and Orsini were not the only poets at the time to sing the praises of Henri II; see, among others, Gaspara Stampa's poem to Henri II, "Sacro re, che gli antichi e novi regi" (Stampa and Franco, *Rime,* 144).

34. Guidiccioni and Beccuti, *Rime,* p. 235; Eisenbichler, *L'opera poetica,* p. 38. Dionigio Atanagi describes Coppetta as "uno de piu belli ingegni, et de piu legiadri poeti, che habbia havuto la nostra età. Morì del 1554 [sic] con molto danno de le buone lettere, et dispiacere de letterati." Atanagi, *De le rime,* fol. 262r. Atanagi is incorrect about the date of death; the *Dizionario biografico degli italiani* gives it as 18 August 1553 *(ad vocem).*

35. Ippolito II d'Este (1509–72) was the son of Duke Alfonso I of Ferrara and Lucretia Borgia.

36. Prunai, "Arrivo a Siena," p. 165; D'Addario, *Problema senese,* pp. 132–33.

37. Manuscript in SI-BCI, MS I. XI.49, fol. 32r. The poem was hitherto unpublished; it appearsi contemporaneously here and in Eisenbichler, *L'opera poetica,* p. 92.

38. Guazzo, *Cronica,* fol. 433v.

39. Jacinto Nini casts doubts on the existence of Livia Fausta and points out that there was no such family in Siena (SI-ASS, MS D 19, vol. 6, p. 112).

40. Hook, "Habsburg Imperialism," p. 299.

41. Cerrón Puga dates Salvi's move to Rome to sometime after 1553 ("Glosas italianas," p. 108 n. 50); however, the August 1554 census would suggest that Salvi was still resident in Siena, at least officially (SI-ASS, Balìa 953, fol. 174r).

42. "Eccoti la bella, saggia, magnanima, signorile, e dotta Verginia Salvi. Vedi con qual grandezza d'animo non potendo sofferire di vedere la patria sua serva, s'habbia fatto patria, la superba Roma." Betussi, *Imagini del tempio* (1556), p. 88. Betussi's dedicatory letter to Giovanna d'Aragona is dated 10 May 1556, less than a year after the fall of Siena.

43. Ill.mo et ecc.mo Sig.r mio osservantiss.o

Ringratio la bontà d'Idio che doppo i nostri lunghi travagli ci habbia voluto ristorare, con provederci una certa quiete, dandoci per Principe, e padrone, un tanto amatore di virtù e di Giustitia come è l'Ecc.a Vostra, di che mi rallegro sommamente, e spero che col mezzo del valor suo possa la gia morta patria mia ritornare in felicissima vita, la quale se ben hora la necessità mi toglie godere ho ancho ferma speranza con l'aiuto di V. Ecc.a raquistare il mio tenutomi fin hora, e poi venire a servirla come sono obligata; in tanto con ogni riverenza humilmente me le raccomando pregando Idio per la sua felicità. Di Roma il dì V di Agosto M. D. Lviiij.

> D. V. Ecc.a
> Humiliss.a serva
> Virginia Martini de' Salvi.

ASF, Mediceo del Principato 480, fol. 62r. The reference to this letter in Cosimo I, *Carteggio universale,* vol. 9, pt. 10, p. 1116, is incorrect; the letter is not on fols. 63 and 76, but on fols. 62r and 77v.

44. Published in Domenichi, *Rime diverse d'alcune nobilissime, et virtuosissime donne,* p. 197; Bulifon, *Rime,* p. 185; Bergalli, *Componimenti poetici,* vol. 1, pp. 155–56; Lisini, "Poetesse senesi degli ultimi anni," pp. 37–38; Eisenbichler, "Poetesse senesi a metà Cinquecento," p. 98, "Chant à l'honneur de la France," pp. 92–93, and *L'opera poetica,* p. 115.

45. Published in Domenichi, *Rime diverse d'alcune nobilissime, et virtuosissime donne,* pp. 199–202; Bulifon, *Rime,* pp. 187–90; Eisenbichler, *L'opera poetica,* pp. 117–20.

46. Collennuccio, Roseo da Fabriano, and Costo, *Compendio dell'istoria,* vol. 10, p. 184.

47. Bottrigari, *Libro quarto delle rime,* p. 189. At v. 2 the text reads "di volere," but the errata sheet corrects this to "di valore." Also published in Eisenbichler, *L'opera poetica,* p. 88.

48. V. Cox, *Women's Writing in Italy,* p. 102.

49. Bottrigari, *Libro quarto delle rime,* p. 190 (at v. 14 the text reads "che gire," but the errata sheet corrects it to "per gire"; Domenichi, *Rime diverse d'alcune nobilissime, et virtuosissime donne,* p. 181; Bulifon, *Rime,* p. 169; Tobia, *Fiori di rimatrici italiane,* p. 22; Eisenbichler, *L'opera poetica,* p. 87.

50. Pietro Bembo was the papal secretary who, at the consistory of June 1517, officially read out the sentence against Cardinal Raffaele Petrucci, guilty of having plotted to assassinate Pope Leo X (see above, chapter 2). Kidwell, *Pietro Bembo,* p. 189. At that time Bembo was in minor orders and not yet a cardinal. For a brief analysis of Bembo's poetic exchanges with contemporary women poets, see V. Cox, *Women's Writing in Italy,* pp. 60–61.

51. Because the poem is addressed simply as "A Pietro Bembo" and does not address him by his title of cardinal, we assume that it was composed before October 1539, when Bembo received the red hat from Pope Paul III Farnese.

52. The poem is also published in Bottrigari, *Libro quarto delle rime,* pp. 190–92; Tobia, *Fiori di rimatrici italiane,* pp. 18–21; *Parnaso italiano* [1851], pp. 1015–16 (where the editor writes the date 1561 after Virginia Salvi's name, but this date is clearly incorrect). It is also published in some collections of Bembo's works, such as his *Rime* (1753), pp. 174–75, followed by Bembo's response, "Almo mio Sole, i cui fulgenti lumi," on pp. 176–78; and Eisenbichler, *L'opera poetica,* pp. 81–83.

53. FI-BNCF, MS Palat. 256, fols. 195r–197r (olim 145r–147r). Published in Arrivabene, *Sesto libro delle rime,* fols. 109v–111v; Rore, *Secondo libro de' mad-*

regali (1557, 1571) and *Secondo libro de' madrigali* (1569), pp. 10–12; Domenichi, *Rime diverse d'alcune nobilissime, et virtuosissime donne,* pp. 186–90; Bembo, *Dolcezza d'amore*; Ferentilli, *Scielta di stanze* (1571), pp. 436–40; (1579), pp. 169–73; and (1584), pp. 174–78 (in each of Ferentilli's editions, the poem is followed by an anonymous response, "Di così finto foco esce il mio ardore"); Bulifon, *Rime,* p. 174; *Rime di poeti italiani,* pp. 135–38; Palestrina, *Opere complete,* vol. 2, pp. 67–107; Cerrón Puga, "Glosas italianas," pp. 118–20; and Eisenbichler, *L'Opera poetica,* pp. 94–106.

54. Emma Scoles and Ines Ravasini define the *glosa* as "a text that incorporates within itself another text or fragment of a text, normally by another author, by way of a systematic pattern of insertion: every stanza of the *glosa* picks up one or more verses of the glossed text respecting the original sequence so that the juxtaposition of the cited verses reconstitutes the work completely." Scoles and Ravasini, "Intertestualità ed interpretazione," p. 616 (my translation); see also Cerrón Puga, "Glosas italianas," and Leoneti, *Virginia Salvi.* The *glosa* is similar to but quite different from the *centone,* which incorporates verses from other authors but not in as systematic and as complete a fashion as the *glosa.* While the *centone* had a long history in Italy, dating back to Petrarch (see, for example, his *RVF* 70, which borrows from Arnaut Daniel, Guido Cavalcanti, Dante, and Cino da Pistoia) and even earlier, the *glosa* was something quite new and innovative. Salvi's female contemporaries had used the *centone* (among them Vittoria Colonna, Laura Terracina, and Chiara Matraini) but not the *glosa.* The closest any of these women authors does come to "glossing" may be Laura Terracina's *Discorso sopra tutti i primi canti d' "Orlando furioso"* (1549), where she "breaks apart the opening octave of each *Furioso* canto, inserts seven of her own poetic lines between each of Ariosto's, and produces a new set of eight octaves, each of which ends with a line from the earlier, model poem" (Shemek, *Ladies Errant,* p. 14; but see also pp. 126–51 for an extended discussion of this work).

55. Cerrón Puga, "Glosas italianas," p. 99. In his fundamental *Italian Madrigal,* Einstein had used the term *parody* to describe these musical and poetic glosses; his work and terminology were then picked up and developed by Haar in his fundamental article "Pace non trovo" and later in his "Arie per cantar."

56. See RISM 155724.

57. Haar, "Pace non trovo," p. 130.

58. Lewis, *Antonio Gardano,* vol. 2, p. 38; Haar, "Pace non trovo," p. 128. Haar uses the word *parody* in its musical sense, that is, to refer to a compositional technique that is equivalent to the literary technique of the "gloss" or "glosa."

59. Cerrón Puga, "Glosas italianas," pp. 108, 113–14.

60. Rore, *Secondo libro de' madregali* (1557, RISM 155724, and 1571 RISM 151710), and *Secondo libro de' madrigali* (1569, RISM 156933); Palestrina, *Primo libro de madrigali* (1596); Palestrina, *Opere complete,* vol. 2, pp. 67–107; Eisenbichler, *L'opera poetica,* pp. 99–102.

61. Cerrón Puga dates it to 1557 but does not indicate on what grounds; "Glosas italianas," pp. 108–9.

62. Cerron Puga ("Glosas italianas," p. 115 n. 80) says that James Haar suggests that Salvi and Palestrina met thanks to Cardinal Ippolito II d'Este, but I have not been able to confirm this. They could just as easily have met through Cardinal Vitelli.

63. Haar, "Madrigal Book," p. 202; Thieffry, "Jean de Turnhout," pp. 34, 42.

64. "Un contrapuntiste habile, sinon toujours inspiré. Technicien éclairé et homme à l'esprit structuré autant dans la conception d'ensemble que dans le raffinement du détail." Thieffry, "Jean de Turnhout," p. 41.

65. Cerrón Puga, "Glosas italianas," p. 102.

66. Doni, *Dialogo della musica,* pp. 147–48. The sonnets are by Antonio Maria Braccioforte ("Né dal sol gl'occhi, o da le grazie il canto"), Luigi Cassola ("Chi vuol vedere in un sol corpo unite"), Ottavio Landi ("Doni, che quella illustre e sacra Idea"), and Giovan Battista Bosello ("Quando contemplo l'unica beltade"). Martha Feldman suggests that Isabetta Guasca may be the real-life name of the dialogue's interlocutor, Selvaggia (*City Culture,* p. 21).

67. D'Alessandro, "Prime ricerche," pp. 172–73; Einstein, "Dialogo della musica," p. 245. On the Ortolani, see del Fante, "Accademia degli Ortolani." The first appearance of Salvi's poetry in print is, in fact, in Doni's dialogue on music; her subsequent appearance would be seven years later in Bottrigari's *Libro quarto delle rime* (1551).

68. "Le seul ensemble important, sinon cohérent, de poèmes d'amour est l'oeuvre de Virginia Martini de' Salvi. . . . On peut penser que la large place que Domenichi accorde à cette poétesse reflète l'estime qu'il a pour ses oeuvres et pour ses capacités à manier le langage poétique de son temps." Piéjus, "Première anthologie" (1982), pp. 208–9. On the anthology, see Piéjus, "Première anthologie." Note especially her hypothesis of a "Tuscan" agenda within the collection (pp. 201–2), her comments on the conscious "feminine" aspect of the collection (pp. 202–3), and the links between women's poetry and contemporary political events (pp. 204–5).

69. Robin, *Publishing Women,* p. 72.

70. An edition of Salvi's poetry is part of my volume *L'opera poetica di Virginia Martini Salvi.*

Epilogue

1. Robin, *Publishing Women,* pp. 1–40.

2. Eisenbichler, review of Robin, *Publishing Women,* pp. 356–57.

3. The first edition of Colonna's *Rime* (Parma: n.p., 1538) contained 136 love poems for her deceased husband, Ferrante Francesco d'Avalos, Marquis of Pescara. Subsequent editions reprinted these poems but kept adding more and more religious poems, thus shifting the balance from love poetry to religious poetry. The modern edition of Colonna's *canzoniere* contains 390 poems, of which 217 are religious/spiritual.

4. Ross, *Birth of Feminism,* p. 1. I should point out that Ross's study does not consider women writers in Siena and in fact does not mention even in passing any Sienese woman, though her reading of Robin's *Publishing Women* should have alerted her at least to the case of Laudomia Forteguerri. The difference in perspective between Ross and me may lie in the fact that Ross looks at late sixteenth-century Italian women, while I look instead at Sienese women in the early and mid–sixteenth century, when the situation, in Italy and Italian society, was clearly quite different.

5. Domenichi, *Rime diverse d'alcune nobilissime, et virtuosissime donne,* pp. 19, 23–30.

6. Domenichi, *Rime diverse d'alcune nobilissime, et virtuosissime donne,* pp. 19–21; *Parnaso italiano* [1847], p. 1007. Some of her works were republished in *Delle donne illustri italiane,* pp. 140–41, and in *Parnaso italiano* [1851], cols. 1399–1400.

7. Lucrezia Figliucci's "Quella chiara virtù, che da' primi anni" and Cassandra Petrucci's "Quanto felici in voi sieno i lieti anni" were published together in Domenichi, *Rime diverse d'alcune nobilissime, et virtuosissime donne,* p. 19.

8. Quadrio, *Della storia e della ragion,* vol. 2, p. 363; Domenichi, *Nobiltà delle donne,* fol. 249r.

9. The sonnet "Quando vedrò di questa mortal luce," attributed to Atalanta Donati in Bergalli, *Componimenti poetici,* vol. 1, p. 162, and in *Parnaso italiano* [1851], col. 1603, is attributed elsewhere to Vittoria Colonna.

10. The life years are from Liberati, "Medaglie senesi," p. 72, repeated by Cagliaritano, *Mamma Siena,* vol. 1, p. 103, and vol. 6, p. 1130. The marriage information is from SI-ASS, MS A 35, fol. 32r, and SI-BCI, MS P. IV.10, fol. 384v. See also SI-ASS, MS A2, fol. 21r.

11. "Fu donata al Mondo per oggetto di marauiglia, e di stupore, mentre arricchita d'altissimo ingegno, ed ornata d'ogni bella virtù, non parlaua, che non rapisse gli affetti altrui, e quella lode, che ad Atalanta diedero le fauolose

penne di sopravanzare ogni più veloce nel corso, ben poteua a lei darsi con verità, mentre co'l volo di sublime intendimento ogn'altra precorreua." Ugurgieri Azzolino, *Pompe sanesi,* vol. 2, p. 400.

12. SI-BCI, MS A.VII.35, fol. 35v.

13. Silvia di Pierfrancesco Piccolomini was baptized on 12 June 1526; SI-ASS, Biccherna 1135, fol. 140r; see also SI-ASS, MS A 51, fol. 246v. For Silvia di Girolamo Carli Piccolomini, see SI-ASS, MS A 51, fol. 248v and Biccherna 1136, fol. 71r (bapt. 6 October 1542).

14. I have postulated Ermellina's birth year by assuming that she was married at about twenty years of age and then calculating back from 1541. For Ermellina's marriage record, see SI-ASS, MS A 34, fol. 28r. For her children's birth records, see SI-ASS, MS A 49, fol. 71v. For Aldobrando Cerretani's birth, see SI-ASS, MS A 49, fol. 71v.

15. Crescimbeni, *Commentari intorno,* vol. 4, p. 120.

16. "Per la povertà gli convenne maritarsi a uno speziale de' Restori [Rettori?], che rimase poi adottato in Bichi, e dopo ammesso alla nobiltà, per tal giusta cagione gli convenne più attendere a manuali lavori, che alla Poesia"; SI-BCI, MS A.VII.35, fol. 76r.

17. "Fu donna assai colta e gentile, ma i suoi versi, se possiamo argomentarlo da un suo sonetto che ci venne fatto di leggere, incominciavano già a risentire i vizii del seguente secolo, i quali invadendo le lettere italiane ne guastarono il gusto, e poco men che non le imbarbarirono." *Delle donne illustri italiane,* p. 162.

18. "In un ritrovo di molte gentildonne, e gentilhuomini di valore era caduto il ragionamento sopra una gentildonna sanese, communemente tenuta per bella, e molto honesta: la quale ancora che quivi fosse lodata quasi da tutti, si come quella che il meritava, vi fu però uno, il quale o per studio di contradire, o per qualche repulsa ricevuta da lei, la tassò di vanità e di leggierezza: onde Madonna Honorata Pecci, la quale era quivi, subitamente disse; ora se voi levate la vanità alle donne, e che rimarrà più loro? (Modesta, e virtuosissima gentildonna.)" Domenichi, *Facetie, motti, & burle,* pp. 363–64.

19. Onorata Tancredi was baptized on 19 June 1503; SI-ASS, Biccherna 1134, fol. 58r; see also SI-ASS, MS A 52, fol. 183r. For her marriage, see SI-ASS, MS A 56, fol. 160r; her dowry at this first marriage was 2,200 florins. Onorata was subsequently widowed and contracted a second marriage in 1538 with Ventura d'Alessandro Venturi; her dowry at this second marriage was 2,500 florins (SI-ASS, MS A 58, fol. 260r). G. A. Pecci reverses her first husband's name and gives it as Giulio di Benvenuto (SI-BCI, MS A.VII.36,

fol. 26r), but that was the groom's father, who married Cassandra di Pier'Antonio di Iacomo da Grosseto in 1490 (MS A 56, fol. 157r).

20. "So pur, M. Claudio, che voi mi avete più fiate detto, che M. Onorata Pecci vostra Sanese così accortamente ragiona delle più ascose cose di filosofia, che i più gentili spiriti di quelle contrade, oltre al piacere, ne prendono grandissima maraviglia: nè me ne ha mai parlato alcuno (che me ne han parlato molti), che non me la abbia dipinta uguale alla mia M. Gostanza in ogne sorte di virtù." Firenzuola, "Epistola in lode," p. 18. Gostanza Amaretta is the main speaker in Firenzuola's *Ragionamenti.*

21. The two sonnets were first published in Domenichi, *Rime diverse d'alcune nobilissime, et virtuosissime donne* (1559), p. 72, and then reprinted in Bulifon, *Rime,* p. 63, and in Bergalli, *Componimenti poetici,* vol. 1, pp. 177–78.

22. SI-ASS, Biccherna 1134, fol. 58r. The marginal note is in a sixteenth-century italic hand seems that seems to date from the first half of the sixteenth century.

23. Ferrante, the third son of Francesco II Gonzaga, Duke of Mantua, and Isabella d'Este, was educated in part in at the Imperial court in Spain, where he was sent at the age of sixteen to serve as page to Emperor Charles V, to whom he remained loyal and devoted for his entire lifetime.

24. Giulia belonged to the Gonzaga who were counts of Sabbioneta, while Ippolita belonged to the Gonzaga who were dukes of Guastalla. Both branches descended directly from Ludovico III Gongaza (1412–78), Marquis of Mantua. Giulia was his great-granddaughter (third generation), while Ippolita was his great-great-granddaughter (fourth generation).

25. "Io m'ho goduto questi pochi giorni la signora principessa [Isabella di Capua] e questi saporitissimi Nini e massime Donna Ippolita mia, che non posso saziarmi di vederla e baciarla." Quoted in Amante, *Giulia Gonzaga,* p. 159.

26. "Bacio mille volte il Nino e diecimila Donna Ippolita mia bellissima e saporitissima." Quoted in Amante, *Giulia Gonzaga,* p. 159; Amato identifies the little boy as Cesare, a sibling of Ippolita.

27. Affò, *Memorie,* pp. 99–100 and 124–25.

28. Tansillo, *Poesie liriche,* p. 293, gives the date of marriage as "autunno 1554" and then speaks of the death of Ippolita's father (1557) and of a "break" with her father-in-law, who had remarried. Difficulties with the father-in-law are also mentioned by Amante, *Giulia Gonzaga,* pp. 161–62. Camilla Russell says that Giulia "fled her miserable marriage by seeking refuge in donna Giulia's Neapolitan convent" but does not indicate when this took place; she does, however, cite a letter of 4 February 1559 from Pietro Carnesecchi to Giulia Gonzaga in which he writes that he is pleased to hear that Ippolita has been

living for some time with Giulia and imagines her [probably Giulia] to be "always in joy and in feasts, having such sweet and dear company" (Russell, *Giulia Gonzaga*, p. 27 n. 86).

29. Antonio Carafa's letter to Giulia Gongaza's nephew, Vespasiano Colonna (once proposed as a possible husband for Ippolita Gonzaga), is dated from Naples on 13 March 1563 and is published in Affò, *Memorie*, pp. 112–13, and republished, in part, in Amante, *Giulia Gonzaga*, pp. 164–65. Luigi Tansillo's two letters from Naples to Onorata Tancredi Pecci (whose whereabouts are not clear) are dated on 12 and 28 March 1563 and have been published in Affò, *Memorie*, pp. 114–18, and then in Tansillo, *Poesie liriche*, pp. 293–98; and in part in Amante, *Giulia Gonzaga*, pp. 165–67. The editor of Tansillo's poems, Francesco Fiorentino, claims incorrectly that Ippolita died the night of 7 March (p. 293), but he has obviously misread both Carafa's letter to Colonna and Tansillo's letters to Tancredi, which clearly report how Ippolita had a severe relapse on 7 March and died on 9 March. The poems in memory of Ippolita were published by Antonio Sicuro in a volume entitled *Rime di diversi eccell. autori in morte della Illustriss. Sig. D. Hippolita Gonzaga*, in 1564.

30. "Col tempo vedrà come ho preposto questa gentildonna piena di quelle vertù, sì che potrei dire non haver pari, con sopportatione d'ogni altra." Affò, *Memorie*, p. 126.

31. "Della signora marchesa del Vasto certamente non potete trovare più grandezza in altra; più magnanimità e più comodità di fortuna; tuttavia bisogna che qualunque persona si mette a servirla, sia atta parimente confrontarsela di sangue; e ciò vi sia esempio la signora Alessandra Piccolomini, la quale non vi è perseverata un anno intero." Quoted in Fiorentino, "Donna Maria d'Aragona," p. 238.

32. "La madre intanto, che dovea fra non molto recarsi nelle sue Terre nel Regno di Napoli, le pose al fianco una eccellentissima governatrice chiamata Onorata Tancredi, al cui valore esaltato da alquanti celebri uomini di quella età attribuir certamente conviene l'avanzamento migliore d'Ippolita ne' signorili costumi, e nelle scienze. Era la Tancredi Gentildonna virtuosissima, e piena di spirito, come la qualificano gli elogj in varie circostanze meritati; onde venuta ai servigj della Gonzaga, ebbe a indirizzarla vie meglio nella buona via, infiammandola a perseverar nello studio delle buone scienze, ed a far conto degli uomini dotti, giacchè per quelle si sarebbe tra le sue pari distinta, e mercè l'applauso di questi avrebbe quella fama ottenuto, di cui gli animi nobili furono maisempre desiderosi. Lontana dunque Ippolita dal seguir il costume di alcune donne, che il matrimonio risguardano come un termine della loro educazione, e giunte al nuovo stato ad una vita si danno libera e conversevole,

continuò nelle intraprese applicazioni, e il fece con tanto ardore, e per tal guisa nell'età di soli quindi anni si mostrò avanzata nella coltura dell'animo, che riscuotendone lode e maraviglia, ebbe l'onore di vedersi coniata una elegante Medaglia col suo Ritratto, nel cui rovescio si rappresentarono i simboli e gli strumenti della Poesìa, della Musica, dell'Astonomìa, e di simili facoltà, col motto NEC TEMPVS, NEC AETAS: quasi volesse dirsi aver ella nel progresso fatto in simili pellegrine cognizioni avanzato di gran lunga l'aspettazione e l'età." Affò, *Memorie,* pp. 100–101.

33. "Questi dì adietro scrissi a V. E. de le cose della Sig.ra D. Hippolita, ora credo che Monsignor d'Otranto [Pietro Antonio di Capua] l'avrà meglio informata. Me doglio che se ne parli così publicamente, et è il bello que loro per far que D. Hippolita non senta la partita di M. Honorata li vogliono dar da intendere che le ha publicate tutte queste cose que se dicono, ma il principe [Don Luigi Carafa, Principe di Stigliano] non lo darà già a me, que lui sa quel que so, li dissi avanti que . . . Honorata venisse et sa ancora de donde lo seppi ma que semplicità tanto grande de credersi loro tener secreto tante cose che non ce lor parente ne servitore fino a li guatari parlano de la poca creanza et mala natura et miseria di quella casa. Queste son cose anteviste in parte et se li tempi e li travaglii di V. E. non l'avessero comportato non se dovevano [blank space in the original] mai li dui capi que il Duca et D. Hippolita stessero apresso alla E. V. et que li dessero il vivere apartato, or qua credo que non andranno primo in Basilicata ma a la rocca [di Mandragone]." Amante, *Giulia Gonzaga,* p. 458. Pietro Antonio di Capua (1513–78 or '79), archbishop of Otranto, was second cousin to Ippolita's mother, Isabella di Capua (their grandparents, Giulio I and Andrea, were brothers) and a close friend of Giulia Gonzaga. Like Giulia, he was a fervent disciple of Juan de Valdés, whom he assisted in his final hours, and he was strongly suspected of heresy by the Inquisition but was never tried because of the strong protection he enjoyed from the emperor and the Gonzaga family. While attending the Council of Trent, Di Capua kept Giulia Gonzaga informed of its proceedings, as Pietro Carnesecchi told the Inquisition during his own trial (Amante, *Giulia Gonzaga,* p. 279). Don Luigi Carafa (1511–76), Prince of Stigliano, was Ippolita's father-in-law.

34. The "Dialogo sulla lontananza" is dated "from Naples the first day of the year 1563" and is currently in the Biblioteca Angelica in Rome, MS 1369, while the "Osservazioni sopra la Commedia di Dante" is dated "from Naples, 17 February 1564," and is in the Biblioteca Comunale degli Intronati di Siena, MS H.VII.20. Benucci also addressed some of his poems to Onorata Tancredi.

35. Hare, *Men and Women,* p. 223.

36. The letter is dated January 1552; see Affò, *Memorie,* pp. 104–5 and 127 nn. 32–33. See also Waddington, *Aretino's Satyr,* p. 74. According to Affò, this is the medal cast by Jacopo del Treppo that shows Ippolita on the recto and a figure of Diana on the reverse.

37. Tasso, *Rime,* son. 23.

38. Vignali, *Cazzaria,* p. 146 n. 173.

39. Belladonna, "Gli Intronati, le donne," p. 53.

40. Benson, *Invention of the Renaissance Woman,* p. 5.

WORKS CITED

Manuscripts

France, Paris, Bibliothèque Nationale (BN)

Italiens 1535.

Italy, Florence, Archivio di Stato di Firenze (FI-ASF)

Mediceo del Principato 480, 2010.

Italy, Florence, Biblioteca Nazionale Centrale di Firenze (FI-BNCF)

Autografi Palatini, vol. 2, "Lettere al Varchi."N. A. 1248, Jacopo Vignali,
 Dulpisto.
Palat. 228 [Miscellanea dei secc. XVI e XVII].
Palat. 256 [Miscellanea dei secc. XVI e XVII].

Italy, Parma, Biblioteca Palatina

Palat. 297 Jacopo Vignali, *Dulpisto.*

Italy, Siena, Archivio di Stato di Siena (SI-ASS)

A 2 Attilio Berlinghieri, "Famiglie nobili senesi: Notizie storiche."
A 15–16 Antonio Aurieri, "Famiglie nobili di Toscana" (2 vols.).
A 26 Notizie storiche sulle famiglie nobili senesi.

A 30/II	Antonio Sestigiani, "Compendio istorico di sanesi nobili per nascita . . ." (1696).
A 32	Manenti, Battezzati famiglie nobili estinte, F-N.
A 34	Manenti, Matrimoni famiglie nobili estinte, A–C.
A 35	Manenti, Matrimoni famiglie nobili estinte, D-O.
A 48	Manenti, Battezzati famiglie nobili esistenti A-B.
A 49	Manenti, Battezzati famiglie nobili esistenti, C–F.
A 50	Manenti, Battezzati famiglie nobili esistenti, G-M.
A 51	Manenti, Battezzati famiglie nobili esistenti, N-P.
A 52	Manenti, Battezzati famiglie nobili esistenti, R-Z.
A 54	Manenti, Matrimoni famiglie nobili esistenti, C-F.
A 56	Manenti, Matrimoni famiglie nobili esistenti, O-P.
A 57	Manenti, Matrimoni famiglie nobili esistenti, R-S.
A 58	Manenti, Matrimoni famiglie nobili esistenti, T-V.
Balìa 952	Censimento c.s. del Terzo di S. Martino, 1553.
Balìa 953	Censimento c.s. del Terzo di San Martino, 1554.

Biccherna 176, 1133, 1134, 1135, 1136.

Concistoro 1233.

D 14	Sepolti in S. Domenico di Siena et altre memorie esistenti in detto luogo.
D 17–21	Giacinto Nini, "De successi, e guerre d'Italia."
D 22–23	Giugurta Tommasi, "Historie di Siena."
D 50	Angiolo Bardi, "Historie di Siena, 1512–1556."

Gabella 335, 386.

Giudice Ordinario 254.

Notarile 1928, Ser Mino Berzi, 1543–44.

Notarile Ante-Cosimiano 2013, 2249, 2350.

Italy, Siena, Biblioteca Municipale degli Intronati di Siena (SI-BCI)

A. III.7	Estratti dell'opera *Laconico discorso della Nobilissima Famiglia Petrucci d'Altomonte di Siena del dott. don Filadelfo Mugnos* . . . (Naples: Andrea Colicchia, 1674).
A. V.19	[Notizie della famiglia Petrucci].
A. VI.54	*Compendio Istorico di Sanesi Nobili per Nascita, Illustri per Attioni, Riguardeuoli per dignità, raccolto, come si dimostra da diuersi Autori, che hanno stampato, da Manuscritti antichi, e moderni, da Archiuij da Contratti publici, e da Scritture esistenti appresso Persone particolari. MDCXCIV.*

A.VII.17	Biccherna, "Spoglio dei registri di Consigli, 1369–1558."
A.VII.35	Giovan Antonio Pecci, *Indice scrittori senesi* (1754), vol. 1.
A.VII.36	Giovan Antonio Pecci, *Indice scrittori senesi* (1754), vol. 2.
C.III.2	Necrologia S. Domenico (morti dal MCCCXXXVI al MDII-IIC).
C.VI.9	"Opuscoli varii di Scrittori senesi."
D.VI.7	[Letters]
D.VII.7	[Letters]
H.X.2	"Rime di alcuni autori senesi."
H.X.7	"Poesie varie di Autori Sanesi."
H.X.12	"Varie Poesie e Prose di Autori Sanesi."
H.X.45	"Raccolta di poesie diverse di vari autori parte tersa . . . 1719."
I.XI.49	"Rime volgari e poesie latine di varij."
P.IV.10–11	Scipione Bichi Borghesi, *Scrittori senesi. Notizie.*
P.IV.14	Scipione Bichi Borghesi, *Scrittori senesi. Notizie.*
P.V.15, fasc. 5	Marc'Antonio Piccolomini, "Se è da credersi che una donna compiuta in tutte quelle parti così del corpo come dell'animo, che si possono desiderare, sia prodotta da la natura a sorte o pensatamente."
P.V.15, fasc. 7	Marc'Antonio Piccolomini, "La vita de la Nob.ma M.a Arithea de Marzi."
R.VIII.011	Cecchino libraio, "La magnifica et honorata festa fatta in Siena per la Madonna d'agosto l'anno 1546."
Y.II.23	"Memorie delle Accademie. . . ."

Vatican City, Vatican Archives

Fondo Borghese, ser. I, 36.

Printed Works

Adriani, Giovan Battista. *Istoria de' suoi tempi.* Prato: Per i fratelli Giachetti, 1823.

Affò, Ireneo. *Memorie di tre celebri principesse della famiglia Gonzaga, cioè di Donna Emilia Gonzaga Colonna, . . . Lucrezia Gonzaga Manfrone, . . . Ippolita Gonzaga Colonna.* Parma: Filippo Carmignani, 1787.

Alighieri, Dante. *La Divina Commedia.* Comm. Tommaso Casini, ed. S. A. Barbi. 3 vols. Florence: G. C. Sansoni, 1967.

———. *Vita nuova.* Ed. Luigi Pietrobono. Florence: G. C. Sansoni, 1968.

Amante, Bruto. *Giulia Gonzaga contessa di Fondi e il movimento religioso femminile del secolo XVI. Con due incisioni e molti documenti inediti.* Bologna: Ditta Nicola Zanichelli, 1896.

Angel, Marc D. "Judah Abrabanel's Philosophy of Love." *Tradition: Journal of Orthodox Jewish Thought* 15 (1975): 81–88.

Arrivabene, Andrea, ed. *Il sesto libro delle rime di diversi eccellenti autori nuovamente raccolte et mandate in luce. Con un discorso di Girolamo Ruscelli.* In Vinegia: Al segno del pozzo, 1553 (In Vinegia: per Giovan Maria Bonelli, 1553).

Atanagi, Dionigi. *De le rime di diversi nobili poeti toscani raccolte da Dionigio Atanagi. Con una tavola del medesimo nella quale oltre ad altre cose degne di notitia, talvolta si dichiarano alcune cose pertinenti a la lingua toscana e a l'arte del poetare.* Ed. Dionigi Atanagi. 2 vols. In Venetia: Appresso Ludovico Avvanzo, 1565.

Baia, Anna. *Leonora di Toledo duchessa di Firenze e di Siena.* Todi: Tip. Z. Foglietti, 1907.

Bargagli, Girolamo. *Dialogo de' giuochi che nelle vegghie sanesi si usano di fare.* Ed. P. D'Incalci Ermini, introd. R. Bruscagli. Siena: Accademia Senese degli Intronati, 1982.

Bargagli, Scipione. "Orazione di Scipion Bargagli in morte di Monsignor Alessandro Piccolomini Arcivescovo di Patrasso, Eletto di Siena 1579." In *Dell'imprese di Scipion Bargagli, gentil'huomo sanese: alla prima parte, la seconda, e la terza nuouamente aggiunte,* pp. 546–73. In Venetia: Appresso Francesco de' Franceschi, 1594.

Belardini, Manuela. "Margherita d'Austria, sposa e vedova del duca Alessandro de' Medici." In *Margherita d'Austria (1522–1586). Costruzioni politiche e diplomazia, tra corte Farnese e Monarchia spagnola,* ed. Silvia Mantini, pp. 25–54. Rome: Bulzoni Editore, 2003.

———. "Quando Margherita d'Austria vedova del Duca Alessandro De' Medici si trovò a soggiornare a Prato." *Bollettino roncioniano* 7 (2007): 51–62.

Belladonna, Rita. "Bartolomeo Caroli, nobile senese, imitatore di Juan de Valdés." *Critica storica* 10 (1973): 143–60.

———. "Bartolomeo Carli Piccolomini's Attitudes towards Religious Ceremonies Compared to That of Erasmus and That of Luther." *BHR* 42, no. 2 (1980): 421–25.

———. "Cenni biografici su Bartolomeo Carli Piccolomini." *Critica storica* 11 (1974): 507–10.

———. "Gli Intronati, le donne, Aonio Paleario e Agostino Museo in un dialogo inedito di Marcantonio Piccolomini il Sodo Intronato (1538)." *Bullettino senese di storia patria* 99 (1992): 59–90.

Bembo, Pietro. *La dolcezza d'amore.* Ferrara: Appresso Valente Panizza Mantovano, 1562.

————. *Opere*. Milan: Società tipografica dei classici italiani, 1808–10. 12 vols.

————. *Rime di Pietro Bembo, corrette, illustrate ed accresciute con le annotazioni di Anton-Federico Seghezzi, e la vita dell'autore novellamente rifatta sopra quella di Monsig. Lodovico Beccatelli.* 2nd ed. In Bergamo: Appresso Pietro Lancelotti, 1753.

Benci, Antonio. "Volgarizzamenti antichi dell'*Eneide* di Virgilio." *Antologia: Giornale di scienze, lettere e arti* 2 (1821): 161–200.

Benson, Pamela Joseph. *The Invention of the Renaissance Woman: The Challenge of Female Independence in the Literature and Thought of Italy and England.* University Park: Pennsylvania State University Press, 1992.

Bergalli, Luisa, ed. *Componimenti poetici delle più illustri rimatrici d'ogni secolo, raccolti da Luisa Bergalli: Parte prima, che contiene le Rimatrici Antiche fino all'Anno 1575.* In Venice: Appresso Antonio Mora, 1726.

Bertini, Fabio. *Feudalità e servizio del Principe nella Toscana del '500: Federigo Barbolani da Montauto, Governatore di Siena.* Introd. L. Lotti. Siena: Cantagalli, 1996.

Betussi, Giuseppe. *Le imagini del tempio della Signora Donna Giovanna Aragona. Dialogo di M. Giuseppe Betussi. Alla Illustriss. S. Donna Vittoria Colonna di Tolledo.* In Fiorenza: (Appresso M. Lorenzo Torrentino), 1556.

————. *Le imagini del tempio della Signora Donna Giovanna Arragona, Dialogo di M. Giuseppe Betussi. Alla Illustrissijma Signora Donna Vittoria Colonna di Tolledo.* In Venetia: Per Giovanni de' Rossi, 1557.

————. *La Leonora*. In *Trattati d'amore del Cinquecento,* ed. Giuseppe Zonta, pp. 305–48. Bari: Gius. Laterza e Figli, 1912.

Borris, Kenneth, ed. *Same-Sex Desire in the English Renaissance: An Anthology of Primary Sources.* New York: Routledge, 2004.

Borsetto, Luciana. *L'"Eneida" tradotta: Riscritture poetiche del testo di Virgilio nel XVI secolo.* Quaderni dell'Istituto di filologia e letteratura italiana / Università degli studi di Padova 6. Milan: Unicopli, 1989.

Botta, Carlo. *Storia d'Italia continuata da quella del Guicciardini sino al 1789.* 8 vols. Turin: Cugini Pomba e Compagnia, 1852.

Bottrigari, Ercole, ed. *Libro quarto delle rime di diversi eccellentiss. autori nella lingua volgare. Novamente raccolte.* In Bologna: Presso Anselmo Giaccarello, 1551.

Brantôme., Pierre de Bourdeille, Seigneur de. *Recueil des Dames, poésies et tombeaux.* Ed. Etienne Vaucheret. Paris: Gallimard, 1991.

Bulifon, Antonio, ed. *Rime di cinquanta illustri poetesse. Di nuovo date in luce e dedicate all'Eccellentissima Signora D. Eleonora Sicilia Spinelli Duchessa d'Atri, &c.* In Napoli: Appresso Antonio Bulifon, 1695.

Buonarroti, Michelangelo. *Rime.* Introd. Giovanni Testori. Ed. Ettore Barelli. Milan: Rizzoli, 1975.

Buti, Maria Bandini, ed. *Poetesse e scrittrici.* 2 vols. 1941. Reprint, Rome: Tosi, 1946.

Cagliaritano, Ubaldo. *Mamma Siena: Dizionario biografico-aneddotico dei Senesi.* 6 vols. Siena: Fonte Gaia, 1971, 1976.

Cairola, Aldo. *Siena/Le Contrade: Storia, feste, territorio, aggregazioni.* Siena: Industria Grafica Pistolesi, 1989.

Canini, Marco Antonio. *Il libro dell'amore: Poesie italiane raccolte e straniere raccolte e tradotte.* Venice: Tipografia dell'Ancora, 1888.

Canonici Fachini, Ginevra. *Prospetto biografico delle donne italiane rinomate in letteratura dal secolo decimoquarto fino a' giorni nostri con una risposta a Lady Morgan risguardante alcune accuse da lei date alle donne italiane nella sua opera l'Italie.* Venice: Dalla tipografia Alvisopoli, 1824.

Cantagalli, Roberto. *La guerra di Siena (1552–1559): I termini della questione senese nella lotta tra Francia e Asburgo nel '500 e il suo risolversi nell'ambito del Principato mediceo.* Monografie di storia e letteratura senese 5. Siena: Accademia senese degli Intronati, 1962.

———. "Un inedito del 1553 dell'Archivio di Stato di Siena: La sentenza di condanna pronunciata dai Quattro Segreti di Badìa e la relazione del Capitano di Giustizia sulla congiura antifrancese di Giulio Salvi Capitano del Popolo." *Bullettino senese di storia patria* 67 (1960): 128–44.

Caponetto, Salvatore. *Aonio Paleario (1503–1570) e la riforma protestante in Toscana.* Turin: Claudiana Editrice, 1979.

Castiglione, Baldassarre. *Il libro del Cortegiano.* Ed. Luigi Preti. Turin: Giulio Einaudi, 1965.

Cecchino libraio. *La magnifica & honorata Festa, Fatta in Siena, per la Madonna d'Agosto, l'anno 1546. Con l'ordine delle Livree, & altri giuochi fatti in essa.* In Siena, Alla Loggia del Papa, 1582.

Centorio degli Ortensi, Ascanio. *La seconda parte de' Commentarii della guerre et de' successi più notabili avvenuti così in Europa come in tutte le parti del mondo dall'anno MDLIII fino a tutto il MDLX.* In Vinetia: G. Giolito di Ferrari, 1568.

Cerreta, Florindo. *Alessandro Piccolomini letterato e filosofo senese del Cinquecento.* Siena: Accademia Senese degli Intronati, 1960.

———. "La Tombaide: Alcune rime inedite su un pellegrinaggio petrarchesco ad Arquà." *Italica* 35 (1958): 162–66.

Cerrón Puga, Maria Luisa. "Glosas italianas: Fortuna musical del género lírico hispánico en el siglo de Palestrina." *Rivista di filologia e letterature ispaniche* 11 (2008): 95–128.

Collennuccio, Pandolfo, Mambrino Roseo da Fabriano, and Tommaso Costo. *Compendio dell'istoria del Regno di Napoli.* 3 vols. Napoli: Nella Stamperia di Giovanni Gravier, 1771.

Conti, Vincenzo, ed. *Rime di diversi autori eccellentiss. Libro nono.* Cremona: Per Vincenzo Conti, 1560.

Contini, Alessandra, and Paola Volpini, eds. *Istruzioni agli ambasciatori e inviati medicei in Spagna e nell' "Italia spagnola" I (1536–1586).* Pubblicazioni dell'Archivio di Stato, Fonti 47. Rome: Ministero per i Beni e le Attività Culturali / Direzione Generale per gli Archivi, 2007.

Cosimo I de' Medici. *Carteggio universale di Cosimo I de' Medici: 1 [2,4,5,9] Archivio di Stato di Firenze.* Ed. Anna Bellinazzi and Claudio Lamioni. Florence: La Nuova Italia Editrice, 1982, 1986.

Courteault, Paul. *Blaise de Monluc historien: Étude critique sur le texte et la valeur historique des Commentaires.* Paris: Librairie Alphonse Picard et fils, 1908.

Cox, Marion E. "The Earliest Edition of the 'Rime' of Vittoria Colonna, Marchesa di Pescara." *Library,* ser. 4, 2, no. 4 (1922): 266–68.

Cox, Virginia. *Women's Writing in Italy, 1400–1650.* Baltimore: Johns Hopkins University Press, 2008.

Crescimbeni, Giovan Mario. *Commentari intorno alla sua istoria della volgar poesia.* 6 vols. Rome: Antonio De' Rossi, 1702–11.

D'Addario, Arnaldo. *Il problema senese nella storia italiana della prima metà del Cinquecento (La guerra di Siena).* Florence: Felice Le Monnier, 1958.

D'Alessandro, A. "Prime ricerche su Lodovico Domenichi." In *Le corti farnesiane di Parma e Piacenza (1545–1622), vol. 2, Forme e istituzioni della produzione culturale,* ed. Amedeo Quondam, 171–200. Rome: Bulzoni, 1978.

del Fante, Alessandra. "L'Accademia degli Ortolani." In *Le corti farnesiane di Parma e Piacenza (1545–1622), vol. 2, Forme e istituzioni della produzione culturale,* ed. Amedeo Quondam, 149–70. Rome: Bulzoni, 1978.

[Delicato, Francisco?]. *Ragionamento del Zoppino fatto frate, e Lodovico, puttaniere, dove contiensi la vita e genealogia di tutte le Cortigiane di Roma.* Milan: Longanesi, 1969.

Delle donne illustri italiane dal XIII al XIX secolo. Rome: Fratelli Pallotta, ca. 1830s.

De' Vecchi, Elena. "Alessandro Piccolomini." *Bullettino senese di storia patria* 41 (1934): 421–54.

Dionisotti, Carlo. *Geografia e storia della letteratura italiana.* Turin: Einaudi, 1977.

Dizionario biografico degli italiani. 68+ vols. Rome: Istituto della Enciclopedia Italiana, 1960–.

Dizionario Garzanti. Milan: Garzanti, 1963.

Domenichi, Lodovico. *Facetie, motti, & burle, di diuersi signori et persone priuate. Raccolte per M. Lodouico Domenichi, & da lui di nuouo del settimo libro ampliate. Con una nuoua aggiunta di motti; raccolti da M. Thomaso Porcacchi, & con un discorso intorno a essi, con ogni diligentia ricorrette, & ristampate.* In Venetia: Appresso Domenico Farri, 1581.

———. *La nobiltà delle donne*. Vinetia: appresso Gabriel Giolito De' Ferrari, 1549.

———, ed. *Rime diverse d'alcune nobilissime, et virtuosissime donne*. Lucca: Per Vincenzo Busdragho, 1559.

———, ed. *Rime diverse di molti eccellentiss. auttori nuovamente raccolte: Libro primo*. In Vinetia: Appresso Gabriel Giolito di Ferrarii, 1545; 2nd ed., 1546; 3rd ed., 1549.

Doni, Antonfrancesco. *Dialogo della musica*. In Anna Maria Monterosso Vacchelli, *L'opera musicale di Antonfranesco Doni*. Cremona: Athenaeum cremonense, 1969.

Douglas, Langton. *A History of Siena*. London: John Murray, 1902.

Edelstein, Bruce. "Nobildonne napoletane e committenza: Elenora d'Aragona ed Eleonora di Toledo a confronto." *Quaderni storici* 2 (2000): 295–330.

Einstein, Alfred. "The 'Dialogo della musica' of Messer Antonio Francesco Doni." *Music and Letters* 15, no. 3 (1934): 244–53.

———. *The Italian Madrigal*. 3 vols. Trans. Alexander H. Krappe et al. Princeton: Princeton University Press, 1949.

Eisenbichler, Konrad. "'Un chant à l'honneur de la France': Women's Voices at the End of the Republic of Siena." *Renaissance and Reformation/Renaissance et Reforme* 27, no. 2 (2003): 87–99.

———, ed. *The Cultural World of Eleonora di Toledo*. Aldershot: Ashgate, 2004.

———. "Laudomia Forteguerri Loves Margaret of Austria." In *Same-Sex Love and Desire among Women in the Middle Ages*, ed. Francesca Canadé Sautman and Pamela Sheingorn, pp. 277–304. New York: Palgrage, 2001.

———. *L'opera poetica di Virginia Martini Salvi (Siena, c. 1510–Roma, post 1571)*. Siena: Accademia degli Intronati di Siena, 2012.

———. "Poetesse senesi a metà Cinquecento: Tra politica e passione." *Studi rinascimentali: Rivista internazionale di letteratura italiana* 1 (2003): 95–102. Published contemporaneously in *Rinascimento e Rinascimenti: Storia, lingua, cultura e periodizzazioni*, 95–102. Salerno: Università di Salerno, 2003.

———. "The Religious Poetry of Michelangelo: The Mystical Sublimation." *Renaissance and Reformation* 23, no. 1 (1987): 123–36. Republished in *Michelangelo: Selected Scholarship in English*, ed. William E. Wallace, vol. 5, pp. 123–36 (New York: Garland, 1995).

———. Review of Diana Robin, *Publishing Women: Salons, the Presses, and the Counter-Reformation in Sixteenth-Century Italy. Rivista di studi italiani* 23, no. 1 (2008): 356–60.

Enciclopedia italiana di scienze, lettere ed arti. 36 vols. Rome: Istituto della Enciclopedia italiana, 1948–52.

Fabiani, Giuseppe. *Memorie per servire alla vita di monsignore Alessandro Piccolomini.* Siena: per Vincenzo Pazzini Carli, 1759.

Feldman, Martha. *City Culture and the Dialogue at Venice.* Berkeley: University of California Press, 1995.

Ferentilli, Agostino. *Primo volume della scielta di stanze di diuersi autori toscani, raccolte da M. Agostino Ferentilli. Et di nuovo con ogni diligenza ricorrette.* In Venetia: Filippo e Bernardo Giunti, 1579.

————. *Primo volume della scielta di stanze di diversi autori toscani, raccolte da Agostino Ferentilli . . . con aggiunta dalcune stanze non più messe in luce.* In Venetia: appresso Bernardo Giunti, & fratelli (appresso gli heredi di Pietro Deuchino), 1584.

————. *Primo volume della scielta di stanze di diuersi autori toscani, raccolte, & nuouamente poste in luce da M. Agostino Ferentilli, et da lui con ogni diligenza riuiste. Al signor Francesco Gentile.* In Venetia: ad instantia de' Giunti di Firenze, 1571.

Fiorentino, Francesco. "Donna Maria d'Aragona Marchesa del Vasto." *Nuova antologia di scienze, lettere e arti* 43, no. 2 (1884): 212–40.

Firenzuola, Agnolo. "Epistola in lode delle donne." In Agnolo Firenzuola, *Opere,* 2 vols. Milan: Dalla Società Tipografica de' Classici Italiani, 1802.

————. *On the Beauty of Women.* Trans. Konrad Eisenbichler and Jacqueline Murray. Philadelphia: University of Pennsylvania Press, 1992.

Flamini, Francesco. "Il Canzoniere inedito di Leone Orsini." In *Raccolta di studi critici dedicata ad Alessandro D'Ancona,* pp. 637–55. Florence: Barbèra, 1901.

Forteguerri, Laudomia. *Sonetti di Madonna Laudomia Forteguerri poetessa senese del secolo XVI.* [Ed. Alessandro Lisini]. Siena: Sordomuti, 1901.

Fumi, Luigi, and Alessandro Lisini, eds. *Genealogia dei Conti Pecci Signori d'Argiano Signori di Argiano.* Pisa: Direzione del Giornale Araldico/Libreria di Stefano Macario, 1880.

Gattoni, Maurizio. *Leone X e la geo-politica dello Stato Pontificio (1513–1521).* Collectanea archivi vaticani 47. Vatican City: Archivio Segreto Vaticano, 2000.

————. *Pandolfo Petrucci e la politica estera della Repubblica di Siena (1487–1512).* Siena: Cantagalli, 1997.

————. "La politica estera e il primato dei Petrucci a Siena (1498–1524)." In *Siena e il suo territorio nel Rinascimento: Renaissance Siena and Its Territory,* ed. Mario Ascheri, pp. 215–22. Siena: Il Leccio, 2000.

Giannetti, Laura. *Lelia's Kiss: Imagining Gender, Sex and Marriage in Italian Renaissance Comedy.* Toronto: University of Toronto Press, 2009.

Giovio, Paolo. *Lettere.* 2 vols. Ed. Giuseppe Guido Ferrero. Rome: Istituto Poligrafico dello Stato, 1956.

Graf, Arturo. *Attraverso il Cinquecento.* Turin: E. Loescher, 1888.

Grendler, Paul F. *The Universities of the Italian Renaissance.* Baltimore: Johns Hopkins University Press, 2002.

Guazzo, Marco. *Cronica di M. Marco Guazzo. Ne la quale ordinatamente contiensi l'essere de gli huomini illustri antiqui, & moderni, le cose, & i fatti di eterna memoria degni, occorsi dal principio del mondo fino a questi nostri tempi. Prima Editione.* In Venetia: Appresso Francesco Bindoni, 1553.

Guidiccioni, Francesco, and Francesco Coppetta Beccuti. *Rime.* Ed. Ezio Chiorboli. Bari: Gius. Laterza e Figli, 1912.

Haar, James. "Arie per cantar stanze ariostesche." In *L'Ariosto, la musica, i musicisti: Quattro studi e sette madrigali ariosteschi,* ed. M.A. Blasan, pp. 31–46. Florence: Leo S. Olschki, 1981.

———. "Pace non trovo: A Study in Literary and Musical Parody." *Musica Disciplina* 20 (1966): 95–149.

———. "The Madrigal Book of Jean Turhout (1589) and Its Relationship to Lasso." In *Orlando di Lasso Studies,* ed. Peter Bergquist, pp. 183–202. Cambridge: Cambridge University Press, 1999.

Hare, Christopher [Marian Andrews]. *Men and Women of the Italian Reformation.* New York: Charles Scribner's Sons, [1914].

Hoby, Sir Thomas. *The Travels and Life of Sir Thomas Hoby, Kt of Bisham Abbey, Written by Himself, 1547–1564.* Edited for the Royal Historical Society by Edgar Powell. London: Offices of the Society, 1902.

Hook, Judith. "Habsburg Imperialism and Italian Particularism: The Case of Charles V and Siena." *European History Quarterly* 9 (1979): 283–312.

Kallendorf, Craig. *A Bibliography of Renaissance Italian Translations of Virgil.* Biblioteca di bibliografia italiana 136. Florence: Olschki, 1994.

———. *A Bibliography of Venetian Editions of Virgil, 1470–1599.* Biblioteca di bibliografia italiana 123. Florence: Olschki, 1991.

Kidwell, Carol. *Pietro Bembo: Lover, Linguist, Cardinal.* Montreal: McGill-Queen's University Press, 2004.

Lee, Egmont, ed. *Descriptio Urbis: The Roman Census of 1527.* Rome: Bulzoni, 1985.

Lefevre, Renato. "La figura di Margarita d'Austria duchessa di Parma e Piacenza." *Aurea Parma* 52, no. 3 (1968): 155–93.

Leone Ebreo. *Dialoghi d'amore.* Ed. and trans. Giacinto Manuppella. Venice: Aldo Manuzio (in casa de figliuoli di Aldo), 1545.

———. *Diálogos de amor.* Ed. Giacinto Manuppella. 2 vols. Lisbon: Instituto Nacional del Investigaçao, 1983.

Leonetti, Francesca. *Virginia Salvi e Pierluigi da Palestrina: Uno studio su glosa e parodia.* Rome: Bagatto Libri, 2008.

Lewis, Mary S. *Antonio Gardano, Venetian Music Printer, 1538–1569*. 3 vols. New York: Garland, 1988.

Liberati, Alfredo. "Chiese, monasteri, oratori e spedali senesi: Ricordi e notizie." *Bullettino senese di storia patria* 48, no. 1 (1941): 66–80.

———. "Medaglie senesi." *Miscellanea storica senese* 6 (1903): 69–76.

Lirici del secolo XVI con cenni biografici. Milan: Edoardo Sonzogno, 1879.

Lisini, Alessandro. "Le poetesse senesi degli ultimi anni della Repubblica di Siena." *Miscellanea storica senese* 5 (1898): 33–38.

———. Introduction to *Sonetti di Madonna Laudomia Forteguerri Poetessa senese del secolo XVI*, ed. Alessandro Lisini. Siena: Sordomuti, 1901.

Lusini, Aldo. "Virginia Salvi ed un processo politico del sec. XVI." *La Diana* 5, no. 2 (1930): 130–54.

Magliani, Eduardo. *Storia letteraria delle donne italiane: Le Trovatrici—Preludi—Trecentiste—Quattrocentiste—Cinquecentiste*. Naples: Antonio Morano, 1885.

Malavolti, Orlando. *Dell'historia de Siena*. Historiae urbium et regionum Italiae rariores 50. 1599. Reprint, Bologna: Forni, 1968.

Mango, Francesco, ed. *La guerra di Camollia e La presa di Roma: Rime del sec. XVI*. 1886. Reprint, Bologna: Forni, 1969.

Marchetti, Valerio. "La formazione dei gruppi eretticali senesi del Cinquecento." In *Essays Presented to Myron P. Gilmore*, ed. Sergio Bertinelli and Gloria Ramakus, 2 vols., vol.1, pp. 115–43. Florence: La Nuova Italia Editrice, 1978.

Marucci, Valerio, ed. *Pasquinate del Cinque e Seicento*. Rome: Salerno Editrice, 1988.

Marucci, Valerio, Antonio Marzo, and Angelo Romano, eds. *Pasquinate romane del Cinquecento*. 2 vols. Rome: Salerno Editrice, 1983.

Marziali, Giovanni, ed. *Pietro Aldi*. Milan: Mezzotta, 1988.

Mauro, Giovanni. "Capitolo del viaggio di Roma al Duca di Malfi." In *Il primo libro dell'opere burlesche di M. Francesco Berni . . .*, pp. 110–11. In Londra: n.p., 1723.

Medici Archive Project. "Barbolani di Montauto, Pierfrancesco (il Signorotto, Otto)." 2005. http://documents.medici.org/people_details.cfm?personid= 922&returnstr=orderby=Name@is_search=1@result_id=10.

Melczer, William. "Platonisme et Aristotélisme dans la pensée de Léon l'Hébreu." In *Platon et Aristote à la Renaissance: XVIᵉ colloque international de Tours (1973)*, pp. 293–306. Paris: J. Vrin, 1976.

Monluc, Blaise de. *Blaise de Monluc all' assedio di Siena e in Montalcino, 1554–1557: Dal 3. e 4. libro dei suoi Commentari*. Trans. and commentary by Mario Filippone, preface by Mario Ascheri. Siena: Cantagalli, 1992; 2nd ed. 2004.

————. *Commentaires.* Ed. Paul Courteault. Paris: Librairie Alphonse Picard et fils, 1913.

————. *La guerra di Siena dopo l'assedio e capitolazione (1555) secondo la narrazione contenuta nel libro 4. dei suoi commentarj, con appendice.* [Ed. G.N.]. Florence: F. Lumachi, 1906.

Morsia, Daniela. "Da una corte all'altra: Il matrimonio con Orazio Farnese." In *Margherita d'Austria: Costruzioni politiche e diplomazia tra corte Farnese e monarchia spagnola,* ed. Silvia Mantini, pp. 55–64. Rome: Bulzoni, 2003.

Murray, Jacqueline. "Agnolo Firenzuola on Female Sexuality and Women's Equality." *Sixteenth Century Journal* 22, no. 2 (1991): 199–213.

Nievola, Fabrizio. *Siena: Constructing the Renaissance City.* New Haven: Yale University Press, 2007.

Novoa, James W. Nelson. "Aurelia Petrucci d'après quelques dédicaces entre 1530 et 1540." *Bullettino senese di storia patria* 109 (2004): 532–55.

————. "Mariano Lenzi: Sienese Editor of Leone Ebreo's *Dialoghi d'amore.*" *Bruniana e Campanelliana* 14, no. 2 (2008): 479–95.

Ottolenghi, D. "Studi demografici sulla popolazione di Siena dal secolo XIV al XIX." *Bullettino senese di storia patria* 10, no. 3 (1903): 297–358.

Ovid. *Fasti.* Trans. Sir George Frazaner. Cambridge, MA: Harvard University Press, 1989.

Palestrina, Giovani Pierluigi da. *Le opere complete.* 3 vols. Ed. Raffaele Casimiri. Rome: F.lli Scalera, 1939.

————. *Il primo libro de madrigali a quattro voci.* Venice: Girolamo Scoto, 1596.

Pardi, Giuseppe. "La popolazione di Siena e del territorio Senese attraverso i secoli." *Bullettino senese di storia patria* 30, no. 2 (1923): 85–132, and 32, nos. 1–2 (1925): 3–62.

Parnaso italiano. Poeti italiani contemporanei maggiori e minori preceduti da un Discorso preliminare intorno a Giuseppe Parini e il suo secolo scritto da Cesare Cantu e seguiti da un saggio di rime di poetesse italiane antiche e moderne scelte da A. Ronna. Paris: Baudry, Libreria Europea, 1847.

Parnaso italiano. Vol. 12. *Lirici.* Venice: G. Antonelli, 1851.

Pastor, Ludwig von. *History of the Popes.* 40 vols. London: K. Paul, Trench, and Trubner, 1891–1961.

Pecci, Giovanni Antonio. *Memorie storico-critiche della città di Siena.* 4 vols. in 2. Siena: Agostino Bindi, 1758. Reprint, Siena: Edizioni Cantagalli, 1988.

————. *Petrarch's Lyric Poems: The "Rime sparse" and Other Lyrics.* Trans. and ed. Robert M. Durling. Cambridge, MA: Harvard University Press, 1976.

————. *Rerum vulgarium fragmenta: Facsimile del codice autografo Vaticana Latina 3195.* Ed. Gino Belloni, Furia Brugnolo, H. Wayne Storey, and Stefano Zamponi. Padua: Antenore, 2003–4.

Piccolomini, Alessandro. *Cento sonetti.* Ed. Giordano Ziletti. Rome: Vincenzo Valgrisi, 1549.

————. *De la institutione di tutta la vita de l'homo nato nobile e in citta libera. Libri X in lingua toscana. Doue e peripateticamente e platonicamente intorno à le cose de l'ethica, iconomica, e parte de la politica, è raccolta la somma di quanto principalmente può concorrere à la perfetta e felice vita di quello composti dal s. Alessandro Piccolomini, à benifitio del nobilissimo fanciullino Alessandro Colombini, pochi giorni innnazi nato; figlio de la immortale mad. Laudomia Forteguerri. Al quale (hauendolo egli sostenuto à battesimo) secondo l'usanza de i compari de i detti libri fà dono.* Venetiis: Apud Hieronymum Scotum, 1542.

————. *De la sfera del mondo. Libri quattro in lingua toscana: i quali non per via di traduttione, nè a qual si voglia particolare scrittore obligati: ma parte da i migliori raccogliendo, e parte di nuovo producento: contengano in se tutto quel ch'intorno a tal materia si possa desiderare, ridotti a tanta ageuolezza, & a così facil modo di dimostrare che qual si voglia poco essercitato negli studij di matemmatica potrà ageuolissimamente & con prestezza intenderne il tutto: de le stelle fisse, libro uno con le sue figure, e con le sue tavole: dove con maravigliosa ageuolezza potrà ciascheduno conoscere qualunque stella dele XLVIII immagini del cielo stellato, e le fauole loro integramente: & sapere in ogni tempo del'anno, a qual si voglia hora di notte, in che parte del cielo si truovino, non solo le dette immagini, ma qualunq[ue] stella di quelle.* Venetia: Giovanantonio & Dominico fratelli di Volpini da Casteliufredo, ad instantia de Andrea Ariuabeno, 1540.

————. *Lettura del S. Alessandro Piccolomini Infiammato fatta nell'Accademia degli Infiammati, M. D. XXXXI.* Bologna: Bartholomeo Bonardo e Marc'Antonio da Carpi, 1541.

————. *Orazione di Monsignore Alessandro Piccolomini fatta in morte di Aurelia Petrucci nel 1542.* Florence: Domenico Marzi e Compagni, 1771.

————. *La Raffaella, ovvero Dialogo della bella creanza delle donne.* Ed. Giancarlo Alfano. Rome: Salerno Editrice, 2001.

Piccolomini, Marc'Antonio. "Se è da credersi che una donna compiuta in tutte quelle parti così del corpo come dell'animo, che si possino desiderare, sia prodotta da la natura a sorte o pensatamente." In Rita Belladonna, "Gli Intronati, le donne, Aonio Paleario e Agostino Museo in un dialogo inedito di Marcantonio Piccolomini il Sodo Intronato (1538)." *Bullettino senese di storia patria* 99 (1992): 48–90.

Piéjus, Marie-Françoise. "La création au féminin dans le discours de quelques poétesses du XVIe siècle." In *Dire la Création: La culture italienne entre poétique et poïétique,* ed. Dominique Budor, pp. 79–90. Lille: Diffusion Presses Universitaires de Lille, 1994. Republished in Piéjus, *Visages et paroles de femmes dans la littérature italienne de la Renaissance,* pp. 209–20 (Paris: Université Paris III Sorbonne Nouvelle, 2009).

————. "Une lecture académique d'Alessandro Piccolomini la poésie féminine à l'honneur." In *Les années trente du XVI^e siècle italien: Actes du colloque (Paris, 3–5 juin 2004),* eds. Danielle Boillet and Michel Plaisance, pp. 237–48. Paris: Centre internuniversitaire de recherce sur la Renaissance Italienne (CIRRI), 2007. Republished in Piéjus, *Visages et paroles de femmes dans la littérature italienne de la Renaissance,* pp. 235–64 (Paris: Université Paris III Sorbonne Nouvelle, 2009).

————. "Les poétesses siennoises entre le jeu et l'écriture." In *Le femmes écrivains en Italie au Moyen âge et à la Renaissance,* pp. 315–32. Aix-en-Provence: Publications de l'Université de Provence, 1994. Republished in Piéjus, *Visages et paroles de femmes dans la littérature italienne de la Renaissance,* pp. 221–34 (Paris: Université Paris III Sorbonne Nouvelle, 2009).

————. "La première anthologie de poèmes féminins: l'écriture filtrée et orientée." In *Le pouvoir et la plume: Incitation, contrôle et répression dans l'Italie du XVI^e siècle. Actes du Colloque international organisé par le Centre Interuniversitaire de Recherche sur la Renaissance italienne et l'Institut Culturel Italien de Marseille: Aix-en-Provence, Marseille, 14–16 mai 1981,* pp. 193–213. Paris: Université de la Sorbonne Nouvelle, 1982. Republished in Piéus, *Visages et paroles de femmes dans la littérature italienne de la Renaissance,* pp. 265–81 (Paris: Université Paris III Sorbonne Nouvelle, 2009).

————. "Venus bifrons: Le double idéal féminin dans *La Raffaella* d'Alessandro Piccolomini." In *Images de la femme dans la littérature italienne de la Renaissance: Préjugés misogynes et aspirations nouvelles,* ed. José Guidi, Marie-Françoise Piéjus, and Adelin-Charles Fiorato, pp. 81–167. Paris: Université de la Sorbonne Nouvelle, 1980. Republished in Piéjus, *Visages et paroles de femmes dans la littérature italienne de la Renaissance,* pp. 73–139 (Paris: Université Paris III Sorbonne Nouvelle, 2009).

Pignotti, Guido. *I pittori senesi della Fondazione Biringucci (1724–1915).* Siena: Giuntini-Bentivoglio Editore, 1916.

Procaccioli, Paolo, ed. *Lettere scritte a Pietro Aretino.* 2 vols. Rome: Salerno Editrice, 2002.

Prunai, Giulio. "L'arrivo a Siena del cardinal di Ferrara." *Bullettino senese di storia patria* 42, no. 2 (1935): 165–67.

Quadrio, Francesco Saverio. *Della storia e della ragion d'ogni poesia.* 4 vols. Bologna: Pisarri, 1739–1752.

Rendina, Claudio. *Pasquino statua parlante: Quattro secoli di pasquinate.* Rome: Newton Compton Editori, 1991.

Repetti, Emanuele. *Dizionario geografico, fisico, storico della Toscana contenente la descrizione di tutti i luoghi del Granducato, Ducato di Lucca, Garfagnana e Lunigiana.* 6 vols. Florence: Presso l'autore e editore, 1833.

Ricorda, Ricciarda. "Travel Writing, 1750–1860." In *A History of Women's Writing in Italy,* ed. Letizia Panizza and Sharon Wood, pp. 107–8. Cambridge: Cambridge University Press, 2000.

Rime di diversi in morte di Donna Livia Colonna. Rome: Per Antonio Barrè, 1555.

Rime di poeti italiani del secolo XVI. Scelta di curiosità letterarie 126. Bologna: Presso Gaetano Romagnoli, 1873.

Robin, Diana. *Publishing Women: Salons, the Presses, and the Counter-Reformation in Sixteenth-Century Italy.* Chicago: University of Chicago Press, 2007.

Rore, Cipriano de. *Il secondo libro de' madregali a quatro voci con una canzon di Gianneto [Palestrina] sopra di Pace non trovo con quattordici stanze novamente per Antonio Gardano stampato et dato in luce.* [Venice]: Appresso di Antonio Gardano, 1557. RISM 1557[24].

———. *Il secondo libro de madregali a quatro voci con una canzon di Gianneto [Palestrina] sopra di Pace non trovo, con quatordeci stanze. Novamente con ogni diligentia ristampato.* Venice: Eredi di Antonio Gardano, 1571. RISM 1517[10].

———. *Il secondo libro de' madrigali a quatro uoci con una Canzon di Gianneto [Palestrina] sopra di Pace non trouo. Con quatordeci stanze nouamente per Antonio Gardano stampato et dato in luce.* Venice: Claudio Merulo da Correggio, 1569 (RISM 1569[33].

Ross, Sarah Gwyneth. *The Birth of Feminism: Woman as Intellect in Renaissance Italy and England.* Cambridge, MA: Harvard University Press, 2009.

Rossi, Maria. "Le opere letterarie di Alessandro Piccolomini." *Bullettino senese di storia patria* 17 (1910): 289–328 and 18 (1911): 3–53.

Ruggiero, Guido. "Marriage, Love, Sex, and Renaissance Civic Morality." In *Sexuality and Gender in Early Modern Europe: Institutions, Texts, Images,* ed. James Grantham Turner, pp. 10–30. Cambridge: Cambridge University Press, 1993.

Russell, Camilla. *Giulia Gonzaga and the Religious Controversies of Sixteenth-Century Italy.* Late Medieval and Early Modern Studies 8. Turnhout: Brepols, 2006.

Sabbatino, Pasquale. "In pellegrinaggio alle dimore poetiche del Petrarca." *Studi rinascimentali* 1 (2003): 61–82.

Sacchetti, Franco. *Il trecento novelle.* Ed. Emilio Faccioli. Turin: G. Einaudi, 1970.

Salza, Abdelkader. "Da Valchiusa ad Arquà." In *Raccolta di studi di storia e critica letteraria dedicata a Francesco Flamini da' suoi discepoli,* pp. 721–83. Pisa: Mariotti, 1918.

Sbaragli, Luigi. "'I Tabelloni' degli Intronati." *Bullettino senese di storia patria* 49, nos. 3–4 (1942): 177–213, 238–67.

Scaglioso, Carolina. "Le carte delle Assicurate, un'accademia femminile senese del XVII secolo." PhD diss., Università degli Studi di Siena, 1991–92.

Scelta di poesie liriche dal primo secolo della lingua fino al 1700. Florence: Felice Le Monnier, 1839.

Scoles, Emma, and Ines Ravasini. "Intertestualità e interpretazione del genere lirico della glosa." In *Nunca fue peña mayor (Estudios de literatura española en homanaje a Brian Dutton),* ed. Ana Menéndez Collera and Victoriano Roncero López, pp. 615–31. Cuenca: Ediciones de la Universidad de Castilla–La Mancha, 1996.

Shemek, Deanna. *Ladies Errant: Wayward Women and Social Order in Early Modern Italy.* Durham: Duke University Press, 1998.

Sicuro, Antonio. *Rime di diversi eccell. autori in morte della Illustriss. Sig. D. Hippolita Gonzaga.* Napoli: I. M. Scotto, 1564.

Smith, Jamie. "Negotiating Absence: Law and the Family in Genoa, 1380–1420." PhD diss., University of Toronto, 2007.

Somerset, Anne. *Elizabeth I.* London: Weidenfeld and Nicolson, 1991.

Sozzini, Alessandro. "Diario delle cose avvenute in Siena dal 20 luglio 1550 al 28 giugno 1555." *Archivio storico italiano* 2 (1842): i–xvi, 1–624. Reprint, Siena: Edizioni Periccioli, [1987].

———. *La guerra di Siena.* "*Il successo delle rivoluzioni della città di Siena d'imperiale franzese e di franzese imperiale scritto da Alessandro di Girolamo Sozzini gentiluomo senese.*" "*Diario delle cose avvenute in Siena dal 20 Luglio 1550 al 28 Giugno 1555.*" Archivio storico italiano 2. Florence: Gio. Pietro Viesseux, 1842. Reprint, Siena: Edizioni Periccioli, [ca. 1970].

Stampa, Gaspara, and Veronica Franco. *Rime.* Ed. Abd-el-Kader Salza. Scrittori d'Italia 52. Bari: Laterza, 1913.

Stortoni, Laura Anna, ed. *Women Poets of the Italian Renaissance: Courtly Ladies and Courtesans.* Trans. Laura Anna Stortoni and Mary Prentice Lillie. New York: Italica Press, 1997.

Tansillo, Luigi. *Poesie liriche edite ed inedite . . . con prefazione e note di F. Fiorentino.* Naples: Domenico Marano, 1883.

Tasso, Bernardo. *L'Amadigi.* In Vinegia: Appresso Gabriel Giolito de' Ferrari, 1560.

———. *Rime.* Ed. Domenico Chiodo. 2 vols. Turin: RES, 1995.

Thieffry, Sandrine. "Jean de Turnhout, compositeur et maître de chapelle à la Cour de Bruxelles (ca 1550–1614)." *Revue belge de musicologie* 58 (2005): 23–43.

Thieme, Ulrich, and Felix Becker. *Allgemeines Lexikon der bildenden Künstler von der Antike bis zur Gegenwart.* 37 vols. 1909–50. Reprint, Leipzig: E. A. Seemann, 1965–66.

Thurman, Judith. "The Anatomy Lesson: Sixteenth-Century Sexual Transgressions." *New Yorker,* 8 December 2003.

Tiraboschi, Girolamo. *Storia della letteratura italiana*. Venice: [Antonio Fortunato Stella], 1796. Reprint, Florence: Presso Molini Landi, 1805–13.4

Tobia, Marco, ed. *Fiori di rimatrici italiane dal secolo XIV al XVIII*. Venice: Tipografia di Alvisopoli, 1846.

Tolomei, Claudio. *De le lettere di M. Clavdio Tolomei lib. sette. Con vna breve dichiarazione in fine di tvtto l'ordin de l'ortografia di qvesta opera*. In Vinegia: Appresso Gabriel Giolito de Ferrari, 1547.

Tommasi, Giugurta. *Dell'historie di Siena: Deca seconda*. Ed. Mario De Gregorio. 4 vols. Siena: Accademia Senese degli Intronati, 2006.

Trucchi, Francesco, ed. *Poesie italiane inedite di dugento autori dall'origine della lingua infino al secolo decimosettimo*. 4 vol. Prato: Guasti, 1846–47.

Ugurgieri Azzolini, Isidoro. *Le pompe sanesi o' vero relazione delli huomini, e donne illustri di Siena, e suo stato*. 2 vols. In Pistoia: Nella Stamperia di Pier'Antonio Fortunati, 1649.

Van Lennep, S. A. *Les années italiennes de Marguerite d'Autriche, duchesse de Parma*. Geneva: Editions Labor et Fides, [1952].

Varchi, Benedetto. *De sonetti di M. Benedetto Varchi*. In Fiorenza: Apresso M. Lorenzo Torrentino, 1555.

———. *Opere*. Ed. Antonio Racheli. Biblioteca classica italiana, secolo XVI, no. 6. Trieste: Lloyd austriaco, 1858–59.

Vasari, Giorgio. *Opere*. Ed. Gateano Milanesi. Florence: Sansoni, 1973.

Vignali, Antonio. *La Cazzaria*. Ed. Pasquale Stoppelli. Rome: Edizioni dell'Elefante, 1984.

———. *Dulpisto*. Ed. James W. Nelson Novoa. http://parnaseo.uv.es/Lemir/Textos/Dulpisto.pdf.

Vigo, Pietro. *Carlo V in Siena nell'aprile del 1536: Relazione di un contemporaneo*. Bologna: Presso Gaetano Romagnoli, 1884.

Virgil. *I sei primi libri del Eneide di Vergilio*. Vinegia: per Giouanni Padouano, Ad instantia e spesa del nobile homo, M. Federico Torresano d'Asola. 1544. Reprint, Bologna: Forni, 2002.

———. *I sei primi libri dell'Eneide di Vergilio, Tradotti à più illustre et honorate Donne. Et tra l'altre à la nobilissima et divina madonna Aurelia Tolomei de Borghesi, à cui ancho è indirizzato tutto il presente volume*. In Vinetia: per Comin da Trino, Ad instantia de Nicolo d'Aristotile detto Zopino, 1540 (Adi xij. del mese di ottobre).

———. *I sei primi libri di Vergilio a più illustre et honorate donne (Venezia, Zoppino, 1540): L'Eneida in Toscano di Aldobrando Cerretani (Firenze, Torrentino, 1560)*. Ed. Luciana Borsetto. Archivi del Cinquecento 3. Bologna: Forni, 2002.

Vocabolario etimologico della lingua italiana. Ed. Ottorino Pianigiani. 1907. Rome: Società editrice Dante Alighieri, 1998. www.etimo.it.

Waddington, Raymond B. *Aretino's Satyr: Sexuality, Satire and Self-Projection in Sixteenth-Century Literature and Art.* Toronto: University of Toronto Press, 2004.

Xenophon. *La Economica di Xenofonte, tradotta di lingva Greca in lingva Toscana, dal S. Alessandro Piccolomini, altrimenti lo Stordito Intronato.* In Vinegia: Al Segno del Pozzo (Comin de Tridino de Monferrato), 1540.

Zeller, Jean. *La diplomatie française vers le milieu du XVIe siècle d'apres la correspondance de Guillaume Pellicier, évèque de Montpellier, ambassadeur de François Ier à Venise (1539–1542).* Paris: Librairie Hachette et Cie, 1881.

INDEX OF FIRST LINES

INDEX OF NAMES

KONRAD EISENBICHLER

is professor of Renaissance and Italian studies at

the University of Toronto. He is the author, translator,

and editor of seventeen books, including *The Renaissance*

in the Streets, Schools, and Studies, and *Renaissance Medievalisms.*